The Shape of Color

n Miró's

Painted Sculpture

Corcoran Gallery of Art
Washington, D.C.
September 21, 2002–January 6, 2003

Salvador Dalí Museum
St. Petersburg, Florida
February 1–May 4, 2003

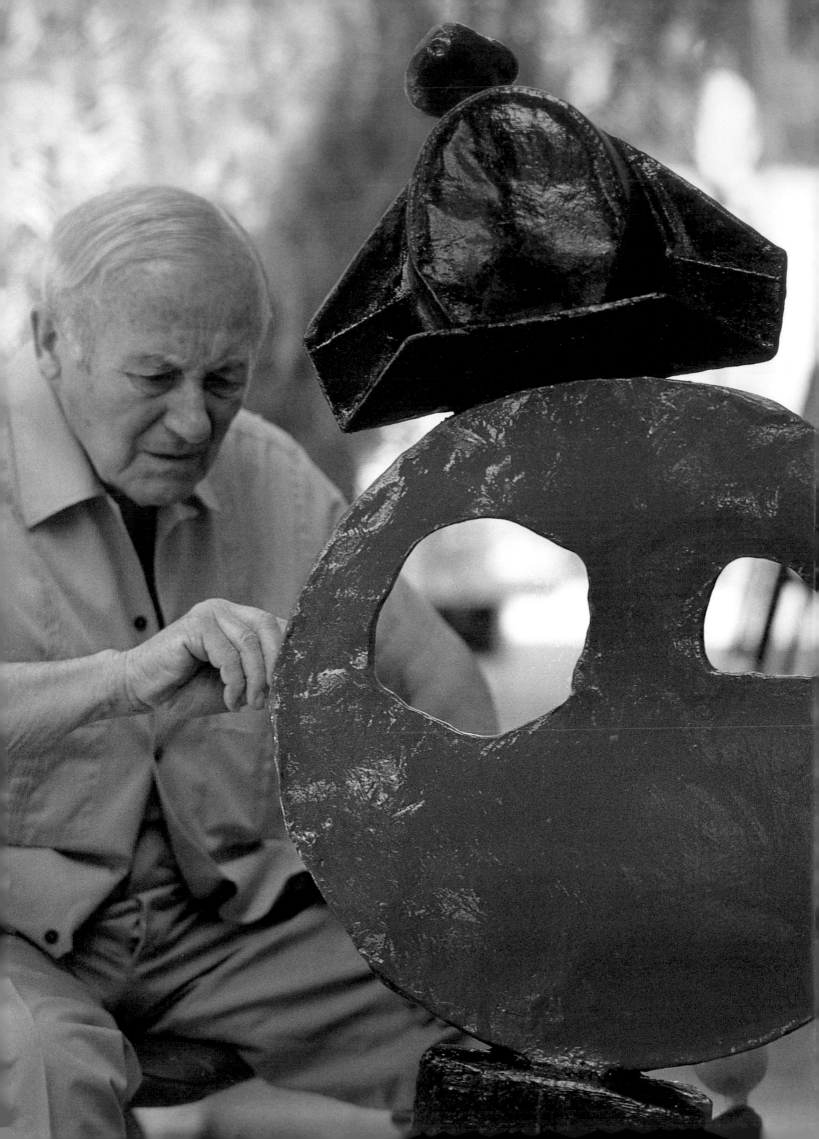

Laura Coyle

William Jeffett

Joan Punyet Miró

The Shape of Color

Joan Miró's
Painted Sculpture

CORCORAN

Corcoran Gallery of Art, Washington, D.C.
Catalogue published in association
with Scala Publishers Ltd., London

SCALA

Front cover:
Joan Miró, *La caresse d'un oiseau* (detail).

Back cover:
Joan Miró painting *La caresse d'un oiseau*.

Frontispiece:
Joan Miró painting *Femme et oiseau*.

General editors: Laura Coyle and William Jeffett
Catalogue consultant: Amy Pastan
Editorial director, Scala Publishers Ltd.: Miranda Harrison
Designer: Yvonne Dedman
Copy-editor: Slaney Begley

Library of Congress Cataloguing-in-Publication Data
is available upon request.

ISBN 1 85759 288 3

The exhibition is supported by the Exxon Mobil Corporation,
Morgan Stanley Private Wealth Management, and the Alcoa
Foundation. At the Corcoran Gallery of Art, the exhibition is
supported by the President's Exhibition Fund.

The catalogue is supported by the Andrew W. Mellon
Publications Fund at the Corcoran Gallery of Art.

Published in 2002 by the Corcoran Gallery of Art,
Washington, D.C., and Scala Publishers Ltd., London.

Printed in Italy

*When I pick up a stone it's a stone;
when Miró picks up a stone it's a Miró.*

Joan Prats

Contents

Foreword

Joan Miró (b. 1893, Barcelona, Spain; d. 1983, Palma de Mallorca, Spain) enjoyed a protean 75-year career as a painter, sculptor, muralist, and printmaker that has earned him a lasting place as one of the most innovative artists of the twentieth century. His work has been, and remains, an inspiring example to several generations of artists around the world.

Miró was raised in Catalonia, Spain, and he returned to this region throughout his life. Its dramatic landscape, agrarian roots, fiercely independent people, and distinctive folk culture continually infused his art. Miró also participated in the major art movements of his time. He exploited the anarchic, rebellious spirit of Dada in the 1920s and the fertile territory of dreams, memory, and the subconscious characteristic of Surrealism in the 1930s. He remained active internationally into the 1980s to create a tremendously varied and original body of work. An unaffected balance of childlike innocence and worldly sophistication; a deep reverence for nature, especially for the rugged rural landscape and the starlit night sky; and a tolerant, playful approach to the universally complex relations between men and women are the unifying threads that weave through his diverse work.

Miró concentrated on sculpture twice during his career. The first time was in the early 1930s, when he questioned the very notion of painting itself. Although Miró worked intermittently on sculpture for the next thirty years, it was not a major focus for him until the 1960s and 1970s. *The Shape of Color: Joan Miró's Painted Sculpture* examines the artist's second period of sculpture.

Miró explored several directions in his work late in his life. He was intensely interested in ceramics, collaborating with his life-long friend Josep Llorens Artigas. Together they produced more than 200 pieces between 1954 and 1956. In the mid-1950s, Miró designed his first ceramic murals, and over the next two decades his colorful, mosaic-tiled walls enhanced public buildings in Europe, the United States, and Japan. About this time, Miró also decided to give up his apartment and studio in Barcelona to move to the beautiful, craggy island of Mallorca. There he lived with his family in the villa Son Abrines and worked in two studios: a magnificent new space designed by his friend Josep Lluís Sert, and Son Boter, an old house converted to a studio nearby. These spaces provided him with enough room to work on a much larger scale, something he had wanted to do for many years. He had nearly stopped painting altogether while he concentrated on ceramics, but when he returned to his canvases, he broadly brushed highly evocative, wide fields of intense color. And in his seventies, at an age when most people justly feel that they can rest on their laurels, he rediscovered sculpture with a passion.

In 1964, with the architect Sert, he planted thirteen monumental sculptures in the beautifully sited garden, "The Labyrinth," at the new Fondation Maeght in the South of France. Two years later he made his first monumental bronzes, *Oiseau lunaire* and *Oiseau solaire*. About the same time he began to work on smaller sculptures, some patinated and others brightly painted. As Miró had wanted them to be, the colorful works were particularly shocking, and also full of mischief and sly humor. Out of these grew the monumental polychrome sculptures of his last years. These vibrant small and large sculptures are the focus of *The Shape of Color*.

This project would have been impossible without the support of those listed on the lenders' page, who generously parted with their precious Mirós for nearly a year. Special mention must be made of the directors and curators at the two Miró foundations, who not only lent most of the works to the show, but also graciously made their collections available for the exhibition's curators to study many times. We owe a tremendous debt of gratitude to Rosa Maria Malet, director of the Fundació Joan Miró in Barcelona, and Aurelio Torrente Larrosa, director of the Fundació Pilar i Joan Miró a Mallorca. The curators at these two foundations, Teresa Montaner in Barcelona and Pilar Baos in Palma de Mallorca, also deserve special recognition for their liberal and affable assistance with all phases of this project.

Joan Miró's grandsons, who manage the Successió Miró, provided valuable guidance at several stages. Emilio Fernández Miró, who is preparing the *catalogue raisonné* of Miró's sculpture, provided crucial leads in locating several works. Joan Punyet Miró, who has written and lectured widely on Miró's work, lent his expertise. He also wrote the illuminating essay in this publication about the impact of Catalan and Mallorcan culture on Miró's work.

The curators for the exhibition and editors of this publication—Laura Coyle, curator of European Art at the Corcoran Gallery of Art, and William Jeffett, curator of exhibitions at the Salvador Dalí Museum—collaborated closely on *The Shape of Color* for more than three years. With Miró as their model, they worked diligently, but always with good humor. At the Corcoran, Jacquelyn Days Serwer, chief curator, enthusiastically backed this project from the moment she joined the museum's staff in 1999, and she remained unstinting in her support of both curators and their joint project to the end.

We are grateful to the Exxon Mobil Corporation, Morgan Stanley Private Wealth Management and the Alcoa Foundation for their support of the exhibition. At the Corcoran, the President's Exhibition Fund also helped to underwrite the show. The Andrew W. Mellon Publications Fund at the Corcoran Gallery of Art paid for this handsome publication.

The Shape of Color brings together Miró's painted sculpture with the relevant artist's sketchbooks, preparatory drawings, and archival photographs. This reunion documents Miró's inspiration and his creative process, from his first quick sketch to the finished work. *The Shape of Color* reveals that even at the end of Miró's long career, his talent and originality bloomed fresh, always bright and forever young.

David C. Levy
President and Director
Corcoran Gallery of Art

Charles Henri Hine
Executive Director
Salvador Dalí Museum

July 1, 2002

Acknowledgments

With gratitude and pleasure, we acknowledge the many people with whom we worked on this project. Those at two institutions in particular deserve our warmest thanks. These are director Rosa Maria Malet and curator Teresa Montaner of the Fundació Joan Miró in Barcelona, and director Aurelio Torrente Larrosa and curator Pilar Baos at the Fundació Pilar i Joan Miró a Mallorca. Without the loans they approved, especially of many fragile and rarely exhibited works on paper, we could not have mounted the exhibition that accompanies this book. In addition to the loans, their support was crucial, as they opened their archives, their storerooms, and many doors outside their own institutions to help us. Françoise Cauët, Elena Bolívar Cordón, Elvira Gaspar, Jordi Juncosa, Teresa Martí, and Anna Noëlle at the Fundació Joan Miró and María Luisa Lax, Aránzazu Miró, and Núria Sureda at the Fundació Pilar i Joan Miró a Mallorca also assisted us.

We are extremely grateful to the other lenders to this exhibition: Acquavella Modern Art; Thomas Ammann Fine Art; Mme Sylvie Baltazart-Eon, Paris; The Eli and Edythe L. Broad Collection, Los Angeles; "Colección Testimonio" de "la Caixa," Barcelona; Marcel Elefant, Monte Carlo, Monaco; the JPMorgan Chase Tower Collection; and the Museum of Fine Arts, Houston. We recognize the decision to lend is never an easy one. We are very grateful for their generosity, which allows us to show the full range of Miró's painted sculpture in the context of its creation for the first time.

The staff of the Successió Miró in Palma de Mallorca have graciously accommodated many requests for information over the last three years. The grandsons of the artist, Emilio Fernández Miró and Joan Punyet Miró, who manage the Successió Miró, have enthusiastically supported this project since its conception. The Successió's archivist, Pilar Ortega, was also of enormous assistance.

In Barcelona, we were welcomed into the archives of two well-known Catalan photographers who were also great friends of Joan Miró and his family. One is that of Joaquim Gomis, run by his daughter and her husband, Odette Gomis Cherbonnier and Josep Viñas Riera. The other archive is of Francesc Català-Roca, managed by his sons, Martí Català Pedersen and Andreu Català Pedersen. The results of this pleasant and productive research may be found throughout this publication, which is greatly enhanced by beautiful and revealing Gomis and Català-Roca photographs.

Others in Spain who received us were Joan Gardy Artigas, Angel Bofarull, Joan Fontcuberta, Anna Guarro and Borja Zabala, María Teresa Ocaña, Santiago Olmo, Laura Medina and Jaume Plensa, Miralda, Isabel Salisachs, and Evru.

In France, we called on Jean-Louis Prat, director of the Fondation Maeght in St. Paul. Along with the Fondation Maeght's extraordinary holdings of Miró's painting and sculpture, we found there several rare films about Miró. Mickaël Phul and Annette Pioud also assisted us at the foundation.

In the United States, many people guided and supported us. These include Jack Cowart, executive director of the Roy Lichtenstein Foundation. When he was deputy director at the Corcoran he suggested to us that Miró's painted sculpture might make an interesting exhibition. Others who advised us include Ann-Marie Curtin; Martin Friedman; Eliane Gans; Roberta Geier, reference librarian, National Gallery of Art Library; Esther Gómez, Tourist Office of Spain; Duncan MacGuigan, Acquavella Galleries, Inc.; Carolyn Lanchner, curator, and Anne Umland, associate curator, department of painting and sculpture, The Museum of Modern Art; Stuart Nielsen; Robert Parks, director of library and museum services, and Robert H. Taylor, curator and department head of literary and historical manuscripts, The Morgan Library, and Inge Dupont, McKenna Lebens, and Sylvie Merian, The Morgan Library Reading Room; Erik M. Stolz; and Antoine Wilson, Nancy Escher, Inc. Thanks are also due to I. M. Pei for generously sharing his recollections of the commissioning of one of Miró's most important public sculptures. Additional thanks are due to Nancy Robinson, his executive assistant.

We are pleased to enjoy the full support of Javier Ruperez, Spanish ambassador to the United States, and his wife Rakela Cerovic. Juan Romero de Terreros, head of the cultural office at the Embassy of Spain in Washington, D.C., graciously met with us several times. Didi Fitzpatrick and Diane Flamini at the embassy also assisted us enthusiastically.

At the Corcoran Gallery of Art, particular thanks go to David C. Levy, director, and Jacquelyn Days Serwer, chief curator. Without their strong endorsement, this project would have been impossible. We also appreciate the enthusiastic support of Katy Ahmed, director of corporate relations and events; Michael Roark, chief financial officer; and Jan Rothschild, chief communications officer. Also deserving of special recognition are Ken Ashton, preparator; registrars Kimberly Davis and Rebekah Sobel; Sara Kuffler Durr, Susan Kenney, and Wilona Sloan, public affairs; research assistants Erin Boyles, Suzanne E. May, and Jennifer O'Keefe; Joan Oshinsky, traveling exhibitions coordinator; and Elizabeth Parr, director of special exhibitions.

Other colleagues who supported us at the Corcoran include Diane Arkin, Susan Badder, Jonathan P. Binstock, Chris Brooks, Steve Brown, Claudia Covert, Yvonne Dailey, Anita de Castro Foden, Abby Frankson, Kate Gibney, Dare Hartwell, Kathryn Keane, Laura Jacobs, David Jung, Christina Knowles, Deborah Mueller, Laura Pasquini, Clyde Paton, Kimberly Pinkston, Donna Stubbs, Rachel Venezian, Robert Villaflor, and Amanda Zucker.

At the Salvador Dalí Museum, Marshall Rousseau, director emeritus, and Charles Henri Hine, current executive director, backed the project wholeheartedly. Dirk Armstrong, assistant curator, Joan Kropf, curator, Kelly Reynolds, assistant curator, Peter Tush, curator of education, and Kathy White, public relations, also aided us.

We received financial support for our research in Spain from several organizations. These include the Embassy of Spain in Washington, D.C., IBATUR, Mallorca; Iberia Airlines; the Office of Spanish Tourism; Spanair; Turespaña, Madrid; and our own museums.

For this handsome publication, we thank Amy Pastan, publications consultant, for her valuable advice and negotiating skills. Helene Aguilar ably translated Joan Punyet Miró's text. The commitment of the staff at Scala Publishers, Ltd., was evident at every stage in producing this book. At Scala, we are grateful to: Slaney Begley, editor; Yvonne Dedman, designer; Miranda Harrison, editorial director; and Margaret Staker, production director. The Corcoran Gallery of Art's Andrew W. Mellon Publications Fund underwrote the publication.

The exhibition was supported by the Exxon Mobil Corporation, Morgan Stanley Private Wealth Management, and the Alcoa Foundation. At the Corcoran Gallery of Art, the exhibition is supported by the President's Exhibition Fund.

Finally to Douglas Robertson, Mariana Virginia Coyle Robertson, and Helena Szépe: they know firsthand just how much time we spent on this project, and we offer them our most heartfelt thanks.

Laura Coyle
Curator of European Art
Corcoran Gallery of Art
Washington, D.C.

William Jeffett
Curator of Exhibitions
Salvador Dalí Museum
St. Petersburg, Florida

Lenders to the Exhibition

Acquavella Modern Art

Thomas Ammann Fine Art

Collection of Mme Sylvie Baltazart-Eon, Paris

The Eli and Edythe L. Broad Collection, Los Angeles

"Colección Testimonio" de "la Caixa," Barcelona

Marcel Elefant, Monte Carlo, Monaco

Fundació Joan Miró, Barcelona

Fundació Pilar i Joan Miró a Mallorca

JPMorgan Chase Tower Collection

Museum of Fine Arts, Houston

1. *(opposite)* **Joan Miró's family home in Montroig.**

2. *(below)* **The farm at Montroig.**

Catalan and Mallorcan Aspects of Miró's Painted Sculpture

Joan Punyet Miró

The intensity that so clearly illuminates Miró's roots is conspicuous in his painted sculpture. All these strange works are the product of an artist born to a Mallorcan mother and a Catalan father. These two polar energies race, glide, and intertwine through the very molecules of his blood. The enormous respect with which Miró regarded the Catalan writer Eugeni D'Ors is worth noting. Among friends Miró often alluded to D'Ors' work titled *La ben plantada* (*The Well-planted One*; "*plantada*" is a loaded word, meaning both "beautiful" and "rooted"), with its description of an allegorical presence: a woman whose roots are firmly grounded in Catalonia, whose strong torso emerges erect, and whose branches reach up to fill the sky.

Miró identified with this image, and his painted sculptures are the physical embodiment of D'Ors' words. All their ingredients come from Miró's farm in the village of Montroig, near Tarragona (figs. 1, 2), and from his studio in Palma de Mallorca. In all his sculpture, both painted and unpainted, Miró communicates the great pull of Catalonia. He was in the habit of using Catalan, his native language, everywhere, as instanced in a letter he sent to the art critic and editor Peter Bellew while engaged on the ceramic murals for UNESCO. Miró asked Bellew to correct a serious spelling error—his first name was listed with a "u" instead of an "o"; even when he visited the United States, where "Joan" is a woman's name, Miró insisted on the Catalan spelling of his name (Joan) rather than the Spanish equivalent (Juan).

How important is the correct spelling of a man's name? Very important indeed, when that man witnessed the collapse of Spain's Second Republic and her servitude under the dictator Franco. In 1939 Catalan culture was facing annihilation, as were all those who fought to save it. Miró never saw armed combat on the front lines, but by sheer tenacity and iron discipline he succeeded in sowing the seeds for the regrowth of this culture in the fainting souls of millions. His greatest weapon, a powerful one if well deployed, was the art of diffusing a codified range of feelings whose secrets are offered to any viewer possessed of a sufficiently well-honed curiosity.

To begin to understand Miró's work it is necessary to observe his creative process, and the objects that awakened it. Every composition started with a stroll along the beach, through the mountains, or across the Catalan and Mallorcan fields. Only a fortunate few accompanied him on these walks, but I can vouch for a couple of anecdotes relating to them. One is the remark made by his intimate friend, Joan Prats, expressing some perplexity: "When I pick up a stone it's a stone; when Miró picks up a stone it's a Miró." This simple sentence sums up the immense, instantaneous force of attraction—unleashed in a tenth of a second—between man and matter. It was a magnetic force, a shock, an attraction to which Miró repeatedly referred, and which brings us back to Eugeni D'Ors. Miró's work, like that of D'Ors, owes its very existence to the groundedness of both artists: a rootedness like that of the protagonist in *La ben plantada*. D'Ors completes the cycle of Earth–Sea–Sky evoked so constantly by Miró in his painted sculpture, through which the pulse of the artist's humanity beats openly before us. Miró was the poet of poor things, humble things, the old, the discarded, and the useless. His eyes were ever open, alert, on the prowl. A second anecdote comes from the poet Jacques Dupin. One day he told me about a walk he and Miró took through the Mallorcan countryside near the artist's house. The two men left the studio together and wandered in silence for an hour. Then an object caught Dupin's attention and he picked it up to show it to Miró, who turned, smiled at his friend, and continued walking. A little later Miró stopped, astonished, before a severed tree root. After studying the root carefully, Miró asked Dupin to hide it and go back for it later—he didn't want his neighbors to see him carting around peculiar objects. Dupin understood that Miró was loath to arouse suspicion about his activities, lest people take him for an outrageous old madman.

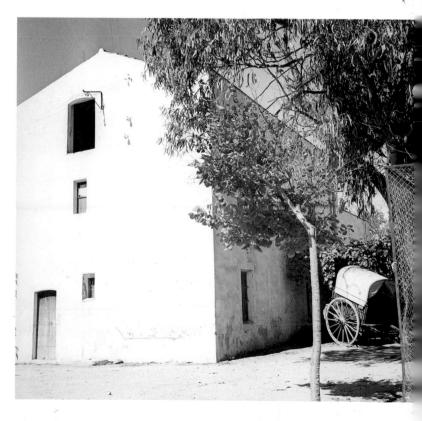

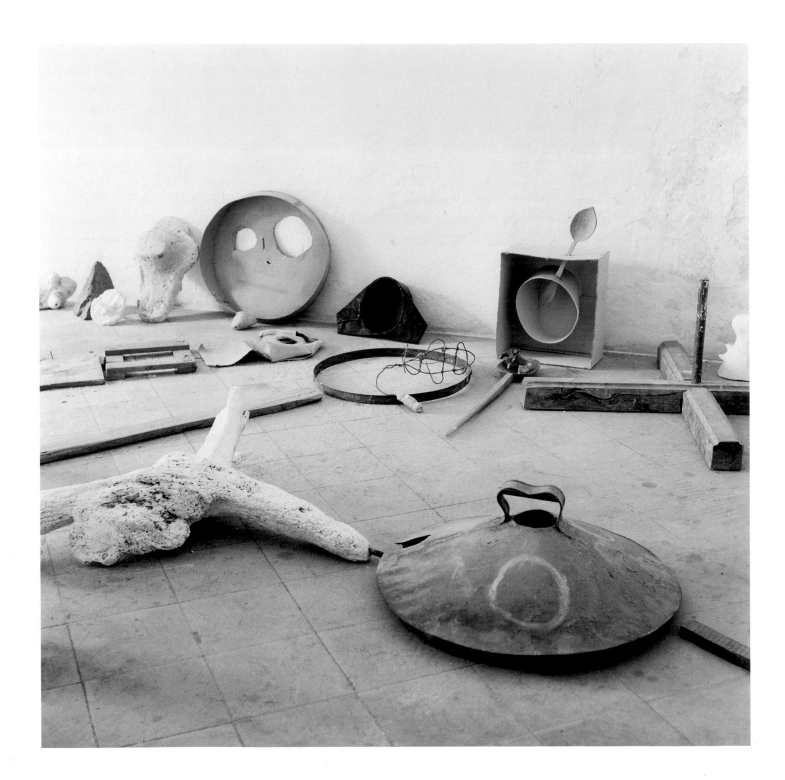

Once inside his studio, Miró would immerse himself in the atmosphere created by disparate, plain, ill-matched, purposeless, and entirely valueless objects (fig. 3). He would set them in circles on the floor and draw out the dialogue, the eccentric magnetism, between one item and another; the strange pull toward intimacy, union, communion; the pure, uninterrupted sequence of linked sensations, such as one finds in a poet's lines. Their life-forces yielded to the tremendous evocative power of Miró's unspoiled imagination, and at that precise moment the two objects fused; henceforth they were forever inseparable, thanks to the artist's intuitive eye. Armed with such sensitivity, Miró simply let the objects themselves dictate the path he should follow. He seemed to move beyond mere decoding to reach the secrets of pure attraction. An eternal current passes between objects produced by Mother Earth, who unleashes this metaphysical energy flow. The sensitivity of the Catalan demiurge was channeled toward the assemblage of shapes, which were then changed—by means of bronze—into sculpture.

Bronze. I should perhaps describe the sensations and experiences that overwhelmed me when I visited the foundry where the painted sculptures were executed. Once Miró had chosen which elements would compose each sculpture, he placed them in boxes and sent them to the Susse Fondeur in Paris. There, after his arrival (and he was always on time), the work commenced. Thirty years later, when I toured the foundry, the items were still where Miró had left them.

I was surprised to find the foundry full of busts of colonels, captains, and major political figures, all waiting to be cast in bronze. This noble, elegant metal had been chosen to confer importance, meaning, and dignity upon statues that were intended to inhabit town halls or key positions in the urban network of some city. There were equestrian statues, too, as well as works by local artists. And further on, in the next area, I began to glimpse objects that came from Catalonia and the Balearic Islands, objects entirely out of context. Many of them I recognized, and they instantly carried me back in time. Among them, for instance, was the spigot from Miró's pool in Montroig, where I used to swim when I was five years old.

I also encountered an endless array of objects that figured in my subconscious; a broken faucet, a root, a piece of dried bread, or a gourd was juxtaposed with a bust of de Gaulle, Balzac, Sartre, or Mitterrand. All the magic of Miró's sculpture derives from this sort of confrontation, along with his fidelity to the great potential that emanates from objects of Catalan origin. Anyone entering the foundry would wonder what all this

garbage was doing there, what kind of a sculptor would work with it, or even what sort of insult was meant by it—who dared trivialize this medium. For bronze is a noble metal, intended for noble ends, and not for fusing toilet seats and ironing boards together. Miró was, in effect, a defiant and young sculptor. Above all, young, with all the risks youth implies. I shall never forget that during the opening of his 1974 retrospective in the Grand Palais, Paris, Miró told Alexander Calder: "I am an established painter but a young sculptor." Miró was 81 when he said this, with a whole lifetime of sculpture ahead of him. He released his powers like an onslaught against the sterile academicism that contaminates the souls of weak creative artists, and he sought, moreover, to bring to all sculptural undertakings a high degree of freedom. His personality bound him firmly to three basic principles: intuition, transformation, and assemblage.

Intuition led him to sense the suggestive power of every object; he could distinguish the thing-in-itself from its original function. One key to Miró's sculptural aesthetic lies in his ability to decontextualize objects in order to endow them with a new dimension, to grant them a new identity, and to transform them into core elements of the sculpture's vital confabulation. Miró had to put the pieces back on the ground so that their silent voices could whisper to him the place in his assemblage where each belonged.

Transformation is unending in the realms of the fortuitous and the fated. Miró observed the elements adopting before his very eyes purposes opposed to their original ones and initiating a new discourse. This discourse of permutating and subversive signs is a ceaseless metamorphosis. Akin to the Duchampian mode, Miró's language transgresses, subjecting the concept to a startling 180-degree shift that estranges it from the world of the obvious, introducing it instead into the realm of suggested affinities. The final result is grotesque, violent, disturbing, or sensual, inside the closed circuit of the ambiguous. Abstraction receives a death sentence, and free reign is granted to an informalism that bears within itself a duality: destruction–creation. In other words, energy is neither created nor destroyed, but simply transformed. Miró dwelt in the bewildering world of transformation, seeking to disclose the mysterious impetuosity of its endless jugglings.

Lastly, assemblage defies the law of gravity and checkmates the sense of balance. Through optical discrepancies and hazardous positioning we glimpse the poetry of this unanticipated marriage of elements, which forces us to approach the painted sculptures cautiously, to avoid injury should they collapse. The

artist's instinct betrays him in his search to depict the hidden associative forces, leaving his collaborators to cope with the technical problems. Miró provokes confrontations between shapes, conflicts in volume, and stress between spaces that nevertheless unite, to turn a bundle of objects into a sculpture. Once the somersaults and pirouettes in Miróland come to a halt, the spatial energy flows gracefully through the veins of a living, pure organism, born of Catalonia, which radically alters the world of sculpture.

Such an alteration would have been impossible from the outset had Miró abandoned his deep ties to his homeland. He was a Catalan sculptor in permanent communion with the land. Just as a gardener must touch a potato, an onion, a tomato, so Miró needed time to grasp each and every one of the elements that formed his sculptures. His bond with the land distanced him from everything flashy, vain, or lascivious and brought him close to the spiritual richness of things serious, humble, and poor. For Miró, the treasure lodged in plain things was infinitely more compelling than the pompous self-importance of luxury. He liked to eat with the local farmers, typical Catalan dishes such as bread with tomatoes, *escudella* (a hearty broth) or *calço-tada* (green onions dipped in sauce, a seasonal delicacy). The *porrón* (a wine carafe, usually made of glass) would pass from hand to hand, providing everyone at the table with wine. His respect for the traditions of his country held him in direct contact with his compatriots. It enriched his life with a magnetically charged integrity and sensitivity that guided his vision toward the realm of figures who existed before his arrival, but who without him would never come to coexist, as they did in the sculptural dimension of his subconscious.

The broken, the twisted, the ruined, all put aside their precarious status and were transformed into a sign, a flower, a fertilized egg, with all the implied vitality therein. The composition had to set its energy free by means of a perfect assemblage: the force had to flow like torrential waters, meeting no obstacle. An avid reader of St. John of the Cross and St. Teresa of Avila, Miró penetrated beyond the material, the visible, the contemporary, and gained access to the mystic dimension of the spiritual, the invisible, the eternal. His gaze sailed the waves of remote seas, oceans that concealed in their depths a secret abundance. Access was restricted to a few, a favored few, who had understood the true meaning of life and grasped its incomparable promise.

One obvious example is the painted sculpture *Jeune fille s'évadant* (*Girl Escaping*), formed by the legs of a mannequin,

two heads, and a faucet (fig. 4). The heads were modeled in clay in Gallifa, where Miró was making pottery with Josep Llorens Artigas and his son, Joan Gardy Artigas. The mannequin legs probably came from some place to which Miró found himself guided by their spell; he must have decided to hold on to them for some future sculpture. And finally, the pool spigot from the Miró farm in Montroig. The spigot, a pervasive Dadaist element, crowns the girl, elucidating her character by contributing a certain coquettishness and style. The base, which serves as its point of support, is so tiny that the sculpture seems to be on the brink of toppling over, while its consistency and masterly choice of elements provide a surprising lightness, checking the force of gravity in its stride.

The composition displays certain parallels with the iron figures designed by Antoni Gaudí. The telluric force of each element seems to seek a spiritual connection with the architect's fantastic constructions such as his unfinished cathedral, the Sagrada Familia, which artfully beckons from the center of Barcelona. Miró accompanied Brassaï, Calder, James Johnson Sweeney, and a great number of other artists on visits to the parks and gardens Gaudí designed. Gaudí was, like Miró, a man with a special sensibility that brought him in touch with the organic, the vibrant, and the latent, even when concealed inside a stone, a faucet, or—why not?—a chunk of twisted, rusty iron. Catalan mysticism prompted both artists to sustain an unspoken dialogue, an uninterrupted tête-à-tête, a dunking in the aura of the Other: the sensed, though unseen; the perceived, though unexplained. I am struck by the intrusive nature of the *Jeune fille*'s gaze. Her eyes have the ability to disturb, or perhaps disconcert. The suggestive power of her hieratic stance distorts the viewer's perception through the terrible disparity of the items that bring her to life. But despite this, and regardless of the discomfort she provokes, red warm blood seems to flow through her veins.

La caresse d'un oiseau (*Caress of a Bird*), a daring sculptural assemblage formed by an ironing board, the shell of a sea tortoise, a toilet seat, a donkey's straw hat, and a stone surmounted by a ceramic moon, plays homage to the magic of the fortuitous. I would never have suspected that such diverse properties could result in so bold a monument to the grace of the accidental. Miró, in a deep state of trance, follows the energy flow of suggestion to link objects from the Mediterranean coast. The Catalan quality of this sculpture intensifies when one notes, for example, something as everyday as the straw hat a farmer would put on his donkey's head to protect it from sunstroke. In the

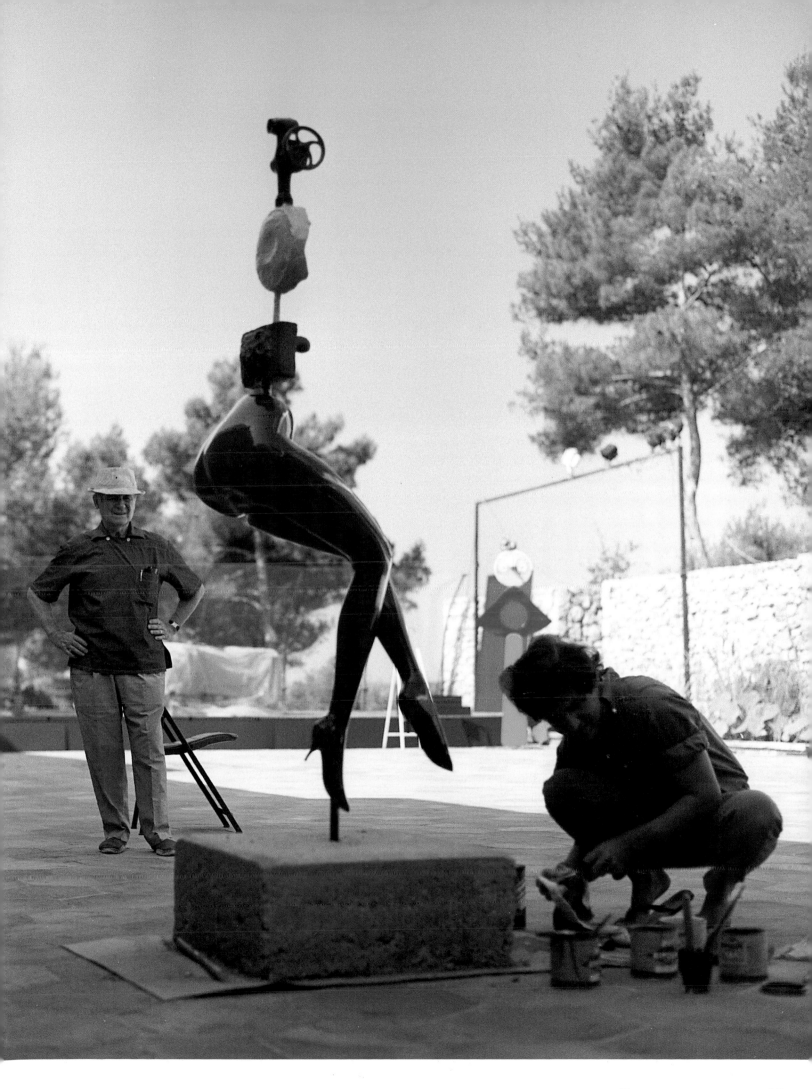

hot summer months Miró used to see peasants fastening the plow to the donkey to work the land. Once again, he has opted for a symbol of rural labor in Catalonia: the donkey's hat becomes the eyes and the nose of the figure caressed by a blue bird. And *La caresse*, nothing more, a *caresse d'un oiseau*, becomes the title of one of the most remarkable painted sculptures. A caress, a passing gesture of affection, of love, of feeling, as incidental as it is fitting, to make, albeit fleetingly, a deep impression on Miró's heart. The tortoise shell symbolizes the female sex organ, open like a tulip. But a woman's sex, for Miró, was synonymous with expansion, life, fruitfulness: all of us alive in this world have passed through here.

The toilet seat. It is unusual for an artist, however tenacious his idiosyncrasy, to turn a toilet seat into a sculptural component. Long years of household chores had led Miró to tramp through every corner of the Montroig home, the source of the seat. I suspect that his defiant repudiation of any concerns about possible adverse criticism contributed, finally, to his rejecting his own prior—and reasonable—hesitations. After all, few visitors to the Corcoran will know that the local farm hands used to set their buttocks down on this seat! We are confronting, once again, Miró's defense of the poor, but authentic, both in the simplicity of its purpose and the lowliness of its origin. Yes, it's a toilet seat. So what? Didn't Duchamp send a urinal to the Armory Show?

Let us now turn to the humble task of ironing, an activity that, like sculpture or painting, offers the practitioner the double advantage of privacy and peace. Shouldn't ironing count as a noble enterprise? Well, so it is, and so is the ironing board employed in its service. In light of so indisputable a truth, Miró used the board in his enigmatic *La caresse d'un oiseau*, with its blue bird at the apex, caressing a multicolored lady. Many viewers consider this a mistake—an error, no doubt—to be judged with great clemency and charity; but let none dare call it deceptive or phony. Miró is Miró, that's all there is to say. And you are you, ditto. So let us just allow the Catalan destroyer of taboos to wreak havoc in the cerebral cortex of all prudent academics and their crippled imaginations.

We move now to *Sa majesté* (*Your Majesty*), the picturesque grouping of a palm tree bearing a gourd, perforated with holes, which in turn sprouts a round loaf of bread. Scatological and simplistic to some, to others far-fetched and juvenile, Miró has concocted *Sa majesté* and imbued it with wit, daring, and a love of life. Here again things that bind him to his homeland combine in a challenge, born of his rich imagination. The time has past,

luckily, when a sculptor was required to provide a guarantee of his talents by carving a block of marble. Now we can admire the suggestive power in the language of intuition, of chance, and even of the ordinary. This language blooms in Miró's Catalan soul and then imprints its powers in the elements whose sap Miró shares. Like that characteristic Mediterranean tree, the pine, Miró's roots tunnel deep into the earth, drawing nourishment from its minerals. Well then, let us allow the palm tree to provide the necessary nutrients; the sculptor's transforming inventiveness invites us to witness the metamorphosis of a Catalan round loaf of bread into Majesty's crown: *Sa majesté*. Miró has created "The Majesty" using humble things. As men, and within our limitations, we are—as Pythagoras claimed—moral because of our fears and immoral because of our desires. So let us unite the fears and the desires, as Miró did, to dismiss Pythagoras' crushing logic and penetrate the world of the mismatched, the dying, and the eternal—a trunk, a gourd, and a loaf of bread. We will then be able to join together the pulses of both blood and soul and give praise for our entry into Miró's transcendent, poetic regions.

Joan Miró is sincere and violent, poetic and elemental, like the earth; upon careful observation we find that the nature of every living being arrives marked by the earth. The painted sculpture *Personnage* (*Figure*) requires no theoretical coloratura. It is drenched with essential being, combining elements impregnated with Catalan agricultural life. Looking down the sculpture from head to toe we see a type of rake, used to separate the wheat from the chaff. The circle of the lid of a wheat container encloses the figure's eyes, nose, and mouth. And to finish things off, the wooden tripod base supporting the whole structure is a butcher's table, upon which innumerable hens have been chopped up. Palpable in Miró's work are the land and the air that surround it, the color and the light of which enter through his eyes: he probes them with delicate fingertips, like a blind man racked by his knowledge. Aldous Huxley's warning was timely: the most odious of treasons is that which an artist commits when he crosses over to the side of the angels. Joan Miró never enlists in the deceptive angelic ranks because he has allied himself with the troops of his imminent reality, in which he discovers the life current of unfocused wandering, akin to the uncertain strides of an adolescent who, headed nowhere in particular, keeps moving fearlessly forward. As this work shows, Miró sculpts about Catalonia, out of Catalonia, and for Catalonia. He feels himself to be, in flesh and blood, a vertebrate constitution of his country.

Although Catalonia occupies a defined space, it serves as a catapult for Miró, launching him far beyond its boundaries. The Miró-Catalonia interaction produces a sculptor at once nomadic and universal, like a tuft of earth tossed by the gale. He is forever questioning the true sculptural potential of the Catalan spirit, and to this end he openly renounces all provincial conventionality, poised knife in hand, ready to kill it off. He seeks to abolish the atmosphere of tradition and high calling that hangs over casting in bronze. And he displays the courage to commit a sacrilege few foundrymen have forgiven: painting his sculptures. Let us recollect the number of 75-year-old sculptors who have dared breach, so ruthlessly, the rules of sculptural tradition, defacing the patina so revered by the foundrymen. Miró dismisses it; turning his back on the patina, he gives yet another vibrant call to rebellion, terrifying casters and gallery owners alike. The former are frightened at witnessing a new kind of creation, unknown, lyrical, and ahistoric; the latter at finding that no collector wants to purchase a sculpture that commingles holiness and criminality. Yet, as Miró murmured to his gallery owner, "We'll discuss it in a few years, my friend." Prophecies of this sort strike many people as ludicrous and many more as reckless: they themselves would never have gambled on such a sculptural turnabout.

The titles of the painted sculptures, too, emerge from a creative region bursting with prescient nostalgias not necessarily reflections of a past reality. Their bewilderment is saturated with suggestiveness, provocation, irony, and images that do not exist, not even in the recesses of our memory. The absence of a bird? Never, in fact, have we experienced such a thing. Never. But for Miró, who insisted that painting and poetry were for him interchangeable, the essential challenge was to mold a concrete image of such elusive, mediate nature. This explains why the titles of his painted sculptures are laden with irony and bear a marked Surrealist accent, the legacy of the wonderful experiments with automatic writing acclaimed by André Breton, Paul Éluard, and Louis Aragon.

Miró's painted sculptures emerge from no banal gimmickry that might cheapen the purity of their origins: the rocks of the coastline, the fruit of the tree, the wave against the beach, or the mother nursing her newborn. In the expansiveness of his assemblages we seem to hear the innocent air itself protesting, as if victimized, the sculptures' theft of its mass—a usurpation dedicated to quickening a sterile space. The imaginary bridge connecting Mallorca and Catalonia allows the artist passage, with eyes swift enough to capture in flight these thematic seeds, trapped by frenzied whirlwinds, and fluttering to get free. It may be superfluous to emphasize Miró's yearning for freedom, but I speak as one born in a country attacked by Romans, African pirates, and Arabs; it should be made absolutely clear, once and for all, that Miró struggled his whole life against seeing Catalonia submit once more to a dictatorship that would castrate almost beyond repair the tremendous cultural strength of her people. Art is a powerful weapon, lethal in the right hands. And in this case, it was indeed in the right hands, for throughout his long life Miró used art to defend the roots binding him to his people, but imposing them on no one. Precisely on account of this solid blend of respect, tolerance, and dignity he showed toward other cultures, Miró succeeded in his aims. With a light, firm, tread he proceeded to carve poetry, to sculpt the specter of the past, to communicate the elemental, skeletal structure of things, sustained by the illusive heartbeat of his sensitive Catalan soul.

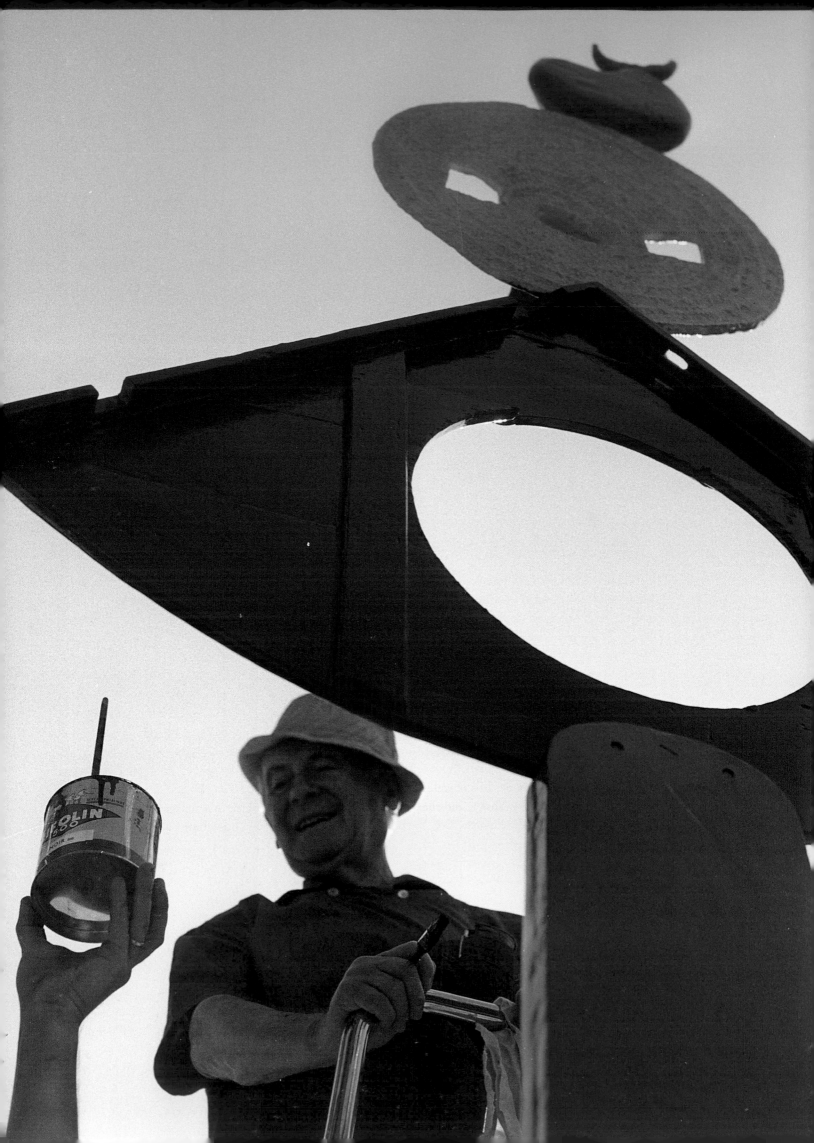

5. *(opposite)* Miró painting *La caresse d'un oiseau* at the Fondation Maeght, St. Paul, France, 1968.

The Shape of Color: Joan Miró's Painted Sculpture, Monumentality, Metaphor

William Jeffett

To paint, to sculpt, to etch, is maybe to give form to a myth, to produce a new reality from a given material, from a physical thrust that forces a gesture to be carried and placed in the world. The real suddenly appears from this struggle. Nothing is foreign to painting, to etching, to sculpture: one can work with anything—everything can be useful. If I frequently integrate the objects as they are, with raw materials, it is not to obtain a plastic effect but by necessity. It is in order to produce the shock of one reality against another . . . I need to walk on my earth, to live among my own, because everything that is popular is necessary for my work.

Joan Miró, *L'Humanité*, 1974

I. Miró's Sculpture in Color, c.1940–1959

Joan Miró's painted bronzes and polychrome resin sculptures are among his most distinctive and important contributions to the sculpture of the twentieth century (fig. 5). Although most of the painted bronzes were executed between the mid-1960s and the mid-1970s, Miró began thinking of them considerably earlier, and they engage with elements of his work that emerged as early as the 1940s, if not before. They fall into two groups: most were cast at the Fonderie Clémenti and at Susse Fondeur between 1967 and 1969, but a second, smaller, group was cast at Valsuani between 1970 and 1973. These bronzes are very humorous, but beyond this highly playful dimension they point toward monumentality.

Miró often chose highly colored surfaces when he realized a number of large-scale public sculptures at the end of the 1970s. This is clear in the massive projects of his late years for Paris, Barcelona, and Houston, as well as an unrealized project that was considered for three locations—outside the Los Angeles County Museum of Art, Central Park (New York), and the Hirshhorn Museum and Sculpture Garden (Washington, D.C.)—but in the end abandoned. There is a distinction between the bronzes and the monuments in that the bronzes take their point of departure from objects and assemblages of objects, while the monuments tend to be based on modeling. A number of large-scale works executed in polyester resin (fiberglass) represent an intermediate scale between sculpture and monument and were realized when Miró was working with Robert Haligon. Again these compositions derive mainly from modeling. These intermediate scale works—generally not monuments in the fixed "site-specific" sense of the word—point toward the public monument and are *de facto* "projects for monuments." Already in the Valsuani bronzes of the early 1970s Miró was thinking of "projects for monuments," and it was around 1971–1972 that Miró

began to develop his thinking regarding public monuments in drawings and models. At this time, he began a series of important projects for commissions.[1]

This study seeks to demonstrate the centrality of the polychrome works to Miró's later sculptural practice through a presentation not only of the sculptures, but also of preparatory drawings for sculptures. In this way we can both explore Miró's artistic process and begin to assess the importance of sculpture within his later work. Documentary photographs by Joaquim Gomis and Francesc Català-Roca provide a sense of the wider context in which sculpture was conceived and executed. Finally, this study will seek to provide an evaluation of the importance of these intriguing sculptures to the art of the twentieth century, both in terms of their relation to other artists, such as Jean Dubuffet, Claes Oldenburg, and Nikki de St. Phalle, and their contribution to a changing notion of metaphor in modern art.

Miró took up painted bronze relatively late in his career, when he turned largely to the making of sculpture. This process of thinking in sculptural terms dates from Miró's return to Mallorca in 1940 following the conclusion of the Spanish Civil War (1936–1939) and the subsequent German invasion of France (1940). During these isolated and difficult years (1940–1945), Miró worked out a number of new directions in his work while living principally in Mallorca. But he also traveled as usual in the summer to his studio and house near the village of Montroig in Tarragona. The Mallorcan landscape provided a connection with nature, as did the landscape of Tarragona.

Sculpture was not entirely new for Miró. In 1930 he had commissioned a carpenter to make a series of constructions, his first documented three-dimensional works, and in 1931 and 1932 he had arranged and painted object assemblages. These two series, executed in Montroig, represented both an attack on painting, which he described in terms of "the assassination of painting," and an extension of the problems and images of painting and drawing into three dimensions.[2] In 1936 he again made Surrealist object assemblages, along the lines of the Surrealist "objects of symbolic function" made by Alberto Giacometti and Salvador Dalí. In later interviews, however, Miró recalled modeling in clay as a student when he worked at the Escola d'Art with the innovative teacher Francesc d'Assis Galí.

The impact of Galí's unorthodox pedagogy on Miró's approach to art was immense. First, it was Galí who recognized Miró's talent, despite the young artist's reserved personality. Miró was a gifted artist who had started drawing at a very young age, but he lacked skill in certain areas, especially that of form.

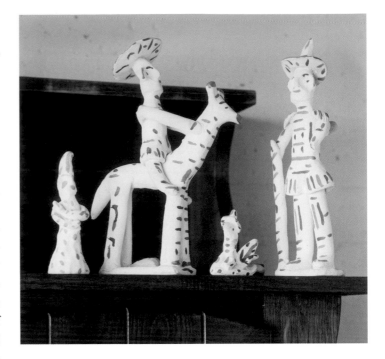

Galí set him a number of unusual exercises to correct these problems, such as putting on a blindfold and feeling an object or a face and then drawing it from memory. The results of some of these drawing experiments remain in the archives of the Fundació Joan Miró, Barcelona.[3] Galí's teaching encompassed a number of other interesting and rather indirect methods, including listening to and reading music. Miró would reveal later in life how Galí would take students on excursions to the mountains and then forbid them to draw: "For instance on Saturdays we used to go for walks in the countryside—in fact, he did not even allow us to use our sketchbooks—but to store up impressions."[4]

Galí regularly exhorted his students to "wear a crown of eyes around your head." Jacques Dupin, basing his account on conversations with Galí conducted in 1957, tells how on the first day of class Galí set Miró the problem of painting a still life made up deliberately of colorless objects, with the result that Miró extracted from the dark objects an extraordinary abundance of color.[5] Alexandre Cirici also recounted this same story, and a number of Galí's other strategies. Galí would ask the students to draw a frontal view of a face viewing it from the profile and on the contrary to draw a profile view of a face when looking at it from the front. A similar exercise consisted of looking at the body of the model from the point of view of the hip in order to view it in relief. Obviously from the point of view of sculpture the exercise of drawing from touch was paramount, and Miró fondly told this story on numerous occasions.[6] Furthermore, in an undated letter written likely in early 1915, Miró wrote from Barcelona to Bartomleu Ferrà in Mallorca, of the advances he was making in his art:

> I am satisfied by my efforts to master form. My drawings of
> objects I touched but did not see have borne fruit, and I have
> acquired a lively notion of form; my works are better con-
> structed than those that you have seen. I believe that this type of
> teaching will finally allow me to draw better.[7]

And in a subsequent letter, dated March 15, 1915, he wrote again to Ferrà: "My work will be stronger, if it is not only beautifully colored but well constructed."[8] These were exercises to grasp not only form, but also the concept of form. Most importantly, as Sebastià Gasch tells us, Miró was set the task of modeling from clay: "Galí made him make terra-cottas which got him used to form."[9] Miró, too, mentions the experience of modeling in Galí's school in later interviews: "In 1912, I enrolled in the School of Art in Barcelona . . . The Director, Francesc Galí, compelled me to model from clay."[10]

Among Miró's fellow students there were a number of future lifelong friends and confidants such as Josep F. Ráfols, Enric C. Ricart, and Joan Prats.[11] Another of the students, Josep Llorens Artigas, would also be a friend for life and artistic collaborator, when Miró turned to the making of ceramic sculpture in the early 1940s. As Anne Umland has pointed out, the exact date of Miró's first meeting with Artigas is unclear, as the accounts are contradictory, but it is possible that their friendship dates from as early as this period of studies with Galí.[12] Certainly they knew each other no later than 1918, when Artigas wrote a review of Miró's first solo exhibition in *La Veu de Catalunya* (November 25, 1918), and both artists participated in the Agrupació Courbet.[13]

Miró's return from Paris to Mallorca, by way of Varengeville and Perpignan, and his renewed contact with the rural landscape and sea, marked a change in his thinking about art. He renewed an interest in popular ceramics, notably terra-cotta figurines such as the painted crèche scenes made at Christmas time. Of particular note are the white whistles with brightly colored highlights made in Mallorca and called "*siurells*" or "*xiulets*."[14] Miró had always been fond of such folkloric objects and early accounts of both his Paris and Montroig studios note their presence (fig. 6). As early as 1930, in the first published account of Miró's foray into sculpture, Gasch on a visit to Montroig comments on their presence. And in a 1934 text published in *Cahiers d'Art*, Robert Desnos draws our attention to their presence in the

rue Blomet studio, in a reference that refers to the period of the 1920s.[15] After his return to Mallorca, these whistles provided a renewed inspiration for Miró's approach to painting, especially as regards color, and they further provided a model for sculpture. It was at this time, in numerous sketchbooks, that he also began to make plans for sculpture. In this way, the twin issues of color (deriving from painting) and sculpture came together.

The notebooks of the period 1940–1941 are telling and worth citing at some length. These are now in the Fundació Joan Miró and were first published by Gaëton Picon in the *Carnets Catalans*.[16] Miró's thinking begins with painting, but moves quickly toward sculpture. In the *Grand Cahier de Palma* he notes in reference to a new series of paintings of the necessity for the greatest possible spontaneity, "like popular paintings and the whistles from Mallorca."[17]

In the *Cahier "Une Femme,"* also of 1940–1941, he turns to sculpture, though he is still thinking in reference to painting: "a grandeur which recalls the sculptures from Easter Island" and "think of the idea of sculpture, that the forms turn and can be touched."[18] In this notebook there are also two references to color that depart from the primitivism Miró saw in the polychrome marks on the *siurells*. One note reads, "that there is a great violence of color," and in a similar tone, "intensity, but great severity in the colors."[19]

In the same notebook he turns to the question of sculpture, vowing to "devote the month that I will pass in Montroig to making sculpture."[20] With sculpture he continued the pattern established in the 1930s of working on sculpture in the summertime in Montroig. He continues this subject in the *Carnet Orange*, also of 1940–1941, emphasizing the importance of the contact with the earth:

> in beginning to make sculpture at Montroig I get back to my concern for the earth, which inspires in me a more human and direct emotion, in the deepest sense of the word—in this environment sculpture made in the country will not be sullied by superficiality or artifice, as it might be in the city, deprived of direct contact with the elements, with the danger of becoming the work of a sculptor who does not go beyond mere shaping of form, like a specialist in printmaking who does not go beyond etching.[21]

He returns to the crèche figurines with reference to sculpture, writing "Color my terra-cottas as they do for the little crèche figures." And under the heading "Céramique" he writes: "Look at the popular objects from Mallorca, decorate them, for example like the pots that they put in farm courtyards for the chickens to drink from, which are suspended."[22]

These final notes point to the two most important directions in Miró's later sculpture: modeled figures that are painted and the assembling and painting of found objects of a folkloric nature, or objects deriving from the rural landscape defined by agriculture.

Miró wrote another set of working notes, which he began in Montroig in July 1941, where he laid out plans for work in a variety of media. The sections devoted to sculpture contain the seeds of his later approach to sculpture in almost every respect. There are two sections devoted to "Sculpture and Studio," and it is clear that as Miró began to think of building a new studio he did so with a concern for sculpture. The studio would be filled with objects, many of which would become the models for the components that made up the sculptures.

> when sculpting, start from the objects I collect, just as I make use of stains on paper and imperfections in canvases . . . make a cast of these objects and work on it like González does until the object as such no longer exists but becomes a sculpture, but not like Picasso—do it like a collage of various elements—the objects I have in Barcelona will not continue to exist as such but will become sculptures.[23]

Here Miró emphasizes that casting represents a transformation of the objects into sculpture. The studio is the site of the transformation: "build myself a big studio, full of sculptures that give you a tremendous feeling of entering a new world . . . the sculptures must resemble living monsters who live in the studio—a world apart."[24]

He goes on to seek the confusion of his sculptures with the elements of nature and to consider taking his sculptures outdoors into the landscape. At the same time, we find the crucial idea that sculpture is indistinguishable from nature, whether it is in the studio or outside in nature. Furthermore, the sculptures are far from inert; they are "living monsters." Already in the notebook Miró is thinking of enlarging his sculptures as monuments, monuments informed by the example of the Mallorcan whistles.

> Have my sculptures reproduced the way they reproduced Pablo's [Picasso] for the pavilion, in reinforced concrete I think it was, and then look for weather-resistant paints to color them . . . Splatter white paint on these cement masses and then paint parts of them with really violent colors, reminiscent of Majorcan whistles, either painting directly on the cement or on the white . . . That way I would create a link with the rest of my production and with nature's real objects, trees, roots.[25]

Here Miró predicts the problems he will face in the 1970s, when he starts to make large-scale sculptures and monumental public sculptures in the material of polyester resin. Curiously, he warns twice against casting his sculptures in metal. This is the one part of these notes that is inconsistent with Miró's later sculptural work. Nevertheless, the notes suggest casting, and the warning seems more pointed at casting in a way that would be the work of a "sculptor" or a "specialist." Apparently his desire was to retain the vital energy associated with the object, rather than a mere concern with "dead things" or technique.

In the second section, "Sculpture and Studio II," Miró returns to a concern both with the Mallorcan whistles and the crèche figurines, again associating them with brightly colored form: "I could even make a plaster reproduction, like the Majorcan whistles, and color it."[26] And "In Palma they make little earthenware figures for the crèches and later bake them; they put wire in certain places so they will hold their shape . . . they paint them with enamel mixed with turpentine and matte varnish."[27]

Objects are of equal importance, and they provide a magical encounter with chance: "use things found by divine chance: bit of metal, stone, etc., the way I use schematic signs drawn at random on the paper or an accident . . . this is the only thing— this magic spark—that counts in art."[28]

At the end of this section Miró returns to the casting of objects, and his concern is principally with the casting of ephemeral objects into bronze, the major task of his mature work in sculpture.

> One could cast different objects . . . think of the doves I saw at Sunyer's place in February 1942; they were very handsome with visible feathers and an overall silvery tone—Gaudí also cast various objects; he even cast children who pleased him and other living beings and later used them as models and as his point of departure. I believe there is a great similarity between my way of working and Gaudí's . . . I could also enlarge objects I find, like that bit of coal on the wheel, and then work with them the way I work in paintings with spots of color and lines that I *find* on the paper or canvas.
>
> Make a mold of a fish on irregular piece of plaster, like the fossils; then incise signs and make some relief, and later have it cast in bronze.[29]

The reference to Antoni Gaudí is telling. Indeed Gaudí took charge of the sculptural compositions destined for the façade of the Sagrada Familia. First he worked with a skeleton, using mirrors to view its position from all sides, and then using plaster he cast from the body of a suitable model. Only following this elaborate procedure was a sculptor brought in to enlarge the figure. A copy of the enlarged figure was then used to establish the exact position destined for the final sculpture. Only at the end of this procedure was the model sent to be carved in stone. Gaudí's intention was to communicate the desired expressiveness and, as with Miró, preserve maximum liveliness.[30] The use of color in architecture, in the form of broken ceramic fragments (called "*trencada*") embedded in cement, was deployed with a similar aim. Miró proposes casting inert objects such as a lump of coal or living entities such as a fish rather than people, but he does so to achieve vitality.

From the notes it is clear Miró began thinking specifically in terms of sculpture shortly after his return to Mallorca in 1940. But there remains the question of whether he actually first started making sculpture at this time. The issue is further confused by the fact that Miró began working in this period in ceramic as well. Sometimes the line between sculpture and ceramic is not clear, and to some extent this is the case at the very beginning. Still even from the outset Miró drew a distinction between ceramic and sculpture. Here Miró's correspondence is an aid in clarifying the sequence of events. On June 1, 1943 he wrote to Pierre Matisse, saying "During the vacation I intend to make sculptures at Montroig."[31] In early 1944 he began working with Artigas in the making of ceramics. The majority of these were vases or plaques to which Miró applied decorations using glazes. We can distinguish between this painterly approach to ceramic and a more fully three-dimensional approach. On June 17, 1944, Miró wrote again to Matisse "this summer I am going to make sculpture."[32] And the result was a small group of fully three-dimensional ceramic sculptures. The following spring, on March 26, 1945, he wrote to Duarte, "This summer I made sculptures, and in addition to that I have done ceramics with Artigas."[33] Here he draws a distinction between the ceramics realized with Artigas and sculpture as a separate activity.

In the summer of 1945, Miró began realizing a group of terracotta sculptures, which he worked on until the end of the year. Annotations in a sketchbook relating to this group of works helps us clarify the sequence of events.[34] These terra-cotta sculptures became the models for the first four bronzes that he began casting at Gimeno in 1946. V. Gimeno Blanes was the administrative director, and probably the owner, of the foundry named Fundición Artística Tanagra, located in Hospitalet. We know this from receipts sent from Gimeno in 1950 and 1952. In conflict with this location, in an undated notebook principally consisting of telephone numbers and addresses, Miró writes:

7. Miró working on
Femme echevelée at
Gimeno, Barcelona,
1946.

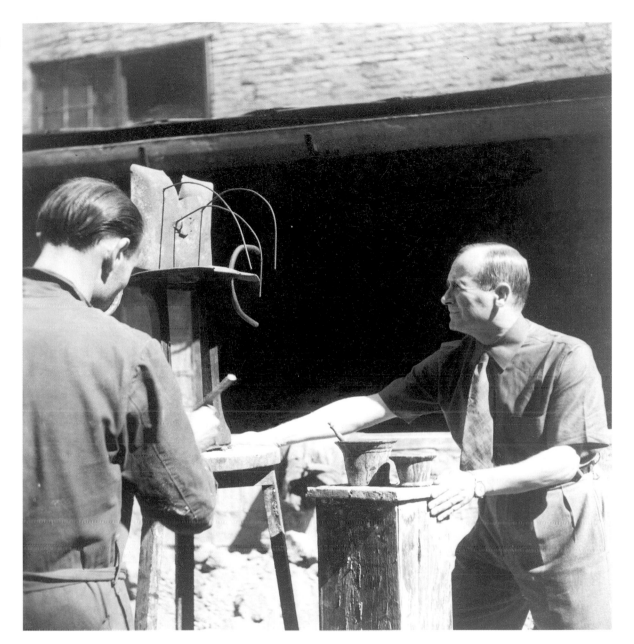

'Fundicón Gimeno, Passeig Cementiri, Valls, Tel. 404.'[35] Did
Gimeno move the foundry from Hospitalet to Valls? This is not
clear. What is certain is that the photographer Joaquim Gomis
documented Miró's working visit to Gimeno in June 1946
(fig. 7).[36] Miró tells us in his notes that at least two sculptures
were cast in bronze between April and November 1946.[37] At this
time the molds were made, and, so Miró tells us, one bronze cast
of the sculptures *Oiseau lunaire* and *Oiseau solaire*. An additional
unnumbered cast was likely made in 1947 of the *Oiseau solaire*
for Pierre Matisse. According to Miró's notes, seven more exam
ples for both sculptures were completed in the spring of 1949.
The final, published edition of eight was numbered and signed.
Gimeno sent Miró a receipt for payment on the January 9, 1950,
which specified "For four sculptures, cast in a series of eight
examples each in bronze, numbered from no. 1 to no. 8. And also
two unnumbered artist's proofs. The total thirty-four pieces."[38]
Between Miró's notebooks and the Gimeno receipt clearly the
most accurate date for the completion of the series is 1949.
These bronzes have yet to introduce the dimension of color and
are finished with even dark patinas.

Following these first bronzes, from 1951 to 1954 Miró made a
series of unique sculptures titled *Projects for Monuments*. These
included objects that were cast in iron and bronze combined
together with found objects and even fragments of ceramic.
Here the strategy of ceramics meets that of casting in bronze,
and Miró first starts to think of monumental sculpture. The
ceramic elements incorporated into sculpture introduce the ele-
ment of color, albeit muted color, for the first time. Where the
iron and bronze components were fabricated remains unclear,
but these works were an important transition toward sculpture as
a central part of Miró's work. Throughout the 1950s Miró
devoted his energy to making ceramics in an intensive collabo-
ration with Artigas. Many of these high-fired ceramics were
fully in the round, and they work essentially like sculpture.
These were presented in Paris with Maeght and in New York
with Pierre Matisse. At Matisse's suggestion, under the rubric
of *Terres de grand feu*, the poetic title indicated the high-fire
technique.

Miró's correspondence is again illuminating, and on January
18, 1955 he wrote to André Breton, "I am still very anxious to

know if the ceramic exhibition that I am preparing, with Artigas, for this summer in Paris will be ready.[39] For this reason he was unable to contribute to the publication Breton was preparing. Having introduced the subject of ceramic he goes on to qualify his use of the word in revealing terms:

> The word ceramic is, of course, only a pretext and a way of reacting against the idiotic things that they have made when using this name. We hope nevertheless that this exhibition will be ready in time and that I may spend a long time in Paris and have a long conversation with you on this subject.[40]

Further along in the same letter, in response to a question about photographs of his paintings, he notes, "for one year I have devoted myself to ceramics, I have scarcely painted."[41] Here he seems to be distinguishing his work in ceramic from ceramic as a genre within decorative arts. That the distinction appears in a letter to Breton is important. Contrary to received wisdom, Miró respected Breton. As early as April 12, 1934, Miró wrote to Breton from Barcelona asking that he view his new collages, "If you are free one day I would appreciate it if you could go to Pierre [Loeb] so that he can show you the last collages that I brought from Spain and [I] would very much like to know what you think of them."[42] Indeed, during the 1930s, Breton acquired by purchase a number of Miró's works, significantly including the painted object assemblages. Examples include *Homme et Femme* (1931) and *L'Objet du couchant* (1936).

Miró's respect for Breton continued until well after the war, and in 1958 when Pierre Matisse began to prepare the project of a book to contain a poem by Breton for each of the *Constellations*, Miró wrote to Breton: "I am *happy* and *proud* that you are writing the text for the *Constellations*. In these times when everything in the world clashes, in these times when space is wrenched apart in every sense, your thought has become prophetic, because of this I am proud to see your text beside these *Constellations* made in 1940."[43] Significantly, Miró completed the *Constellations* just after his return to Mallorca, at a time when he first began to rethink his use of color and to lay out plans for making sculptures. When in 1959 Breton came to prepare the International Surrealist Exhibition for Paris at the Galerie Daniel Cordier, he contacted Miró. Breton's letter, dated August 1, 1959, specifically requested the inclusion of an object, sculpture, or ceramic, and he emphasized that it be of as large as possible.[44] A subsequent letter from Breton to Miró, dated September 21, 1959,[45] mentions the many problems of organizing the exhibition and the final decision to include *L'Objet du couchant*, which as we have seen was in Breton's own collection. This exchange of letters both demonstrates Miró's respect for Breton, and reveals Breton's sustained interest in Miró, in particular in the latter's more sculptural work.

In the light of Miró's comments to Breton we might speculate that his work on ceramic in the mid-1950s pointed increasingly toward sculpture realized in metal. In 1955 and 1956 Miró was in the process of closing his studio and apartment in Barcelona and moving to Palma, where his new studio, designed by Josep Lluís Sert, was being built. During these two years he painted little, but he did travel frequently to Gallifa to work with Artigas. On January 16, 1956 he wrote to Pierre Matisse "I consider this year 55/56 as purely transitional, a long and effective reflection to strengthen the muscles and to withdraw so as to be in good form to begin a new stage in my life."[46] He goes on with reference to ceramic, speaking in much the same terms he did with regard to sculpture in the 1940s, "I throw myself into ceramic during these moments of transition; it was an excellent thing for me, a break that will enrich and refresh my pictorial work with new possibilities and give it a new direction in my mature years."[47] He then explains he will keep the studio in Montroig, "Naturally, I am going to keep Montroig, which has left such a strong imprint on my life and work."[48]

Returning to ceramic he explains this work is not to do with commissions, but is an art of ideas, "For this stage of ceramic, it is not at all a question of a commission, but of the realization of several ideas on which we [Artigas and I] are engaged, a conversation of ideas that often encompasses a much broader scope than anticipated."[49] Again Miró distinguishes ceramic from its conventional decorative functions. Finally Miró concludes by expressing his concern that Matisse considers his ceramic "irrelevant to the rest of his work" and that commercially it is not viable for Matisse, but he asks Matisse to reconsider and offer his opinion, "Unnecessary to tell you that Artigas as much as myself will be extremely responsive if our ceramics interest you; because your opinion is invaluable to us."[50] Miró then asks that if Matisse reserves pieces for his gallery, that he allow them to be presented in the exhibition he was preparing for Maeght in June 1956. Matisse's response to the letter denies Miró's concerns, though he suggests that when in 1953 the ceramics were first presented, the prices were so high they shocked the American audience. Indeed, Matisse then prepared the major exhibition *Terres de grand feu* in December 1959, but his concerns about prices suggests that ceramics were not commercially attractive. Further, the unique ceramics were fragile, and this may have been

another problem. Some of the later bronzes include fragments of ceramic cast into bronze, and bronze certainly offered a more stable material.

II. Painted Bronzes: 1959–1973

Miró did not return to sculpture cast in bronze until around 1957–1958. In 1957 Aimé Maeght came up with the idea of creating a private museum in the South of France for his artists. The site would be on a hill above the village of St. Paul de Vence, adjacent to his own country house. Miró appears to have returned to thinking about sculpture in metal in a serious way at this time, and many of the ideas for the first series of painted bronzes bear dates from 1958 to 1960. Miró's elaborate sculpture gardens at the Fondation Maeght are likely to have prompted this activity; equally Miró continued to be involved with projects for the Fondation Maeght after its opening in 1964.

Miró's drawings for painted sculptures, as with many other ideas for sculpture, were all worked out at least in terms of composition by 1964, though they were only cast in Paris at the Clémenti and Susse Foundries from 1967 to 1969. Again we can see a very long delay from the moment of conception to the realization of the finished bronzes. Miró refers to this as a period of "gestation." He repeatedly described the encounter with the object as a "shock," and it was this element of surprise that he sought to preserve in the final sculpture. In formulating this idea of external shock, which Miró also called a "magic spark," he situated inspiration in the exterior realm of nature rather than the internal sphere of the Freudian unconscious.

Having gathered a large body of found objects, largely of a rural or folkloric nature, from the areas around his studios in Montroig and Mallorca, Miró meditated a long time on them. Photographs taken by Gomis and Català-Roca document the Barcelona and Montroig studios in the 1940s and the studios in Mallorca from the mid-1950s onward. As early as 1944, we find objects in Miró's Barcelona studio that will appear in sculptures only cast in 1967 (fig. 8). Later the objects and plaster models for the sculptures, principally in the Montroig studio and in the Son Boter studio in 1961, were documented in photography (figs. 9 and 10). It is important to note that Miró generally made sculpture in Montroig until he built the Sert studio in Mallorca in 1956. Even then, having filled the new studio with similar objects, he tended to make sculpture in Montroig. In 1960 Miró acquired the Son Boter studio, which he also dedicated to sculpture. Located on an adjacent piece of property to the Sert studio,

Son Boter completed the complex of buildings in Mallorca and now Miró could work on not only painting, but also sculpture and other media within three minutes walk of his house Son Abrines. The photographs taken in the studios give a sense of how objects performed a role beyond models in that they formed part of the overall "atmosphere" of the studios. In this way they also inspired Miró's thinking on painting and sculpture.

At the time of the casting, Miró took the found objects with him to the foundries in Paris, and there he used them, presumably along with drawings, as a guide to explain to the workers how he wanted the sculptures fabricated. In the Fundació Joan Miró there are photographs by Claude Gaspari that document these arrangements of the objects in preparation for the casting. Miró is present in some of these photographs positioning the different objects. On at least one photograph Miró wrote annotations further indicating the positioning of the objects. Miró's presence is further revealed in the photograph of *Personnage* (cat. 4.2), for the photograph is as much a portrait of Miró as an indication of placement of the objects. The finished bronzes were taken to the Fondation Maeght, where Miró, with the assistance of Joan Gardy Artigas, painted them. Gaspari and Català-Roca documented Miró painting these objects. Finally the sculptures were exhibited at the Fondation Maeght in the summer 1968 Miró retrospective, and then again in Barcelona the following autumn at the Hospital de Santa Cruz.

We know from the drawings that Miró came up with the basic compositions relatively early in the process. These then underwent subsequent modification as Miró rethought the composition in drawings. Miró's drawings are not abstract compositions; they are based on objects and documents of possible configurations of objects with sculpture in mind. Many of these objects reoccur in numerous of Miró's sculptures, and they become as component units making up a pictorial vocabulary, being recycled and deployed in different syntactic functions within the overall vocabulary of the sculpture. In this way, each object is open to different and multiple readings on the part of the viewer. Even within a single sculpture, while they perform relatively specific iconographic functions, each object is open to double and triple meanings. There is in general a light-hearted and poetic sense of humor in all of these works. On the whole they depict female figures rather than male figures, or couples more often than not caught in the act of lovemaking. The humor is typically activated with wordplay and visual as well as verbal puns and relates powerfully to the titles.

8. *(right)* **Miró's studio at Passatge del Credit, Barcelona in 1945.**

9. and 10. *(below left and below right)* **Objects and plaster models for sculpture in Miró's Son Boter studio,** *c.*1961.

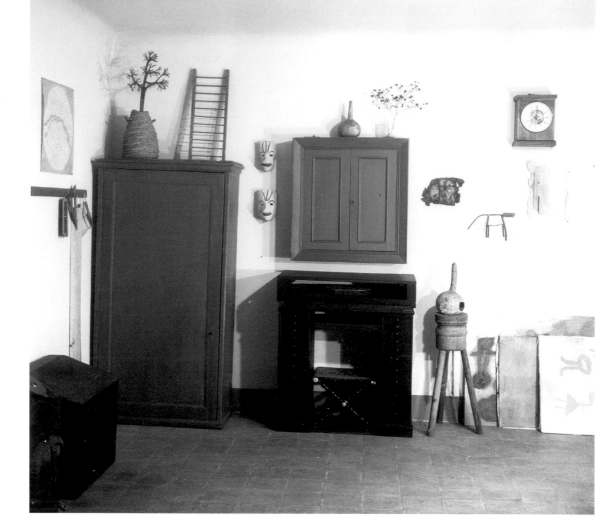

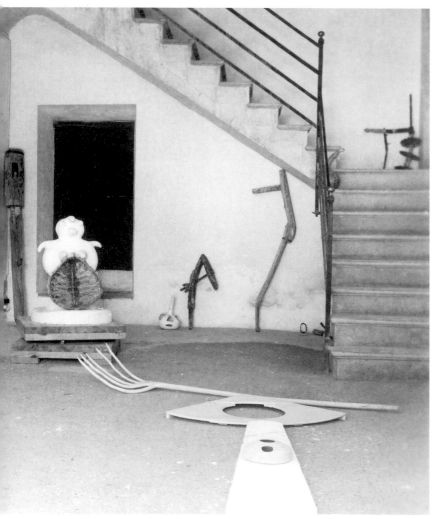

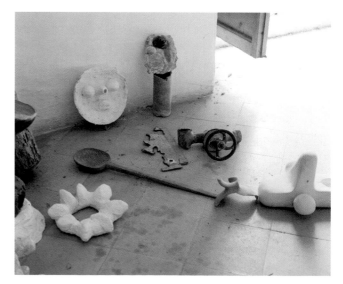

If Miró's drawings came after the objects, they clearly preceded the sculpture, often by some years. The earliest preparatory drawings for the painted sculptures appear toward the end of a 1958–1959 sketchbook and were made in the latter half of 1959.[51] As this sketchbook also includes drawings for the enlargement of works such as *Oiseau lunaire* and *Oiseau solaire*, it may be related to Miró's 1961–1963 sketchbook plans for the Fondation Maeght, a sketchbook that does not include drawings for the painted sculptures.[52] Another early sculpture sketchbook dates from 1961 to 1964 and includes projects for painted sculptures, all of which are dated December 5, 1963.[53] During these years Miró made many drawings often on small scraps of paper or loose pages torn from his diary; this was a practice he would continue through the 1960s and 1970s.

Beginning on November 20, 1964, Miró began a sculpture sketchbook labeled "Escultures I" into which he pasted some of the loose drawings, or recorded compositions worked out previously in loose drawings. He continued this notebook until September 24, 1969. It provides us with the most substantial record of his sculptural work, including of course many of the painted bronzes.[54] This record-keeping function was extended in an undated sketchbook that included works related to projects finished at the beginning of the 1970s.[55] An undated portfolio labeled "Escultures Acabades" included both drawings for sculptures and photographs of the arrangements of the object models.[56] These photographs served as indicators to the foundry workers of the placement of the objects in the final compositions, and the portfolio in general provided Miró with a record of completed works. An additional group of drawings removed from this portfolio served a similar purpose, and included drawings for the resin sculptures of the early 1970s.[57]

Finally, two sheets of colored drawings date from 1967, that is toward the end of the casting process, and indicate the possible placements of the colors on the finished sculpture.[58] Taken as a whole the above drawings and sketchbooks document each stage of Miró's artistic process from initial conception to the final casting and painting of the sculpture.

Generally with sculpture, Miró opted for either generic or highly poetic titles. Often these are so general and repetitive as to be of little help in identifying the pieces. Such examples include *Femme*, *Oiseau*, *Femme et oiseau*, and *Personnage*. In the painted bronzes the poetic titles are in most cases among the most elaborate and specific, and they reflect transformations of Miró's thinking of the compositional arrangements. As the sketchbook pages are often annotated with the titles, it is not

unreasonable to surmise that these titles may aid us in reading the sculpture, and such a project, indeed, does bear fruit. Moreover, Miró in some cases placed great emphasis on the importance of the titles, as he explained to Pierre Matisse in a letter of May 4, 1969: "It is very important to write down the titles of all of these pieces. I am going to do it with [Daniel] Lelong, tell him to send you a copy."[59]

Poetic titles such as *La caresse d'un oiseau*, *Jeune fille s'évadant*, *Sa majesté*, and *Homme et femme dans la nuit* point to a transformation of objects into figures. Miró's figuration while indirect is accessible to us. Even the more general titles *Femme et oiseau* or *Tête et oiseau* are specifically deployed and the corresponding elements are evident in the sculpture. The pleasure we derive in looking at these sculptures, therefore, comes from their transparency and not their opacity.

The generic title *Personnage* is so prevalent in Miró's sculptural work that perhaps it has a meaning beyond such literal translations as character or figure. The title may be read in terms of ethnography. Sidra Stich has demonstrated the extent to which Miró's work from the 1920s to the 1940s was framed by the discourse surrounding ethnography and specifically the study of prehistory.[60] She has pointed to the consistent presence of works by Henri Breuil, George-Henri Luquet, and Lucien Lévy-Bruhl, among others, which were available to Miró through articles that appeared in prominent art magazines such as *Esprit nouveau*, *Cahiers d'Art*, and *Documents*. Moreover, Michel Leiris, a curator at the Musée de l'Homme, was Miró's close friend and confidant. Leiris, and a number of these other scholars, had all studied at the École Pratique des Hautes Études under Marcel Mauss, himself a disciple of his uncle Émile Durkheim. Mauss' teachings shaped the new ethnography and an entire generation of thinkers.

The study of prehistoric cave painting was a relatively new discipline, as Altamira had only been discovered at the turn of the century, and the serious study of this subject only began in the 1920s. Following the war, there was a renewed interest in the subject, due to the discovery in France of Lascaux (1940), a find that prompted Georges Bataille, another acquaintance of Miró's, to write a book on the subject in the mid-1950s.[61]

We know that Miró visited Altamira with Artigas in 1957, at the time they were preparing the UNESCO wall mural. Miró's general approach to ceramics and painting in the 1940s was imbued with an interest in prehistory, or what we might call primordialism, and was received in such terms. Tristan Tzara, for example, wrote in his article "Joan Miró et l'interrogation

11. *(opposite)* View of the foundry during the casting of the public sculpture *Miss Chicago,* c.1980–1981.

naissante" that "Miró rediscovers the secret of cave painting buried in man's consciousness . . . He rediscovers the childhood of art at the level of contemporary man."[62] Typical review articles of the period have titles such as Frank Elgar's "Miró et la préhistoire."[63] And the following year Raymond Queneau devoted a monograph to Miró with the title *Joan Miró ou le poète préhistorique.*[64]

In 1938 Marcel Mauss made a significant distinction between the idea of *personne* (person) and *personnage* (character, role) in an important article titled "A category of the human mind: the notion of person; the notion of self."[65] Mauss situates the *moi* or self in a distant pre-modern time, though he notes that there is a concept of bodily individuality in all cultures and periods. He, therefore, tends to avoid the primitivism of writers such as Lévy-Bruhl and Luquet who had posited a pre-logical mentality in prehistory and in tribal cultures alike. Mauss views the arrival of the concept of the person as coming with Roman and Latin culture, because Roman law for the first time provided a definition of the person and individual rights. He links the even more modern idea of the identification of the person with the self to the epoch of Christianity.

The concept of *personnage* predates the idea of person and self and is, therefore, the most archaic category. The *personnage* performs a role handed down from ancestors, a role which determines name, class, and social status:

> Plainly what emerges from it [our demonstration] is that a whole immense group of societies have arrived at the notion of "role" (*personnage*), of the role played by the individual in sacred dramas, just as one plays a role in family life. The function had already created the formula in very primitive societies and subsists in societies at the present day.[66]

The concept of *personnage* is more general than that of the masquerade, though the two concepts are clearly related. In the masquerade the performer takes on the identity of the mask while acting out the ritual, while the *personnage* is permanently cast in a role in the larger social sphere.

Miró was familiar with such ideas, whether or not he would have read this specific article, for it formed part of the nexus of ideas surrounding his work. Two of the early painted sculptures named *Personnage* (cats. 4 and 9) seem neither male nor female; rather they appear as fantastic characters performing some sort of magical, ongoing role. In his working notes of 1940–1941, Miró wrote: "it is in sculpture that I will create a truly phantasmagoric world of living monsters."[67] And in the two sculptures called *Personnage* an embodiment of these monsters seem to stand before us. In the photograph described above of Miró standing by *Personnage* (cat. 4.2), the objects become a fantastic creature, and Miró's presence alongside it suggests it is his alter ego, a benign but powerful character performing the role of Miró.

In Miró's sculpture the *personnage* functions like a power object to connect with a distant past. Again, if we consider the reception of these painted works, such a suggestion is not far-fetched. Català-Roca's photographs of Miró painting these sculptures appeared in the pages of French *Vogue* in the December 1979–January 1980 issue (fig. 5). The colorful images of Miró working were accompanied by a text titled "Naissance de la source" by the eminent pre-historian André Leroi-Gourhan.[68] The article tells us that prehistoric art and cave painting is understood within the terms of a religious magic with a utilitarian aim. Figuration and monumentality are two prominent characteristics of this ancient wall painting. These two concepts are close to those surrounding Miró's work, but Leroi-Gourhan warns us that Miró's art remains structurally part of the liberated, individualistic, and "abstract" art of the last four centuries, rather than the magic art of prehistory. Despite this the images of Miró painting these sculptures, a photograph of Miró and Artigas looking at the murals in Altamira, and one of Miró's paintings from the 1950s link Miró's work to that of prehistory.

Miró chose the foundries he worked with according to the techniques of casting each provided and especially according to the patinas and surface finishes he desired (fig. 11). The painted sculptures stood apart from the patinated sculptures and were cast at Clémenti and Susse; later an additional series was cast with Valsuani. Clémenti worked exclusively in lost-wax casting, while Susse worked in both lost-wax and sand casting. Most of the painted bronzes of the period 1967–1970 were made at Clémenti, where lost-wax facilitated the accurate casting of found objects; but two of this early group were cast at Susse, because their larger and flatter configurations worked better for the sand casting technique. Valsuani cast painted bronzes from 1970–1972. Like Clémenti, Valsuani specialized in lost-wax casting, and could make accurate casts of detailed objects. (Parellada, too, made lost-wax casts, though none of the Parellada works were painted.) The making of the sculptures was not a mere matter of simply casting the objects directly into bronze. The nature of bronze casting meant that Miró intervened at the intermediate stages of the plasters and waxes to add linear

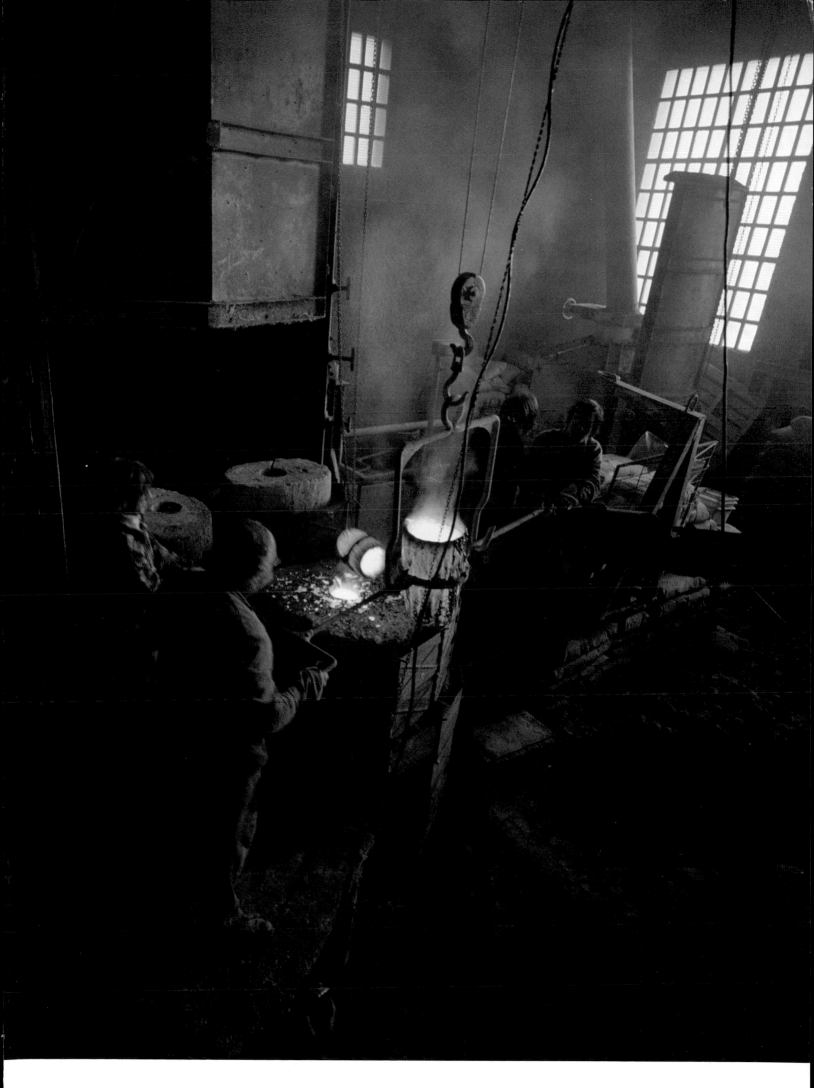

designs in the surface and to modify the composition. The patina and surface finish were the very final stage of the process. In general Miró relied on the skill of the foundry artisans, and he often sought their advice for the solution of technical problems. He also relied on them to achieve his desired results. As he had done with Artigas, so here sculpture entailed a collaborative mode of operation. This appealed to Miró, for it submerged individuality in a collective strategy.

Miró's correspondence with Pierre Matisse reveals much of his general thinking about patinas, techniques, and the painted bronzes. The private nature of this correspondence offers insight beyond the more public statements Miró made regarding these matters. Throughout the 1970s Miró presented his sculpture in exhibitions in the United States. His thoughts, especially about the exhibitions in New York and Minneapolis in 1970 and 1971, are revealing. In February 1969, Miró wrote to Pierre Matisse regarding his interest in staging an important exhibition of sculpture in Paris and New York, and there he explained the different patinas corresponding to each of the foundries:

> One must think about the large bronzes at Susse and about the plasters that Bousquet is enlarging as large, imposing works.
>
> The series by Parellada, of which you know several examples, will be finished in several weeks and I will send it immediately. I worked on the new waxes at his place and I gave the new pieces to him, which are going to make rather sensational things.
>
> Clémenti made new, very successful bronzes, and I entrusted him with the patinas, to make another variation and to enrich the overall exhibition. I also worked on the new waxes at his place and I am going to turn over the new pieces to him.[69]

Here Miró is referring exclusively to patinated sculpture. The following month Miró announced that the foundry, without specifying which one, has promised the series of sculptures will be finished within a week, and he asks Matisse if they can be shipped directly to New York.[70] Finally, in May 1969, he wrote again to Matisse, "I worked on the new sculptures, which are in progress. Things are getting stronger and stronger, and we are going to make an exhibition that will be a big hit.[71]

At the same time, Miró is preoccupied with the shipment of the recently finished sculptures, which are now finished, from Barcelona. In this letter, he specifically mentions the painted bronzes cast at Susse and Clémenti:

> Naturally, one is always cast for you. It seems to me, however, that you have not confirmed that it was necessary to cast the

series of amusing ones decorated with ripolin. In this case you must place the order with Susse and Clémenti, you know this type of work takes time. It is important to me that you have all of my completed sculpture.[72]

The reference to the sculptures as "amusing" and as painted with "ripolin," a standard industrial paint commonly used in France as house paint, demonstrates that wit and humor is an explicit part of these sculptures and that this wit derives in part from the rather mundane nature of the brightly colored paint. The following February, still making preparations for his first major sculpture exhibition in New York, Miró wrote again to Pierre Matisse, explaining the patinas foundry by foundry:

> *Susse.* Bronzes with noble patinas, black, dark red, broad greenish surfaces.
>
> *Clémenti.* Rich and personal patinas, very magical.
>
> *Parellada.* Pure patinas created during the casting conserve all of the expressive force of these bronzes, in a savage and powerful state. These pieces cannot be conceived in any other way—they would be ruined.[73]

Here the letter does not refer to painted sculpture, but only to patinated sculpture. Miró continues with the idea of exhibiting some works at an intermediate stage of completion.

> I also suggest we exhibit some sculpture in process, to give a sense of monumentality. In plaster in its final form. The plaster has great beauty, and this white will provide a strong accent in the exhibition.
>
> No fear of the monotony, then, that appears to have disturbed you; on the contrary this will make a very beautiful ensemble.[74]

The plasters to which Miró refers are most likely the large-scale ones that Susse was casting. Many of these enlargements were realized by the plaster reducer and enlarger R. Bousquet. As this letter is laying out Miró's thoughts for the exhibition, which opened in May, it is curious that he does not mention the painted sculptures. Matisse was concerned that the show would be monotonous because, compared to the paintings, patinated bronzes are generally more limited in color. Miró went to some lengths to explain how varied the patinas actually were, and elsewhere in the letter he also suggests adding a touch of color by hanging etchings on the walls.

There is a plausible explanation for Miró's omission of the painted bronzes. While the Pierre Matisse catalogue lists sculptures that without doubt correspond to painted works, the entries are strangely not described as painted. Matisse and Miró were simultaneously planning a museum exhibition to be staged

at the Walker Art Center in October 1971. This was the first American museum exhibition to give a substantial treatment to Miró's sculpture. We know from the loan request forms dated December 17, 1970, and the loan receipt forms dated September 9, 1971, which were sent to Pierre Matisse by the Walker, that seven of the painted bronzes were sent to Minneapolis in an unpainted state, to be painted in Minneapolis by the museum staff.[75] Moreover, a letter of authorization dated August 18, 1971 confirming permission to do this was sent to Pierre Matisse from the curator Dean Swanson. This letter begins the "Walker Art Center has received permission from Joan Miró to paint the following sculptures scheduled for exhibition" and concludes:

The seven containers of paint have arrived in Minneapolis from Lucien Lefebre-Foinet, per your order, and we expect to begin painting when the works arrive in September.

May we request your authorization of this project, as agent for the owner of the sculptures, by signing and returning the enclosed copy of this letter?[76]

We know that Pierre Matisse kept paint samples in his files of Valentine "Valenite Briliant 412."[77] Further there are photographs that document the bronzes in both their unpainted and painted states.[78] Photographs of the sculptures taken in New York show them not yet painted, which indicates that Matisse had arranged for them to be shipped from France to be painted in America. But questions remain. Were the bronzes that were ultimately painted exhibited at the Pierre Matisse Gallery in May 1970? If so, were they exhibited in New York in their painted or unpainted states?[79]

The exact same casts of *Sa majesté* and *Femme assise et enfant* are listed in the exhibition catalogue for Matisse's gallery and were certainly exhibited in their painted form at the Walker Art Center.[80] But it is not clear which of these works were on view in the Pierre Matisse Gallery, because only one, *Personnage*, appears in the installation photographs of the exhibition.[81]

Who paints the bronze is clearly not important, for Miró merely sent instructions and permission. Among those sculptures painted in St. Paul de Vence, we know that Joan Gardy Artigas assisted in the painting under Miró's direction as this was documented by Català-Roca in the run up to the opening of Miró's retrospective at the Fondation Maeght.[82] Indeed, as these works are often shown outside, they periodically require repainting.

The act of painting a sculpture negates the preciousness of bronze as it is traditionally understood. Bronze sculpture is associated with a rich array of possible patinas, with many textures and nuances of dark colors, ranging from black to green, and including deep reddish hues. Miró was especially sensitive to these possibilities and to the traditional perception of sculpture as a rich and costly material. Painting bronze, given all of these nuances, moreover painting bronze with the industrial house paint "ripolin," ironically subverted all of these associations. The seriousness of "high" culture is replaced by humorous and playful jokes and verbal and visual puns.

Miró chose bright primary and secondary colors to paint these sculptures, using different colors for each of the objects. In doing so, he emphasized the component parts that made up the sculpture, rather than submerging the objects into a harmonious whole with the application of a uniform patina. In his *Entretiens* with Raillard (1977), Miró spoke about his general use of color in terms of contrast, "I look for the contrast of colors, the contrast of pure colors."[83] In emphasizing the contrast of the objects that make up the sculpture, Miró asserts their double identity as both object and sculpture, the totality making up the assemblage producing the transformation of the parts into a "living" character. We therefore can read these sculptures as both the objects they derive from *and* as fantastic figures. In this way they are three-dimensional collages. Again in the *Entretiens*, Miró said, "my collages, today, are my sculptures."[84] In contrast with the Freudian idea of deriving imagery from the unconscious, as the Surrealists had done according to André Breton's "interior model," Miró sought inspiration in what he called the shock or "spark" of a chance encounter with objects in the outside world. He described this approach to Raillard:

All of these finds, all that in which I am in the middle of now, are rather recent. I was magnetized. When I go for a stroll, I don't search for things like one searches for mushrooms. There is a force—clack!—that makes me bend my head downward, a magnetic force. [85]

Miró's choice of language is both revealing and apparently accurate, at least according to Jacques Dupin's account of his walks with Miró.

Part of the fascination of sculpture for Miró was also his desire to get out of the painting studio, to take a breath of fresh air and to broaden his outlook . . . At the end of the day he liked to leave his work and walk along the seashore (at Montroig) or into the mountains (in Majorca). I often accompanied him on his strolls and on these daily gatherings I carried the game-bag, always without questioning, for Miró was a hunter of images and objects and sudden discoveries.[86]

Miró's choice of words in the 1970s recalls his notes discussed above of the early 1940s. The departure from the Freudian model is also important. Already in September 1936, at a time when he was engaged with making painted Surrealist objects such as *Objet du couchant* (1936; Centre Georges Pompidou), he wrote to Pierre Matisse in lucid terms:

> You speak to me of my objects and ask how I conceive them. I never think about it in advance. I feel myself attracted by a magnetic force toward an object, and then I feel myself being drawn toward another object which is added to the first, and their combination creates a poetic shock—not to mention their original formal impact—which makes the poetry truly moving, and without which it would have no effect.[87]

He continues with the following cautionary remarks, explicitly rejecting the Freudian model.

> I am therefore totally removed from the ideas—Freudian, theoretical, etc., etc., etc., etc.—that people apply to my work. If my work exists, it is in a human and living way, with nothing literary or intellectual about it—which is the sign of a stillborn and rotten thing, destined to disappear almost immediately.[88]

Psychoanalytic meaning is not, however, entirely foreclosed, but a theoretical application of "dream imagery" is rejected by Miró. This approach was, if not literary in the above terms, poetic and spontaneous, based on chance encounters, and the provocation of chance through techniques such as controlled accident.

The painted bronzes, finally, function on a poetic level. If they are collages in three-dimensions, it is important to recognize the importance of collage as a visual equivalent to the poetic trope of metaphor. The surprise or shock Miró speaks about is also to be found in the writings of Guillaume Apollinaire. Writers such as Louis Aragon, thinking specifically of collage, referred to it as the "Marvelous." Finally the idea of a metaphoric substitution of one signifier for another is to be found in one of Breton's most important poems, "Union libre," where poetic images often of a natural order stand in for the parts of the woman's body.

It must be noted that the painted bronzes while principally consisting of assemblages of objects cast in bronze, sometimes include elements that were first modeled in clay and cast in plaster and then in bronze. The nature of Miró's modeling is spontaneous and on the level of the signifier arbitrary, and most often consists of simply and rather crudely modeled forms. Here the matter of earth and clay is asserted in relation to the object. How we interpret the modeled forms and situate them within the semantics of the sculpture is determined by their position in relation to the other objects. In this way if a modeled form is on a head, it becomes, for example, a bird or hat. At the stage of the waxes Miró further incised designs into the surface of the objects, thereby implicitly transforming them into a sign language. Equally, the production of signification is generated only within the overall arrangement of objects. The same object appearing in different works produces different meanings. Further, an object in a single work may suggest more than one reading. Here we see how Miró's use of objects as signifiers is open-ended and plural, a strong example of what Umberto Eco called the "Open Work."

Bearing in mind the poetic and plural nature of Miró's signifiers, let us look at the sculpture and offer a poetic reading. In *Femme et oiseau* (1967, cat. 1) the central shape cast from a wood crate comes to represent both the body of the woman and the bird. A peasant's pitchfork is erected vertically to signify the woman, its prongs representing her hair. By placing a green tail on one side of the crate and a red sphere on the top of it, cast from a toy soccer ball, Miró evokes the presence of the bird in the form of the crate. There is a constant shifting between the two readings of the objects, which resist any reductive understanding of the sculpture's significance. Is the red ball the head of the bird, or is it the bird depicted as resting on the lap of the woman? Does the red sphere double as an image of a child sitting on the lap of a seated woman? The many preparatory drawings Miró made for this sculpture reveal the development of his thought.

Though undated, perhaps the earliest drawing appears in a sketchbook page (cat. 1.4), where we find the pitchfork and an anthropomorphic chair or stool labeled "*Femme assise*" or "seated woman". This metaphorical substitution announces much to come. The woman has a face located midway up the pitchfork (cat. 1.1), which we know from photographs is based on a ceramic bird feeder Miró considered incorporating with the other elements of the sculpture. Miró's annotations already tell us about color, with the bronze head to be painted red and the chair to be painted blue. A second drawing (cat. 1.2), on a page from a diary, is dated May 11, 1961 and consists of a fork and the chair-like support. Miró's annotations tell us, again indicating a thinking about the chair and color: "*Cadira blava*" ("blue chair") and "*Forca vermella*" ("red fork"). The drawing also bears the title *Femme assise*. This was a subject Miró had treated in paintings such as *Seated Woman I* (1938; Museum of Modern Art), where a rectangular form represents the sex and womb of the woman. A third drawing (cat. 1.3), dated February 13, 1962,

establishes the definitive elements of the pitchfork and the crate, but still retains the title *Femme assise*. A fourth drawing (cat. 1.5), dated November 24, 1963, retains the face and adds the bird perched at the top of the pitchfork. An annotation explains "*plume en un costat*" ("feather on one side") and bears the changed title *Femme assise attrapant un oiseau*, suggesting that the placement of the bird on the prongs of pitchfork represents the image of a woman grasping a bird. Still part of this title has been crossed out. The composition was finally solidified in drawings dated between October and December 1964. The first of these (cat. 1.7), dated September 11, 1964, crosses out the superfluous elements including the bird. The tail makes its first appearance, and the title is now *Femme assise et oiseau*. Four more drawings explore the basic arrangement of the elements with the bird still situated in the prongs of the pitchfork (cats. 1.6, 1.8, 1.9, and 1.10). In one (cat. 1.9), dated November 17, 1964, the title *Femme assise* is still present. Finally the definitive arrangement and the title *Femme et oiseau* (cat. 1.11) is recorded in an undated page of the sketchbook in which Miró recorded his sculptures.[89]

In *Femme et oiseau* (1967, cat. 2) the elements consist of a wood base with vertical rod, a root or a piece of driftwood, a metal lid, and a long, thin piece of wood in a kind of hatchet-like shape to which is affixed a small stone (see fig. 3, page 14). The piece of driftwood is the body of the woman, the lid her face and the hatchet-shaped piece of wood and stone is the bird of the title. The identification of the body of woman with the branch of a tree is the central image of Eugenio D'Ors' celebrated philosophical novel *La ben plantada* (1911), which Miró certainly greatly admired. The subject of the novel is Teresa, the well-planted one, who becomes a symbol of the ideal Mediterranean woman rooted in the soil of a reborn Catalonia. Miró, though avant-garde, and in this way distinct from the neo-classicism of D'Ors' writing and art criticism, shared D'Ors' strong commitment to Catalan nationalism. In the novel, D'Ors tells us that,

> The symbol of The Well-planted One is a tree. One does not say to a well-planted tree, are your strong roots in your earth? Yes, but, mind you that the branches are some other roots, some higher roots. By the lower roots the tree is planted in the earth. By the higher roots it is well planted in the air and sky.[90]

In this way the roots are anchored in the earth and the branches in the sky. That in the sculpture the root-like form is raised up above the ground as if floating in the air suggests a dual rela-

tionship with both earth and sky. Miró had fully worked out the composition in a sketchbook drawing dated October 7, 1959 (cat. 2.2), situating his thinking about this sculpture during the period he was working on the Fondation Maeght. A subsequent sketchbook drawing (cat. 2.3), dated December 5, 1963, also reveals all of the elements in their definitive arrangement and bears the title *Femme*. The final title, however, only appears in Miró's sketchbook recording completed sculpture (cat. 2.5). It appears also in an April 1967 sheet of drawings relating to this series in which Miró used colored pencils to explore options for the placement of the colors (cat. 2.4). Here the final decisions regarding title and color came very late in the process, and this is true for a number of works, though it is clear in the drawing annotations for other sculptures that the idea of color came early on in Miró's thinking.

The coming together of the image of a woman and bird appears again in *La caresse d'un oiseau* (1967, cat. 3). As we know from Joan Punyet Miró's contribution to this publication, here a straw donkey's hat represents the woman's face, beneath which a triangular shape with a negative circle cut in it represents her sex. This device is taken from the seat of a traditional Mallorcan outhouse. Here the donkey's hat and seat reveal how objects still common in the 1960s are now difficult to identify. The shape of the outhouse seat further echoes Miró incorporation of the architect's set square, which had appeared in Miró's *Danseuse espagnole* collages of 1929, and in his paintings *Portrait de Mme K* (1924) and *Maternité* (1924). Its origin as an outhouse seat suggests a subversion of the mathematical order associated with Cubism and other rational modes of art-making. This element is painted red, perhaps an indication of passion, and in the choice of color it mirrors the red tortoise shell, another three-dimensional representation of her sex. Above the figure, painted blue, the color of the sky, perches an almost bull-like bird whose body is cast from a stone. Its modeled wings almost resemble horns, and though ready for flight, it somehow seems predominantly telluric. The buttocks of the woman are depicted by a pair of miniature soccer balls, which flank her anus represented by a circular indentation. The outhouse seat, with its circular void, permits us to see through the figure to the landscape beyond. At the same time, there is a reference to one of the most basic human functions. Transparency and biological function are linked, for transparency allows us the closest possible contact with what lies beyond illusion. The use of the outhouse seat turned on its side and as a frame looking on to nature represents a transformation of the most common matter into spirit.

The components of the outhouse seat and the ironing board appear on a larger scale in the monumental *La Forche* (1963), which forms part of the garden complex of sculptures at the Fondation Maeght, though there they are joined with the pitchfork. Here the enormous scale and the site of the hillside garden invites us to look through the sculpture to the landscape beyond and the sky above. An undated drawing relating to *La Forche* clearly shows the ironing board and the outhouse seat (cat. 3.1). Miró had used an ironing board as the ground for a calligraphic painting in 1953. The tortoise shell appears set against a tree-like form with a bird resting on it in a drawing dated November 1, 1963 and titled *Femme et oiseau* (cat. 3.4). The donkey hat appears with the detail of dangling chains standing in for hair in a drawing dated November 27, 1963 (cat. 3.5). Something close to the definitive composition appears first on a sketchbook drawing dated December 5, 1963, though the figure still has hair and the title remains *Femme et oiseau* (cat. 3.7). Through a process of distillation Miró arrived at the final composition, and the hair disappears in the drawing dated March 10, 1964 (cat. 3.6). That Miró's conception is fully sculptural is clear in two drawings dated August 7, 1964 and September 11, 1964 (cats. 3.8 and 3.9), which represent the figure from behind. The definitive title yet again appears in the sketchbook where Miró recorded his sculpture (cat. 3.10). It is dated May 25, 1965 and indicates that the poetic titles often came relatively late in the thought process, that the poetic dimension of the title derives from the ongoing process of the interplay of objects. Here again we see both the front and the back of the sculpture, and in this aspect the drawing follows the arrangement of objects documented in photographs revealing both front and back which were processed at Casa Planas in Palma. The photograph of the rear view is retouched, indicating the anus and the wings of the bird (cat. 3.15). These retouches demonstrate that Miró used the photographs much as he did the drawings. A final colored drawing in pencil indicates the element of color, with the sex colored red and the ironing board annotated as green as in the final sculpture (cat. 3.13).

Personnage (1967, cat. 4) consists of a wood tripod supporting a traditional butcher's block, which is painted red, its legs being painted black. Its yellow face is taken from the lid of a wheat container and above its head rises a rake used for separating wheat from grain. Painted marks and incisions in the surface of this face indicate the eyes and mouth. As already suggested, this character is neither male nor female; it is more of a fantastic apparition of a mythic creature. Miró's portrait alongside the models raises the question as to whether such characters somehow function as an alter ego to the artist. A sketchbook drawing for this sculpture already reveals the definitive composition and title, as if the composition was worked out from the start (cat. 4.1). Another drawing (cat. 4.3) indicates the colors, including the face as yellow and the top of the block as red. We know from Gomis' photographs that Miró kept such tripods in his Barcelona studio as early as 1944 (fig. 8), and of course later such blocks formed part of the "atmosphere" of the Sert studio.

Femme assise et enfant (1967, cat. 5) functions as a Surrealist wordplay, for the "seated woman" of the title is represented by a chair cast in bronze. However, the meaning conveyed by the supporting structure of chair only occurs in conjunction with the other elements of the sculpture. The child is represented by a stone, with its two holes suggesting the eyes, which rests on the seat of the chair, while the flat modeled head and a lumpen face in relief is positioned on the back of the chair. That the face and the child are both red sets up an identification between the two. The round head of the woman is painted blue, and this color identifies the head with the elements of sea or sky, perhaps as does the upward pointing arrow inscribed in its surface. This reading is sustained by the sketchbook drawing for the sculpture (cat. 5.1) where the face is clearly depicted and in which the title "*mère*," "mother," is crossed out in favor of "*femme assise et enfant*," "seated woman and child." The humor of this sculpture resides not only in the playful arrangement of the objects, but also in the fact that sculpture inhabits the field of real space, and the normal function of chair is denied as a means of eliciting an ambiguous response from the viewer. Theoretically we might sit in this chair. But as it is not a chair, we cannot sit on it. There is an alteration of our understanding of the word and object "chair." This dislocation serves to bring the viewer into a reconsideration of the world of inert objects as part of a living world. As Miró explained in 1977, there is more than mere humor in this, "I do not make this to play; I value that 'this' goes on 'that.' And then if on a chair made only for sitting on, a chair that one does not see, you place an object, it becomes alive."[91] Here he asserts the importance of the collage principle, with the mechanism being one object resting on another object.

Beyond the object components, this sculpture is enigmatic for the modeled elements of the head and face. These were elements that required intermediate plaster models, which can be seen in a photograph of Miró positioning the elements of the sculpture (cat. 5.2). Both the textured surface of the head and the lumpen face point to unshaped raw materials. Of particular note is the face, which points to the modeling of clay in such a

way as to retain a sense of unformed matter, a kind of metaphor of the image of a child playing with excrement. This is not to say that Miró necessarily cast this shape from excrement, but that such modeled elements in these sculptures sometimes point to the possible reading of them in these terms. This is not overly speculative, for Miró wrote in his 1941–1942 working notes, "make clay bas-reliefs, making shapes like little turds with a pastry tube and also put some well-proportioned volumes."[92] And in his *Entretiens*, Miró spoke of paintings using excrement,

> Yes, yes. This is made of shit. I was there, I had to crap; I let down my trousers, and there, I crapped on the brand new sandpaper. And then, bang! I pressed the other paper on it. And I left it, and that produced this beautiful material.[93]

The reference to excrement, echoes the *Cagner* (literally "crapper"), a small squatting figure relieving himself, who forms part of the traditional Catalan crèche scene. As we have seen, Miró considered such scenes in his thinking about sculpture, and he also kept one, complete with *Cagner*, in the cabinet of popular figurines located in the Sert studio.[94] In Catalan culture this figure represents an agricultural symbol of fertilization and rebirth. Miró's use of such organic and ephemeral materials contributes to the transformation of the inert into the living. In France artists such as Gérard Gasiorowski painted with excrement, and of course in Italy Pierro Manzoni packaged it in a tin can, which he sold as an edition, though Miró cautions us that his work is not intended as a provocation and for this reason it differs from that of Manzoni.[95] That Miró was fascinated with the problems of casting such ephemeral materials is to be found in an anecdote told by Diego Giacometti, as James Lord recounts, "Diego . . . soon learned to cast delicate objects without a flaw. He welcomed complicated tasks as a challenge to his skill. Miró once asked him if he could cast a plum tart, and he did it."[96] Miró's encounter with Diego took place around 1939, just months before Miró's return to Spain at which time, we now know, he took up the idea of sculpture.

In *Femme et oiseau* (1967, cat. 6) a small wood table, or *banquet*, turned on its side represents the body of a woman with outstretched arms and legs. Above the stool is the circular lid of a box for an *ensaimada*, the most famous Mallorcan pastry. The eyes are holes cut in the box, so again we can see through the sculpture. The nose is a vertical line incised between the eyes. Resting on her head is a fantastic bird made up of a cast from a Guardia Civil hat and a small stone with two holes representing eyes. Another bird in the form of small barbell perches on one of the table legs, perhaps also an image doubling as a child.

The use of the Guardia Civil hat shows how the playful is at once serious and a good example of Miró's poetic strategy. First, the hat is instantly recognizable as the Guardia Civil is the national military guard. Second, historically the Guardia Civil has also been used against the civilian population, especially during the dictatorships of Primo de Rivera (1923–1930) and Francisco Franco (1939–1975). So here the incorporation of this image into so playful an image represents the transformation of a symbol of repression into an image of liberation. The repressive nature of the Guardia Civil is to be found in Federico García Lorca's tragic poem "Romance de la Guardia Civil," where the Guardia Civil is associated with the color black and contrasted with the spontaneity of the gypsies whom they chase. In the end "the imagination is burned."[97]

The use of repressive images as a symbol of liberation is also to be found in Joan Brossa's poetry and object poems. Brossa first met Miró around 1941, and he would become the major proponent of post-war neo-Surrealism in Catalonia. In 1966 Brossa devoted a poem in recognition of the siege by the police of intellectuals and artists inside the Capuchin Monastery at Sarrià, dubbed the "Caputxinada." After three days the police broke in and arrested a number of prominent artists and intellectuals, including Antoni Tàpies, who was briefly imprisoned. A similar meeting, known as the "Tancade," took place in December 1970 at the monastery of Montserrat to which Tàpies, Brossa, and Miró attended, but because of Miró's age they left before the police arrived.

Brossa's object poems of the late 1960s, like Tàpies' sculptures of 1970, are set up along similar lines to those of Miró's painted sculptures. For example, Brossa's use of ephemeral materials such as leaves may suggest that it is only through such materials that freedom of expression is possible, while Tàpies' sculptures of 1970 make reference to the austere life of the monks enclosed in the monastery. In *Femme et oiseau*, therefore, we may view the woman as an image of political as well as spiritual regeneration. She is rooted in the landscape of Catalonia, which resists repression. The ironic redirection of the image of the Guardia Civil hat saps it of its primary meaning and introduces a secondary meaning within the context of the work, transforming it into a playful image of sexual liberation. At the same time it reminds us that Miró made this group of sculptures against a backdrop of renewed political repression.

Again Miró had initially worked out the composition for this sculpture by 1960. We find the *ensaimada* face on top of the table

in an undated, but early sketchbook drawing (cat. 6.2) bearing the title *Femme* and the annotation "*taula robada*" ("stolen table"). A second drawing (cat. 6.1), dated September 27, 1960, includes a hat, and the stone bird above, as well as the weight attached to one of the legs of the table and again the annotation "*taula robada.*" A drawing of a few days later (cat. 6.4), dated October 2, 1960, depicts a fork that is crossed out in the position of the weight. A separate undated drawing (cat. 6.5) depicts the box lid with the annotation "*per caixa ensaimades*" ("for box of *ensaimades*"), and then the weight with the annotation "*posar un pes en lloc d'una cullera*" ("put a weight in place of a spoon"). The final title rises out of this process of adaptation. As in a number of other instances, it appears in the sketchbook recording sculpture (cat. 6.6), and again in an April 1967 drawing (cat. 6.3) indicating the placement of colors, where significantly we find the black of the Guardia Civil hat being the only color that corresponds to the finished sculpture.

Sa majesté (1967–1968, cat. 7) is another purely object sculpture consisting of the three elements of a palm tree trunk on which rests a gourd crowned with a circular piece of bread. The palm trunk is painted black. The yellow gourd has a void cut into the front revealing its interior and a second circular void cut into its rear. The circular bread is painted red, this "crown" recalling the Galí dictum to "wear a crown of eyes around your head." The ring of eyes may further be suggestive of the disembodied eye of pure interior vision, the visionary eye of Arthur Rimbaud's *Lettre au voyant*, representing the desire to become a seer. The shape of the gourd, together with its void, suggests the body, sex, and womb of the female body, its circular rear void depicting her anus. That the sculpture was gendered as female is born out in Miró's early sketchbook drawings, where we find the title "*Sa majesté*" substituting for a crossed-out "*La Reine*" (cat. 7.1). There is an indication in the annotations of the base as "*Bronze / tronc palmera,*" and it appears Miró considered leaving the ring of bread loose: "*elements mòbils no fixos*" ("mobile elements not fixed"). On the following page of the same sketchbook (cat. 7.6) there appears again the note "*tronc palmera*" alongside the image of the trunk superimposed on a triangular shape. Here the triangle as an image of the female sex is replaced by the tree trunk, another symbol of the female that is rooted in the soil of Catalonia. Again we can establish a link with D'Ors' *La ben plantada* in the image of a tree-woman. A third early drawing from another sketchbook (cat. 7.2), dated December 5, 1963, bears the similar, but more general title of "*Personnage royal.*" While within the panorama of poly-

morphous sexuality laid out by Freud, this sculpture may just as well be read as an erect, phallic image of male sexuality, arguably Miró in this instance privileges female symbolism. The yellow gourd and the red bread appear in the April 1967 drawing (cat. 7.7) indicating the possible application of colors, and we find the telling note "*entregades XII/66*" suggesting that Miró delivered the models for this sculpture to the foundry in December 1966.

The metaphorically running *Jeune fille s'évadant* (1968, cat. 8) consists of a pair of shop-window mannequin legs cast into bronze and painted bright red. The girl's round yellow face derives from a ceramic element, as does the second blue face situated in her midsection. The presence of this second face recalls the sense in which many of these sculptures are as actors performing a ritual or masquerade. She wears a red hat, which, as Joan Punyet Miró tells us, is cast from the tap of a cistern from Miró's Montroig farm. The second face is the most curious element, as it allows the double reading as a torso made up of breasts, navel, and sex, and a separate face—perhaps the child she may one day bear, a child whose future is implicit in her coquettish and ironic sexuality, suggested also in her elegantly curving legs. A drawing (cat. 8.7) indicating colors, and executed with colored pencils, specifically mentions this face with the note "*portar carota*" ("to carry mask"), to which is added the word "*guix,*" indicating that this element required an intermediate plaster model. A group of five drawings executed from November 25, 1964 to February 1, 1965 (cats. 8.1, 8.2, 8.3, 8.4, and 8.5) reveals that Miró began with the idea of the legs. The emphasis is further placed on the legs in the title, which appears for the first time in an untitled drawing from the sketchbook documenting sculpture (cat. 8.6). As her legs are slightly bent, and she is supported by a vertical rod, the idea is suggested that she is somehow turning away from us in a flirtatious gesture. The legs further introduce the very 1960s idea of sex appeal, again offered as an antidote to social and moral repression. The hat on her head may equally double as a bird (following the imagery of other works). Beyond such symbolism the tap also suggests a playful *double entendre*, for the tap suggests that we can "turn her on, or turn her off," while the color red provides a visual association between her slender legs and the tap, so that opening the tap might prompt her also to open her legs.

Personnage (1968, cat. 9) takes its point of departure from objects that Miró kept in his Barcelona studio in the 1940s and had used in the earlier series of *Projects for a monument* from 1951 to 1954. As with some of the above works, the sculpture is

made up out of just four objects. A bent metal pole in green forms the body of this character, and its white head is made out of an oddly shaped piece of metal. A black sphere stands in for its eye, and the teeth of a small rake painted blue represent a hat or a bird resting on its head. The metal armature used for the head is to be found in a photograph taken by Gomis in 1945 (fig. 12). As with the other painted works bearing the title *Personnage*, this sculpture represents a fantastic being without gender. The objects seem to have determined the composition, for this sculpture appears only in a drawing of the final arrangement (cat. 9.1), and there is no variation or modification of either composition or title, which appears in the same drawing and again in the April 1967 drawing (cat. 9.4) indicating colors, where the green of the pipe and the blue of the rake correspond to the colors of the sculpture.

In *Monsieur et madame* (1969, cat. 10) two completely separate objects stand together as a pair. A square stool painted red stands in for the man, and supports a rectangular white box with a circular face with either a mouth or a moustache painted on it in black. A round stool painted black stands in for the woman, and provides a support for a yellow egg, perhaps representing her round face. Though separate, the two stools go together as a couple. In one drawing (cat. 10.3) Miró shows both together on a common base. An annotation tells us *"ces deux objets doivent se déplacer librement posés sur un socle"* ("one must be able to place these two objects in any way on the base"). As Miró explained to Raillard, "I found the two stools in the courtyard, I cast them in bronze, I placed the egg on one and I etched the other. These are two characters made to go together."[98] Miró seems to have adopted the title at the last minute, for the sculpture sketchbook drawing (cat. 10.4) shows the words "*Homme et Femme*" crossed out in favor of "*Monsieur, madame*." Such a deliberate choice of title may indicate an ironic parody of bourgeois propriety, as well as perhaps being a discrete gesture of self-mockery.

A similar humor is present in the pendant piece *Homme et femme dans la nuit* (1969, cat. 11), where we are presented with a couple in bed at night, caught in the act of lovemaking. The man is represented by a black square stool on which rests a modeled circular head with a wing-like crescent shape painted red. The woman is represented by an upturned round stool, painted blue, and perched on top of one of her legs is a yellow crescent-shaped bird. Again this pair goes together, with metaphorically the woman on her back and the man on top. In one drawing (cat. 11.1) Miró presents the stools as adjacent on a base with the note *"ces objets doivent rester fixé sur le socle."* As with *Femme assise et enfant*, both *Monsieur et madame* and *Homme et femme dans la nuit* unfold in the real field of the viewer. Though they are separated physically by virtue of being set off on a base, it is in the nature of these objects that we might sit on them.

From 1971 to 1973 Miró made a second series of painted bronzes at the French foundry Valusani. This smaller series of bronzes was cast in editions of two examples. Unlike the painted bronzes cast at Susse and Clémenti, and the patinated bronzes cast at foundries such as Parellada and Bonvicini, the Valsuani casts were not designated for the Fondation Maeght or the Fundació Joan Miró, Barcelona. In this series, Valsuani provided Miró with the possibility of detailed castings using the lost wax technique. In this way, this group of sculptures extended the concerns of those bronzes cast by Clémenti.

These bronzes are based as much on modeled forms, into which are inscribed signs, as on the casting of objects. An important aspect of this series is the presentation of the woman's body as a tree or root. This body becomes the armature for the application of cast found objects or modeled forms, applied as three-dimensional signs equivalent to the inscriptions embedded in the surface of the sculpture. We have already considered the importance of the amalgamation of the tree and the body of woman, and this powerful image of Catalan identity may also be found in *Femme et oiseau* (1971, cat. 14), where the torso of the woman is made up of the trunk of a tree, which is painted blue. To reinforce this reading of the central armature of the sculpture, Miró has cut a void in the shape of a female sex in one side, and on another a circular void that is also a similar sign for the sex. Two modeled spheres, each painted yellow, represent buttocks, and one of them is projected out from the body on a black form cast from a tin can. In this way at least one of the figure's two sexes may offer the second reading as an anus. A circular form set on top of the trunk-base represents the figure's face. This form recalls the shape and dimensions of the *ensaimada* box lid that Miró had already used some years before, and its surface is encrusted with an array of small objects, most notably

including partially melted paint tubes. Miró wrote in his working notes of around 1941 the following idea for sculpture: "Melt down the metal of my empty paint tubes and use the resulting shapes as my starting point."[99]

Again we are presented with Miró slowly working out projects first conceived decades earlier. In the sculpture the red face is made up of such recycled objects, and parts of the tubes of paint are clearly visible. There is a witty irony in using the materials of painting to make up the form of a sculpture, which is then subsequently painted. Painting understood as a fine art, that is as painting on canvas, is effectively negated in a way similar to how bronze is negated by the application of paint. Through irony, Miró takes us from anti-painting to anti-sculpture. A ring cast from a found piece of metal is fixed to one side of the face. To the other side of the face of this woman is a green bird cantilevered out in space and complete with a pair small holes representing its eyes. Cast from what appears as a piece of wood, this bird offers a counterpart to the rooted element of the tree, a vehicle that connects also to the sky above as in D'Ors' *La ben plantada*. The idea of the trunk with a sex appears in numerous early sketchbook drawings for sculpture as in one drawing dated December 5, 1963 (cat. 3.7), though this drawing is not a study for this particular sculpture. The clear facial reading of the head is suggested in an undated drawing (cat. 14.4), and in the final drawings for this work (cats. 14.2 and 14.3), we find most of the elements which occur in the final sculpture, save two: a tail and three marks on the alongside the base.

Oiseau sur un rocher (1971, cat. 15) consists of a rounded base representing a rock into which is inscribed a line and a star. A cast piece of wood cantilevered above it represents the body of a bird (perched on the rock below) and a circular armature its face, with modeled relief elements representing the eyes. Miró apparently completed his thinking about this sculpture shortly before it was cast, as there is a drawing dated December 4, 1971 (cat. 15.1). As the sculpture is dated 1971, the casting must have taken place shortly before the end of the year. That he planned for it to be painted is indicated in the inscription "*peint*" and another annotation indicates the foundry. The positions of the surface incisions representing the eyes of the bird and the star in the rock are also present. In the archives of the Pierre Matisse Gallery, photographs of both the unpainted and painted version of this sculpture point to the likelihood that at least one version of this work was painted after being sent to New York.[100] As with the sculptures cast at Clémenti, these photographs suggest that the actual painting likely took place very late in the process.

Femme (1971; cat. 16) consists of a rounded gourd or bottle form with a void cut out of it in the shape of a woman's sex. A modeled sphere has been attached to one side and a longer pointed form to the other. The upper torso and neck are represented by an inverted funnel, and the face by a modeled form above. The undated drawing for the sculpture (cat. 16.1) suggests the modeled sphere might be read as a breast or buttocks, while the more ambiguous pointed elements may be read simultaneously at least three ways: as an erect clitoris, some sort of fantastic tail, or even as a phallus. The drawing further tells us the area of the face was modeled from "*fang*," meaning that it was modeled from mud or clay. The eye indicated in the depiction of the face is preserved in the final composition. That the subject is a woman is indicated in the title of both the drawing and the sculpture. And again the presence of the word "*couleur*" indicates that Miró planned for it to be painted.

A number of works in this series express the tree-woman metaphor as verticality, and this concern informed Miró's early thinking with regard to monumental sculpture. In *Femme* (1971; cat. 17) the body of woman becomes a more elongated tree form. Her arms are attenuated, and like truncated branches. An inscription indicating her sex runs the entire length of her black body. Her head is a yellow root, again suggesting the upper branches mentioned in D'Ors' description of *La ben plantada*. Her bright red sex suggests a passionate opening to nature.

In a similar vein the sculpture *Projet pour un monument* (1973, cat. 22) extends this image from the idea of an independent sculpture to monumental public sculpture, though Miró never made such a work into a monument. Curiously, the two examples of this sculpture have dramatically different paint applied. In the first the main body of the sculpture is white, with the painted inscriptions being black and the void area representing the sex is red. The top of the vertical armature is green above which is modeled element painted red. This version was the one that passed through the hands of Pierre Matisse, for it appears in the black and white photographs in the Pierre Matisse Gallery Archives, where we see it photographed outdoors by the sea.[101] In the second version the lower half of the sculpture, including the attenuated arms, is painted black and the void of the sex is red. The upper half is painted yellow, including the area of the linear inscriptions. As with the other version, the top is green and the modeled element above is red. It is not clear why there are two such different applications of the paint. One possible explanation is that Miró tried out different options with the idea of using this as the basis for a public sculpture. Importantly, this bronze was

made at a time when Miró first began seriously to consider making public sculpture. Here as in most of his public works he presents an image of woman as the focus of the monument.

The vertical presentation of woman is a feature also of *Femme* (1973, cat. 23), where a cast plank of wood painted black becomes the central armature and body of a woman. Her apparently outstretched arms are represented by two modeled forms attached to the sides of this body: a green crescent and a red protrusion, the latter an almost phallic shape. Her head is again represented by an inverted funnel, painted yellow, above which a modeled form painted blue suggests the figure's face. The choice of blue perhaps points to a connection with the sky or sea. That the blue form might also be a bird is indicated by Miró's more literal treatment of this element in the drawings related to the sculpture, for example the one dated March 22, 1971 (cat. 23.1). This work was photographed by the sea, as if to reinforce its connection with the elements.[102]

III. Color and Monumentality: 1970–1982

As we have seen, bronze served Miró well during the 1960s and the beginning of the 1970s. While he would continue to use bronze throughout the 1970s, he increasingly turned his attention to large-format sculpture and ambitious permanently installed public monuments. Even his bronzes of these years were realized in an increasingly large scale, and these he cast with Bovicini in Verona and Susse in Paris. Nevertheless, the requirements of monumental public sculpture, not to mention the sheer cost, and the need for the colors to resist the elements, led him to begin working with the then relatively new material of polyester resin, popularly known as fiberglass.

The main advantage of polyester resin over bronze is that it is lightweight and costs less to fabricate. At the same time, casting in this material from plaster models provides a high degree of flexibility. Finally, the use of polymer paint provides stable, weather resistant color, or so it was thought at the time.

Miró was not alone in his use of this material, and both Dubuffet and Nikki de St. Phalle adopted it early on, arguably for reasons not dissimilar to Miró. All three worked with Robert Haligon in Périgy-sur-Yerres for the fabrication of sculpture, though Dubuffet would later set up his own studio adjacent to Haligon's. Miró worked with Haligon from around 1970–1971, when he began a maquette for a public sculpture for the Los Angeles County Museum of Art (cat. 19). This was the first of several monumental sculpture projects briefly outlined here and explored in more detail later in this section. After this short-lived *Projet pour un monument*, he again took up this composition from 1971 through around 1977, with the idea of installing it in Central Park or a similar location in New York. At this time he also considered at least one alternative composition, known as *Personnage* (cat. 24), which was cast in polyester resin with Haligon in a large-scale format in 1974. Finally, the Hirshhorn Museum revived the plan for the Los Angeles Monument in 1978, taking it to the final board approval level, when the project was surprisingly rejected. A second model for this project was eventually made in plaster in 1979 and cast in a polychromed bronze edition in 1985 (cat. 19c). No monument was realized of this composition, but large-scale bronzes with dark patinas were cast of both compositions: *Personnage* by Susse in 1976 and *Projet pour un monument* by Bonvicini in 1981 (fig. 13). Though such large-scale bronzes are not monuments, two have found their way to public locations: one is sited in a square in Milan, and another in front of the Kimbell Art Museum in Fort Worth, Texas (fig. 13). Also in 1978, Miró completed the large monument at La Défense in Paris, which was destined to be his final monument realized in this material (fig. 14).

At this time Miró apparently decided he did not like the surface quality of the resin casts. Most of the works cast at Haligon derive from crude modeled forms, and are enlarged to large-scale independent formats, or to a monumental public scale for permanent outdoor installations. Numerous of these compositions derive from Miró's earliest bronzes cast at Gimeno in 1949–1950. In their modeled forms and in the application of polychrome surfaces they recall the *siurells* so influential on Miró's early thinking about sculpture. Even the large-scale resin sculptures take their point of departure in the idea of the public monument. As with the bronzes of the 1970s cast at Susse, many of these resins are now sited in permanent or semi-permanent outdoor locations.

Miró gave up the use of polyester resin after 1978, when he again returned to working principally with bronze. The largest and most substantial of his public sculptures *Personnage et oiseaux* (1982; fig. 16) consists of elements cast in bronze and iron, the latter employed for structural reasons. A second polychromatic work, executed in collaboration with Joan Gardy Artigas, was completed the same year in reinforced concrete into the surface of which were embedded shards of ceramic (fig. 18). Departing from bronze this technique, known as *trencada*, recalls Miró's earlier collaborations with Josep Llorens Artigas in the making of ceramic murals. At the same time it returns to

Gaudí's fantastic public environments (Parc Güell) in seeking an authentically popular form.

Miró's decision to place art within the architectural and urban context was indebted to his collaboration on the Fondation Maeght with the architect Josep Lluís Sert. In a 1976 catalogue of Miró's sculptures, Sert in his essay "Sculptures in Architecture" wrote:

> Miró has also proved his awareness of the environment in which his works are placed. He willingly adapts his work to the local conditions, being influenced by them. He also has a remarkable sense of the appropriate scale or size of his work that the space and place require . . .The appropriate enlargement is part of the character of the piece. But, some of his pieces have an inherent monumental quality . . .These large sculptures are meant to be used in public spaces for ordinary people. They are human and oftentimes humorous. Like Gaudí's work, they can become "popular."[103]

The question of scale was one of the appropriate relation between sculpture and site. Miró's monumental public sculptures differ from his large-scale bronzes not only in the fact that they are not movable, but in that they bear a particular relationship to a given urban context on the level both of architecture and of the pedestrian. Permanently placed sculpture was termed "site-specific" in the contemporary context.

Two of the most important sculptors advocating the idea of "site-specific" sculpture in the 1960s and 1970s were Richard Serra and Robert Smithson, both of whom virtually defined sculpture in relation to designated spaces. For Serra sculpture was to be such a part of the site that to remove it would destroy the work. Smithson further expanded this idea with the notion of "non-site" works, which removed raw earth from a given site and placed it in a gallery space alongside documentation showing maps, photographs and the location of the site.[104] Miró's monumental public works involve a conceptual and physical fusion with the site as a means of integrating the work with its immediate environment.

A number of Miró's resin sculptures return to his earliest modeled bronzes made at Gimeno in the 1940s. As such they return to his interest in primitive and popular images not the least being the *siurells*. Here Miró's primordialism is related to a bold sexual imagery evocative of prehistoric fertility figurines. For example, *Personnage* (1972, cat. 18) returns to the composition of an earlier bronze.[105] The central cavity of the sculpture bears an enormous painted sign of a female sex. This area of the sculpture is supported by the enormous feet that seem to merge into the earth from which they draw their strength. The figure's arms, by comparison, are reduced with one being painted blue, and the similarly small head looks down from above with two small painted eyes. A curious, almost phallic protrusion is painted black and emerges from one leg, while the other leg bears an inscription in black suggestive of buttocks. When viewed from behind we find another pair of buttocks—one, protruding, is painted yellow—and a second pair of eyes in the back of the head.

Personnage (1972; cat. 20) also returns to a 1945 terra-cotta[106] and a 1949 bronze.[107] In the resin version the inscriptions are painted on the surface and can be seen as both areas of color and as black signs. This overtly sexual image is given a blatant and humorous form in the greatly enlarged version made by Haligon, with the giant, phallic clitoris of the female figure being among its most prominent features. Its mound-like structure suggests not so much a vertical statuary but an enclosing and embracing womb-like structure—what Gaston Bachelard called the "cave of being"—symbolized by the concave void of the figure's sex. Though not conceived as a fixed monument, this work is now located at the Hakone Open-Air Museum in Japan.

The humorous sexual reading of these resin sculptures is born out by *Personnage* (1972, cat. 21), which consists of an oblong phallic shape cantilevered so it rests on an angle, almost like a bird poised for flight. Running nearly the entire length of the figure is a large cavity painted red, which signifies a female sex. Its body is a vehicle for the sex and its other attributes are similarly reduced. It has one yellow eye and another blue one to which is fixed a black sphere. A black linear incision in its surface perhaps traces the flight of a bird, and its bottom is truncated and also painted black. Though this sculpture was not derived from one the 1949 bronzes, its erect treatment of the female sex recalls the phallic clitoris of the previous work discussed. Though not strictly a public monument this work was originally sited at the Fondation Maeght just at the beginning of Miró's elaborate sculpture garden called *Labyrinthe*. Now it is sited just past the general entrance to the foundation as one of the first works of art you see when entering.

As mentioned above, sometime in 1971 Miró began working on a public sculpture to be sited in front of the Los Angeles County Museum of Art. Miró made a number of drawings related to the sculpture in early November 1971, and there is a photomontage showing the scale and site for the sculpture (cat. 19.11). A maquette for *Projet pour un monument* was realized in plaster in 1972 (cat. 19a) working from a ceramic model. The

white textured sculpture depicts a female figure with outspread arms as if she is about to embrace us. An open female sex is painted in red on the central cavity of her body. Black marks indicate the sex's passionate vibration, and have the second meaning of pubic hairs. A similar additional mark stands in for the mouth. One eye is painted black and the other red; likewise, one arm is green and the other yellow. On one leg there is a circle containing an area of blue in the center of which is a black spot, a mark that perhaps can be read as a sign for a breast. Though not based on the 1949 bronzes, this sculpture captures the same tone in its ribald and sexy gesture to the public.

Maurice Tuchman represented the Los Angeles County Museum of Art on the commissioning of the project, for he attempted to contact Miró in October 1971. On October 6, 1971 Miró wrote from Mallorca to Pierre Matisse saying Tuchman wanted to meet him in Paris and noting, "I have the impression that this is for something important."[108] By this time, however, it seems that some problems had already emerged with the commission, for Matisse responded to Miró the same day, "Mr. Tuchman from the Los Angeles Museum asked me to see you, he is in Paris at this moment. Be careful in case he asks you for something."[109] On October 12 Miró responded assuring Matisse he would keep him abreast of any developments.[110] Matisse's response, sent by telegram on October 12, was blunt and to the point, "do not engage with Tuchman."[111] Again on October 20, Matisse reiterated this point in a telegram, "ignore the Tuchman project; he has never said anything to me about it."[112] What problem had caused the rupture with Tuchman, and how the project had died so quickly, is not clear. What is certain is that the project would continue to fascinate Miró for some time, and there would be two more possibilities of reviving it for important commissions, neither of which was successful. In a letter dated December 29, 1978 Matisse wrote to Miró suggesting that the Los Angeles Museum of Art had rejected the commission, referring to "the maquette of your sculpture 'Projet pour un monument,' which was presented to Los Angeles and refused."[113] Such problems, indeed, would in the long run plague the future of this sculpture despite the efforts of Matisse and a number of energetic curators to see it completed.

Despite the negative response in Los Angeles, Miró continued working on drawings for the sculpture, a number of which are dated November 1971. Miró's desire to create a monumental sculpture to be sited in relation to the museum's architecture can be found in a drawing made on an envelope and dated November 2, 1971 (cat. 19.2). In the drawing the viewers are depicted as approaching the sculpture by the stairs of the museum so that at the top of the steps they arrive at a structure around six times larger than life, between whose legs one could walk. The title is here indicated as *Femme s'adressant à la foule* to which is added the annotation "*el blanc l'embrutarà la gent?*" ("the white will brutalize the people") and an indication of the exit, "*sortie*." Finally he notes the price, "ask for a net price of $200,000," and mentions that Miró's sculpture assistant Joan Gardy Artigas should go to take charge and help with the installation. The next day Miró made two drawings (cats. 19.3 and 19.4) highlighted with colored wax pencils that show a similar, but alternate composition, presumably quickly rejected. On November 4, 1971, Miró then returned to the composition that had first appeared on the envelope. Here (cat. 19.5) we find the larger than life female form, this time with colors applied in wax pencils. The sheer size of the sculpture is suggested by the miniature viewers who are dwarfed by it. The title is now indicated as "*Femme devant la foule*," which from this point onward became the working title. Another alternate selection, in an undated drawing (cat. 19.6), mentions a scale of 4m. In order to think in terms of scale, Miró made several photographs of the plaster model of the sculpture viewed from different angles, so as to exaggerate the effect of monumentality (cat. 19.10). Further, after the model was painted, Miró created a photomontage showing the sculpture sited at the entrance to the Los Angeles County Museum of Art (cat. 19.11), again emphasizing its scale as around four times life-size.

By the end of 1971 the project for Los Angeles had fallen through. By this time the Guggenheim Museum began preparing the exhibition *Joan Miró: Magnetic Fields* scheduled to open in October 1972 and co-curated by Rosalind Krauss and Margit Rowell. On July 26, 1972, Rowell wrote to Miró with a proposal of siting the sculpture in Central Park, suggesting that it be unveiled at the time of the opening. The keys of the city were to be presented to Miró at this time. The idea was that the city would pay the production costs, and the sculpture would be dedicated to the children of New York.[114] A formal invitation from the New York City Cultural Council followed on August 11.[115] Both letters stressed that if Miró was in agreement, the approximate size should be stated and a model produced. On September 18, Rowell again wrote to Miró requesting him to visit New York City to choose an appropriate site.[116] She suggests the desirability of locating the sculpture in a children's garden that, for the security of the sculpture, is open in the daytime and closed at night. She notes that there are three possible gardens in

Central Park, all accessible to Fifth Avenue and equally close to the Pierre Matisse Gallery and the Guggenheim. Furthermore, the possibility of an additional garden outside Central Park might provide more space. On the same day, Rowell wrote to Haligon requesting a preliminary estimate for the fabrication.[117] The next letter from Rowell, dated September 26, 1972, again refers to three locations in Central Park, the inclusion of photographs and a map of the park. Intriguingly, there is again mention of the fourth park outside Central Park:

> There is a fourth site, which is in a large park by the river and which is equally under consideration. I enclose the photos of this park with a playground for children. In some of these photos you can see the river in the background. This site has the advantage of being still larger, more varied, and less congested than Central Park. It is close to Central Park.[118]

This option corresponds with a photograph in the Fundació Joan Miró (cat. 19.12) indicated as "*site sur le fleuve*," where the river and urban landscape beyond can be seen in the background. A second photomontage in the Fundació Pilar i Joan Miró (cat. 19.13) shows the maquette sited in the same location. Scale is indicated by a figure strangely wearing nineteenth-century costume to the left of the sculpture and by another small figure drawn in ink standing at the base. The new site, confirmed by Margit Rowell, was Carl Schurz Park, located at 86th Street and the East River. Carl Schurz Park has both a view of the river and is located in the vicinity of the Guggenheim Museum.

A blue ink preparatory drawing from around this period (cat. 19.8) reveals the change of location from Los Angeles to Central Park. It bears the inscription "esc. Los Angeles" which is crossed out and below which is added "per Central-Park," the latter being circled in red ink. As of November 3, 1972, Rowell had neither received a maquette, nor had Miró been able to come to New York for the opening of his exhibition at the Guggenheim. Little had changed by February 19, 1973, when Rowell again wrote to Miró requesting more information in the form of photographs of the maquettes, their scale and materials:

> I am still thinking about our sculpture project and wondering where we stand with it. Would it be possible for you to send me a photo (or photos) of the maquettes or plaster models currently with Haligon? I would like it if you could say a little more precisely the material that you wish and the scale.[119]

Continuing with a consideration of the choice of the site, Rowell expresses a concern regarding the scale of the sculpture.

> In the end I think that the best way to proceed is to choose the site as a function of the sculpture, and not the other way around. I understand you spoke to me of a 15 to 20 meter sculpture on the telephone last October. Because I did not envision such a large sculpture, the sites under consideration are not big enough. Above all what would be useful would be photographs so that I can imagine its silhouette.[120]

On April 18, 1973, Matisse wrote to Miró reminding him that "The sculpture project is still up in the air."[121] At this time there was still no mention of more than one maquette, but shortly it would become clear that Miró was working on at least two options. In a letter sent from Rowell to Miró dated May 29, 1973, there is now mention of two maquettes: "I am happy to learn that there are two maquettes in progress with Haligon who seems right to you for this project."[122] Rowell mentions using an engineer named Carl Nesjar, who is a specialist in reinforced concrete. And she stresses the need to see the maquettes on her next visit to Paris, planned for September.

The second option considered for this project was *Personnage* (1974, cat. 24), which was finally fabricated in polyester resin. The sculpture presents a bulbous figure, whose lower half has a single breast or female sex painted in red and black and a tail painted yellow. Its rounded head has a black incision and blue eye in the form of a sphere attached to it. A preparatory drawing (cat. 24.5) presents the colored areas of the sculpture rendered in blue, black, yellow, green and orange wax pencil. Though these colors differ from the sculpture, the composition corresponds with all of the details of the final sculpture, and an annotation tells us: "Central Park?" A second drawing in pen (cat. 24.6) also includes the elements of the final sculpture and a number of telling inscriptions, including an indication that a large-scale white marble was a possibility: "*marbre blanc, més gran*." Another inscription "*Haligon*" and "*Achevé*" indicates that the final work was realized by Haligon. The predominant white of the final sculpture may derive from the idea of white marble, though there is no other mention of marble in the correspondence with Rowell. As all of the drawings for this sculpture are undated, it is difficult to establish the exact sequence or the date Miró conceived of this work with relation to the other model. Another colored drawing (cat. 24.3) reveals the base as blue with the breast-sex as yellow and the tail black. The head is red and the eye form is black in this variation. One sketch in blue ink (cat. 24.7) offers us the title of *Femme, oiseaux*, which makes perfect sense when we consider the presence of the tail. A final two drawings (cats. 24.1 and 24.2) appear

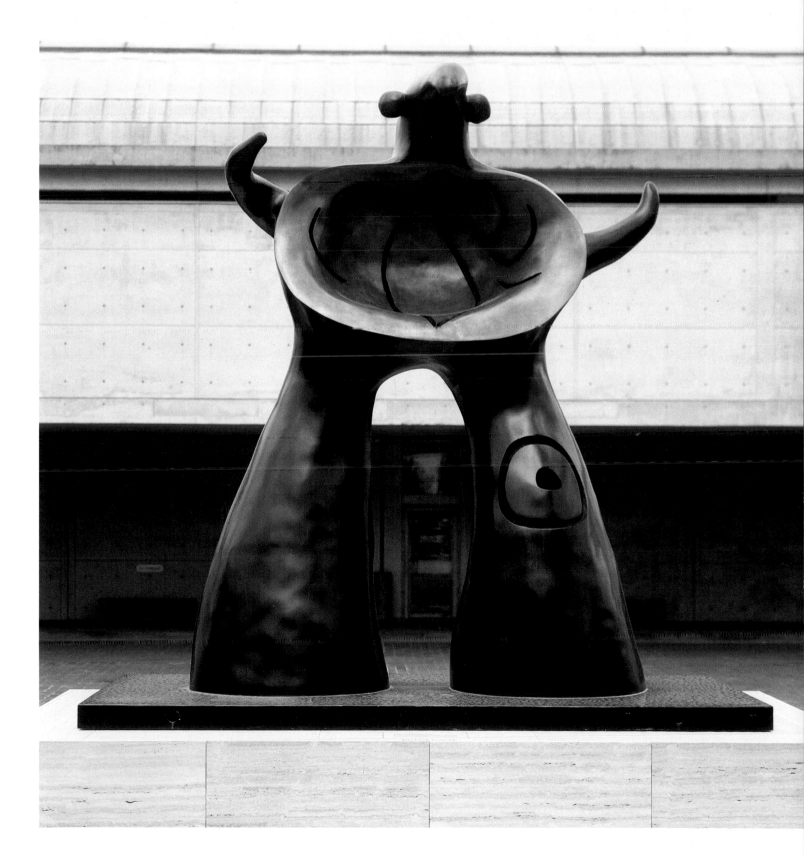

as records of the completed idea in both the sculpture sketch-book begun in 1964 and the undated sketchbook of drawings for sculptures dating from the early 1970s.

On August 22, 1973, Rowell wrote to Pierre Matisse requesting that he speak with Miró while on his trip to Europe, and asking him to make photographs at Haligon's studio of the maquettes.[123] In January 1974, Rowell traveled to Paris. There she visited Haligon and Bousquet's studios to see the two maquettes, and also met with Artigas as well as Jacques Dupin and Michèle Venard from the Galerie Maeght. On March 4 Venard reported back to Matisse on Rowell's visit, enclosing Haligon's February estimates for the two options. "Madame Margit Noël [Rowell] responsible for studying the possibility of installing in New York—Central Park—a sculpture by Miró, went to Haligon and Bousquet where two projects particularly interested her . . . She asked me to have him draw up an estimate.[124]

The following March 15, Rowell wrote to Miró with her thoughts on the two maquettes.

> Since the sculpture will be dedicated to the Children of New York City, we thought it was desirable to plan a sculpture on a human scale, or nearly human, and a sculpture that the children can play on or have fun around. The model in progress that I saw at Bousquet, and which pleased me enormously, is your *Femme Oiseau*. Given the openings and the hollows, as well as its reassuring silhouette—at once maternal, stable, primordial and a little amusing—this is the ideal sculpture for a park or a public garden in New York.[125]

It appears that this description refers not to *Projet pour un monument* ("La Femme devant la foule;" cat. 19) but to *Personnage* ("Femme, Oiseau;" cat. 24). It is not clear at this stage which of the two options Miró preferred. As we have seen, the first of these appears in the photomontage Miró made for the New York project, and was the maquette presented in New York.[126] On the other hand, the second is the object of the correspondence with Rowell. The distinction between the titles is clear from the estimate that Haligon supplied the Galerie Maeght on February 26, 1974. There Model A is described as "Femme Oiseau" and "Projet de monument pour New York" with a quote for enlargements to 1.70m, 2.00m and 2.95m. Model B is described as "*Personnage debout, initialement prévu pour Los Angelès*," with an estimate for enlargements to 1.70m, 2.60m, and 3.50m. A photo labeled Model B is included which corresponds with *Projet pour un monument*.[127] Returning to Rowell's letter of March 15, 1974, she mentions the desirability of realizing the sculpture at a height of 3m, and she continues reporting her correspondence with Haligon: "I therefore asked and received an estimate from Haligon for a production in epoxy at 2m 95."[128]

This dimension corresponds with that which appears as Model A in the February estimate prepared by Haligon for Galerie Maeght, undoubtedly the same one forwarded to Rowell. At this stage the plaster model remained unpainted. Rowell then requests two things from Miró: first, that a reduction of the plaster model be made by Bousquet and sent to New York for a presentation; and second has Miró decided the placement of the colors intended for the surface painting, and when will he do this. Indeed, on this very same day Matisse wrote to Bousquet requesting a half-scale reduction of "Femme Oiseau."[129] Finally, Rowell responds to what must have been Miró's concerns about the "cold" quality of the fiberglass surface texture. "I agree with you that Haligon's smooth and shiny material is too cold and I hope that Joanet [Joan Gardy Artigas] will find a more subtle material."[130] As things were moving quickly in New York, Rowell urgently wanted to release the information to the press and thereby definitively secure the commission. Though not yet clear, the concern over the surface texture would become an obstacle to the realization of this work.

Other commitments were also emerging with the arrival of 1974 in the form of Miró's retrospective for the Grand Palais in Paris and a major public commission of a monument for La Défense. These would quickly come to upstage the New York project. On April 10, 1974, the same day as Rowell's letter to Miró, the Visual Arts Committee of the New York City Cultural Council reported on both her March correspondence with Miró and the February estimates received from Haligon. At this stage the entire project including fabrication, packing, transport, and installation was estimated not to exceed $50,000, a figure that was perfectly feasible. However, by the early summer Miró began to favor bronze as a more desirable option for this sculpture. On June 18, Michèle Venard wrote to Matisse referring to the interim plasters, "the latter plaster was reserved by Margit Noël [Rowell] for Central Park—its title is Femme-Oiseau. With regard to that, Bousquet will have finished by the end of the month the small maquette that you asked him to make for the latter project."[131] Venard wrote she would prepare a dossier for Rowell with the estimates for plaster enlargement, casting of the enlargement in bronze, and transport and insurance. Accordingly, on July 8, Bousquet estimated that to make a 4m-high plaster enlargement of *Femme Oiseau* would cost 50,000 francs. On July 12, 1974 Susse prepared a quote for casting to

the dimensions of 4m height, at a weight of 9 tons, at a cost of 1,250,000 Francs. Finally, on July 23, Delmare provided estimated costs for packing, transport, and insurance at a cost of 146,353 Francs.[132] Following receipt of this new information, Rowell responded in shock in a letter to Miró dated November 21, 1974, "When I received the estimate from Susse for the fabrication in bronze of Femme Oiseau it completely took my breath away . . . You can therefore understand my great confusion!"[133]

She continues stating her conviction that, "the artist must have the last word as concerns form, scale, and the materials of his work. Since you want the Femme-Oiseau in bronze, I am obliged to accept your decision and to try to find a solution."[134] However, she states that it will be impossible to find the necessary sum to cast "Femme Oiseau" in bronze. This leads her to ask Miró to reconsider some form of plastic material, or as an alternative option, reinforced concrete.

> I'm writing to you today, therefore, to suggest that we return to our first idea of realizing it in an ordinary plastic material or even in concrete. I think that *Femme-Oiseau* in a white material with patches of color would be magnificent. I have always believed this, and I still believe it, independently of all questions of price. The sculpture would stand out well against the landscape, it would be more cheerful, more luminous, and more pleasant for the children than a sculpture in bronze.[135]

She concludes by saying that they should not forget the first idea that the sculpture is dedicated to the children of the city.

Miró's undated response to this letter offers an explanation for the change in tack. First, it would be expensive because it had to be done in bronze, and this could only be properly achieved by Susse. Second, Miró was beginning to encounter technical problems with the use of resin in the monument for La Défense.

> We are working now in Paris on a 15-m high sculpture to be placed at La Défense, which will also be in very brilliant and robust colors. This therefore presents us with the same problems we dismissed with the idea of producing in plastic material because the result is so cold and I have little confidence in the permanence of the colors.[136]

Miró points out that Dubuffet's polyester resin sculpture in Chase Manhattan Plaza, *Group of Four Trees* (1969), was largely in black (with white), and he expresses his hope that the engineers and technicians will achieve a good result for Paris.

Pierre Matisse then wrote on November 25, 1974 to Miró's lawyer Ramón Viladás in Barcelona asking why Miró had changed his mind regarding the choice of material. The change annulled any hope of realizing the project, and Matisse expresses his astonishment.

> For my part, I don't understand it at all, because he was 100 per cent in favor of a sculpture in epoxy from Haligon in color . . . You know how much Miró loves these big projects, and this one for which he had shown a particular enthusiasm, so it is difficult to understand his change of mind.[137]

Viladás' response clarifies the concerns expressed by Miró to Rowell:

> In your letter of November 25, you speak of the sculpture project for Central Park that was first conceived of in the material that is made at Haligon. Effectively, Miró considers that it is no longer possible to continue working with this material because he does not like it.[138]

He continues noting that Miró is preparing the large sculpture for the new quarter of La Défense. Because of the scale of this monument, it cannot be cast in bronze. Rather it could be made in cement and painted in a special way so as to achieve the color Miró desired. The same technique could be used for New York: "he thinks that the same process would be followed for the large sculpture in Central Park."[139] Miró is going to write to Rowell, and Viladás wonders if Matisse can ask her to consider whether this method will be adequate for Central Park. Obviously, at this stage it is impossible to estimate a price. At this point the New York commission seems to have effectively come to a conclusion. Still, Miró somehow managed to cast large-scale versions in bronze of both *Personnage* with Susse in 1976 and *Projet pour un monument* with Bonvicini in 1981.

Curiously, despite these strong reservations, Miró continued with the use of polyester resin. As we have seen, a large-scale version of *Personnage* (cat. 24) was made in 1974, but it was never mentioned in the correspondence regarding the Central Park project. Having made this work, was Miró unsatisfied with the smooth finish of the surface? This is not certain. Equally strange, he continued using polyester resin with *Couple d'amoreaux aux jeux de fleurs d'amandier. Monument pour La Défense* (1978; fig. 14). A 3m-tall interim model was made in 1975,[140] Haligon signed a contract in 1976 with EPAD (Etablissement public pour l'aménagement de la region de la Défense), and the sculpture was completed in November 1978. At La Défense, Miró approached the scale he desired for the Central Park and Los Angeles projects, and the resulting monument was 12m tall. Why he continued with this material given the reservations

expressed is not certain. Concrete may have been too expensive, and the crudely modeled forms of the final sculpture may in the end have been appropriate for casting in resin at a monumental scale. The sculpture consists of two separate male and female parts (fig. 14). Sited on a walking promenade that excludes vehicular traffic, the sculpture establishes a dialogue with both the workers in the buildings surrounding the sculpture and, on a larger than life scale, with the individual pedestrian. In this way, it acts as a mediator between the human scale of the viewer and the gigantic scale of the modern office block. As Miró told Raillard in 1977, "I am making a large sculpture, fifteen meters high, for La Défense in Paris, in very violent colors. There, it is a question of playing with the architecture and not with the natural landscape, with the large buildings in concrete, steel, and glass."[141]

The male figure consists of a vertical element in red and yellow crowned by a blue head with a red and black eye. He bends slightly towards his female counterpart. The female figure consists of a blue vertical armature, to which is fixed a red crescent head with two eyes, and she is slightly inclined away from the male figure, to whom she seems to extend her arms in a gesture of embrace. A black linear incision appears in both and metaphorically binds them together. The more vertical and phallic shape of the male may be associated with the sun, while the embracing female's crescent shape may be associated with the moon. This celestial couple, as with the Los Angeles project, revealing themselves to the crowd, is a monumental image of gestation and fertility. Still, *Monument pour La Défense* would be Miró's final project with Haligon.

Despite the problems with the New York commission, Miró continued thinking about both the Central Park and Los Angeles Projects. By 1978 the *Projet pour un monument* which he had considered for Los Angeles and as one of he options for New York emerged again as a possible commission for the Hirshhorn Museum and Sculpture Garden. On July 28, 1978 Charles Millard, the Chief Curator at the Hirshhorn, wrote to Matisse inquiring about the possibility of commissioning the unrealized Los Angeles project.

> I remember seeing the maquette which struck me as a masterpiece. My memory is that the piece was called *Femme devant la Foule*. I am enclosing photocopies of some montage photographs of it that were made at the time. As I recall, it was to be executed on a scale of something like thirty feet.[142]

He continues by asking about the materials, fabrication time, and approximate cost, and emphasizing the need for the sculpture to withstand the Washington climate. Matisse responded on August 9 saying that he would discuss the project with Miró on his September trip to Palma, and answering Millard's questions, "the piece was made in epoxy resin and was polychromed on white. I have a feeling that this material was abandoned for one reason or another. However, one huge piece is being made for the Défense Towers in Paris."[143]

Presumably following his return from Europe and a discussion with Miró, Matisse then telegraphed on October 24 to Haligon with a commission for two additional maquettes in white. He then set about trying to locate the 1972 maquette, which the LACMA informed him had been sent to the Galerie Maeght in January 1974. Haligon sent an estimate on November 30, 1978 based on fabricating a 12-m high enlargement. The cost would be 950,000 Francs for fabrication and 60,000 Francs for installation. On December 1, 1978 Millard wrote to Matisse saying "Our Board has approved the acquisition of the monumental Miró in principle, but would like to have more concrete details."[144] He also asked for "all the foreseeable expenses" in dollars. Further, Millard communicated the board's desire for the maquette to become the property of the museum. He concluded by asking, "Incidentally, is it correct that in addition to being called *Projet pour un monument* the piece is entitled 'Femme devant la foule?'"[145]

Matisse's answer to this question is not available, but this was indeed the working title Miró used in his sketches for the sculpture. The more general *Projet pour un monument* seems to have been used for pieces with no specific destination. Millard again wrote to Matisse on December 15 regarding the 15 m height of the sculpture: "The piece was originally intended for the Los Angeles County Museum—a building surrounded by a considerable amount of open space. When we install it, it will have to go on our Plaza, a concrete environment considerably more restricted than that of Los Angeles."[146]

He then asked if it was possible to have the monument fabricated in a smaller scale. Acknowledging that Miró's wishes in this matter need to be respected, he wondered if Matisse might "tactfully" explore this possibility with the artist. Margit Rowell then brought a second plaster maquette of *Projet pour un monument* made at Haligon to Miró in Mallorca on behalf of Matisse. Matisse explained to Miró, in a letter dated December 29, 1978, the interest expressed by Millard in reviving the Los Angeles *Projet pour un monument* and that the original plaster model had been returned to the Galerie Maeght in 1974, but it now appeared to be "lost." This is the reason he commissioned a new

14. Miró's public sculpture
*Couple d'amoureux aux
jeux de fleurs d'amandier.
Monument pour La Défense*
at La Défense, 1978.

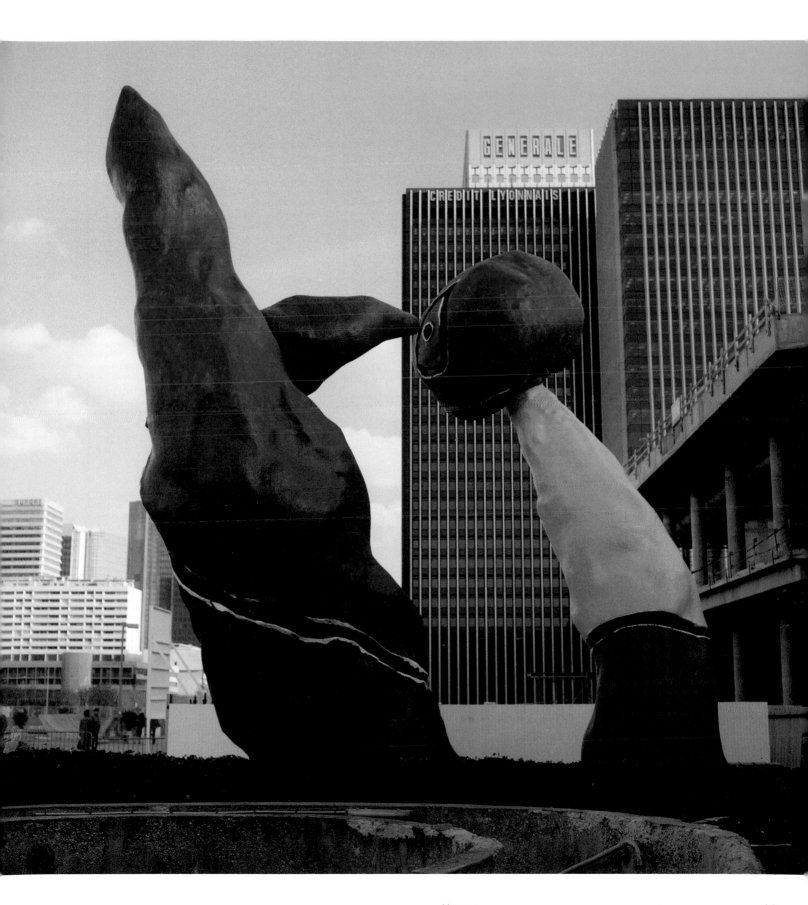

plaster and sent it with Rowell to Miró, with the idea that Miró indicate the colors.

> Since the maquette for Los Angeles was supposedly lost I was able to have Haligon make another one and send it to you [to indicate the colors] so he can put the colors on it. To save time Margit Rowell kindly offered to take it since she was going to see you after her trip to Madrid. The people from the Hirshhorn Museum are very serious and I would very much like to show them this maquette.[147]

This new maquette was cast in a polychromed bronze edition in 1985 by Bonvicini (cat. 19c) and painted by Joan Gardy Artigas following Miró's plaster. The painted design of the later plaster and bronze, though following the 1972 painted plaster, is more elaborate. The sex in the central void is red with black pubic hairs as in the earlier version, but the border demarcating this cavity is painted yellow, as if framing the sex. While one eye is black, as in the first version, the other one is blue rather than red. The marks denoting a breast on one leg is now red rather than blue; and on the other leg a new, black rectangular form has been added. These later two forms add a symbolic anchor to the solid foundation of the legs suggesting a telluric source of fecund power.

Millard wrote again to Matisse on March 2, 1979 expressing the museum's "serious interest" in commissioning the sculpture and requesting a maquette and a firm estimate of costs. Accordingly, Matisse sent a telegram to Lefoinet requesting that the maquette be sent from Paris to Washington. Millard confirmed its arrival in a letter of May 7, 1979 to Matisse, "a note to tell you that the Miró maquette has arrived safely. Needless to say I am enchanted by it."[148] He continues saying it would be presented to the board's committee on collections and, thereafter, to the full board. Milliard's next letter, dated June 18, 1979, begins with the following upbeat report: "I am delighted to be able to tell you that our Board has unanimously approved the commission of the Miró sculpture."[149] But, he added the more ominous caveat: "This is not the final word, since the project must now be approved by the Secretary of the Smithsonian, but it is a long step forward."[150]

Millard proceeded to request a fabrication and payment schedule, reiterating the desire of the board to acquire the maquette and that the final work be unique. Also, he asked how the sculpture would be constructed and mounted. Millard then introduced the issue of keeping the rough surface texture of the maquette in the final enlargement:

> Part of the effect of the piece to me is its irregularity—both the eccentricity of its silhouette and the texture of its surface. I hope that great care will be taken to maintain this effect in the final work and that it will not be too much "perfected."[151]

Finally, he mentioned the need for the sculpture to stand up to the snow and rain typical of the variable Washington climate.

Matisse then wrote to Miró in a letter dated July 30, 1979 explaining the progress and that the project had been accepted subject to final approval:

> As I told you, the project is accepted, but they have not officially announced it, for it must be countersigned—that will be done any minute, along with the last details from Haligon for the construction and the installation of the sculpture at the museum, which will be done by Haligon's team.[152]

There remained the question of Miró's fee. As the Hirshhorn was preparing a big exhibition of Miró's paintings for the following spring, it was still not clear if the sculpture could be ready for the opening.

Matisse also wrote to Haligon in an undated letter, probably written at some point during the early summer, requesting an answer for the same questions put by Millard. Haligon responded to Matisse with a detailed letter dated August 2, 1979 that laid out the three stages of enlargement resulting in the final height of 15m. The production time was estimated at 24 months, and a contract would be necessary to agree the estimated costs as previously quoted plus 10 per cent because of the delay in taking up the previous offer. The final sculpture would be made in stratified polyester resin with a reinforced metal structure inside; the color applied in a two-component polyurethane paint protected by a satin-matte polyurethane varnish; the sculpture mounted on a slab of concrete, the technique varying depending on whether it was intended to be permanent or movable. The reproductive use of a panthograph machine (a machine with a double stylus for copying or enlarging three-dimensional objects) would preserve the variations of the surface of the maquette. On this point, however, Haligon, in a letter dated August 2, 1979, questioned Matisse and Millard's desire to preserve the rough texture of the maquette: "The quality of the surface, roughness, I don't think Miró wants that and I think one must look instead to the appearance of the monument at La Défense, that is to say vibrant but not too shocking."[153] This surface would reduce the amount of time in fabrication. As for the climate, the surface would degrade no more rapidly than stone or bronze. Only the varnish would be affected, not the

underlying layer of paint. The varnish would need to be replaced every five to seven years in order to keep the sculpture fresh, however it would be advisable to wash it from time to time with water or even a mild detergent.

Matisse forwarded this document as well as a copy of the contract signed between Haligon and EPAD with the idea that the latter could be a model for the agreement. His letter of August 26, 1979 explained the estimated time of 20–24 months and explained that Haligon could not work exclusively on this project. He then stated Miró's fee as $100,000, plus $10,000 for sundry expenses, and agreed that the maquette would be included in the agreement "at no extra cost," though it would have to be sent to Haligon to use as the maquette for the enlargement.

Despite the propitious tone of the exchange the Board of Trustees rejected the project. Why is not entirely clear. What we know is Matisse's November 21, 1979 response to Millard, which expressed his disappointment, and then noted,

> I had understood from your communication of last May that the project had been unanimously accepted and was only waiting for the final routine signature from the Smithsonian Institution. On the strength of this I informed Miró accordingly. Not only am I disappointed myself but also mostly for the sake of the artist who unfortunately belongs to a class of artists who are not apt to understand the meanders of board of trustees meetings.[154]

On December 4, Pierre Matisse received the maquette from the Hirshhorn. The same day he wrote by telegram to Miró informing him and announcing a plan for a new exhibition of painted sculptures: "am sorry to inform you Hirshhorn Museum Washington abandoned project large sculpture Haligon stop."[155] And almost as a consolation: "we are preparing for spring [an] exhibition of your painted sculpture."[156] The same day Matisse also informed Haligon by telegram.

Though this sculpture was not destined to be made as a monument, it was finally cast in 1981 by Bonvicini in a large format bronze in a rich, dark brown patina (cat. 13). Following the idea of the painted maquette the interior cavity of the area of the sex was treated in a different manner to achieve a creamy and more luminous surface color, thereby drawing the viewer's attention to this focal point. One undated drawing (cat. 19.9) reveals Miró's thinking with regard to bronze. He revealingly titles the work as *Maternité*, motherhood, and notes down the idea of casting it with Parellada, "*donar a fondre a Parellada.*" Finally, a crossed out note tells us "*Com personnage gothique bronze*" referring to another large-format sculpture. Though the sculpture

Personnage gothique was never executed in polychrome, there is at least one drawing (cat. 24.9), dated October 30, 1971, that suggests Miró may have momentarily considered this option, for it depicts the composition with the addition of red, blue, and yellow wax pencils. It bears the title *Personnage*, but its form follows the final version of *Personnage gothique* and the annotations tells us it was destined for Valsuani, though the final version of the sculpture was cast at Susse. One inscription suggests a height of 1 m 80 cm. Most importantly, the date of October 30, 1971 places it immediately before the first drawings related to *Project for a Monument* of the first days of November. An additional line drawing in pencil (FPIJM DP-0719.1) depicts the contour of the figure's composition. This undated drawing bears the simple annotation in blue ink, "*Lyon bronze,*" suggesting that this sculpture was intended for a public site in France. An example of this bronze sculpture was eventually sited in Milan, and later another one in Fort Worth.

Personnage (1974, cat. 26) is unique within the group of cast resin sculptures for its central armature departs not from modeled forms but from a found object, in this case a simple clothespin greatly enlarged to dramatic effect. The sculpture is further unusual in that its predominant color scheme is black rather than white. The clothespin supports a black sphere with an irregular oval red area of paint applied, the two functioning as a sign of a head and face. Above this head is a vertical blue egg shape with a red sphere attached, perhaps signifying a bird resting on the figure's head. In this way the vertical clothespin may be read as the body and legs of, most likely, a female standing figure, the two, now giant enclosed voids formed by the pinching mechanism functioning as signs for the figure's sex and perhaps also her anus. This witty iconography is consistent with Miró's thinking on the Los Angeles and Paris projects.

Personnage (1974), in its dramatic use of the clothespin, comes closest to the position of the Nouveau Réalisme and Pop Art practiced by Christo and Oldenburg. Christo initially wrapped up objects as enigmatic packages, later packaging whole buildings, while Oldenburg began with banal objects, often tools, and then greatly enlarged them as public monuments. In 1962, the leader of the New Realism, proclaimed "the direct appropriation of the real is the law of our present."[157] Oldenburg was successful in realizing a transformation of the humble object into a public form of poetry based on enlargement, a monumental poetry akin to that sought by Miró in his synthetic resin sculptures. Oldenburg achieved this most strikingly with works such as the 3.6 m-tall *Giant Trowel* (1971) at the

Rijksmuseum Kröller-Müller and even more intriguingly with *Clothespin* (1976), sited at Center Square Plaza in downtown Philadelphia. Based on an idea Oldenburg had considered since 1967, *Clothespin* functions by virtue of enlarging the model to a public scale. Miró incorporates enlargement with other elements to transform the sculpture into a fantastic representation of a figure. Oldenburg's sculpture, nevertheless is not without human and even erotic overtones, which are strikingly close to those of Miró. In conceiving *Clothespin*, Oldenburg thought of Constantin Brancusi's *Kiss*: "because both contained two structure's pressing close together and held in an embrace."[158] On a more intimate scale, Brossa's *Poema objecte* (1967) presents a clothespin so that one part is slipped in the spring mechanism joining the two pieces; it appears like a couple griped in an embrace while making love. Inscribed in handwritten pencil on the upper part of the pin is the Catalan word for freedom: "*Llibertat*," suggesting that freedom is only possible in the private sphere of sexual interaction. In 1975 Brossa again returned to the subject of the clothespin in another *Poema objecte*, also known as *Duet*, in which we find an ordinary sized clothespin presented alongside a miniature clothespin. We are faced with the surprise of dislocation through reduction rather than enlargement. On a more poetic level perhaps the miniature clothespin is the offspring of the larger one, the fruit borne of the earlier 1967 poem object's metaphysical embrace. Brossa described his relation with objects in much the same terms as Miró in a 1990 interview:

> I like to observe the objects and have a dialogue with them. In this dialogue many ideas are born. Sometimes the idea is born first, and sometimes the object itself awakens the idea. I do not like objects that are too personal: I prefer common and ordinary objects so that the metamorphosis would be more obvious.[159]

Miró's *Personnage*, like Oldenbug's *Clothespin*, achieves surprise through enlargement rather than reduction, though Miró's poetic approach retains much of Brossa's sensibility. Indeed, as early as 1960, when he was beginning to develop his thoughts on sculpture, Miró wrote to Brossa speaking of the "affinity with things of mine, things that I am doing now or preparing."[160] In Miró's case, dramatic shifts in scale amounted to an elevation of the ordinary to poetry. This placed him in a position both rooted in the Surrealism of his origins and not dissimilar to Brossa's neo-Surrealism; equally, he was in harmony with the contemporary sculpture of Christo and Oldenburg, both of whom found a new aesthetic dimension within the sphere of daily experience and a new form of collective and environmental art beyond the limits of the individual artist-painter.

Though never cast as a monument, *Personnage* may indeed be grouped with the project for Central Park as yet another option finally realized only as a large-scale sculpture. It is clear that this sculpture was conceived at the time Miró began thinking of the project, because one drawing is dated October 26, 1971, just days before the drawings were executed relating to *Projet pour un monument*. The drawing (cat. 26.1) loosely depicts the clothespin and the two spherical elements set on top of it. A note suggests enlarging it, "*agrandir comme bouteille*" linking it to another bronze cast at Bonvicini called *Personnage* (1970), cast from a greatly enlarged bottle and also considered as a possible monument.[161] Also the note "*a reveure guix i terra*," meaning "review the plaster and clay," suggests there is already a model in plaster. This drawing indicates how the vertical structure of the clothespin, when enlarged, is transformed into a statue. A somewhat more detailed, but undated, drawing in pen (cat. 26.2) reveals how Miró conceived the voids in the clothespin as a female sex, for he has merged the two voids as one giant sex. Finally, Miró devoted one sketchbook labeled "Central Park" to this sculpture, revealing his desire that it be fabricated at a monumental scale.[162] The sketchbook contains only one page with a drawing as well as a number of loose notes and a clipping. The drawing (cat. 26.3) is dated September 22, 1972 and bears the annotation "*15 à 20 m.*" which contrasts with the actual height of 3.74 m. This was a height, as we have seen, related to his thinking for the other options for Central Park. Miró presents the sculpture as seemingly gigantic by placing it in the foreground of the drawing so its feet touch the edge of the paper. The clothespin's sex is red and the anal void black. The head is yellow with a section of blue. A red circular face is bounded by a black line, and its mouth is a black dot in the center of the red. As in the final sculpture, a blue egg rests on its head. The sculpture is sited in a field of green, suggesting a garden setting, and the exaggerated scale is stated by the diminutive stick figure seen beyond it at the limit of the green field. Separate notes indicate the location as Central Park, and the need for Artigas to go to New York. A small handwritten map shows the location of the Guggenheim on the Upper East Side. Finally, there is a note mentioning that Dubuffet's resin sculpture in Chase Manhattan Plaza is not painted in color but in black and white, along with a press cutting reproducing the Dubuffet piece. The latter may have been important in his thinking about how color would function in this material.

This series of projects for monuments, nevertheless, remained unrealized. But it did pave the way for Miró to explore the possibility of making permanent monuments in public locations, the project that would represent the culmination of his work in sculpture and the solution to the problem raised long before of how to go beyond painting.

Miró repeatedly mentioned the Central Park project throughout the 1970s and, more than his enthusiasm for the project, his comments reveal his interest in the monumental scale of 15–20 m and the public function of the sculpture as creating an environment. In a 1974 *XXième Siècle* interview with Yvon Taillandier, while the project was still very much alive, Miró stated,

> Would I want to make environments? Of course I would . . .
> Also this sculpture for Central Park. This will be an object like a
> house that is already planned so children may enter; and we are
> studying it so that it would be painted not only on the outside
> but also on the inside.[163]

Miró seems to have abandoned the idea of entering the interior of the sculpture in favor of designing it to transform the environment surrounding it. In 1977, still very much thinking of the project as viable, he told Raillard, offering an indication of the problems with the commission: "Currently I am working on a sculpture for Central Park in New York, but, as you know the financial affairs of New York are not very good at this time. Because of this we are at a small impasse, as long as there is no money."[164]

And in 1978 he indicated the projected size of the sculpture as, "a sculpture 14 m high for New York, near Central Park."[165] The desire to create an environmental sculpture is of particular interest to the process of enlargement as the basis for public sculpture. In the early 1970s Haligon was the enlarger to whom Miró looked to help him forge a monumental and popular art in sculpture. Dubuffet had used Haligon's studio to enlarge and fabricate his synthetic resin sculptures. He then undertook the creation of an in-house studio and foundation, located adjacent to Haligon's studio, where he created his largest environmental sculpture, a work notable for the fact that one can walk around it, through it, and, even, in it. In 1974–1975, on a smaller scale, Dubuffet had created the environment now housed in the Centre Pompidou, Paris. Probably Dubuffet's collaboration with Haligon drew Miró's attention to his sculpture as one possible model for a monumental environmental sculpture. The cavernous quality of Dubuffet's projects paralleled Miró's incorporation of both labyrinthine structures and enclosing feminine images as an alternative to a masculine statuary. Another possible source for a cavernous environmental sculpture would have been the collective work of Jean Tinguely and Nikki de St. Phalle, such as *Hon Elle, la femme-cathédrale* for Stockholm in 1966, or their *Le Cyclope-La Tête*, begun in 1969 in the forest of Fountainbleau; both artists also collaborated with Haligon during the 1960s and 1970s.

Miró completed two monumental projects in 1982 for Houston and for Barcelona, each of which respectively returned to direct casting and modeling. These two solutions reflected the divergent urban contexts for which they were commissioned, and the very real differences between the two cities where they were installed. Both sculptures are sited in densely crowded urban spaces with the intent of creating a more civic space. The Houston commission is located in the center of the city in United Energy Plaza, at the intersection of Milam and Capitol streets, and is adjacent to what was formerly called the Texas Commerce Tower and now known as Chase Tower. The Barcelona commission is located toward the edge of the center of Barcelona, in the former Parc Escorxador, subsequently renamed Parc Joan Miró. Adjacent to and behind the bullring at the Plaça Espanya, the sculpture is sited alongside calle Tarragona and indirectly is on axis with the ascent to the Palau Nacional in the Parc de Montjuic, near where the Fundació Joan Miró is also located.

The Houston composition, *Personnage et oiseaux* (fig. 16) was not based on a new sculpture, but chosen from the range of already existing works for its potential as a monumental sculpture. The architect for the 80-storey building and the plaza, which was inset in one corner of the building, was I. M. Pei who early on in the project chose Miró for the sculpture commission. The client was Block 67 and United Energy Resources Inc., a consortium made up of the three partners in the commissioning of the tower: Ben Love, Chairman of Texas Commerce Bancshares; J. Hugh Roff Jr., chairman of United Energy Resources Inc.; and Gerald D. Hines, developer. The idea of Miró being involved in the project was floated as early as December 29, 1978, when Matisse wrote to Miró explaining, "On the other hand on the 20 January the director of a large bank in the South, whose architect is I. M. Pei, must come with him [Pei] to see you in Palma to confer about an immense sculpture of 15–20 m height."[166]

Beyond proposing the artist, Pei was also responsible for the choice of the sculpture. Initially, he considered *Femme échevelée* (cat. 12), one of the patinated bronzes made at Clémenti in 1969, based on a work Miró initially fabricated in June 1946 when he

worked with Gimeno, as documented in photographs taken by Joaquim Gomis. The sculpture's most striking features are the strands of disheveled hair flowing from behind its head. Curiously it was not cast as an edition in the 1940s, and Miró only returned to the idea in the 1960s, with a preparatory drawing titled simply *Femme* (cat. 12.1) preceding the final bronze edition. It was one of these that Pei selected. Matisse explained to Miró in a letter dated July 30, 1979, curiously mistaking the name of the city: "Giant sculpture for Dallas after the bronze of the "FEMME ECHEVELLE." This project is by I. M. Pei who is coming specially to Palma in March to discuss the addition of the colors."[167]

The sculpture would be 15 m tall so that it could be seen by the pedestrians walking by as well as by the workers in the building, with the color seen from both above and below. The question of the color was entirely up to Miró's discretion, and the number of hairs in the sculpture would be the same as the original bronze, which Miró had already received from Matisse. Matisse continued, "You said to me that you think you will finish painting the bronze maquette toward the end of August. Pei wants to bring the people in charge of the project . . . to Palma for the presentation at your place."[168]

Matisse advised Miró to receive Pei and the clients in the studio. In anticipation of this visit, Miró probably painted the first bronze example of *Femme échevelée* late in the summer of 1979, at that time giving her colorful facial features and arms as well as richly polychromed strands of flowing hair. Matisse would include this painted version in his exhibition of Miró's painted sculpture the following May, when he reproduced it on the cover of the exhibition catalogue, however by that time the sculpture was rejected as the model for the commission.[169] The second option was selected for structural reasons of stability:

> As I told you on the telephone the first plan with *Femme échevelée* had to be abandoned because of construction problems. In its place Pei chose the sculpture *Personnage et oiseau* illustrated in one of our last catalogues and of which I enclose a photocopy annotated with dimensions and color notes.[170]

The photocopy explained, as did the letter, that the upper part of the sculpture would be made in bronze with the areas of the birds each painted a different color to be determined.[171] The triangular base would be in the more expensive stainless steel rather than rolled steel, budget permitting. The sculpture would be 15 m and sited at the entrance of an 80-storey skyscraper. Color was highly desirable, from Pei's point of view, because of the great austerity of the building.

Personnage et oiseau was another of the patinated bronzes made at the Clémenti foundry in 1970. Miró had originally conceived it in 1963 in an early sketchbook made at a time when he was still working on the Fondation Maeght (cat. 27.2). An undated drawing (cat. 27.5) lays out the elements of the sculpture, and indicates the construction in steel, the height, "*15 m. Texas,*" and most importantly the idea that all areas of the sculpture would be painted, but not with oil paint. The drawing is on the back of an October 1980 telegram from Matisse to Miró announcing the delivery of the bronze *Personnage et oiseau*.

In November 1980 Miró made a reduced wood maquette (cat. 27), which he painted with the assistance of his grandson Emilio, as a guide for the placement of the colors in the final monument. This maquette was then presented to Pei, the three clients, Matisse, and their wives when they finally visited Miró's Palma studio on November 23, 1980, an occasion documented in numerous photographs by Francesc Català-Roca (fig. 15).[172] In a letter dated March 2, Matisse laid out his preliminary thoughts on the proposed agreement, specifically mentioning the two sculptures considered as models for the monument and concluded, "Both these sculptures were selected by Mr. I. M. Pei with the agreement of the artist to be enlarged."[173] This memorandum stated the fees of $100,000 for permission to enlarge the work selected and an additional $150,000 for the acquisition of the painted version of "Disheveled Woman" and "Personnage and Birds." The Houston clients apparently were agreeable to such an arrangement, though there still were outstanding questions. As Matisse's lawyer, Martin Bressler, explained in a letter of March 27, 1981 there was still the issue of whether the wood maquette was included in the agreement, described by Gerald Hine's lawyer Richard S. Siluk as "a wooden maquette painted by Miró and including a base signed by Miró."[174] Miró still had to give Matisse power to act on his behalf, and the right of the purchaser to reproduce the work needed to be addressed. Miró signed the authorization for Matisse to act on his behalf on April 24, and the same day his lawyer wired confirmation to Gerald Hines. The final contract established Miró's copyright and the non-exclusive rights of the clients to reproduce the work. The $250,000 fee was sent to Matisse on May 7, 1981, and the wood maquette delivered to Pei's office on May 19. Pei agreed to arrange the fabrication of the sculpture following Miró's wishes. His firm would do the structural engineering, and, because of the monument's size, fabrication would take place in the United States.[175] Following several meetings between Pei's team, Matisse, and Clayton Stone (Hine's representative), Pei arrived

15. I. M. Pei with Miró in Mallorca with the maquette for *Personnage et oiseaux*.

at a solution for the technical problems regarding the construction of such a large work. The lower portion of the sculpture would be fabricated by Lippincott in stainless steel sections to be joined with bolts. The upper part would be cast in bronze by Modern Art Foundry. Lippincott would undertake prior assembly, painting, and on-site installation. Shipment to Houston was scheduled for March 1982, but installation would not be complete before April 15.[176] On September 2, 1981 Pei's office sent Matisse a structural drawing explaining in further detail the recessed bolt connections and the pre-assembly process, which would limit the "fieldwork" installation.[177] In October, Pei, Hugh Roff, and Barbara Rose planned the inauguration of the sculpture for April 20, Miró's birthday. Miró was interested in attending, and Roff offered to provide a private jet to fly Miró from Palma to Houston. The opening date would correspond with the opening of the exhibition *Miró in America* at the Houston Museum of Fine Arts. The sculpture was in the end ready on schedule, but Miró was sadly unable to attend for health reasons.

The form and imagery of *Personnage et oiseaux* (fig. 16) followed the bronze and wood models on which it was based. The important changes came with the addition of color, achieved through the application of a polyurethane gloss paint, and the change in the title from the singular to the plural for the word bird, the three birds referring to the three commissioning clients.

The face of the figure consists of a gourd-like shape turned on its side with two holes in it, which represent the eyes. A modeled element placed between these holes signifies the nose. A strange construction seemingly formed from the dismantled legs of a chair, together with three other irregularly shaped fragments, signifies the fluttery presence of the bird. This ensemble of head and bird rests on top of a rectangular steel armature poised on the apex of a triangular construction. This triangular base represents the body and torso of the figure. In many previous works a triangular torso indicates a female figure by a metaphoric substitution of the triangle for the shape of the female figure's sex, and here such a reading is confirmed by the incorporation of yet another clitoral element protruding outward from the center of the sculpture. In the first bronze version, this shape appears to be cast from a discarded tin can. In the larger version, by virtue of the process of enlargement, this shape takes on more monumental associations, raising the possibility that we are presented with what might be called a phallic clitoris.

Unlike many of Miró's other public sculptures, *Personnage et oiseaux* returns to the principle of the assemblage of found objects (fig. 16). Its poetic impact lies in the familiarity of the objects and in their transformation through metaphoric association into a human figure. The fact that this figure can be read as female may be telling given the context of the site. The scale of

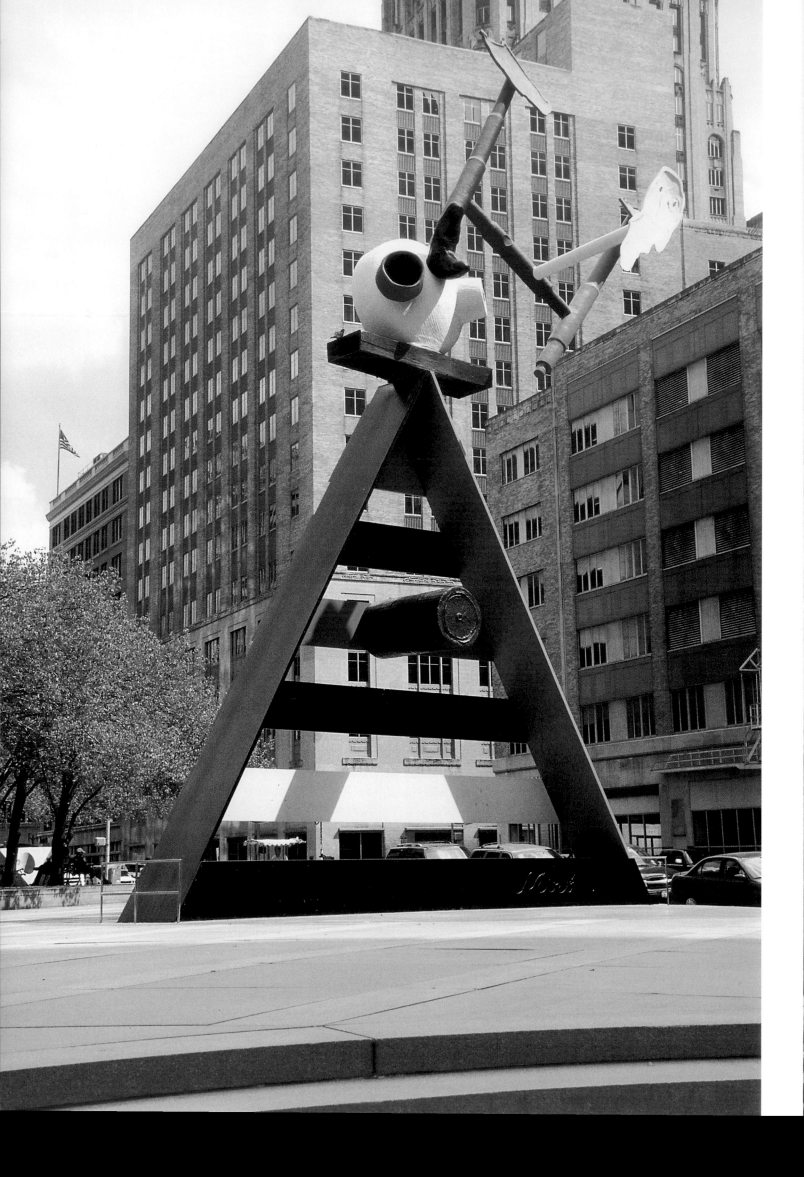

the enlargement may be understood as a means by which to establish a relationship with the enormous building adjacent to the sculpture. Given the vertical form of the skyscraper, his choice of a female figure may not be altogether surprising. In 1947, on a visit to New York, Miró had told Francis Lee that, "To me the real skyscrapers express force as do the pyramids in Egypt."[178] It is clear that the vitality of America's urban architecture inspired Miró. In the Houston monument, Miró may well have identified the statuesque skyscraper with male symbolism. Had not his friend Leiris noted already in 1930, "the building, which scrapes, is a phallus more markedly than the tower of Babel."[179] The figure's pyramidic structure would have provided a visual counterpoint to the soaring verticality of the building (fig. 16). The idea of a disruption of the order and authority expressed by architecture was an idea put forward by another of Miró's friends Bataille, who wrote of how "certain" painters open the way to "the expression (even exaltation) of psychological processes most incompatible with social stability."[180] Bataille's desire to disrupt the uniformity of the architecture conformed with Pei's motive for selecting Miró for the commission. As Pei explained to the Houston press at the time of the opening, "Texas Commerce Tower is a conservative building for a serious business—just what the client wanted. For the plaza, however, I felt and the clients did, too—that we needed something light and cheerful . . . It wasn't just form alone we were searching for. It was Miró's mischievous aspect that appealed to me. His work is a celebration of life."[181]

The Barcelona monument, *Femme et oiseau* (1982; fig. 18) returned both to the principles of the Fondation Maeght and to the precedent of Gaudí's Parc Güell. In this public work, Miró collaborated with Joan Gardy Artigas, the son of the ceramist. As in Gaudí's park, this park is located in Barcelona, though its setting is urban rather than natural. Originally the site of a slaughterhouse, this park is now known as the Parc Joan Miró. *Femme et oiseau* is fabricated from concrete into which fragments of ceramic tiles are encrusted.

Miró worked through several stages before realizing the final monumental version of *Femme et oiseau* (fig. 18). The composition originated in a ceramic sculpture made in collaboration with Llorens Artigas in 1962, now in the Fundació Pilar i Joan Miró.[182] The general verticality of the sculpture may bear a relationship to Miró's preoccupation with the image of the trunk of a palm tree in some of the plans for the Fondation Maeght. It may also be a vehicle for connecting the earthy image of rootedness with flight, the woman's body connecting these two realms.

The ceramic version of *Femme et oiseau* is divided into sections to facilitate the firing of the sculpture.

Miró returned to the same composition in 1981 when he transferred this composition into the medium of bronze, this time with a dark monochromatic patina that contrasted with the colored glazes of the earlier ceramic.[183] Also in 1981 Miró and Gardy Artigas made a reduced plaster model for the final version on to which they indicated the choice of colors with gouache.[184] Photographs by Català-Roca reveal the way Miró and Artigas used colored papers to decide the placement of the colors (fig. 17). Because it was cast concrete the process of installing it differed from the technique of enlarging plaster models. Rather moulds and frames were used to support the liquid concrete. Note that the upper parts form a second section, which is incorporated into the lower supporting armature.

Miró's work with Gardy Artigas on this monument was a collaboration in the fullest sense of the word. At this stage in his life Miró could not undertake heavy work, so the younger artist carried out the actual fabrication of the sculpture.

Miró here took the image and embodiment of female sexuality as the central poetic metaphor for the regeneration of modern culture. The sculpture contains the two entities of the woman and bird indicated in the title. The bird can be divided into two components: one, a polychrome cylinder, and the other, a familiar yellow crescent shape. The first may be read as a symbol of the female, and the second as the male. The conjunction of these two images to represent a bird may be read as a symbol of the union of male and female. The central armature on which the bird rests seemingly elides the image of the palm tree and the body of a woman. This columnar shape is dominated by the vertical void, encrusted with black ceramic fragments, which is a sign for the figure's sex. The choice of the columnar shape for the body of the woman appropriates the structure of statuary for a monument to maternity. The placement of such imagery within the urban context amounted to an affirmation of the instinctual forces Miró associated with nature, and which he held up in opposition to the false sophistication of modern society.

Among the technical problems encountered in making this sculpture was the preparation of the different glazes required to obtain the colors Miró desired. These tiles then had to be fired, and the fragments of colored ceramic had to be prepared in the irregular shapes that activate the surface of the existing monument. Finally, there was the engineering problem raised by the construction of the cement armature into which the fragments of ceramic were embedded.

17. Maquette for *Femme et oiseau*, 1981, Fundació Joan Miró, Barcelona.

18. *(opposite)* *Femme et oiseau*, 1982, Parc Joan Miró, Barcelona.

The choice of cast concrete was also a technical solution for extending the scale of the ceramic sculpture to a monumental size. The choice of the polychromatic ceramic surfaces of *Femme et oiseau* drew on the example of the park benches of Gaudí's Parc Güell, both artists choosing this design strategy as a means of activating the constant source of light typical of a Mediterranean setting. Miró's *Femme et oiseau*, his last major public monument, also pays homage to Gaudí's profoundly mystical and peculiarly Catalan sensibility, though in this case the spiritual is projected on to an almost archetypal image of woman.

IV. Conclusion: The Shape of Color

Color is unbounded in Miró. If we consider a very famous painting, such as *Ceci est la couleur de mes rêves* (1925), a spot of blue color represents a category beyond the rationally knowable. The presence of this blue spot within the painting, therefore, disrupts both the classical and modern systems of representation. This is a disruption that destabilizes representation.

This was all the more clear when, in 1930, he created what can only be described as a series of anti-paintings. These remarkable and little known works consist of figurative images that have been crossed out. This in itself is not so strange until we know the degree of calculation that went into this series, for Miró made detailed sketches for each painting, including the cancellations. He then carefully replicated both the image and its cancellation in the final painting. In this way he did not simply kill a "certain" kind of painting, he murdered it with forethought.

Again in these anti-paintings the marks of the cancellation undermine models of representation such as Cubism. That this group of paintings was reproduced in Bataille's review *Documents* is revealing. There Bataille wrote of Miró's professed desire "to assassinate" painting and of how the subsequent "decomposition" was pushed to such an extreme that the remaining marks were only the traces of a disaster.

> In the end Miró himself professed that he wanted "to kill painting," the decomposition was pushed to such a point that there remains only some formless spots on the lid of the box of tricks. Then the small colored and crazy elements proceeded toward a new eruption, and then they disappeared one more time today in these paintings, leaving only the traces of who knows what disaster.[185]

The disruption of representation, marking the imprint of a destruction, characterizes Miró's intervention in the language of painting. The stain or spot radically retains its nature as physical matter, and undifferentiated color resists being placed at the service of form. In those paintings where the networks of colored marks form part of the cancellation process, this is most clear.

The use of color in sculpture is somewhat different. By its very nature sculpture operates in the field of the real, though traditionally sculpture has been placed at the service of representation. Bronze has been historically used to convey timeless values and historical memory. This is achieved not only by duplicating an effigy but also through the rich quality of the material. Painting bronze negates these traditional qualities associated with the material. The casting of found objects, like the casting of the most basic and primordial of modeled forms, represents also an insistence on "real" matter. In sculpture Miró does not cancel representation, as he does in painting, rather for it he substitutes presentation.

In painting the objects that compose the sculpture, Miró insists on their identity as objects as well as their role as figuration.

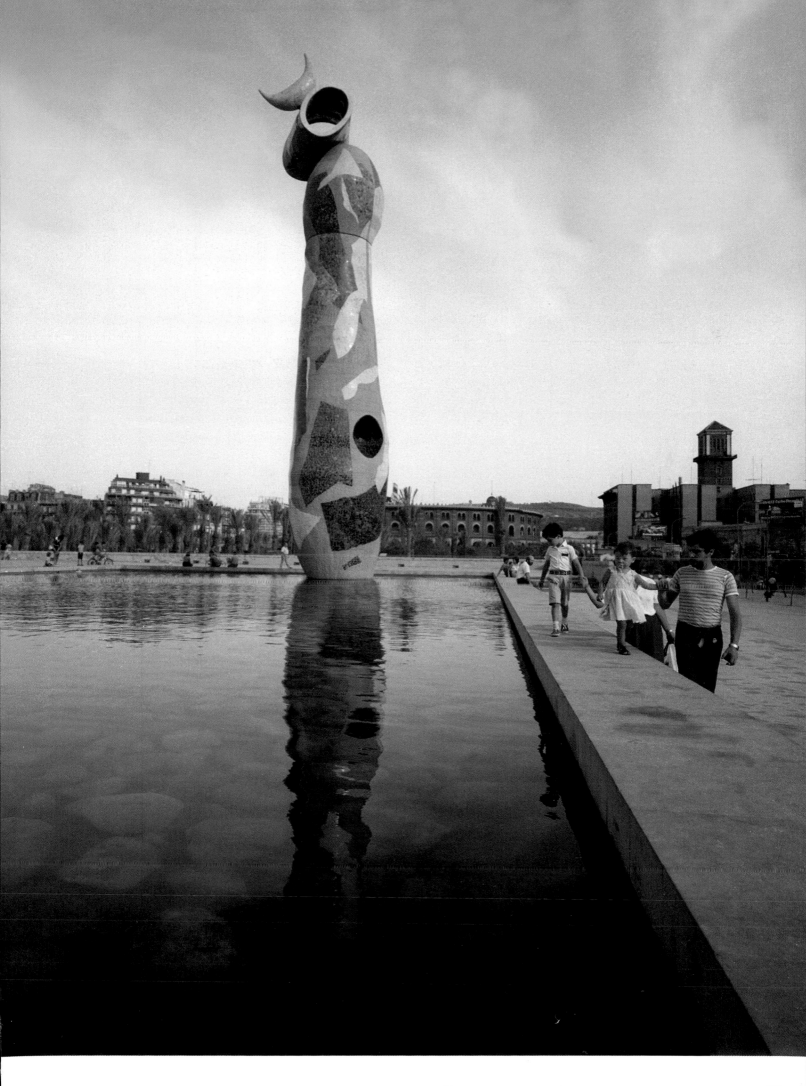

We read the sculpture as an object or group of objects at the same time as we read it as a woman or a woman and child. In this way, Miró's sculpture presents us with a Surrealist approach to metaphor. Objects become signs that convey meaning, and they function like the calligraphic sign language inscribed in the surfaces of the sculptures or the apparently random marks that appear on his canvases.

Miró's disruption of representation in painting by insisting on the materiality of paint and the unbounded presence of color may be related to the idea of the *informe* as laid out by Michel Leiris and Georges Bataille in their "critical dictionary" entries published in *Documents* in the final issue of 1929. Leiris' entry on "spit" (*Crachat*) concludes: "Spit is finally, by its inconsistency, its undefined contours, the relative imprecision of its color, its wetness, the symbol of the *informe*, the unverifiable, the non-hierarchical."[186]

Bataille's entry on the *informe* ("shapeless" or "formless") famously defined it not as an adjective, but as a derangement, what Yves-Alain Bois has called an "operation."[187] What the *informe* designates is crushed like a spider or an earthworm. Bataille concludes the entry, employing the same metaphor as Leiris by explaining the metaphysical implications of this: "In contrast to affirm that the universe resembles nothing and is only *informe* is also to say that the universe is something like a spider or spit."[188] Miró's use of raw matter, like his use of found objects, reflects a disruption of the language of art just as his use of color acts as a cancellation of the traditional functions of sculpture. This cancellation serves a function on the level of language, and it is a function, despite Miró's disclaimer, not without psychoanalytic implications.

According to Bataille, when the child sticks its fingers in a can of paint and proceeds to mark a wall or a sheet of paper it does so not in terms of a primitive figuration but to destroy the wall or the paper. It is an attack. Miró's use of marks as a cancellation in painting, like his fingers in the metaphorical mud-pie of clay or his painting of bronze sculpture, represents both an attack on the support and an affirmation of its material presence. In this way the classical function of the support as a vehicle for representation is undermined and radically transformed. But this is not entirely a negative operation, just as the action of the child is not entirely negative. Bataille raised such issues again in his review of Luquet's book *L'Art primitif*, which appeared immediately before his article on Miró in *Documents*. More than a destruction, the act of the child was for Bataille an "alteration" of the support or of an object. This alteration takes on a new dimension in which the destroyed object is changed to such a point that it is transformed into a new object. The new object is then further altered through a series of deformations or sequential destructions. Now this chain of destructions would seem a perfect description of Miró's new approach to the problem of representation in painting and sculpture. Bataille's article on Miró was framed on the one side by the Luquet review and the other by Leiris' "L'oeil de l'ethnographe," setting Miró's anti-paintings in an anthropological context. Moreover, it was precisely at this moment—when Miró not only proclaimed painting dead, but also demonstrated exactly how and why it was dead in his anti-paintings—that he took up sculpture for the first time.

The nearly random discovery of the found object brought to life in the sculpture, like the primordial modeling of clay, demonstrated the very arbitrary nature of the process of representation. Miró did this by preserving the thing from which the figuration was born, and this presentation was another way of cancelling representation. This lump of clay when enlarged is a monument; this chair when cast in bronze is a sculpture. In both of these examples the resulting sculpture represents a woman, but not in conventional terms. Rather Miró established a new set of conventions that were predicated on the disruption and destruction of the old ones.

With Miró's painted sculptures we are confronted with visual metaphors. A woman is a chair; a chair is a woman. As we have seen, these works share much in common with the visual poetry of artists such as Brossa for which they are indeed a model or paradigm. Leiris tells us again in *Documents* that metaphor is a "play of transpositions" and that knowledge proceeds by comparison, the two objects of the comparison being so interdependant it is not always possible to tell which is designated by its proper name and which is the metaphor of the other name. He gives as an example, "Man is a movable tree, as the tree, a rooted man."[189] This collapsing of the two terms of metaphor is something we find in Miró; it is that which sets up the chain of destructions that results in a succession of new meanings. Moreover, the example given by Leiris is revealing when we consider the metaphor "woman is a tree," which we have seen was so often used by Miró. As in Eugenio D'Ors' image of *La ben plantada*, woman is a tree with her roots firmly planted in the earth and with her branches rooted in the sky; equally the earth is woman, Miró's source of inspiration. To explore the country is to explore woman.

Jacques Lacan offers, in his "Agency of the Letter in the unconscious" (1957), further insight into the functioning of

metaphor, which he defines simply as "one word for another." Following the examples of modern poetry and Surrealism, he suggests that the conjunction of any two signifiers might constitute a metaphor assuming the greatest possible disparity of the images signified. Automatic poetry is the example Lacan has in mind. To it we might add collage based on the conjunction of two images brought together in a new relation with the idea of generating a third meaning different from that of either of the independent images. Indeed, Miró's sculpture may be best understood as three-dimensional collage. But, Lacan qualifies his definition, and he questions the Surrealist position. It is not the conjunction of *any* two signifiers but the substitution of one for another that produces metaphor:

> The creative spark of the metaphor does not spring from the presentation of two images, that is, of two signifiers equally actualized. It flashes between two signifiers one of which has taken the place of the other in the signifying chain, the occulted signifier remaining present through its (metonymic) connexion with the rest of the chain.[190]

Lacan's choice of language is remarkably close to that of Miró, who referred to the "magic spark" provoked by the discovery of found objects, a spark activated by an ongoing process of arrangement and rearrangement of the objects.

Further metaphor enacts the linguistic annihilation of the thing signified. In this way writing and art entails the necessary destruction of the writer or artist. This is the proper terrain of metaphor. The tree replaces the woman. When we enter language it annihilates us: "it is between the signifier in the form of the proper name of a man and the signifier that metaphorically abolishes him that the poetic spark is produced."[191]

The magic spark of metaphor entails equally a loss of self. Again, curiously, Lacan's language mirrors Miró's own, when Miró stresses moving towards collectivity and anonymity. As he told Yvon Taillandier in a famous 1959 interview,

> Anonymity allows me to renounce myself, but in renouncing myself I come to affirm myself even more. In the same way silence is the denial of noise—but the smallest noise in the midst of silence become enormous. The same process makes me look for the noise hidden in silence, the movement in immobility, life in inanimate things, the infinite in the finite forms in a void, and myself in anonymity.[192]

For Lacan modern metaphor has the same structure as classical metaphor, and "metaphor occurs at the precise point at which sense emerges from non-sense."[193]

Of course, both Lacan and Miró owe much to the example of Surrealist poetics; however, Lacan's critical caveat with regard to Surrealism is ill-founded. Automatic writing, while asserting the arbitrariness of the signifier and presenting a radical example of metaphor, is not random. For example, in Tzara's poetry and poetic prose grammatical syntax in the sentence is preserved while semantics are challenged through unconventional word choices. This is true also in much of Breton's writing and is a feature of *Cadavre exquis* writing, where each word though independently chosen is selected for its grammatical function in the sentence; meaning is preserved by the sequence subject-verb-object. Equally there is nothing random in Miró's placement of objects in sculpture. Given this we might speculate that the presence of the *informe* in Miró's art is necessary. But what does this necessity tell us?

Lacan opposes metaphor to metonymy, which he defines as "word to word connexion," as the part taken for the whole. On the level of the unconscious, metaphor is linked to condensation and metonymy to displacement. Metonymy is the connection between signifier and signifier, what Lacan calls a "veering off of signification," while metaphor, as we have seen, is the substitution of signifier for signifier, what he calls "signification." Metonymy is the trope of desire, lack, and narcissism; it is characterized by the perverse and the fetishistic. Metaphor is the trope of the symptom, being, and a suspension of the ego; it is characterized by meaning and the cure. In short, metonymy is a dialectic of return, and metaphor is discourse, insofar as it brings us into the symbolic realm of language. It is here on the level of language that masquerade comes into play, for masquerade falls in the domain of the symbolic. As Lacan tells us in *The Four Fundamental Concepts of Psycho-Analysis*, "Masquerade has another meaning in the human domain, and that is precisely to play not at the imaginary, but at the symbolic level."[194]

It was to be in sculpture that Miró would bring to life a "phantasmagorical" world of living monsters. Sculpture performs a ritual of the symbolic, because it conjures forth figures from the inert matter of the real.

Miró's poetic approach to sculpture privileges metaphor over metonymy. In Lacan's terms, rather than the lack we are faced with a metaphor for the fecundity of plenitude, but this is done on the symbolic level of a sign language. Much of Surrealism is situated on the side of metonymy and fetishistic displacement, as in the examples of Meret Oppenheim, Salvador Dalí, and Giacometti, artists who take desire as their terrain. But Miró offers up a gift. The hands-in-the-mud dimension of Miró's

19. Miró's annotation, dated July 13, 1969, saying "I want to go saying shit to everything" in the collection of the Fundació Pilar i Joan Miró, Mallorca.

modeling of fertility monuments may be linked to the anal phase, which Lacan situates on the side of metaphor. He tells us,

> The anal level is the locus of metaphor—one object for another, given the faeces in place of the phallus. This shows you why the anal drive is the domain . . . of the gift. Where one is caught short, where one cannot, as a result of the lack, give what is to be given, one can always give something else.[195]

At the level of the anal drive, far from the obsessive function of primary narcissism, the feces also functions as representation.

> And yet, *se faire chier* has a meaning! When one says here, *on se fait rudement chier*, one has the *emmerdeur éternel* in mind. It is quite wrong simply to identify the celebrated scybala with the function given it in the metabolism of obsessional neurosis. It is quite wrong to separate it from what it represents, a gift, as it happens, and from the relation it has with soiling, purification, catharsis . . . In short, the object, here, is not very far from the domain that is called that of the soul.[196]

In this passage we are brought back to Bataille's image of the child destroying the wall or the paper, and we are also brought back to the *informe*. For Lacan, borrowing from Freud, the metaphor for the anal object is "a spindle of lava."[197] In this way, it is similar to Leiris' example of spit, something without shape. Lacan's construction of the anal object, like Bataille's *informe*, is clearly distinct from the neurotic and terrifying construction of Julia Kisteva's "abject or demoniacal potential of the feminine," with which it is sometimes conflated.[198]

Miró was quite fond of saying the French word "*merde*" as a kind of denunciation of established values and norms in art and society. In this he followed general Surrealist practice, which took its inspiration from the iconoclastic French playwright Alfred Jarry, whose character King Ubu repeatedly enunciated this word. Ubu was a kind of caricature of all that was rotten in modern society, and of course when Jarry's three Ubu plays were first performed in Paris they scandalized the French public. The Surrealists' 1937 tract devoted to *Ubu enchainé*, including an illustration by Miró, further invested this irreverent character with politics. By way of example, in 1974, the *New York Times* reprinted Miró's conversation with Pierre Schneider, in which he proclaimed, "I have reached an age—over 81—when I am no longer chained to anything. I often say I hope my dying word will be "*merde*."[199] As if to drive this point home for us, Miró left an annotation on a small scrap of paper dated July 13, 1969 in his archives in Palma (fig. 19) which reads "*je veux m'en aller en disant merde à tout.*"[200] As if to add emphasis the word

"*merde*" is underscored with a red spot aggressively drawn in colored pencil. That such a red spot is directly related to Miró's sculptural thinking is evidenced by a note attached to one page of a sculpture sketchbook which reads "*Especular amb matèries bronze,*" meaning "speculate with bronze materials," and "*grans possibilitats / i accents / color violents / oli i altres,*" meaning "great possibilities / and accents / violent colors / oil and others."[201] Again these last phrases are aggressively underscored by an almost identical red spot. We are presented in these two drawings with a cancellation and presentation of color as unbounded and shapeless matter. In part, as with Jarry, this is a rejection of a society that would reduce art to financial value, but it is more, for this rejection is an affirmation of the very material that constitutes the human subject, and indeed an affirmation of the human subject.

Miró's playful deployment of scatological metaphors is far from the horror of Kirsteva's devouring abject where metaphor is failed and collapses in on itself as fetishistic metonymy. Miró's scatology further participates in the peculiarly Catalan celebration of the bodily function best illustrated in the figure of the *Caganer*, who reveals within the drama of spiritual birth the basic reality of our being. In this way, Miró's sculptures are metaphors that return us to the earth. Like the child smearing paint, these sculptures are only in part a negation, for they set in motion a chain of negations that produces in the end an affirmation. This affirmation is born of the transformation of the raw material of the sculpture, what Lacan calls the gift, into an image or, more properly, into a visual language. It is on the level of this enactment of language that Miró presents to us the shape of color.

Notes on The Shape of Color: Joan Miró's Painted Sculpture, Monumentality, Metaphor

1. María Luisa Lax, the archivist at the Fundació Pilar i Joan Miró, is preparing an extensive study of Miró's public commissions as an M.A. thesis for the Univertat de Balears.

2. See my *Objects into Sculpture; Sculpture into Objects: A Study of Joan Miró in the context of the Parisian and Catalan Avant-gardes, 1928–1983* (Ph.D. thesis University of London, Courtauld Institute of Art, 1992 and "A 'Constellation' of Images: Poetry and Painting, Joan Miró 1929–1941" in *Joan Miró Paintings and Drawings 1929–1941* (London: Whitechapel Art Gallery, 1989).

3. FJM 145.

4. "L'esprit créateur dans l'art et dans la science: interview de Joan Miró," *Impact: science et société*, v. XIX, no. 4 (1969), 343.

5. Jacques Dupin, *Miró* (New York, Abrams, 1962), 49.

6. Alexandre Cirici-Pellicer, "Francesc D'Assis Galí, L'homme de tota una època," *Serra d'Or* (Montserrat), second series, v. 4, no. 12 (December 1962), 63.

7. Pere Serra, *Miró i Mallorca* (Barcelona, Polígrafa, 1984), 224–225.

8. Serra 1984, 226.

9. Sebastià Gasch, *Joan Miró* (Barcelona, Editorial Alcides, 1963), 15.

10. Daniel Marchesseau, "Interview de Joan Miró par Daniel Marchesseau à Saint Paul-de-Vence," October 14, 1978, *L'Oeil*, no. 281 (December 1978), 36.

11. Georges Raillard, *Ceci est la couleur des mes rêves, Entretiens avec Georges Raillard* (Paris, Seuil, 1977), 116.

12. Anne Umland, "Chronology," in Carolyn Lanchner, *Joan Miró* exh.cat. (New York, Museum of Modern Art, 1993), 319.

13. In Victoria Combalía, *El Descubrimiento de Miró, Miró y sus Críticos, 1918–1929*, (Barcelona, Ediciones Destino, 1990), 105–107.

14. See Nicolas Watson, "Miró and the 'siurells,'" *The Burlington Magazine* (London), no. 1043, v. CXXXII (February 1990), 90–95.

15. Sebastià Gasch, "Escultures de Joan Miró," *La Publicitat* (Barcelona, October 15, 1930), 5, and Robert Desnos, *Écrits sur les peintres* (Paris, Flammarion, 1984), 145.

16. Gaëton Picon, *Carnets catalans* (Geneva, Skira, 1976).

17. Picon 1976, 32.

18. Picon 1976, 48–49.

19. Picon 1976, 51–52.

20. Picon 1976, 54.

21. Picon 1976, 76.

22. Picon 1976, 77.

23. *Joan Miró: Selected Writings and Interviews*, edited by Margit Rowell. Translations from the French by Paul Auster. Translations from the Spanish and Catalan by Patricia Mathews (Boston, G. K. Hall and Company, 1986; republished Cambridge, Mass., De Capo Press, 1992), 175.

24. Rowell 1992, 175.

25. Rowell 1992, 176.

26. Rowell 1992, 190.

27. Rowell 1992, 191.

28. Rowell 1992, 191.

29. Rowell 1992, 192.

30. César Martinell, *Gaudí, His Life, His Theories, His Work* (Cambridge, The MIT Press, 1967), 148–151.

31. Miró to Pierre Matisse, June 1, 1943, The Pierre Matisse Gallery Archives, The Pierpont Morgan Library, New York. MA 502., hereafter referred to as PMGA, B18, F34; Umland 1993, 336.

32. Miró to Pierre Matisse, June 17, 1944, PMGA, B18, F78; Umland 1993, 336.

33. Miró to Duarte, March 26, 1945, PMGA, B18, F35; Umland 1993, 337.

34. FJM 3509-3533.

35. FJM 4446.

36. See photos published here and Daniel Giralt-Miracle, *Joaqim Gomis, Joan Miró Fotografies 1941–1981* (Barcelona, Editorial Gustavo Gili, 1994), 60–61.

37. FJM 3520-3521.

38. V. Gimeno Blanes to Miró, January 9, 1950, PMGA, B18, F50.

39. Miró to André Breton, January 18, 1955, Bibliothèque littéraire Jacques Doucet, Paris. BRT.C. 2141 1/2 Joan Miró.

40. Ibid

41. Ibid.

42. Miró to André Breton, April 12, 1934, Bibliothèque littéraire Jacques Doucet, Paris. BBAT.C. 1240 Joan Miró and BAT.C. 2134.

43. Miró to André Breton, 21 January 1958, Bibliothèque littéraire Jacques Doucet, Paris. BAT.C. 2624 1.2/2.

44. André Breton to Miró, August 1, 1959, FPIJM, C-0040.

45. André Breton to Miró, September 21, 1959, FPIJM, C-0041.

46. Miró to Pierre Matisse, January 16, 1956, PMGA, B18, F57.

47. Ibid.

48. Ibid.

49. Ibid.

50. Ibid.

51. FPIJM Q I.

52. FPIJM Q II.

53. FPIJM Q III.

54. FJM 3534-3663.

55. FJM 3664-3719.

56. FJM 3897-4057.

57. FJM 3808-3896.

58. FJM 4005-4006; 4051-4052.

59. Miró to Pierre Matisse, May 4, 1969, PMGA, B19, F35.

60. Sidra Stich, *Joan Miró: The Development of a Sign Language* (St. Louis, Washington University Gallery of Art, 1980).

61. Georges Bataille, *La peinture préhistorique; Lascaux ou la naissance de l'art* (Laussanne, Skira, 1955).

62. Tristan Tzara, "Joan Miró et l'interrogation naissante," *Derrière le miroir*, n. 14–15 (November–December 1948), in *Oeuvres Complètes, 1947–1963*, v. 4, 428.

63. Frank Elgar, "Miró et la préhistoire," *Carrefour*, (1 December 1948).

64. Raymond Queneau, *Joan Miró ou le poète préhistorique* (Paris, Skira, 1949).

65. Michael Carrithers, Steven Collin, Steven Lukes (eds), *The Category of the person: anthropology, philosophy, history* (Cambridge, Cambridge University Press, 1985).

66. Carrithers et al. 1985, 120.

67. FJM 4399b; Rowell 1986, 175.

68. André Leroi-Gourhan, "Naissance de la source," *Vogue* (Paris), n. 602 (December 1979–January 1980), 262–269.

69. Miró to Pierre Matisse, February 9, 1969, PMGA, B19, F35.

70. Miró to Pierre Matisse, March 31, 1969, PMGA, B19, F35.

71. Miró to Pierre Matisse, May 4, 1969, PMGA, B19, F35.

72. Ibid.

73. Miró to Pierre Matisse, February 17, 1970, PMGA, B21, F4.

74. Ibid.

75. Walker Art Center loan request forms sent to Pierre Matisse, December 17, 1970, PMGA, B20, F11; Walker Art Center loan receipt forms sent to Pierre Matisse, September 9, 1971, PMGA, B20, F10.

76. Dean Swanson to Pierre Matisse, August 18, 1971, PMGA, B20, F10.

77. PMGA, B22, F35.

78. PMGA, B140, F6 and F8.

79. None of the critics covering the exhibition mentioned the bronzes that were painted—and surely they would have given how different they were from anything Miró had made before—it at least seems very unlikely that Matisse exhibited any of them in their painted form.

80. The sculpture *Sa majesté* is listed in the 1970 Pierre Matisse catalogue (no. 44) as cast 1/4 and this same example number appears in the Walker loan forms. Likewise, *Femme assise et enfant* appears in the 1970 catalogue (no. 47) as example 1/4 and again on the Walker loan forms as example 1/4. This evidence indicates that at least two of the sculptures remained unpainted in 1970 and were only painted in 1971. But it is not clear if these works were on view in the gallery, because these sculptures do not appear in the installation photographs of the exhibition.

81. See Laura Coyle's essay in this volume and William M. Griswold and Jennifer Tonkovich, *Pierre Matisse and his Artists*, exh.cat. (New York, The Pierpont Morgan Library, 2002), 271. For installation photographs, including *Personnage*, see PMGA, B138, F24.

82. See Català-Roca photographs in this volume.

83. Raillard 1977, 98.

84. Raillard 1977, 139.

85. Raillard 1977, 159.

86. Jacques Dupin, *Joan Miró* (London, Annely Juda Gallery, 1995), not paged.

87. Miró to Pierre Matisse, September 1936, PMGA, B18, F21; Rowell 1992, 126.

88. Ibid.

89. FJM 3534-3663.

90. Eugenio D'Ors, *La ben plantada* (Barcelona, Ediciones 62, 1980), 78.

91. Raillard 1977, 116.

92. FJM 4430; Rowell 1992, 192.

93. Raillard 1977, 40. For an example of the yellow sandpaper collages see *Pesonnage et oiseau*, February 18, 1976, FPIJM M-0030.

94. FPIJM, OB-0864.

95. Raillard 1977, 42.

96. James Lord, *Giacometti* (London, Faber and Faber, 1986), 211.

97. Federico García Lorca, *Prosa* (Madrid, Alianza Editorial, 1969), 84.

98. Raillard 1977, 115.

99. FJM 4399; Rowell 1992, 175.

100. PMGA, B140, F12.

101. PMGA, B140, F12.

102. PMGA, B140, F12.

103. J.-L. Sert, "Sculptures in Architecture," *Miró* (New York, Pierre Matisse Gallery, April 1976), not paged.

104. See Douglas Crimp, "Serra's Public Sculpture: Redefining Site Specificity," in Ernst-Gerhard Güse, (ed.), *Richard Serra*, (New York, Rizzoli, 1988), 26–39 and also Robert Smithson, "A Sedimentation of the Mind," *Artforum* (September 1968) reprinted in Nancy Holt, (ed.), *The Writings of Robert Smithson* (New York, NYU Press, 1979), 82–91.

105. JT 33.

106. FJM 7240.

107. JT31, FJM 7239.

108. Miró to Pierre Matisse, October 6, 1971, PMGA, B21, F4.

109. Pierre Matisse to Miró, October 6, 1971, PMGA, B21, F4.

110. Miró to Pierre Matisse, October 12, 1971, PMGA, B21, F4.

111. Pierre Matisse to Miró, October 12, 1971, PMGA, B21, F4.

112. Pierre Matisse to Miró, October 20, 1971, PMGA, B21, F4.

113. Pierre Matisse to Miró, December 29, 1978, PMGA, B21, F4.

114. Margit Rowell to Miró, July 26, 1972, PMGA, B20, F24; FPIJM C-0243; we are grateful to María Luisa Lax for drawing our attention to the correspondence and drawings related to this sculpture in the Fundació Pilar i Joan Miró.

115. New York City Cultural Council to Miró, August 11, 1972, PMGA, B20, F24.

116. Margit Rowell to Miró, September 18, 1972, PMGA, B20, F24; FPIJM C-0244.

117. Margit Rowell to Haligon, September 18, 1972, FPIJM C-0245.

118. Margit Rowell to Miró, September 26, 1972, FPIJM C-0246.

119. Margit Rowell to Miró, February 19, 1973, FPIJM C-0247.

120. Ibid.

121. Pierre Matisse to Miró, April 18, 1973, PMGA, B21, F4.

122. Margit Rowell to Miró, May 29, 1973, PMGA, B20, F24.

123. Margit Rowell to Pierre Matisse, August 22, 1973, PMGA, B20, F24.

124. Michèle Venard to Pierre Matisse, March 4, 1974, PMGA, B22, F9.

125. Margit Rowell to Miró, March 15, 1974, PMGA, B20, F24.

126. Correspondence of the author with Margit Rowell, March 31, 2002.

127. Haligon to the Galerie Maeght, February 26, 1974, PMGA, B22, F9.

128. Margit Rowell to Miró, March 15, 1974, PMGA, B20, F24; FPIJM C-0248.

129. Pierre Matisse to Bousquet, March 15, 1974, PMGA, B22, F9.

130. Margit Rowell to Miró, March 15, 1974, PMGA, B20, F24; FPIJM C-0248.

131. Michèle Venard to Pierre Matisse, June 18, 1974, PMGA, B22, F9.

132. For the three estimates, see PMGA, B20, F24.

133. Margit Rowell to Miró, November 21, 1974, PMGA, B20, F24.

134. Ibid.

135. Ibid.

136. Miró to Margit Rowell, undated, PMGA, B20, F24.

137. Pierre Matisse to Ramón Viladás, November 25, 1974, PMGA, B20, F24.

138. Ramón Viladás to Pierre Matisse, January 20, 1975, PMGA, B20, F24.

139. Ibid.

140. FJM 7380 and FJM 7381.

141. Raillard 1977, 114.

142. Charles Millard to Pierre Matisse, July 28, 1978, PMGA, B21, F3.

143. Pierre Matisse to Charles Millard, August 9, 1978, PMGA, B21, F3.

144. Charles Millard to Pierre Matisse, December 1, 1978, PMGA, B21, F3.

145. Ibid.

146. Charles Millard to Pierre Matisse, December 15, 1978, PMGA, B21, F3.

147. Pierre Matisse to Miró, December 29, 1978, PMGA, B21, F4.

148. Charles Millard to Pierre Matisse, May 7, 1979, PMGA, B21, F3.

149. Charles Millard to Pierre Matisse, June 18, 1979, PMGA, B21, F3.

150. Ibid.

151. Ibid.

152. Pierre Matisse to Miró, July 30, 1979, PMGA, B21, F4.

153. Haligon to Pierre Matisse, August 2, 1979, PMGA, B21, F3.

154. Pierre Matisse to Charles Millard, November 21, 1979, PMGA, B21, F3.

155. Pierre Matisse to Miró, December 4, 1979, PMGA, B21, F3.

156. Ibid.

157. Pierre Restany, *Avec le Nouveau Réalisme sur l'autre face de l'art* (Paris, Éditions Jacqueline Chambon, 2000), 51.

158. Martin Friedman, *Oldenburg: Six Themes* (Minneapolis, Walker Art Center, 1975), 63; quoted in Harriet F. Sennie, *Contemporary Public Sculpture* (New York, Oxford University Press, 1992), 53.

159. Alfonso Alegre Heitzmann, "Joan Brossa: Azar y esencia de la poesía," *Rosa Cúbica* no.5 (Barcelona, winter 1990–1991), 21.

160. Miró to Brossa, January 1, 1960, in *Joan Brossa o les paraules són les coses*, (Barcelona: Fundació Joan Miró, 1986), 11.

161. JT 152; FJM 3669 for drawing.

162. FPIJM Quadern VI.

163. Yvon Taillandier, 'Miró: Maintenant je travaille par terre', *XXième Siècle*, no. 43 (Paris, May 30, 1974), 17.

164. Raillard 1977, 115.

165. Daniel Marchesseau, "Interview de Joan Miró," *L'Oeil*, no. 281 (Paris, December 1978), 37.

166. Pierre Matisse to Miró, December 29, 1978, PMGA, B21, F4.

167. Pierre Matisse to Miró, July 30, 1979, PMGA, B21, F4.

168. Ibid.

169. *Miró Painted Sculpture and Ceramics* (New York, Pierre Matisse Gallery, 13 May–7 June 1980).

170. FPIJM C-0429.

171. FPIJM C-0429.3.

172. Letter from J. Hugh Roff, Jr. to Miró, January 19, 1981, B22, F23.

173. Letter from Matisse, March 2, 1981, PMGA, B22, F23.

174. Letter from Martin Bressler, March 27, 1981, PMGA, B22, F23.

175. PMGA, B22, F23.

176. Copy of letter from I. M. Pei to Ben Love, PMGA, B22, F23.

177. I. M. Pei's office to Pierre Matisse, PMGA, B22, F23.

178. Francis Lee, "Interview with Miró," *Possibilities*, no. 1 (New York, Winter, 1947–1948), 67.

179. Michel Leiris, "Dictionnaire: Gratte-ciel," *Documents*, v. 2, no. 7, (Paris, 1930), 433.

180. Georges Bataille, "Dictionnaire: Gratte-ciel," *Documents*, v.1, no 2 (Paris, 1929), 117.

181. Mimi Crossley, "Colorful Personnage, Miró/Pei Sculpture Stops Traffic," *Houston Post* (Houston, 9 May 1982), 1 and 19A.

182. FPIJM ES-0031; dimensions are 320 x 46 x 60 cm.

183. Maeght-Lelong, Zurich, 1985, cat. no. 1, height 330 cm; see also Maeght, 'Joan Miró 90e anniversaire', *reperes: cahiers d'art contemporain*, no. 5, 1983, cat. no. 14.

184. FJM 9825 and FJM 9826; FJM cat. no. 1660; dimensions are 114 x 21.5 x 22 cm.

185. Georges Bataille, "Joan Miró: peintres récentes," *Documents*, vol. 2, no., 7 (Paris, 1930), 399.

186. Michel Leiris, "Crachat," *Documents*, v. 1, no. 7 (Paris, 1929), 382.

187. Yves-Alain Bois, "Formless: A user's guide," *October*, no. 78 (Cambridge, fall 1996), 29.

188. Georges Bataille, "Dictionnaire: Informe," *Documents*, v. 1, no. 7 (Paris, 1929), 382.

189. Michel Leiris, "Dictionnaire: Métaphore," *Documents*, v. 1, no. 3 (Paris, 1929), 170.

190. Jacques Lacan, *Écrits: a selection* (London, Routledge, 1977), 157.

191. Lacan 1977, 158.

192. Rowell 1992, 253.

193. Lacan, 1977, 158.

194. Jacques Lacan, *The Four Fundamental Concepts of Psycho-Analysis* (New York, Norton & Co., 1973), 193.

195. Lacan 1973, 104.

196. Lacan 1973, 196.

197. Lacan 1973, 181.

198. Julia Kristeva, *Powers of Horror: An Essay on Abjection* (New York, Columbia University Press, 1982), 61.

199. *New York Times*, July 6, 1974.

200. Reproduced in *Guide Fundació Pilar i Joan Miró a Mallorca* (Madrid: Electa, 2001), 78.

201. FPIJM D-3674; QIII: p. 4.

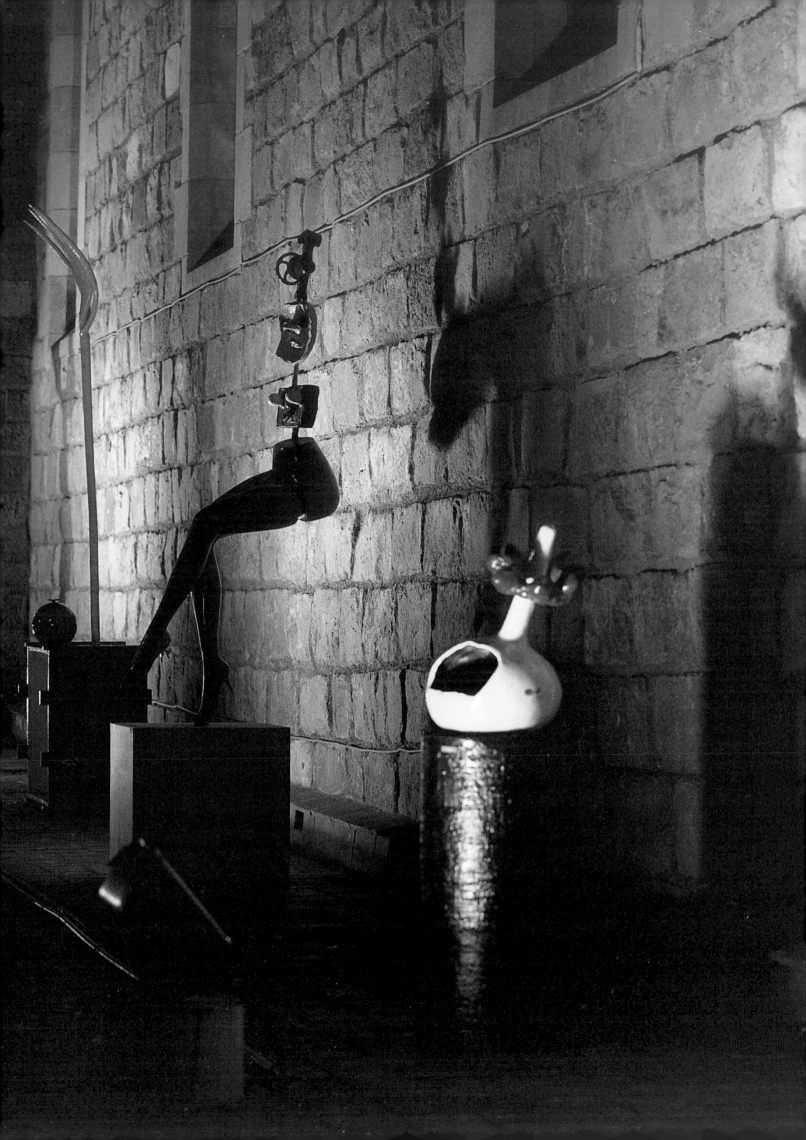

20. *(opposite)* "The Monsters," 1969.

The Monsters in America: the Presentation and Reception of Miró's Sculpture in the United States

Laura Coyle

It is in my sculpture that I will create a truly phantasmagoric world of living monsters; what I do in painting is more conventional. Joan Miró, 1941–1942[1]

By the time Miró's colorfully painted sculpture went on view in the United States in the early 1970s,[2] the Catalan artist was already famous there, with a long and distinguished record of exhibitions in major American art museums and galleries and a substantial body of writing about him in English.[3] These writings include dozens of essays for exhibition catalogues, a number of thoughtful and influential monographs, several interviews and profiles, and hundreds of articles about his work in art magazines and the popular press. In this essay, I explore the critical environment surrounding Miró's late sculpture, particularly the painted "monsters," when they first arrived in America, and the reception of these striking works.

The critical environment was a complex assemblage of observations, interpretations, and opinions about Miró published in English over four decades, often inspired by presentations of Miró's work in the United States. These writings were geared toward an American audience interested in and at least somewhat knowledgeable about modern art: museum-goers, collectors, curators, and art writers. To understand how writers received the painted sculpture, it is essential to examine how curators and Miró's dealer in the United States, Pierre Matisse, presented Miró's work, and how the critical environment developed over time. These exhibitions and this criticism prepared—or did not prepare—discerning American audiences for this surprising new body of work and affected its reception.

Miró's admiration for America, and Americans' admiration for him, began almost at the start of his career. Even before he left for Paris in 1920, and decades before he first visited the United States, Miró considered the change in style necessary to capture the energy of a New York street and the idea of "transplanting the primitive soul to ultramodern New York."[4] After he arrived in Paris, Miró shared his enthusiasm for and fascination with a dynamic, heroic, modern vision of New York with the Dadaists he came to know, including Tristan Tzara and Francis Picabia.[5]

If Miró's ideas about America at this time were somewhat fantastic, based substantially on Futurist and Dadaist manifestos and poetry, the early interest Americans showed in his work was quite real. By the late 1920s, Miró had shown two paintings in the Société Anonyme's International Exhibition of Modern Art in New York City, his first American exhibition. He had also met

the American poet and art writer James Johnson Sweeney, had corresponded with American sculptor Alexander Calder,[6] and had sold a major painting, *Dog Barking to the Moon*, 1927, to the influential American collector A. E. Gallatin.[7] Not long after, the tremendously influential Alfred H. Barr, Jr., director of the Museum of Modern Art, included Miró's work in two landmark exhibitions: *Cubism and Abstract Art* in 1936 and *Fantastic Art, Dada, Surrealism* in 1936–1937.[8]

Although Miró's paintings puzzled some early writers, most critics viewed his art favorably. From the moment his work reached American shores until the day he died nearly six decades later, Miró consistently enjoyed more success—sales, exhibitions, favorable reviews, admiration, and emulation—in the United States, and especially in New York City, than anywhere else in the world.

In America, the earliest writers about Miró naturally viewed him in the context of Surrealism, which was still active into the 1940s. Early on critics generally divided the Surrealist artists into two camps, based on Alfred H. Barr's division of Surrealist painting into two kinds, "automatic pictures" and "dream pictures."[9] "The first kind," Barr wrote, "suggests a maximum of technical spontaneity, a direct record of uncensored graphic or pictorial impulse. To this category belongs much of the work of Masson, Miró, Arp . . ." In addition, Barr wrote that Miró and André Masson based their art "practically [on] an automatic drawing done almost without conscious control."[10] "The second kind of Surrealist painting," Barr argued, "also depends on spontaneity of imagination but not of technique. Chirico . . . Tanguy, Dalí, Magritte . . . in their effort to make as convincing as possible a fantastic or dream-like world, use a technique as realistic and deliberate as that of a Flemish or Italian master of the 15th century."[11] Thereafter Miró was branded an "automatist" Surrealist, who worked spontaneously from the unconscious, often in a naïve, trance-like state to create abstract pictures while Dalí was cast as a "literary" Surrealist, who worked unadventurously in a conservative style to create mimetic pictures.

Barr did much to promote his interpretations of Miró, Dalí, and Surrealism, when in 1941 he sponsored side-by-side one-artist exhibitions of Miró and Dalí at the Museum of Modern Art. The rest of the complex history of the interpretation of Surrealism in America is largely outside the scope of this essay, but it is important to note three factors that helped shape the critical response to Miró's work through the end of his career and beyond. First, no matter when they are writing or what they

are writing about, critics usually identify Miró as a Surrealist. Surrealism certainly did have a crucial, lasting impact on Miró, but the critics' understanding of Miró's Surrealism and how it manifested itself in his work over his long career was often muddled if not simply wrong. This is particularly true of their understanding of Miró's use of automatism.[12]

Second, the critics often played up the division between "automatist" and "literary" Surrealism, approving wholeheartedly of Miró's automatist Surrealism and distastefully dismissing Dalí's literary Surrealism. This increased the tendency to interpret Miró's work as abstract, which was completely antithetical to Miró's aims.

Finally, critics primarily and sometimes exclusively viewed Miró as a painter. This obscured the fact that Miró seriously explored many different kinds of media throughout his career, and that especially in his later years he produced significant bodies of work in collage, assemblage, ceramic, sculpture, and even fabric. Although some writers had challenged all three of these assumptions by the time Miró presented his painted sculpture in the United States, these assumptions continued—and still continue—to influence many interpretations of Miró's work.

The first Miró interview published in English served to reinforce the importance of a particular kind of automatism in Miró's work. He stated that during his first years in Paris, hallucinations caused by hunger helped inspire his imagery.[13] One of the most widely cited passages in the American literature on Miró, it conjured a tenacious, inaccurate image of Miró as an artist working in a daze, without knowing or understanding what he was doing. It took time for other critics to challenge this view of Miró and, even now, the myth of Miró as a naïve artist persists in some quarters.[14] But as his earliest published correspondence demonstrates, Miró was highly self-aware, well-read, and sophisticated.[15]

Miró also knew what he needed to do to promote and sell his work. Early in his career he forged a strong relationship with Pierre Matisse (fig. 21), the person in the United States who would play the greatest role in his life.[16] Matisse, a gallery owner in New York City, was the son of the artist Henri Matisse. Pierre and Joan met in Paris in 1930, and their meeting was timely. For several years, Miró had wanted to establish himself in America, and Matisse was looking for a major European artist whose career he could shape.[17]

One cannot overestimate the importance of their relationship. As John Russell points out, one of the best things that ever happened to the Pierre Matisse Gallery was that Miró came on board in 1932.[18] Surely the reverse is true as well, that working with the Pierre Matisse Gallery was one of the wisest things Miró ever decided to do. Matisse presented Miró's work more often than that of any of the other artists he handled, showing hundreds of Miró's paintings, drawings, collages, sculptures, ceramics, and tapestries in more than thirty solo exhibitions and several group shows over fifty years.[19] With a well-considered, patient strategy, and generally with Miró's knowledge and approval, Matisse courted influential curators and important private collectors, subtly encouraging them to buy, commission, exhibit, and write about Miró's work. At the opening of the 1982 *Miró in America* exhibition in Houston, a reporter noticed Matisse looking carefully around the room. He heard the dealer exclaim happily, "These are all my babies!"[20] The "babies" were Mirós that Matisse had placed in American collections.

Miró was keen to promote his work in the United States, but he never considered pandering to the market, something he absolutely despised.[21] He recognized, though, that it would not always be easy to sell his work: "I am very happy, my dear Matisse, to let you share in my output," he wrote in 1934 and added, "I am well aware that it is not easy to handle my paintings. It calls for almost as much courage as it does for me to paint them."[22] Nonetheless he considered it Matisse's job and duty to convince curators and collectors to buy whatever he wanted to produce.

The paintings were easy to sell compared to other kinds of work Miró would eventually send Matisse. These included funny little terra-cotta figures, enormous, fragile ceramics, and huge, knotted wool tapestries. Understandably Matisse preferred Miró's paintings.[23] This occasionally caused serious tensions between artist and dealer, but for the most part Matisse gamely exhibited every kind of work Miró produced, and alternated these exhibitions with shows of paintings that were less problematic to sell.

Curators, then as now, have more freedom to pick and choose what works they wish to exhibit and write about. In 1941, poet, art critic, and guest curator James Johnson Sweeney, under the watchful eye of museum director Barr, presented Miró in America in two intimately embracing ways: a major retrospective of Miró's work at the Museum of Modern Art and a compact monograph published a few months later.[24] Thousands

of people flocked to the exhibition to see the first large survey of Miró's work anywhere in the world. But this experience was intrinsically ephemeral, and had a more profound and lasting influence on artists than on writers.[25] After the exhibition closed, Sweeney's monograph, with its well-written, abundantly illustrated, and cogently argued essay, had particular consequences for how later writers and curators dealt with Miró's sculpture. The Museum of Modern Art's authority was unmatched, and the publication quickly became the standard reference work on Miró in English. It was to have a tremendous impact on Miró's reception, the understanding of his artistic personality, and later presentations of his work.

Sweeney argued that Miró was above all a painter, but importantly he recognized that Miró was a poet.[26] He affirmed Miró's commitment to subject matter, and credited him with introducing "a new tonic element into contemporary painting without compromising an essential pictorial approach."[27] Although Sweeney sympathized with the poetic aspect of Miró's work, he firmly believed this tendency needed to be held carefully in check by more important formal values. Sweeney further insisted that "the line of [Miró's] evolution is remarkably straight,"[28] from highly detailed representations to the "almost abstract" forms he painted as the leading Surrealist artist of the day.[29] Although he consistently reminded the reader that the works are not merely abstract, his analysis of their subject matter—so dear to Miró—was superficial, even for this kind of overview.

Sweeney's emphasis on Miró the painter led him to ignore almost completely the remarkable object-sculptures Miró made in the early 1930s. Sweeney glossed over them in one paragraph, never using the word sculpture to describe them. None are illustrated in the book, and he included only one in the exhibition. Sweeney probably ignored these works because strange assemblages of humble, often cast-off objects do not lend themselves to the kind of formal analysis Sweeney applied to the paintings. Their form was, in fact, partly incidental, created for the poetic effect the varied objects suggested.[30] This was something Sweeney the poet may have understood, but Sweeney the curator was not eager to grapple with this idea in the exhibition and catalogue.

Sweeney also did not mention the impetus that inspired the sculptures—Miró's desire to murder painting, to eliminate it completely for a time to allow him to experiment with other forms of expression.[31] This was a convenient point to ignore when introducing Miró as an artist who "since 1915 . . . has devoted himself entirely to painting."[32] It was much simpler to treat these works and Miró's motivation for making them as a temporary aberration that did not merit discussion.

Miró resuscitated painting fairly quickly. Consequently those just learning about Miró's art—including most American art lovers—would not have noticed the gap in Sweeney's exhibition and narrative. But even as Sweeney was organizing the show and writing the book, Miró was thinking deeply about sculpture, and the place it would eventually have in his work.

Miró had left Spain for France in 1936 to escape the Civil War. Deciding in the summer of 1940, in advance of the Nazi invasion of France, that his family would be safer in Spain, he moved to the home town of his mother's family, Palma de Mallorca. Only in 1941 was he able to return to his beloved small farm, house, and studio in Montroig. Hopeful that he would finally be able to concentrate more fully on his work, he began to think seriously about making sculpture. Although it was a few years before he actually produced any, he had a clear vision of what he wanted to do: to create the marvelous sculptures mentioned in the epigraph, which would keep him company in a big studio. This studio would be "full of sculptures that give you a tremendous feeling of entering a new world," and again he referred to them as creatures: "the sculptures must resemble living monsters who live in the studio—a world apart."[33]

Miró had to wait several more decades for his own big studio, but he soon began working in three-dimensions, collaborating with Josep Llorens Artigas on their first series of ceramics in 1944.[34] Miró made his own terra-cotta sculptures in 1945, two of which—*Oiseau lunaire* and *Oiseau solaire*—were cast in bronze the following year.[35] Matisse exhibited these two little birds in 1947. They were the only sculptures among a large group of recent paintings Matisse ambitiously hoped would challenge reports in the American press that European art was dead.[36]

Just at this time, as if to prove bodily that European art was still alive, Miró made his first visit to the United States, from February 8 to October 15, 1947. Miró's interest in the States had only increased after the end of the war. He wrote to Matisse, "In the future world, America, full of dynamism and vitality, will play a primary role. It follows that, at the time of my exhibition, I should be in New York to make direct and personal contact with your country; besides, my work will benefit from the shock."[37]

He primarily came to work on a commission for a mural for the Terrace Plaza Hotel in Cincinnati, which he painted in Carl Holty's admirably large New York City studio.[38] He also made

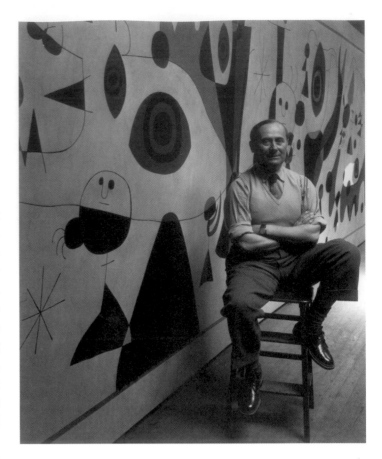

prints in Stanley William Hayter's studio in Greenwich Village, where Thomas Bouchard shot parts of two of the rare films that show Miró at work, *Miró Makes a Print* (released in 1948) and *Around and About with Joan Miró* (released in 1955), and he visited both Cincinnati and Connecticut, staying with Alexander Calder and his family. During his trip Irving Penn and Arnold Newman both photographed Miró. In one of Newman's photographs (fig. 22), a very faint smile plays across Miró's lips as he sits on a stool in front of his mural, sleeves rolled up, but wearing a tie and immaculate, shiny shoes.[39] Eventually a wide American audience knew not only what his work looked like but also what the artist looked like. He expected—and received—the jolt he desired from this trip, remembering forty years later that it had given him "a terrific sense of energy and expansiveness."[40]

Just after Miró visited New York, two interviews with him appeared in English. Sweeney published one of them, and it reinforced his view of Miró as primarily a painter.[41] Instead of a straightforward record of a question-and-answer session, Sweeney distilled many conversations he and Miró had shared over the years.[42] Not surprisingly, the "interview" complemented Sweeney's 1941 catalogue essay, emphasizing Miró's love of poetry and music, the importance of Miró's painting *The Farm*, 1921–1922 (which Sweeney had consecrated in his book), and the *Constellations*, Miró's most important recent work in two dimensions. Although Miró was mainly interested in ceramics and sculpture in the years immediately before the interview appeared, neither is mentioned.

Sweeney also published (and perhaps polished) one of Miró's most famous observations about his people and himself: "The Catalan character is not like that of Malaga or other parts of Spain. It is very much down-to-earth. We Catalans believe you must always plant your feet firmly on the ground if you want to be able to jump up in the air. The fact that I come down to earth from time to time makes it possible for me to jump all the higher."[43] This brief statement suggests a great deal, especially about actual and metaphoric dualities. These include earth versus sky, rootedness versus flight, pragmatism versus fancy, rationality versus irrationality, and confinement versus freedom. It also reflected the image of Miró in America at this time, supported by contemporary photographs of Miró in the United States, of his dual character: the practical, bourgeois family man on one side and the visionary, risk-taking artist on the other.

The man with his feet firmly on the ground is the Miró that dominates the second interview. Questioned by Francis Lee, he comes across as an artist of discipline and a man of habit, who

shies away from social events and works mainly in isolation. He also affirmed his love of poetry and music, and its importance for his art, but only in the most general terms, and he briefly discussed his admiration for young American painters and the positive influence of American "force and vitality" on his own work. Finally, he provided a brief but insightful reply when asked why during earlier periods such as the Renaissance, unlike now, only "more or less one kind of painting" existed. He replied, "There are always different kinds of painting in an epoch. What we see in the museums today is only the résumé of what has come through."[44]

Miró must have been well aware that this winnowing process also applied to individual artists' careers, and that by now the critical construction of his own work was well underway. His desire to "isolate myself from others in order to see clearly" was a way to maintain his freedom to work as he pleased, regardless of what others expected of him. When one realizes the next major tastemaker to tackle Miró was the critic Clement Greenberg, Miró's defensive strategy seems like a good idea.

In 1948 Greenberg published *Joan Miró*, the author's first and only monograph.[45] After an ambitious beginning—he proposed a sweeping and completely unsubstantiated theory about why Spain had produced so many great modern painters[46]—Greenberg turned to a survey of Miró's painting, which he discussed almost exclusively in formal terms. With his usual assurance, Greenberg's pronouncements alternated between the prescriptive, "[Miró's and Masson's] painting is abstract and anti-illusionist in tendency, this being the profoundest, because most fruitful direction of modern painting,"[47] and the definitive, "It is settled now that the main substance of [Miró's] painting is

to be the silhouette; that shape, line and flat color will take precedence over texture, plane and mass."[48]

Although Sweeney's exhibition catalogue and interview with Miró were two of the very few sources Greenberg cited, Sweeney's insistence that poetry and subject matter were central to Miró's enterprise was simply of no concern to Greenberg. When several pages into the essay Greenberg briefly addressed this crucial aspect of Miró's work, he condescendingly put the word poetry in quotes. "Miró," he wrote,

> still aspires toward "poetry" in "The Tilled Field . . . but the "poetry" is now integrated with the formal structure, and only here and there in the foreground of this painting does the configuration of the "poetic" objects fail to fuse completely with the total design. Such lapses were to be remedied as he progressed further toward the abstract.[49]

Greenberg's interest was in painting, pure and simple, or rather flat and abstract. No mention was made of Miró's object-sculptures of the 1930s, and Greenberg dismissed with distaste Miró's relationship with the Dadaists, claiming Miró was "only for a little while misled by the Surrealist revival of the anti-art, pseudo-abstract, 'irrationalities' of Marcel Duchamp, Francis Picabia, and *Dada*."[50] Although illustrations of the bronze birds were interspersed through the text, he made no mention of Miró's sculpture.

He did discuss Miró's fascination with automatism and accident. Greenberg approved of this as long as it was the means, and not the end, of a work of art.[51] And somewhat surprisingly, in the last section of the book he explored the hedonistic aspect of Miró's work. Greenberg found it laced with the terrible and the macabre despite its initial impression of "cheerful flamboyance."[52] This intriguing observation was not, however, discussed in relation to any specific works.

Greenberg's description of Miró the man also bled him dry of any poetry, humor, or spirit. Consequently Miró sounded nearly as flat as the paintings Greenberg adored.

> Those who had the opportunity to meet Miró while he was here saw a short, compact, rather dapper man in a dark blue business suit. He has a neat round head with closely trimmed dark hair, pale skin, small regular features, quick eyes and movements. He is slightly nervous and at the same time impersonal in the company of strangers, and his conversation and manner are non-committal to an extreme. One asked oneself what could have brought this bourgeois to modern painting, the Left Bank, and Surrealism.[53]

Although Greenberg's "steady machine-gun fire of absolute value judgments" irritated at least one critic,[54] his lucid writing style and perceptive observations found a wide audience. Ultimately his influence on art historians, curators, and other critics would be enormous, and his formalist interpretation of Miró still has plenty of adherents today. Whether or not Miró agreed with Greenberg's interpretation of his work, the artist realized the distinguished critic's favorable opinion of his painting would win him much support. When the new edition of Greenberg's *Joan Miró* was proposed in 1950, Miró wanted to know exactly how large the print run would be, what new material would be introduced, and what size the book would be.[55]

If Greenberg's book helped make Miró's painting more widely accepted, it may have made Miró's ceramics—and later the sculpture—more difficult to sell. When Greenberg was writing the book, it is possible that he had not seen much of Miró's work in ceramic or bronze because very little of it had been exhibited in America. But this was not the case when the book was revised and, unlike Sweeney's book, the omission was noticeable.

Several reasons may account for why Greenberg did not deal with the three-dimensional works. One is simply that he could not be bothered to update the book with discussion of the most recent work. But this begs the question why not? The real reason was that Greenberg had staked his reputation as an arbiter of painting, and it was in "pure" painting that Greenberg was most interested. Further, the ceramics were collaborative works between Miró and Artigas, and this did not fit well with Greenberg's conception of an artist, who was above all a creative *individual*.

Meanwhile Miró continued to move in an astonishing number of directions during the 1950s. Among other projects, he accepted and completed a mural project at Harvard University, visited the United States twice, created a substantial group of paintings, was featured in Thomas Bouchard's film *Around and About Joan Miró*, collaborated with Artigas on another series of sculptural ceramics, designed two ceramic murals for the UNESCO headquarters in Paris, received the Guggenheim prize in 1958 for the UNESCO murals, and had five one-artist exhibitions at Pierre Matisse Gallery. Professionally, the decade culminated in 1959 with Miró's second retrospective at the Museum of Modern Art.[56]

The 1950s were a time of transition for Miró. In 1954 he gave up his apartment and studio in Barcelona, and purchased property in Palma de Mallorca. There he commissioned Josep Lluís

Sert to design the big studio he had always dreamed about.[57] Two years later, he moved into the villa Son Abrines on his new property, and began to settle into the magnificent Sert studio.[58] Miró wrote to Matisse in early 1956 that he was reflecting on his accomplishments and preparing to begin a new stage in his life.[59] At the time of his move, he rediscovered many of his early drawings, sketchbooks, paintings, and notes. He ruthlessly pruned his collection, destroying everything that displeased him.[60]

Between 1954 and 1956, Miró virtually stopped painting to collaborate with Artigas. They produced more than 200 ceramics, including several very large pieces. Miró was thrilled with the results. His dealer was not, and their relationship was rocky throughout the spring and summer.[61] Still, despite the difficulty inherent in shipping, installing, and selling these fragile works, Matisse featured them in December 1956 in an exhibition he called *Terres de grand feu*.[62] This title was less generic and more poetic than the usual "Ceramics." Matisse also wrote to the photographer Sabine Weiss to ask her if any of her recent photographs of Miró showed him modeling clay; she replied regrettably they did not.[63] No doubt Matisse wanted to counter assumptions that Miró merely decorated the ceramics Artigas created. Like the exhibition title, photographs of Miró working with the clay would help align these collaborative works more closely with high-art sculpture than middle-brow ceramics.

The previous June, Hugo Weiss had featured the collaboration between Miró and Artigas in *Art News*, accompanied by Sabine Weiss' photographs.[64] The photographs showed the two close friends working side-by-side at Artigas' farm and ceramics studio in Galifa, a rural Catalan town in the mountains about two hours from Barcelona. Weiss recorded Miró drawing directly on to the large red rocks common to this area, emulating the Paleolithic cave artists he so greatly admired. She also photographed several of the large, sculptural ceramics embedded in the rugged Catalan landscape. Hugo Weiss claimed that "Miró has, in the past few years, changed the frontiers of his identity,"[65] and emphasized the impact of Galifa's environment on the artist. Miró and Artigas recreated some of this environment—rocks, leaves, fossils—as well as other natural things, such as gourds and a palm tree trunk, that would appear again a decade later in the patinated and painted bronze sculptures. Weiss' inquiries about these casts are helpful for understanding not only the ceramics, but also these later works:

> I asked Miró why he didn't just paint on the gourds or rocks themselves, without troubling to take casts of them. This idea

was inconceivable to him; as though it had nothing to do with the problem at all. The problem, even at the start, was not to make a painted rock but to create a new object, which could be made only in ceramics, since the object had been conceived in this medium.[66]

The article and photographs whetted the reviewers' appetites, and *Terres de grand feu* was an enormous critical success:

> The show . . . has finally given New York a chance to see the work which has occupied the artist in the last few years. It comes as no surprise to anyone that these works are delightful, full of a wild fancy which roams freely over plant and animal, geologic and human forms, always conceived with a sparkling wit and a surrealist sense of incongruity and allusion. The ceramics take many forms—plates, plaques, two- and three-dimensional constructions, figures in the round, and some even in the shapes of pebbles and rock forms, which always nonetheless bear the iconographic inscription of Miró's personal imagery.[67]

The view expressed here is important for the understanding and reception of Miró's later patinated and painted bronzes. When the reviewer referred to the works as Surrealist, he was not using the term to imply the simplistic and misleading "automatist Surrealism" usually associated with Miró. Instead the work is Surrealist in "its sense of incongruity and allusion," which related these new works to Miró's poetic object sculptures of the 1930s.[68] The sculptures exploited and celebrated the extraordinary embedded in the everyday, famously summed up by Lautréamont: "As beautiful as the chance meeting on a dissecting table of a sewing machine and an umbrella."[69]

Matisse reported to Miró that *Terres de grand feu* had created a stir and that the gallery was teeming with people. It was sensational, Matisse added, in everything but sales.[70] This was a problem for Matisse and for Miró, who expected more than good reviews at this stage of his career. About the same time, some dealers began to court Miró. He wrote a long letter to Matisse, telling him others had approached him about representing him in the United States and asked the dealer frankly if he was less enthusiastic about his work than he had been before. In short, he gave Matisse the option of ending their contract.[71] Matisse responded, "Categorically No, my dear Miró, my interest in your work has not diminished!"[72] The crisis was averted, but clearly from Matisse's point of view, a strong show of painting was in order to encourage sales.

Since Miró appeared to have temporarily lost interest in painting, the show would have to be of earlier work. And so

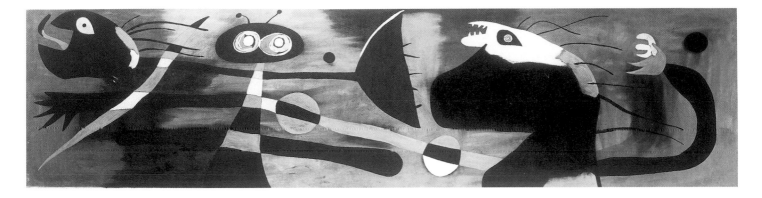

Matisse organized *Miró: "peintures sauvages" 1934 to 1953*. Although it did not include any three-dimensional work, it was extremely important for later considerations of Miró's sculpture because it forced everyone who experienced the show or read the catalogue to grapple with Miró's subject matter and to consider alternatives to the dominant formalist interpretations of Miró's work. It also dealt with monsters, Miró's pet name in his early notes for his sculpture, and the monstrous in Miró's work.

Peintures sauvages featured a powerful group of twenty-one paintings with highly-charged, frankly scary images of monstrous personages. It included, for example, the perverse mural, *Woman Haunted by the Passage of the Bird-Dragonfly Omen of Bad News*, 1938, that Miró had painted for Pierre Matisse's children's nursery (fig. 23). This was the one Peter Matisse "thought . . . had altogether too many teeth" and frightened him so badly he could not sleep at night.[73] The only way to avoid confronting Miró's subject matter with these pictures was to avoid the pictures altogether.

Matisse met the challenge head on, and hired James Fitzsimmons to write the essay for the catalogue. Fitzsimmons took on the Greenbergians, beginning with a tongue-in-cheek disclaimer:

> I will not attempt in these somewhat haphazard notes to discuss Miró's *peintures sauvages* in terms of their formal virtues, preferring to leave such considerations to those better qualified for their elucidation, the art critics, who may be counted upon to establish the value of these paintings in the context of the artist's *oeuvre*, for the public and posterity. Instead, I will try to get at a few of their possible meanings, what they may signify or evoke at the level of feeling, as highly nuanced communications of states of being which, with most people, are largely suppressed (where perceived at all) with psychologically deplorable results.[74]

Relying not only on what he could see, but also on what he knew about the artist, Fitzsimmons claimed Miró's work was about "the natural elements, the relations of the sexes, and the demonic principalities . . . of what children and primitives know: that everything hangs on the interplay of sun and moon . . . but here we are dealing with the art of a highly informed, reflective, and well-balanced man . . . [whose art] can only signify his awareness of the eternal ambiguity of our human existence."[75] Miró's concerns, he argued, are the

> primordial and ineluctable problems of human existence: sex, death, and transformations and transfigurations of instinct and emotion, man's relations with the earth and moon, flowers, earth, fire and water, the night, dogs, birds and snakes, by shorthand gestures of appetancy, hope, enchantment, hatred and despair. . . But for him the human condition is not a prison . . . but an unexplored garden where not all the plants are harmless and not all the animals friendly.[76]

Fitzsimmons revealed as much about his own worldview as Miró's. The writer was a thoughtful American living in Europe, during a century that included two vicious world wars and was now deeply involved in a third, cold one. But that was partly Fitzsimmon's point: for many the *peintures sauvages* touched an extremely raw nerve. He argued that Miró's unique, powerful means of expressing his personal vision tells us a great deal about what we share as fellow humans.[77]

The show received enthusiastic reviews, as critics noted the paintings' "ferocious content"[78] and Miró's world "of primitive magic and sexual symbolism, of fantasy and lyricism;" a world with a "tragic and even sinister side."[79] Fitzsimmons' interpretation of the *peintures sauvages* did not apply to all the works Miró created. But the writer's overall mission to find out what a work signified or evoked could be applied to any aspect of Miró's work. In his essay Fitzsimmons tried to liberate art writers from the narrow confines of formalist criticism.

He was not always successful. A prominent and influential example is James Thrall Soby in his exhibition catalogue for Miró's second retrospective at the Museum of Modern Art. Soby did touch briefly on the subject matter of a few of the featured works, but he remained firmly in the formalist camp. For example, after attempting to explain some of the imagery in *Catalan Landscape (The Hunter)*, 1923–1924, and conceding that the painting's iconography could be discerned, he concluded this was "by no means essential to an appreciation of Miró's uncanny pictorial eloquence."[80] He admired Miró's relief constructions, but he viewed them as a "personal extension of his aims as a painter" in metal and wood.[81] Either he did not know or ignored the fact that Miró had made these constructions in opposition to painting; he also dismissed the influence of Dada on Miró.[82] Cautiously he admitted that the subject of Miró's mural *The Reaper*, 1937, commissioned by the Spanish Republican government to hang with Picasso's *Guernica* in the Spanish Pavilion at the Paris World's Fair, might have significance. "It has always seemed more than possible," he wrote, "that its ferocious and tormented central figure of a reaper was meant to have a symbolic rather than decorative meaning."[83] Given the political context surrounding the pavilion, this now appears so obvious.

Soby did, however, address the issue of automatism in Miró's work. He explained that in relation to Miró, the concept was often misunderstood. He quoted Sweeney's interview with Miró, in which the artist explained that while an accidental mark "may suggest a beginning of a picture ... the second stage ... is carefully calculated ... in keeping with that desire for disciplined work I have felt from the beginning."[84]

Timed to coincide with Miró's exhibition, Robert Motherwell expanded on this discussion with a cogent discussion of Miró's automatism:

Miró's method is profoundly and essentially Surrealist...

The resistance to the word "automatism" seems to come from interpreting its meaning as "unconscious," in the sense of being stone-drunk or asleep, not knowing what one is doing.

The truth is that the unconscious is inaccessible to the will by definition ... [and t]here are countless methods of automatism possible in literature and art—which are all generically forms of free association ... but the plastic version that dominates Miró's art ... is most easily and immediately recognized by calling the method "doodling" ...

Once the labyrinth of "doodling" is made, one suppresses what one doesn't want, adds and interprets as one likes, and "finishes" the picture according to one's aesthetic and ethic.[85]

The Museum of Modern Art exhibition emphasized the early work, with few works on paper and a "parsimonious selection of ... ceramics."[86] Another lamented that, if you did not already like Miró's work, "Soby's text will, I'm afraid, do little to advance your appreciation or even understanding of his subject."[87] He found the text "scholarly," in that it precisely documented when and where Miró worked, and what he created, but added "you won't know the artist any better than if you had looked him up in 'Who's Who.'"[88]

Writing for the *New York Times Magazine*, John Canaday tried to explain Miró's importance to those still baffled by him—and among Canaday's public, there were many:

This is difficult to explain without summarizing the development of contemporary painting, but in a crowded nutshell it would go something like this:

Miró, in working through successive stages of his own development, has had the experience of conventional academic training, has absorbed the revolutionary color theory of Fauvism (too complicated to discuss here), has experimented with the structural fissions and reunions of cubism (even more complicated), and has been a leader in the wild mixture of nonsense, showmanship, compulsive insolence, and serious experiment which was first "Dada" and then surrealism, the cult of the rational-irrational.

From all of these he has kept what suited him as an intensely personal artist. In a world more and more given over to practical and scientific values, he has affirmed the legitimacy of the magical, the poetic, the lyrical. He has kept open for us a door to a world we have almost forgotten, the world of myth and the supernatural, a world sometimes joyous, sometime monstrous, grotesque, ludicrous, sometimes lovely, sometimes terrifying, but always fascinating because it is rooted in the earliest consciousness of man.[89]

Also addressing Miró's place in the artistic pantheon, Hilton Kramer reviewed the retrospective for the presumably better-informed audience in *Arts Magazine*. He wrote that Miró's position in contemporary painting was extremely ambiguous. He argued that although Miró had had a tremendous influence on almost every single important painter then working in New York, he remained "aloof from the whole temper of postwar aesthetics, with its relentless drive to empty its pockets of every last evidence of negotiable imagery."[90] Instead, Kramer wrote, "He remains a Parisian, a Catalan, a European, a Surrealist, a romantic sentimentalist with a wicked sense of humor, an image-maker in love with poetry, a symbol-monger and a visual

punster with one thing on his mind at all times—a comical and cosmological fantasy of eroticism."[91]

Sex: it had been in Miró's work all along, but art writers and critics generally underplayed the rampant and raucous sexual imagery in Miró's work, as if it were a subject not to be discussed, at least at length, in polite art company. Fitzsimmons had been straightforward, but relatively brief:

> The ambiguity of the sexual symbolism in so many of his paintings—where a linear motif signifying 'testicles,' for example, may equally well express buttocks, breasts, or the female pelvis; or where displaced almond eyes, long noses and tumescent toes are clearly genitals—reminds one of those delightful analyses of foot-fetishism, sneezing and nose blowing which we owe the Freudians.[92]

Soby was much less frank and took care of the matter in little more than a paragraph.[93] The formalists promoting pure plastic values washed their hands of the topic altogether. Kramer pointed out that since formalism continued "to dominate the language of art criticism—and especially the language 'art appreciation,'" the public's appreciation of Miró was comically inadequate:

> [T]here was something wonderfully appropriate—one wants to call it Miróesque—in the procession of pony-tailed little girls from the progressive schools side by side with stylish matrons from the suburbs marching through the Miró exhibition at the Museum of Modern Art with all the solemnity of their art-appreciation classes clearly visible in the earnestness of their faces. Indeed, the spectacle of these ladies, young and old, taking such a serious, dead-pan interest in an art which celebrates—in all manner of irreverent and comical means—the absurd and sublime mysteries of eroticism, would itself make a delightful subject for one of Miró's future works. It could be called *Little Girls and Devoted Ladies Attending My Exhibition at the Museum of Modern Art in Search of Pure Plastic Values*, and it would be a wonderful picture. Of course, there was a time—not so long ago really—when prudent mothers would have kept their little girls away from a public art exhibition so flagrantly erotic in its subject matter. Now, however, mothers may be reasonably confident that their daughters' innocence will be preserved by the vagaries of modern aesthetic pedagogy, which guarantees that the life of plastic forms will be given priority even in the face of the most provocative and scandalous materials.[94]

Beneath the humor, Kramer was making a serious point. Instead of helping viewers appreciate the significance of Miró's art, art education based on formalism actually blinded people from seeing what, with their own uneducated eyes, would have been quite obvious. Miró's emperors—his peasants, hunters, women, and sardines—not only had no clothes, they had their clothes off for a very good reason. But hardly anyone in this well-educated crowd at the Museum of Modern Art wished to see it, let alone say it.

About this time, Miró granted an interview to Edouard Roditi,[95] even though Pierre Matisse had just warned Miró that interviews were a waste of time.[96] In this case, Matisse was right. Miró obviously was not comfortable with Roditi; he answered most of the interviewer's self-consciously erudite, leading questions with a monosyllable or a short sentence. Miró's strategy was to give the interviewer the answer he wanted to hear without giving away much else in the process. Roditi was completely frustrated by the end of the interview. He commented: "One thing was clear: to those who fail to find a satisfactory explanation of Miró's art in his actual works, no more explicit verbal explanation can be expected from the artist himself. Miró remains one of those artists to whom the magic of their own creative activity poses no problems . . . Their art is their only way of being articulate."[97]

But Miró could express himself well with words when he wanted to, as his published letters and other interviews demonstrate. Countering the dismal portrait of the artist Roditi painted, Motherwell in the article discussed above wrote that Miró had "spoken eloquently about all this recently,"[98] and he quoted him:

> I do not dream of a paradise, but I have a profound conviction of a society better than that in which we live at this moment, and of which we are still prisoners. I have faith in the future collective culture, vast as the seas and lands of our globe, where the sensibility of each individual will be enlarged . . . For my part, my desire always has been to work as a team, fraternally. In America, the artisan has been killed. In Europe, we must save him. I believe that he is going to revive, with force and beauty.[99]

In the late 1950s Miró had also begun to work closely with the French poet Jacques Dupin on a new monograph for an English-speaking audience, in an attempt to set the record straight about his life and work. Although Miró was healthy and still working vigorously, as he approached his seventies it probably occurred to him that it would not be wise to put that project off. Miró and Pierre Matisse went to great lengths to help Dupin with the substantial, well-illustrated tome, first published in 1961. Dupin combined a thorough, well-documented biography with a

solidly art historical, contextual approach to Miró's work, interpreting it not only in relation to Miró's ideas and background but also to the art of his peers in the context of the major art and literary movements of his time. With much new and corrected information about Miró, Dupin's *Miró* immediately became— and remains— the most important and informative monograph in English for a very wide audience, from the general public curious about the Catalan artist's life and work to Miró specialists.

The first edition of Dupin's book devoted a full chapter to Miró's "assassination of painting," but he discussed only briefly the poetic objects of the early 1930s. Nor did he devote much space to the more recent three-dimensional works, which is not surprising since Miró had so far made so few of them. He did write, "Very often sculptures and objects are linked with other means of expression—collage, painting, or ceramics—in unpredictable, continually new combinations, in such a way that it would be ridiculous to try to introduce clear-cut classifications into this part of Miró's art, the part which is most strongly dominated by fantasy and the spirit of playfulness."[100] When Dupin revised his book in 1993, he realized that given the "broad place and force" sculpture took in Miró's last two decades, he needed to modify drastically his previous considerations and views.[101] He did, adding a chapter on the sculpture and another on the ceramics and monumental art, both notable contributions to the literature on the three-dimensional works.

Meanwhile, early in the 1960s, Miró began to paint again and started to work on a large project for the new Fondation Maeght in the South of France. In 1964, with the architect Sert, he planted thirteen large sculptures in the beautifully sited garden of the Fondation Maeght, which became known as the "Labyrinth." Two years later he made a pair of monumental bronzes, *Oiseau lunaire* and *Oiseau solaire*, based on sculptures from the mid-1940s. These massive birds, like huge robins in the spring, heralded the appearance of a large flock of smaller patinated and painted bronzes over the next few years. During the 1960s he was also featured again at the Museum of Modern Art, this time in the influential exhibition and catalogue, *Dada, Surrealism, and its Heritage.*[102]

Matisse also continued to show Miró's work, presenting him in four exhibitions, all of recent work, between 1961 and 1969. The reviews varied widely, as critics tried to come to terms with Miró's newest creations. Many of his recent paintings were very large, and more spare and enigmatic than before. Miró insisted the subject matter was there, but unlike the *peintures sauvages*, the subjects of these new works were much less obvious. Since few could write about the formal qualities of a picture as lucidly as Greenberg could, this made for some mystifying reviews.

The first show in 1961, *Recent Paintings and Ceramics*, for example, featured three very large, very blue, nearly abstract paintings, which "anchored the show firmly to the master's central concerns."[103] The reviewer seemed to like them, but his description of the big blue works and a few other paintings probably did little to help anyone appreciate them:

> The vast teleologic sneakiness of the endless track that prongs a red plasm in *Blue, 3* was a triumph of Miro's Pegesean orthography. There was a *Birds in Space* that glowed and sputtered in a perfect circuit of privately planetary iconography. Several *Women* and *Women and Birds* painted on burlap sacking were like emergency, instantly negotiable affidavits in the crackling world of affairs that is Miró's energy-echoing mind.[104]

Another critic asked, "Has Miró really become an action painter?"[105] The author (I think) answers no:

> If the blue canvases can be traced to certain respectable prototypes of Miró's earlier years, the "action" group suggests an inevitable reaction to the meticulousness and systematization that had claimed his spontaneity—or had begun to—as far back as twenty years ago. But even in his more "plastic" style, the paroxysms are measured, the celestial stains pose rather occur. With literature largely abandoned now, psychological ambiguity—homeless—is converted into the irony of a freedom that is being sought while its very means diminish.[106]

Miró may have been pleased that for a change his work was considered in a contemporary, rather than historical, context. Alternatively, perhaps he thought he would be better off if the critics, indulging in the latest critical jargon and suggesting his newest work might be derivative of the New York School, simply left him alone. Or he may have been too busy with his first retrospective in Paris in 1962 to care one way or another.

Unlike the 1959 exhibition at the Museum of Modern Art, the show in Paris featured a great deal of his most recent work, and it challenged even his most staunch supporters. Pierre Schneider, a great fan and acquaintance of Miró, wrote it was "a pity [the exhibition] insists so much on the postwar period at the expense of the years 1923–1940 and of the more experimental aspects of the artist's work. Had it been the other way around, the show would have drawn attention more effectively to the unique merit of Miró's career: he maintained, for nearly quarter of a century, creative tension in the most difficult of all contexts, that of absolute liberty."[107]

Tactfully, Schneider did not exactly say he disliked the new work. Some who loved Miró's earlier works had a hard time adjusting to his newer ones, especially because Miró had secured his place as a major figure in the pre-war history of modern art. Roditi—who was still smarting over that terrible interview—found the collaboration between Miró and Artigas "a really questionable product" that was "frankly slovenly."[108] And the thinly veiled "C. G." insulted Miró and wrote that he found his recent efforts "diminished greatly in stature," a view that he arrogantly claimed saddened him.[109]

But most of the critics, especially those not so committed to formalism, were much more positive about Miró's new work. One wrote about his new "painted, gouged, scratched, burned, folded" Cartones: " Miró always acts as though he has just discovered his medium but has always known exactly what to do with it."[110] The artist was not willing to repeat himself, and challenged the critics to move along, just as he had.

He still craved the "shock"—the unexpected jolt brought on by a new or unexpected experience—that he believed sparked his best work.[111] He made sure he did not become too isolated or complacent in Palma,[112] and he visited the United States five times between 1959 and 1969. The press reports of his visits, his correspondence with Matisse, and Matisse's records of his visits make it clear that Miró came to New York not to be celebrated but because the city was full of young artists and stimulating new ideas.

He missed the opening of his retrospective at the Museum of Modern Art because his wife, Pilar, had problems obtaining a visa, but this did not matter to him. He wanted to see the exhibition, of course, but he preferred meeting artists to socializing. He wrote to Matisse, "I think I would also like to get to know the American painters; not only does American painting interest me very much, I also never want to take on that air of superiority that my European contemporaries take on when they visit America, far from it."[113]

When they planned a visit to the United States in 1961, Matisse offered Miró and his wife his home in upper Manhattan. Miró declined, "I'm afraid that as we're going to behave a bit like tourists, it would be a little far from the city center. But thanks very much for your offer."[114] He wrote upon his return, "That trip to America did me a lot of good. I am currently in a period of gestation, I am . . . preparing a series of large paintings . . . not the poor little stories (histoires) of my illustrious contemporaries."[115]

Four years later John Gruen reported on Miró's visit to "zestful" New York.[116] He wrote that he was at the Film-Makers'

Cinematheque's New Cinema Festival, among "the young East Village crowd gathered here to see it all, hear it all, love it all . . . when, who should be sitting there, all neat and crisp and alert—but Joan Miró."[117] Miró loosened up and was positively loquacious, "I come to New York to be recharged. This city is the best pep-up pill ever invented . . . Ah, what vitamins! This city is a tonic! This city is a doctor!"[118] Miró spoke freely of his life in Palma and his art, and as if to answer those who wished him to stand still, exclaimed, "How I detest labels! And how I despise the concept of Les Grands Maîtres! When I see old friends . . . when I see Picasso, for example, we never talk about art at all."[119]

He told Gruen that when he and his wife came to New York, few people knew about it because he would "rather slip into town quietly, walk about the streets, see a few close friends and visit such offbeat places as the Cinémathèque."[120] During this visit he also attended a performance of Robert Rauschenberg's dance troupe, a screening of four "underground" films at the Museum of Modern Art, and possibly a "happening" at Astor Place Playhouse.[121] After he returned to Palma, he wrote to Matisse that his trip had been stimulating, "renewing and reviving my ardor for work, with new ideas . . . I am working very hard, and hope to see you soon so that we may talk about all our projects."[122]

One of the projects was the casting of two enormous bronze birds, Oiseau lunaire and Oiseau solaire, that Matisse presented in 1967.[123] The concurrent sexual revolution that encouraged a more positive attitude and openness toward sex appeared to help those writing about Miró's highly erotic bronze birds. Miró probably approved, both of the revolution and the approaches to his work resulting from it. He had written many years earlier, "Remember that in primitive, non-decadent races the sex organ was a magic sign of which man was proud, far from feeling the shame that today's decadent races feel."[124] Society was no doubt still decadent, but now it was the 1960s. Sex was back in style.

Matisse hired David Sylvester to write the catalogue essay for his 1967 show. Sylvester almost too enthusiastically explored the sculptures' suggestive forms and overwhelming sexuality. He observed, "The Solar Bird changes identity most markedly as one's viewpoint changes, but also suggests at least two or three identities from any single angle. From one position or another, it is a charging elephant, a seal, a boat, a horse, a motorbike, a turtle swimming, a beast of burden, a sort of crucified figure, and a woman on her back." With both male and female protuberances and appendages, Sylvester suggested The Solar Bird

"might be a prototype for the third human sex which a sated world seems longing to discover." "*The Lunar Bird*," Sylvester continued, "rises, all rampant libido, looming up over human kind . . . [from the front it] is cocky, bullying, tumescent, and one can imagine avid women urging themselves onto the great spike that sticks out in front of it"[125]

About the same time, two influential publications geared to quite different audiences featured Miró (fig. 24). The first was *Vogue* magazine.[126] The second was William Rubin's *Dada, Surrealism, and its Heritage*.[127] Although Rubin's book was obviously much more serious, and a great deal more important art historically than a feature in a fashion magazine, both added insights into Miró's life and work.

Ostensibly the article in *Vogue* was not about Miró's art. Rather, it was about Miró's other love: food. Miró was at ease with the reporter, and he chatted good-humoredly about the meal they had just enjoyed:

"Now we can talk calmly about food," he said, "It is a very serious subject, especially from a poetic point of view, which is why I want to speak as an Epicurean poet. I am fundamentally an Epicure, perhaps because I was a frail child with hardly any appetite—I have made up for it since."

The malicious eye of Miró cleared as he continued: "The Melba toast I showed you at lunch reminded me of the rough, brown surface of a ploughed field. I see the sea in sardines with their scales like waves. I like peppers—green, yellow, red, like a rainbow; strawberries that smell of the forest; dandelion and watercress that I gather myself; watermelons and their black seeds that children fling clattering to the floor; from my own farm, wine and olive oil—the perfume is incomparable. All this puts me in touch with the essence of things, nature."[128]

He continued,

"In Majorca, there is a small turn-of-the-century pastry shop, old-fashioned but charming, called Can Jomen. All the old ladies go there for apricot ice cream, and most of all for almond ice cream, which is really unique. I often go too, but always alone, to sample it tranquilly . . . It is almost a religious rite—the liturgy of almond ice cream."

His poetic discussion of food purposely coincided with his ideas about art; Miró knew exactly what he was doing. About French cuisine, he mused:

"I spent a long time in France. How superb and subtle French cooking is. But, for me it is too skilled, too intellectual. I am anti-Cordon Bleu, too much like the Sorbonne—with all respect to the Sorbonne. I actively dislike sauce béarnaise, which in the long run explains much about my painting."[129]

In this short article, Miró conveyed some very important things about himself that could help *Vogue* readers appreciate his art: his sensuality, his sense of poetry, his strong Catalan roots and love of his homeland, his humor, and even his attitude toward French culture, art, and intellectualism. And with all of this came four recipes from Joan and Pilar's kitchen.[130]

In contrast to the light interview, Rubin's book was scholarly. The Dada and Surrealist revolution continued to have a tremendous impact on art and life in the second half of the twentieth century, but there was no thorough accounting of this revolution or its impact.[131] As John Ashbery pointed out in his review of Rubin's book and exhibition, "We all 'grew up surrealist' without even being aware of it."[132]

Rubin carefully documented the people, events, texts, and works of art associated with the Dada and Surrealist movements, bringing order and clarity to the study of the chaotic. He also made the first serious effort in English to deal with Dada and Surrealist art in the context of art history. To do this he searched for "some common properties of style and many common denominators of characteristic iconography and intent."[133]

Rubin discussed Miró's object sculptures in the section on the Surrealist object, which the art historian described as "essentially a three-dimensional collage of 'found' articles that were chosen for their poetic meaning rather than their possible visual value."[134] Although he categorized Miró's works along with Meret Oppenheim's *Fur-Covered Cup, Saucer, and Spoon* and Salvador Dalí's *The Venus de Milo of the Drawers*, he maintained that Miró's, like Masson's, "constructions and sculptures remained true to their respective form languages." He continued, "Even Miro's *Poetic Object*, a rare instance in which he collaged such real articles as a stuffed parrot, a derby, and a map, is informed by an aesthetic—epitomized in its carved wooden centerpiece—alien to the pure Surrealist object."[135]

It took thirty years for a major American art writer to suggest that the objects in Miró's sculptures were not only found and assembled but also posed, and that the compositional language the artist used in these sculptures could be related to Miró's other work. Rubin was no doubt helped in seeing this, in part, by his appreciation for contemporary American art. In itself, this was nothing new: American critics had often viewed Miró's work through the lens of contemporary American art and criticism.

24. Joan and Pilar Miró,
1966, photographed
for *Vogue* magazine by
Cecil Beaton.

But as long as the American movements that most interested the critics were Abstract Expressionism or Post-painterly Abstraction, the critics tended to ignore Miró's sculptural objects. By 1968, the scene had changed, and Pop Art was well established in the United States. When critics such as Leo Steinberg argued persuasively that critics needed new criteria to appreciate the work of younger artists who incorporated objects into their work like Robert Rauschenberg and Jasper Johns,[136] they created an environment in which Miró's decades-old object sculptures suddenly appeared more relevant, more accessible, and more art historically important.

Just at this time, as if *Oiseau solaire* and *Oiseau lunaire* had learned to reproduce madly, Miró suddenly offered dozens of new bronzes to Matisse. In 1970 he presented 60 of them in *Sculpture in Bronze and Ceramic, 1967–1969* (fig. 25). The sculptures ranged from a few inches to about 3 feet tall. The smallest pieces sat on shelves in a display case, where the effect was not unlike that of the famous cabinet of curios Miró kept in his Sert studio. Most of the works were assemblage sculptures, bronze casts of various objects Miró had collected; each was an odd, not-quite-human creature.[137] After twenty-five year's gestation, Miró's monsters were born.

They surprised and delighted almost all who met them. John Russell wrote for the catalogue that Miró's art was "without parallel for the energy, the sense of fun, the gift of metamorphosis, the implicit violence and the darting, imperious, unballasted imagination which has been put to multifarious uses for well over fifty years."[138] In this essay he was one of the first to insist on the importance of Miró's three-dimensional work, and he presented the new sculpture in a historical context that harked back to the 1930s object sculptures, referring to some of the new works' as "characteristic Miró-people" and the earlier ones as their "ancestors." John Canaday found them "so alive, so vigorous and so inventive, that everything he has done until now begins to look like a series of preparatory exercises," with a livelier wit and more varied fantasies than ever before,[139] while Emily Genauer claimed the "76-year-old Catalonian imp of the devil, Joan Miró" had done it again; she found the sculptures "marvelously and just a little bit frighteningly mad—but younger and more spirited than ever before."[140] Hilton Kramer was dazzled, calling Miró "one of the great poetic minds of modern times," but also insisted that to speak of imagery was not enough. Miró, he argued, made "no distinction between the image and the form."[141] And one reviewer saw them just as Miró had suggested—as living monsters. But they were quite unlike the painted monsters that terrified little Peter Matisse and so moved the viewers of the *Peintures sauvages* exhibition.

> All the sculptures, in one way or another, seem to express the fantasy of matter becoming animate, walls speaking or stones laughing. But they do it in such a way that not even the most timid child would be frightened. These monsters are friendly, or at the most burlesquely frightening like the Meanies in the Beatles cartoon film, something to giggle about rather than cry over, an attempt, perhaps, on Miró's part to laugh us out of our bad dreams.[142]

John Ashbery also found them a "new and alien, if friendly, race of creatures . . . that were strange and familiar at the same time."[143] Michael Brenson wrote a few years later, "One has the sense of having stumbled into an underground shelter on another planet. These creatures . . . seem enchanted, alive, and despite the terror that inhabits a number of them, friendly."[144]

The assemblage sculptures were familiar because Miró created them out of recognizable things: parts of plants and trees, abandoned shells, simple farm tools, pieces of machinery, casts of ceramics he and Artigas had made, and some plain old trash. They were unquestionably Mirós; no paternity test is needed to identify the father of these little monsters. But it seems that Miró was also promiscuous, fooling around with muses who might be named Botanica, Organica, Agricola, Fabrica, Ceramica, and Refusa. And the offspring were indeed strange. Unlike terrestrials, many of them appeared to have more than one mother and be of more than one sex. Perhaps this is the source of their gently nagging threat. If all the stuff forgotten or cast-away suddenly assembled itself, mobilized, and procreated, in no time at all a new race of monsters—friendly or not—could take over the world.

The Walker Art Center invited nearly all of Miró's monsters to Minneapolis; this was probably the first place one could see the painted sculptures in America.[145] The exhibition featured about 60 sculptures, almost all of them cast since 1965 (fig. 26). The show traveled to the Cleveland Museum of Art, the Art Institute of Chicago, and the Baltimore Museum of Art, and it was notable for several reasons. Although casts of many unpainted and possibly a few painted sculptures in the Walker exhibition had already been shown at Matisse's gallery in New York, this was the first show at an American museum devoted solely to Miró's sculpture. It was also the first to take the monsters from Manhattan, to the American heartland and the mid-Atlantic coast. The show also treated Miró as a contemporary, not an historical, artist. Interestingly, the Museum of

Modern Art considered hosting the exhibition, but only on the condition that earlier work be added.[146] Martin Friedman, Director of the Walker Art Center, insisted that the show be of recent art, in keeping with the mission of his institution. He asked Pierre Matisse to help him get the most recent works; the casts of the painted sculptures were so fresh from the foundry that Miró granted permission to the Walker Art Center's staff to paint them when they arrived in Minnesota.[147]

The catalogue included an essay by Dupin on Miró's sculpture, in which he described how Miró collected and transformed the objects he used for his sculpture: "It all begins with an impromptu harvest. Miró slips out of his studio like a shadow and comes back loaded down like a peddler with worthless, unusable things, everything that nature and men have abandoned, forgotten."[148]

Dupin also noted that Miró worked differently when sculpting rather than painting.

> In his paintings, Miró brings forth images from within his creative imagination and projects them onto the canvas through analogies with reality. By contrast, sculpture allows him to begin with concrete realities which he interiorizes and plunges back into the crucible of his imagination. This results in images that echo those of his paintings, without directly identifying with them.[149]

In an interview with Dean Swanson, Miró described how he gathered objects in his studio and assembled his sculptures, working directly from the objects.[150] His sculpture, Miró succinctly told Swanson, "has to do with the unlikely marriage of recognizable forms."[151]

The exhibition received little attention from the New York-centric art press, whose writers had seen much of the work the previous year, but the regional critics immediately understood what the Miró sculpture was about. Mike Steele wrote that Miró, at 78, "appears indestructible," and that as "the jester in the court of high art," he found the sculpture very funny. He also noted that it was a "Romper Room of sexual imagery, a reducto ad absurdum of funky sex."[152] Another critic recognized that Miró had launched "a second artistic career." He continued:

> this is not a show which attempts to sort out the relationships between phases of an old man's career and to define the essence of a corpus of expression. On the contrary, it is a show which invites us to participate in the discovery of the talent of a new artist who is himself in the midst of discovering and developing his ideas and techniques . . . "Miró's Sculptures" is the budding

of a talent that—however much nourished by experience—has all the best qualities of youth: inquisitiveness, energy, dedication, flexibility, and freshness.[153]

When the monsters reached Baltimore, Benjamin Fogery of the *Washington Star* recognized, "There it is, the whole kooky menagerie that inhabits Miró's painting parading around in real space and in bronze, yet." He particularly liked "a number of socko life-size bronzes painted in unmodulated and characteristically brilliant hues. The coloring, too, is perfectly calculated to effect, and these pieces have their, more slapstick, charm." He continued, "Miró's art, in painting and in sculpture, possesses a strong narrative streak, though the story line is profoundly idiosyncratic . . . One is in the presence of a visionary of the absurd, the creator of a world with its own intense logic, and though this world does indeed have parallels in the real world of human interaction, one generalizes or schematizes at considerable peril."[154]

Since the mid-1960s, when the universities expanded to include a much larger and more diverse student body as part of a much greater social revolution, art history and art criticism has become more varied and often more sophisticated. The work of scholars such as William Rubin emerged from this environment, as did that of Margit Rowell—another pioneer in Miró scholarship—who examined carefully the relationship of Miró's work to that of the Surrealist poets.[155]

At the same time, formalist interpretations of Miró's work continued to thrive in certain quarters, especially among critics who championed contemporary American abstract painting.[156] Using their approach in a strict, consistent way, formalist critics could build tight, intelligent arguments. But this rigor often limited rather than expanded the way an artist's work could be interpreted, and critics of formalism accused its practitioners of distorting the artist's intent to serve their own ends. When in 1972 Rosalind Krauss writing in the catalogue for the exhibition at the Solomon R. Guggenheim Museum *Magnetic Fields: Joan Miró* interpreted Miró's paintings as if they were totally abstract, an inflamed critic not-so-gently reminded her that Miró insisted that "his marks on the canvas, no matter how obscure, refer to the actual thing."[157] However, since after the mid-1960s those with a formalist bent tended to ignore Miró's sculpture, they had little impact on its critical literature.

Most other art writers tended to appreciate and enjoy the wit of Miró's recent sculpture, which they had a chance to see in New York at Matisse's gallery five times between 1973 and 1983,

the last decade of Miró's life. Kramer, again on the scene and on the mark, noted that after seeing the Guggenheim's spare interpretation of Miró in *Magnetic Fields*, he was delighted to report that "we are restored to Miró's poetic vision in all its glory. This is wonderful work that abounds in wonderful visual jokes and wicked flights of fancy." He also noted, "Miró remains an incredibly surprising and forceful artist, and this show offers eloquent testimony to the fact that, at 80, his powers are undiminished and his wild sense of humor is still at work."[158]

A lot of the humor was a specific kind; as one reviewer noted, Miró was "an artist for whom the sexual aspects of human nature and human activities have provided a wonderfully continuous scenario."[159] The reviewers now understood Miró's language, and they enjoyed the game. No illustration accompanied the sculpture described in the review quoted below, but none was really needed:

> In 1967 bronze, "Personnage" . . . offers us the figure of a man, constructed largely of a perfect void formed by a circular hoop and spindly legs, fitted out with a very large faucet attachment. Aside from its formal wit, the sculpture is a marvelous comment on the way our plumbing fixtures imitate our anatomical equipment. Art, even a technical art like plumbing, Miró seems to be saying, inevitably imitates nature.[160]

When Barbara Rose asked the 88-year-old Miró about the eroticism of his work, he told her "I have often drawn and painted couples making love. But pornography is a low, base thing. Eros is sacred. If I represent sex, it is in the religious sense—like the Hindus. Love is for the gods, pornography for the pigs."[161] That said, the sex in Miró's late sculpture is undeniably earthy, delightful, and fun. As Peter Schjeldahl noted, Miró's

> women, birds, and personages may indeed have "universal" significance, but they are important primarily for their ability to hold Miró's interest through long series of protean transformations—as in his incredible number of variations on the theme of the vagina, each with the gladness and awe of an adolescent boy's first discovery.[162]

While Pierre Matisse now consistently presented Miró's most recent work, across town a completely different aspect of the artists' work was featured in *Miró in the Collection of the Museum of Modern Art*. The museum owned and exhibited forty-six major drawings, paintings, objects, and sculptures, along with many works on paper. Several of the works were important, early paintings that once again confirmed Miró's crucial role in the history of modern art. In the 1970s, therefore,

Miró found himself in the peculiar—if not unenviable—position of being both a major historical figure and a bright and lively presence on the contemporary art scene.

When Miró turned 85 in 1978, he told an interviewer that he wanted the public to see his latest work, "so that they know I'm still breathing."[163] Occasionally the fact that Miró was still living, breathing, and working seemed to irritate critics. One wrote in response to his exhibition at the Grand Palais in Paris, which Miró had a hand in choosing, that the emphasis on recent work proved Miró to be "a very self-indulgent painter" spoiling his work with "gratuitous freedom."[164] But more common was the response to his 1976 exhibition, which considered Miró in the context of Surrealism, without making him a prisoner of it:

> Miró's painted bronze and bronze sculptures which incorporate found objects recast in bronze are adding humor and zest to spring in New York. Especially delightful are the painted bronze works where bright, primary colors often contrast with black; here the witty transformation of objects into new, fresh metaphors are indeed apparent . . .
>
> All this places his work firmly in the tradition of Surrealist sculpture, of familiar forms recombined with fresh imagination and amplified meaning. Many of the works here . . . seem to have been created in a spirit of inspired relaxation and it is in this playfully spontaneous aspect of Miró's creation which is so appealing.[165]

Miró continued to make sculpture nearly until the day he died, on Christmas Day, 1983. In 1987, the Pierre Matisse Gallery presented *Miró: The Last Bronze Sculptures*, featuring twenty-six pieces Miró began in 1981 and cast in 1983. Rowell wrote the essay in the exhibition catalogue, which was sprinkled with Miró's own words about sculpture that she had made accessible to an English-speaking audience the year before in a volume of selected writings and interviews. What he had to say was revealing and moving: "Use things found by divine chance," he wrote in about 1941, "bits of metal, stone, etc., the way I use schematic signs drawn at random on the paper or an accident . . . that is the only thing—this magic spark—that counts in art."[166]

This consideration of the presentation and reception of Miró's sculpture ends here, in the early 1980s. In the decade before and after, the Miró literature swelled, partly because scholarship on the modern period overall grew tremendously, and partly because Miró's passing inspired many homages and reassessments of his work. The exhibition *Miró in America* at the Museum of Fine Arts in Houston 1982 and its catalogue, for example, confirmed Kramer's 1959 assertion that one would

need "a magnifying glass to discover a single post-war painter of importance who has not at one time or another submitted to Miró's spell,"[167] while dissertations turned into books and exhibitions, such as Sidra Stich's *Joan Miró: Development of a Sign Language* in 1980, provided important new keys for interpreting Miró's painting.[168] In 1993 the Museum of Modern Art presented Miró's third retrospective,[169] and about the same time *Artforum Magazine* published appreciations of Miró written by artists, historians, and critics.[170]

Paradoxically, contemporary painters began to take Miró's contribution for granted and his work ceased to be relevant for them. As Schjeldahl wrote in 1984, in the catalogue essay for an exhibition of Miró's sculpture at the Pace Gallery, New York, "His influence now functions at many removes from him, and a retroactive family resemblance to his descendants makes him as unsurprising as an old-shoe uncle whose wonderful stories, retold for generations, lose luster by association to the ennui of retelling."[171]

Those writing about Miró after the early 1980s also tended to view him primarily as an historical figure and almost exclusively as a painter, celebrating his early production and disparaging his later work. This was in part because there were few shows of recent work to review; writing about Miró was more and more by historians and less and less by critics. Miró literature continues to proliferate, and much of the work is engaging, but the more detailed and specialized the interpretations become, the more scholars focus on (and argue about) the details. This threatens the loss of the whole vital, magical Miró forest for a few dry leaves.

The literature on Miró's sculpture in the early 1980s, however, was and remains to this day small. The sculpture itself is also much less famous, especially in the United States. Schjeldahl suggested that this situation created a distinct opportunity. Two decades ago he encouraged his readers to take a fresh look at Miró by focusing on his sculpture. He directed part of his commentary toward artists, but what he had to say is as valuable for others interested in Miró and still valid today:

> With luck and guile, we may break the carapace of overfamiliarity and recover a sense of Miró's strangeness, thus preparing ourselves for the new face he will wear when, inevitably, a new turn of consciousness puts his art at issue again. Such a turn may be nearer than we expect. If so, it could well involve Miró's little regarded, little-discussed sculpture to the exclusion of his thoroughly assimilated painting and graphic work. Can we view this sculpture not as the tail of a modernist past but as the dog of a

post-modernist present and future? There will be rewards, I think, in trying.[172]

Schjeldahl added that Miró's sculpture, with its emphasis on profile, surface, and the human image, might help contemporary sculptors find their way out of their modernist and Minimalist cul-de-sac, to assist them also in recovering an "aptitude for Miró's kind of play—a capacity of 'the transcendently imaginary.'" He argued further that "If Miró's art, or that of any past master, is to live, it must speak to our changing needs, not rebuke us for having them," and part of this need was to "reinvest psychological and poetic content in [sculpture]."

The provocative question of whether a revitalization of contemporary sculpture took or is taking place will be left to the critics and other art historians But it is appropriate to note here that remarkably there has not been a major museum exhibition of Miró's sculpture in the United States since that organized by the Walker Art Center in 1971.[173] In America the painted sculptures are particularly difficult to see.[174] It is impossible to know whether Miró's late sculpture lives unless people can see it, think about it, and, yes, write about it.

When Miró's monsters arrived in America, now more than thirty years ago, perceptive critics appreciated the Surrealist roots and formal strength of these sculptures, as well as their contemporary humor, wit, sex appeal, and charm. Those who had presented and written about Miró's earlier work assisted those who wrote about Miró's late sculpture if they were discriminating enough to read critically, always measuring what they read against what they could see. This meant sorting out the meaning of Surrealism and Miró's place in it, understanding that the present always affects the interpretation of the past, recognizing that presentations of an artist's work reflect conscious choices, knowing that what an artist says depends upon to whom he or she is speaking, and realizing that every author worth reading writes from a point of view. The history of the presentation and reception of Miró's late sculpture in America, of which this exhibition and publication are now honored to be a part, promises to become nearly as rich, complex, and full of contradictions as the brilliant work of the artist himself.

Notes on The Monsters in America: the Presentation and Reception of Miró's Sculpture in the United States

1. *Joan Miró: Selected Writings and Interviews*, edited by Margit Rowell. Translations from the French by Paul Auster. Translations from the Spanish and Catalan by Patricia Mathews (Boston, G. K. Hall and Company, 1986; republished Cambridge, Mass., De Capo Press, 1992), 175.

2. The first presentation was probably at the Walker Art Center, Minneapolis, Minn., in 1971, but possibly the Pierre Matisse Gallery in 1970. See note 137 below and Jeffett in this volume, 33.

3. See Barbara Rose, *Miró in America*, exh.cat. (Houston, Museum of Fine Arts, 1982), 5–45; Judith McCandless, "Miró Seen by his American Critics," 49–65, in Rose 1982; Anne Umland, "Chronology," 317–361 and Lilian Tone, "Exhibition History," 437–457, in Carolyn Lanchner, *Joan Miró* exh.cat. (New York, The Museum of Modern Art, 1993).

4. Miró to J. F. Ràfols, Montroig, September 13, 1917, in Rowell 1992, 51 and Miró to E. C. Ricart, Barcelona [October 1, 1917?], in Rowell 1992, 53. These letters reflect Miró's exposure to Futurist and Dadaist ideas in Spain before he went to Paris.

5. Rose 1982, 12–14.

6. Umland 1993, 327.

7. Umland 1993, 325.

8. Tone 1993, 441.

9. Alfred H. Barr, Jr., *Cubism and Abstract Art*, exh.cat. (New York, The Museum of Modern Art, 1936, reprinted 1974), 179. For a general history of Surrealism, see William S. Rubin, *Dada and Surrealist Art* (New York, The Museum of Modern Art, 1970), 149–341.

10. Barr 1936, 180.

11. Barr 1936, 179–180.

12. Robert Motherwell was one of the first Americans to address this seriously in "The Significance of Miró," *Art News*, v. 58 (May 1959), 32–33, 65–67.

13. Miró, "Je rêve d'un grand atelier," *XXe Siècle*, v. 1 (May 1938), 25–28, excerpted and translated as "I Dream of a Big Studio," in *Joan Miró: Exhibition of Early Paintings, 1918-1925*, exh.cat. (New York, Pierre Matisse Gallery, 1940), reprinted in Rose 1982, 113. "In spite of these first sales times were still hard enough. For the *Carnival de Harlequin* and the *Danseuse Español* I made many drawings into which I put the hallucinations provoked by my hunger. In the evening I would come home without having eaten and put down my sensations on paper." This passage is translated in a slightly different way in Rowell 1992, 161.

14. See Dorothy Tanning's comments about Miró in Linda Yablonsky, "Surrealist Views from a Real Live One," *The New York Times* (March 24, 2002), Section 2, 35.

15. Miró in Rowell 1992, 46–122.

16. See John Russell, *Matisse: Father and Son* (New York, Harry N. Abrams, Inc., Publishers, 1999), 110–132.

17. Russell 1999, 111, 112. From the very beginning, Miró carefully considered how best to promote his work. In 1919, he wrote to E. C. Ricart, "I would give all my work, without thinking, for 1,000 pesetas, *with the requirement that [the dealer] organize an exhibition of my work within a fixed period of time*, plus a percentage upon sale." Umland 1993, 321.

18. Russell 1999, 110.

19. William M. Griswold and Jennifer Tonkavich, *Pierre Matisse and his Artists*, exh.cat. (New York, The Pierpont Morgan Library, 2002), 32.

20. Betty Ewing, "Audience Toasts Miró as City Gets a Grand View of Artist's Work," *Houston Chronicle* (April 24, 1982), section 3, 11.

21. Miró in Rowell 1992, 71–77.

22. Russell 1999, 114.

23. Griswold and Tonkavich 2002, 32.

24. James Johnson Sweeney, *Joan Miró* (New York, The Museum of Modern Art, 1941).

25. Rose 1982, 19–21.

26. Sweeney 1941, 13.

27. Sweeney 1941, 14.

28. Sweeney 1941, 21.

29. Sweeney 1941, 36.

30. Jeffett in this publication.

31. William Jeffett, "Joan Miró's Vagabond Sculpture," *Joan Miró Sculpture*, exh.cat. (London: South Bank Centre, 1990, 7.

32. Sweeney 1941, 14.

33. "Working Notes, 1941–1942," Rowell 1992, 175.

34. The relationship between Miró's ceramics and sculpture is explored in Jeffett, this volume, 24–26.

35. See Jeffett, in this volume, 25.

36. Griswold and Tonkavich 2002, 210.

37. Umland 1993, 337.

38. Duncan MacMillian, "Miró's Public Art," in Rose 1982, 102. The mural is now in the Cincinnati Art Museum.

39. Illustrated in Rose 1982, 3.

40. Rose 1982, 120.

41. "Joan Miró: Comment and Interview," by James Johnson Sweeney, *Partisan Review*, v. 15 (February 1948), 206–212, in Rowell 1992, 207–211.

42. Sweeney prefaced the article with this notice: "The following remarks do not pretend to be verbatim, but are based on several formal and informal discussions with the artist." Rowell 1992, 207.

43. Rowell 1992, 211.

44. "Interview with Miró," by Francis Lee, *Possibilities*, no. 1 (Winter, 1947–1948), 66–67, in Rowell 1992, 204.

45. Clement Greenberg, *Joan Miró* (New York, The Quadrangle Press, 1948).

46. Greenberg 1948, 7–9.

47. Greenberg 1948, 40.

48. Greenberg 1948, 20.

49. Greenberg 1948, 21.

50. Greenberg 1948, 26.

51. Greenberg 1948, 26.

52. Greenberg 1948, 42.

53. Greenberg 1948, 38.

54. Thomas B. Hess, "Catalan grotesque," *Art News*, v. 47, February 1949, 9.

55. Pierre Matisse to Milton Rugoff at Chanticleer Press, Inc., October 12, 1950, PMGA, B18, F51.

56. Miró was understandably thrilled when the Museum of Modern Art scheduled his second retrospective just after *Peintures sauvages*. Added to his public commissions, his recent critical success, and the Guggenheim Prize, the show was the jewel in his professional crown. Miró, as always, was well aware of this. He wrote to Matisse: "Cette exposition été faute à son temps: Mural UNESCO: Prix Guggenheim: Exposition Sauvage: Livre constellations: Exposition Museum of Modern Art. Pour ceci me semble une magnifique stratégie. Pourriez vous m'envoyer quelque coupe de presse, pour connaître les réprecussions." Miró to Pierre Matisse, November 11, 1958, PMGA, B18, F57.

57. "Studio for Joan Miró," *Architectural Record*, v. 123 (January 1958), 138–140.

58. With the money from his Guggenheim Prize, Miró also bought an old house nearby, Son Boter, that he used primarily for making three-dimensional work.

59. Miró to Pierre Matisse, January 16, 1956, PMGA, B18, F57.

60. "Propos de Miró," by Rosamund Bernier, *L'Oeil* nos. 79–80 (July–August 1961), 12–19 in Rowell 1992, 257.

61. Miró wrote to Matisse in April 1956, complaining that he was not attentive enough. Matisse was furious, and he fired back a two-and-a-half page, single-spaced, typewritten letter, reminding Miró of all he had done to promote his work in America, including the placement of 150 works with private collectors and of 15 in museums. Meanwhile, Matisse had not been informed by Miró or his dealer in France that Sweeney, now at the Guggenheim Museum, was planning to exhibit Miró's new ceramics. When he found out, he was extremely irritated. Sweeney backed down, and Miró was disappointed. Miró to Pierre Matisse, April 29, 1956, PMGA, B18, F56. Pierre Matisse to Miró, May 26, 1956, PMGA, B18, F56. Pierre Matisse to James Johnson Sweeney, July 26, 1956, PMGA, B18, F56. Sweeney to Pierre Matisse, July 31, 1956, PMGA, B18, F56.

62. Griswold and Tonkavich 2002, 134–235. The title translates badly as "Works of Clay from the Great Fire" or "Inferno."

63. Sabine Weiss to Pierre Matisse, November 26, 1956, PMGA, B18, F56.

64. Hugo Weiss, "Miró-magic with Rocks," *Art News* v. 55 (June 1956), 48–49, 56–57.

65. Weiss 1956, 48

66. Weiss 1956, 57.

67. *Arts Magazine*, v. 31, 1957, 46.

68. This aspect of Surrealism derived from Dadaism, of which automatism was only a part: "the unexpected juxtaposition of elements alien to each other; the abrupt focus on banal elements of daily experience; automatism; and the exploitation of chance, soon to be thought of as a kind of poetic Mallarméan hazard." George Heard Hamilton, *Painting and Sculpture in Europe: 1880–1940* (New York and London, Yale University Press, 1993), 388.

69. Lautréamont, cited in Hamilton 1993, 389.

70. Griswold and Tonkavich 2002, 235.

71. Miró to Pierre Matisse, September 9, 1957, PMGA, B18, F57.

72. Pierre Matisse to Miró, October 3, 1957, PMGA, B18, F57.

73. Russell 1999, 130.

74. Fitzsimmons 1958, not paged.

75. Fitzsimmons 1958, not paged.

76. Fitzsimmons 1958, not paged

77. Fitzsimmons 1958, not paged.

78. F.P., "Reviews and Previews," *Art News*, v. 57 (December 1958), 12.

79. H.M., "Joan Miró," *Arts Magazine*, v. 33 (December 1958), 53.

80. James Thrall Soby, *Joan Miró*, exh.cat. (New York, The Museum of Modern Art 1959), 38. On the criticism of this exhibition see, Deborah A. Goldberg, "The 1959 Miró Retrospective at the MOMA," *Apollo* v. 139 (June 1994), 47–51.

81. Soby 1959, 66.

82. Soby 1959, 23.

83. Soby 1959, 88.

84. Soby 1959, 121.

85. Motherwell 1959, excerpted in Rose 1982, 122–123.

86. Hilton Kramer, "Month in Review," *Arts Magazine* v. 33 (May 1959), 49.

87. Wolf von Eckert, "The Delightful Wiggles of Miró," *American Institute of Architects Journal* (November 1959), v.32, 40.

88. Von Eckert 1959, 40.

89. John Canaday, "Miró 'Barks' Merrily at His Critics," *The New York Times Magazine* (March 15, 1959), 23–25.

90. Kramer 1959, 48.

91. Kramer 1959, 48.

92. Fitzsimmons 1959, not paged.

93. Soby 1959, 74.

94. Kramer 1959, 48.

95. Edouard Roditi, "Interview with Joan Miró," *Arts Magazine*, v. 33 (October 1958), 39–43.

96. Russell 1999, 125.

97. Roditi 1958, 43.

98. Motherwell 1959, 33.

99. Motherwell 1959, 33.

100. Cited in Jacques Dupin, *Miró* (Barcelona and New York, Ediciones Polígrafa, S. A. and Harry N. Abrams, Inc., Publishers), 1993, 361.

101. Dupin 1993, 361. The new edition added a chapter each on Miró's sculpture and on his ceramics and monumental works. The sculpture chapter stretched back to 1912, when Miró's art teacher in Barcelona, Francesc Galí, encouraged his students to work blindfolded and draw from touch. Then Dupin moved swiftly to a thoughtful investigation first of the collages and constructions of the late 1920s and 1930s, and then explored the sculpture from the mid-1940s to the end of Miró's career.

102. William S. Rubin, *Dada, Surrealism, and their Heritage*, exh.cat. (New York, The Museum of Modern Art), 1968.

103. J. K., "Reviews and Previews," *Art News*, v. 60 (December 1961), 10.

104. J. K. 1961, 10.

105. S. T., "Joan Miró," *Arts Magazine*, v. 36 (January 1962), 34.

106. S. T. 1962, 35.

107. Pierre Schneider, "Paris: Miró," *Art News*, v. 61 (October 1962), 48.

108. Edouard Roditi, "The Summer's Over," *Arts Magazine*, v. 38 (October 1963), 35.

109. C. G., "Miro, Fowl of Venus," *Arts Magazine*, v. 42 (December 1967), 59.

110. W. B., "Joan Miró," *Arts Magazine*, v. 40 (December 1965), 46.

111. See Jeffett in this volume, 24.

112. On several occasions, Miró badgered Matisse to keep his subscriptions to English-language art periodicals up-to-date, in part to know how the critics received his work, but also to know what artists in the United States were up to. See for example Miró to Pierre Matisse, October 25, 1959, PMGA, B19, F1; Miró to Pierre Matisse, March 12, 1968, PMGA, B19, F33.

113. Miró to Pierre Matisse, April 14, 1959, PMGA, B19, F1. He also wanted to visit collectors, and to strategize with Matisse, writing to him, "One must find a way to glide with the suppleness and elegance of a snake." Miró to Pierre Matisse, April 14, 1959, PMGA, B19, F1. Matisse later gave Miró a snake as a present. Miró to Patricia Matisse, February 11, 1967, PMGA, B19, F31. "Thank you for the beautiful snake, its colors and the movements it makes as it glides give me ideas".

114. "Mais j'ai peur que comme nous venons un peu en touristes, ce serait un peu loin du centre de la ville. Merci de tout coeur." Miró to Pierre Matisse, October 22, 1961, PMGA, B19, F21.

115. Miró to Pierre Matisse, February 11, 1962, PMGA, B19, F22. "Ce séjour en Amérique m'a fait un grand bien. Je suis maintenant en période de gestation. Je . . . prépare une série de grandes toiles . . . pas mal de petites histoires de mes illustres confrères."

116. John Gruen, "Miró Slips into 'Zestful' New York," New York Herald Tribune, Paris (November 27–28, 1965), 5.

117. Gruen 1965, 5.

118. Gruen 1965, 5.

119. Gruen 1965, 5.

120. PMGA B19, F26. He did, however, agree to a cocktail party in his honor that Matisse hosted. It included a number of notable guests. Among them were young and old American artists, one famous American writer (who happened to own The Farm), an eminent art historian, and a French artist-emigré: Ellsworth Kelly, Alexander Calder, Mrs. Robert Goldwater—better known today as Louise Bourgeois—Alexander Liberman, Barnett Newman, Saul Steinberg, David Tudor, Ernest Hemingway, and Jacques Lipchitz. PMGA, B19, F26.

121. PMGA B19, F26.

122. Miró to Pierre Matisse, [1966], PMGA, B19, F30. "pendant notre séjour à New York, qui m'a fait un grand bien, en renouvelant, et en vivifiant mon ardeur de travail, avec des idées fraîche . . . Je travaille très dur, et espère vous voir bientôt pour parler de tous nos projets."

123. In Miró: Oiseau Solaire Oiseau Lunaire Étincelles. The show was also supposed to include a dozen paintings, but they did not arrive on time. Matisse informed Miró that although there was not a lot of press, the show had created a sensation. The architect Gordon Bunshaft had bought Oiseau lunaire for his country house, and Marcel Breuer had an idea for a monumental sculpture. Pierre Matisse to Miró, December 13, 1967, PMGA, B19, F31.

124. "Working Notes, 1941–1942," Rowell 1992, 192.

125. David Sylvester, "Fowl of Venus," in Miró: Oiseau Solaire, Oiseau Lunaire, Étincelles, exh.cat., (New York, Pierre Matisse Gallery, 1967), 5–6, 8–9.

126. Ninette Lyon, "Pilar and Joan Miró: A Second Fame: Good Food," Vogue (March 1, 1966), 188–190, the clipping in the PMGA was not marked with volume number.

127. Rubin 1968.

128. Lyon 1966, 189.

129. Lyon 1966, 189.

130. These were for Cod Esquexada, Cod à la Vizcaina, Crème Brulée, and one of my favorite Catalan dishes, Spinach à la Majorquaise, spinach with garlic, pine nuts, and raisins. Lyon 1966, 190.

131. Hilton Kramer, "The Secret History of Dada and Surrealism," Art in America, v. 56 (March–April 1968), 108.

132. John Ashbery, "Growing Up Surreal," Art News, vol. 67 (May 1968), 41.

133. Rubin 1968, 12. Kramer rightly predicted that the book would change thinking on Dada and Surrealism, suggesting it might clarify the present. These were the late 1960s, chaotic and confusing in art as in everything else. Kramer 1968, 108.

134. Rubin 1968, 143.

135. Rubin 1968, 146.

136. Leo Steinberg, "Other Criteria," based on a lecture given at the Museum of Modern Art, New York, March 1968, published in part in Artforum (March 1972), in Leo Steinberg, Other Criteria: Confrontations with Modern Art (New York, Oxford University Press, 1972), 55–91.

137. This group may have included the first painted bronzes shown in America. The titles, dates, dimensions, foundry, and number in the edition listed for catalogue numbers 43, 44, 45, 46, and 47 correspond precisely to five of the painted sculptures in Alain Jouffroy and Joan Teixidor, Miró Sculpture (New York and Paris, Leon Amiel Publisher and Maeght Éditeur, 1973) numbered 87, 90, 85, 89, and 88. But Matisse did not list the sculptures he exhibited as painted, and generally he was meticulous. The installation photograph published in Griswold and Tonkavich 2002, 271, does not show any painted sculpture, though another in the PMGA shows a sculpture that may be painted. None of the critics mentioned that any of the works were painted. It seems likely, then, that they were not shown in the United States until the next year at the Walker Art Center. See below and Jeffett in this volume, 33.

138. John Russell, Miró: Sculpture in Bronze and Ceramic 1967–1969, exh.cat. (New York, Pierre Matisse Gallery, 1970), not paged.

139. John Canaday, "Art: Two Great Shows on 64th Street," New York Times (May 9, 1970), clipping in Vertical Files of the National Gallery of Art not marked with page number.

140. Emily Genauer, "Art and the Artist," New York Post Magazine (May 16, 1979), 36.

141. Hilton Kramer, "Enchanted Objects," New York Times (May 24, 1970), D25.

142. N. H. F., "Miró at Pierre Matisse," Arts Magazine, v. 44 (May 1970), 25.

143. John Ashbery, ""Miró's Bronze Age," Art News, v. 69 (May 1970), 36.

144. Michael Brenson, "Report from Paris: Two in Review: La Ruche, Miró Sculpture," Art in America, v. 67 (March 1979), 45.

145. See note 137 above.

146. Martin Friedman to Pierre Matisse, April 8, 1970, PMGA, B20, F10.

147. Martin Friedman to Pierre Matisse, April 7, 1969, PMGA, B20, F10, Dean Swanson to Devera Ehrenberg, August 18, 1971, PMGA, B20, F10.

148. Jacques Dupin, "Miró as Sculptor," Miró's Sculptures, exh.cat., Minneapolis, Walker Art Center, 1971), 1971, not paged.

149. Dupin 1971, not paged.

150. "The Artist's Comments," Miró's Sculptures 1971, not paged.

151. "The Artist's Comments" 1971, not paged.

152. Mike Steele, "Speaking of Art," Minneapolis Tribune (October 10, 1971), 6D.

153. Peter Altman, "Miró's Sculptures Show Unslowed Creativity of 78-year-old Artist," Minneapolis Star, October 4, 1971, 6B.

154. Benjamin Forgey, "A Painter Produces Characteristically Magical Sculpture," Washington Star (July 16, 1972), clipping in Vertical Files at National Gallery of Art Library Vertical Files not marked with page number.

155. Margit Rowell, "Miró, Apollinaire and 'L'Enchanteur pourrissant'," Art News, vol. 71 (October 1972), 64–67.

156. See for example Kermit Champa, "Miró," Artforum, v. 11 (February 1973), 57–61.

157. See Harold Rosenberg, "Miró's Fertile Fields," Art International, v. 17 (Summer 1973), 16, written in response to Rosalind Krauss' interpretation of Miró's "field" paintings of the 1920s and 1960s in Joan Miró: Magnetic Fields,

exh.cat., The Solomon R. Guggenheim Museum (New York, 1972).

158. Hilton Kramer, "Art: The Poetic Vision of Miró," *New York Times* (May 12, 1973), clipping in Vertical Files at National Gallery of Art Library Vertical Files not marked with page number.

159. James R. Mellow, "Joan Miró and the Comic Possibilities of the Absurd," *New York Times* (May 20 1973), clipping in Vertical Files at National Gallery of Art Library Vertical Files not marked with page number.

160. Mellow 1973.

161. Miró in Rose 1982, 120.

162. Schjeldahl, "Toward a New Miró," in *Miró Sculpture*, exh.cat. (New York, The Pace Gallery, 1984), not paged.

163. James M. Markham, "Miró at 85: A Diminutive Giant Who is Still Hard at Work," *New York Times* (April 15, 1978), clipping in Vertical Files at National Gallery of Art Library not marked with page number.

164. John Elderfield, "Joan Miró at the Grand Palais," *Art in America*, v. 62 (November 1974), 127. Kenworth Moffett expressed a similar view in "Miró at the Grand Palais," *Arts Magazine*, v. 49 (October 1974), 42–45.

165. "Miró," *Arts Magazine*, v. 50 (June 1976), 20.

166. Cited in Margit Rowell, "Introduction," *The Last Bronze Sculptures*, exh.cat. (Pierre Matisse Gallery 1987), not paged, also in Rowell 1992, 191.

167. Rose 1982 and Kramer 1959, 49.

168. Sidra Stitch, *Joan Miró: The Development of a Sign Language*, exh.cat. (St. Louis, Missouri, Washington University Gallery of Art, 1980).

169. Lanchner 1993.

170. "Young at Art: Miró at 100," *Artforum*, v. 32 (January 1994), 72–81.

171. Schjeldahl 1984, not paged.

172. Schjeldahl 1984, not paged.

173. The Miró retrospective at the Museum of Modern Art in 1993 emphasized Miró's work before 1955. The show included a few pieces of sculpture, but none of the painted bronzes. Carolyn Lanchner's informative essay for the exhibition catalogue, "*Peinture-Poésie*, Its Logic and Logistics," deals primarily with Miró's working methods from 1923 to 1945.

174. We have yet to locate a single painted bronze in an art museum in the United States.

Catalogue of Painted Bronze and Painted Resin Sculpture with Related Works

Note to the Catalogue

In the catalogue of Miró's painted sculpture and related works that follows, dimensions are presented so that height precedes width precedes depth.

The JT no. listed with the sculpture refers to its number in Alain Jouffroy and Joan Teixidor, *Miró Sculptures* (Paris, Maeght Éditeur, 1980). The inventory numbers of works housed at the Fundació Joan Miró, Barcelona, are preceded by the letters FJM; those at the Fundació Pilar i Joan Miró a Mallorca, are preceded by FPIJM.

An exhibition checklist of the works presented in *The Shape of Color: Joan Miró's Painted Sculpture* at the Corcoran Gallery of Art in Washington, D.C., is provided on pages 164–170.

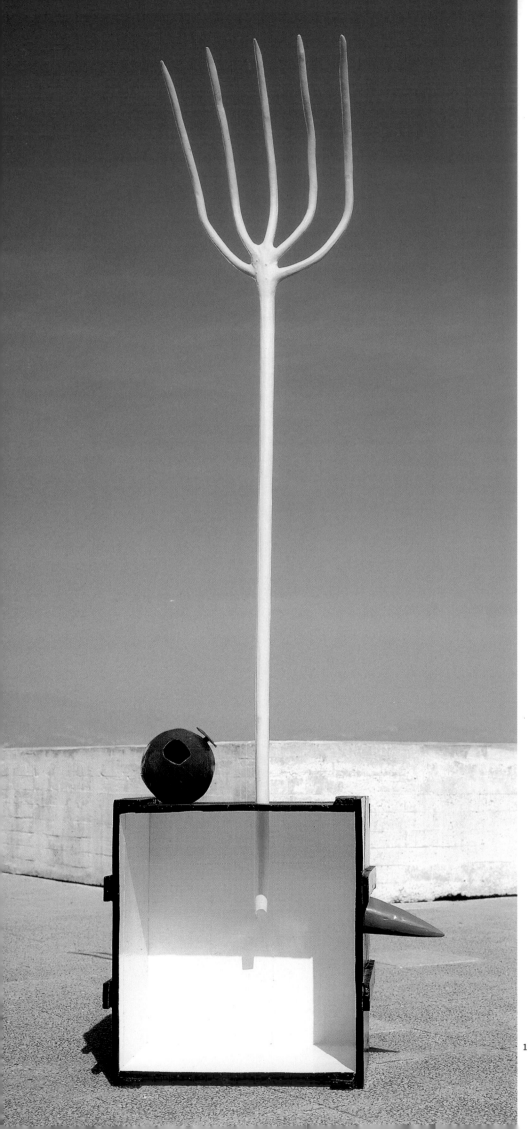

1 Femme et oiseau, 1967
Painted bronze
260 × 85 × 48 cm
102⅜ × 33½ × 18⅞ in
JT no. 57
Foundry: Suisse-Fondeur,
Arcueil
Four numbered examples

GROUP 1

Femme et oiseau
Woman and Bird

1

1.1

1.1 Untitled sketchbook drawing

Ballpoint pen and wax color on paper (sketchbook Q I)

34.7 × 24.5 cm

13⅝ × 9⅝ in

Inscriptions: *X*

Collection of the Fundació Pilar i Joan Miró a Mallorca

FPIJM DP-0779; Q I: p. I

1.2 Femme assise, May 11, 1961

Ballpoint pen and graphite on paper

12.5 × 7.9 cm

4⅞ × 3⅛ in

Inscriptions: *Femme / assise / Cadira blava / Forca vermella / X 11/5/61*

Collection of the Fundació Pilar i Joan Miró a Mallorca

FPIJM DP-0617

1.2

1.3 Personnage, Femme assise, Personnage, February 13, 1962

Pencil on paper (calendar back)

29 × 42.5 cm

11⅜ × 16¾ in

Inscriptions: *Personnage / Femme assise / Personnage / X / 13/2/62 I*

Collection of the Fundació Pilar i Joan Miró a Mallorca

FPIJM DP-0623

1.3

1.4 Untitled sketchbook drawing

Graphite on paper
(sketchbook Q 1)
24.5 × 34.9 cm
9⅝ × 13¾ in
Inscriptions: *veure l'altre /
Femme / Taula / robada* [?]
*/ Femme / auleta petita /
Femme / assise / guarda /
2 fragments / pedra / tronc
/ palmera / X / cap bronze
nas pintat vermell / silló
natural* [pintat] *blau*
Collection of the Fundació
Pilar i Joan Miró a Mallorca
FPIJM DP-0798; Q 1 : p. 11

1.4

1.5 Femme assise, November 24, 1963

Ballpoint pen on paper
12.4 × 8.0 cm
4⅞ × 3⅛ in
Inscriptions: *femme / assise / attra- / ~~pant~~ / ~~un~~ / ~~oiseau~~ / plume en / un costat / 24/XI/63*
Collection of the Fundació Pilar i Joan Miró
a Mallorca
FPIJM DP-0629

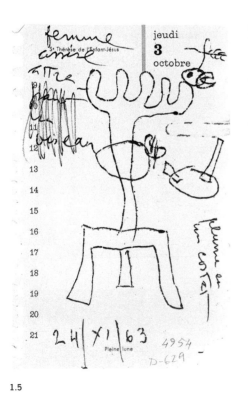

1.5

1.6 Untitled drawing, September 23, 1964

Ballpoint pen on paper
12.5 × 8.1 cm
4⅞ × 3¼ in
Inscriptions: *23/9/64*
Collection of the Fundació Pilar i Joan Miró
a Mallorca
FPIJM DP-0583

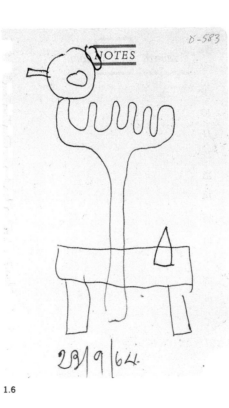

1.6

1.7 Femme assise et oiseau, September 11, 1964

Ballpoint pen on paper
12.6 × 8.1 cm
5 × 3¼ in
Inscriptions: *Femme assise et oiseau / 11/9/64*
Collection of the Fundació Pilar i Joan Miró
a Mallorca
FPIJM DP-0584

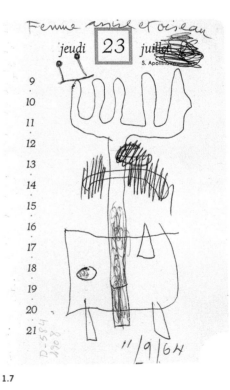

1.7

1.8 Untitled drawing,
October 29, 1964
Ballpoint pen on paper
15.6 × 11.3 cm
6⅛ × 4½ in
Inscriptions: *29/10/64*
Collection of the Fundació
Pilar i Joan Miró a Mallorca
FPIJM DP-0582

1.9 Femme assise,
November 17, 1964
Ballpoint pen on paper
19.8 × 15.1 cm
7¾ × 5⅞ in
Inscriptions: *Femme assise /
17/XI/64*
Collection of the Fundació
Pilar i Joan Miró a Mallorca
FPIJM DP-0581

1.10 Untitled drawing,
January 10, 1965
Ballpoint pen on paper
19.6 × 14.9 cm
7¾ × 5⅞ in
Inscriptions: *10/1/65*
Collection of the Fundació
Pilar i Joan Miró a Mallorca
FPIJM DP-0580

1.11 Femme et oiseau
Ballpoint pen on paper (sketchbook
"Escultures 1" FJM 3534-3663)
19 × 15 cm
7½ × 5⅞ in
Inscriptions: *Femme et oiseau*
Collection of the Fundació Joan
Miró, Barcelona
FJM 3628 (attached to FJM 3626-b)

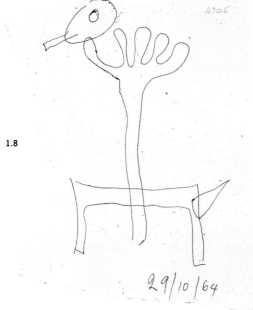

1.8

1.9

1.10

1.11

1.12 Untitled drawing
Ballpoint pen, colored pencil,
and graphite pencil on paper
(calendar back)
33.2 × 48.9 cm
13 × 19¼ in
Inscriptions: *groc / falta fer / ? /
verd // verd / verd / groc // groc /
verd / portar carota / guix*
Collection of the Fundació Joan
Miró, Barcelona
FJM 4051–4052

**1.13 Photograph by
Casa Planas, retouched
by Joan Miró**
24.× 17.6 cm
9½ × 6⅞ in
Collection of the Fundació
Joan Miró, Barcelona
FJM 4053

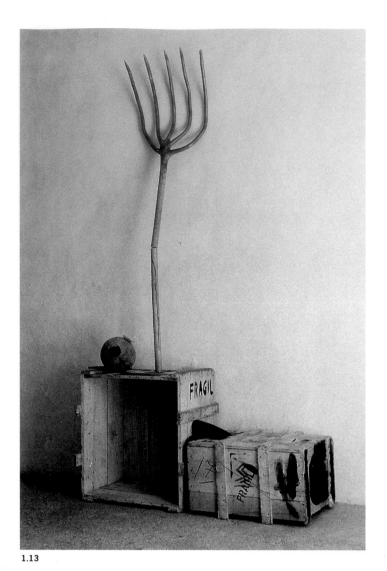

1.13

1.12

GROUP 2

Femme et oiseau
Woman and Bird

2 Femme et oiseau (also known as Tête et oiseau), **1967**
Painted bronze
200 × 115 × 72 cm
78¾ × 45¼ × 28⅜ in
JT no. 85
Foundry: T. Clémenti, Meudon
Four numbered examples

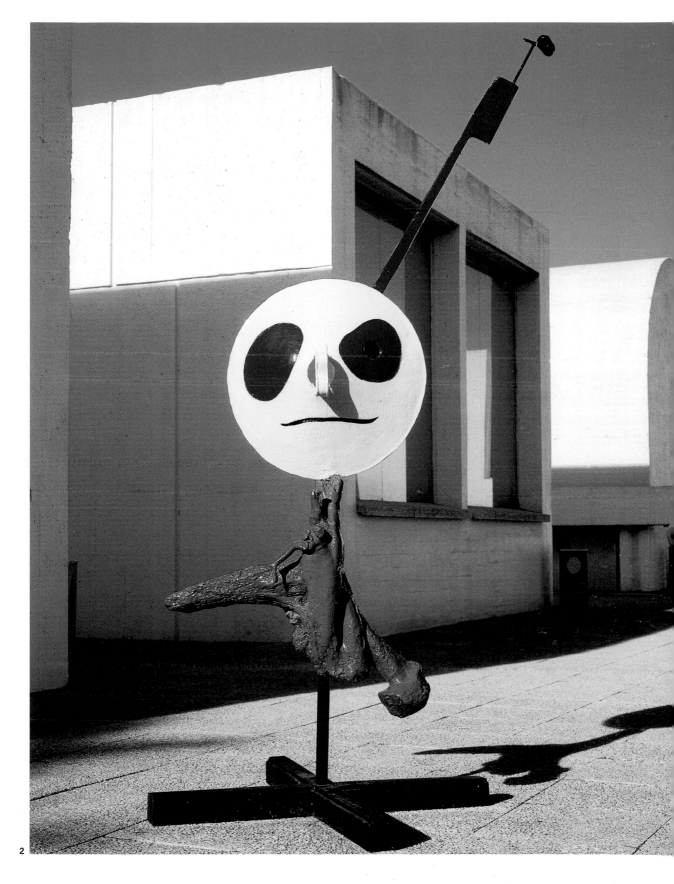

2

2.1 Untitled sketchbook drawing, October 7, 1959
Ballpoint pen and ink on cardboard (sketchbook Q I)
34.7 × 24.5 cm
13⅝ × 9⅝ in
Inscriptions: *3 m. 0'50 sense l'ocell / X / 0'33 / 7/10/59*
Collection of the Fundació Pilar i Joan Miró a Mallorca
FPIJM DP-0791; Q I: p. 7

2.2 Untitled sketchbook drawing, October 7, 1959
Ballpoint pen on paper (sketchbook Q I)
24.5 cm × 34 cm
9¾ × 13½ in
Inscriptions: *X / X / 7/10/59*
Collection of the Fundació Pilar i Joan Miró a Mallorca
FPIJM D-0795; Q I: p. 9

2.3 Femme and Femme et oiseau, December 5, 1963
Graphite and ballpoint pen on paper (sketchbook Q III)
24.3 × 34.3 cm
9½ × 13½ in
Inscriptions: *femme / V / Mateix tamany / Femme et oiseau / Femme / 5/12/63*
Collection of the Fundació Pilar i Joan Miró a Mallorca
FPIJM DP-0840; Q III: p. 12

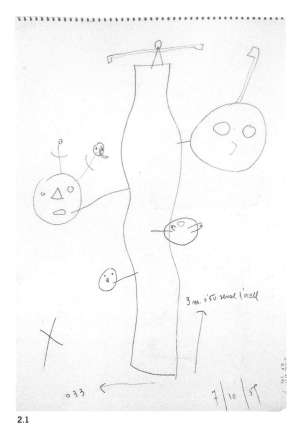

2.1

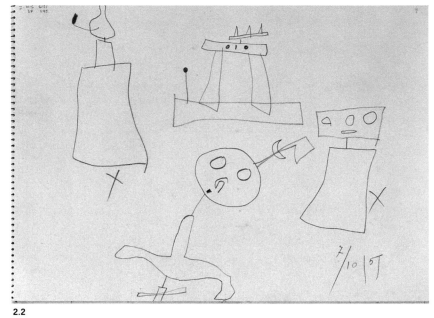

2.2

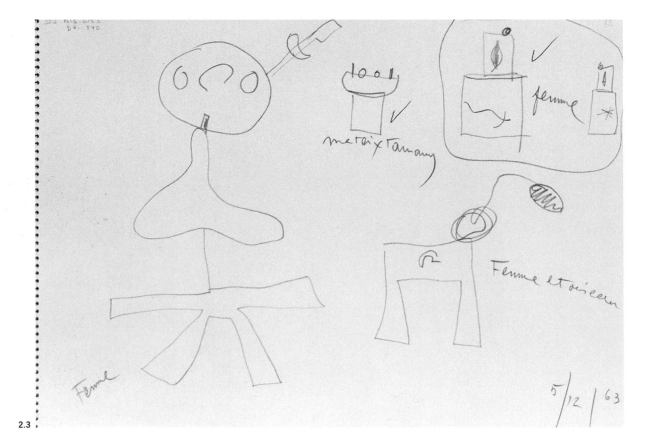

2.3

2.4 **Femme et oiseau, Personnage, Sa majesté,**
Femme et oiseau, Personnage
Ballpoint pen, graphite pencil, and colored pencil
on paper (calendar back)
48.8 × 33.2 cm
19¼ × 13 in
Inscriptions: *Femme et oiseau / ~~unreadable~~ IV/67 / verso*
// verso / Personnage // entregades XII/66 / Sa Majesté
IV/67 // Femme et oiseau / ? / Barret / ? / verso /
Collection of the Fundació Joan Miró, Barcelona
FJM 4005-4006

2.5 **Femme et oiseau**
Ballpoint pen on paper (sketchbook
"Escultures 1" FJM 3534-3663)
21.3 × 31 cm
8⅜ × 12¼ in
Inscriptions: *Femme et oiseau / 41*
Collection of the Fundació Joan
Miró, Barcelona
FJM 3547-a

2.4

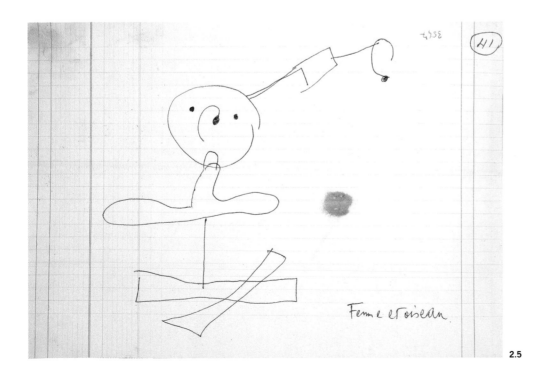

2.5

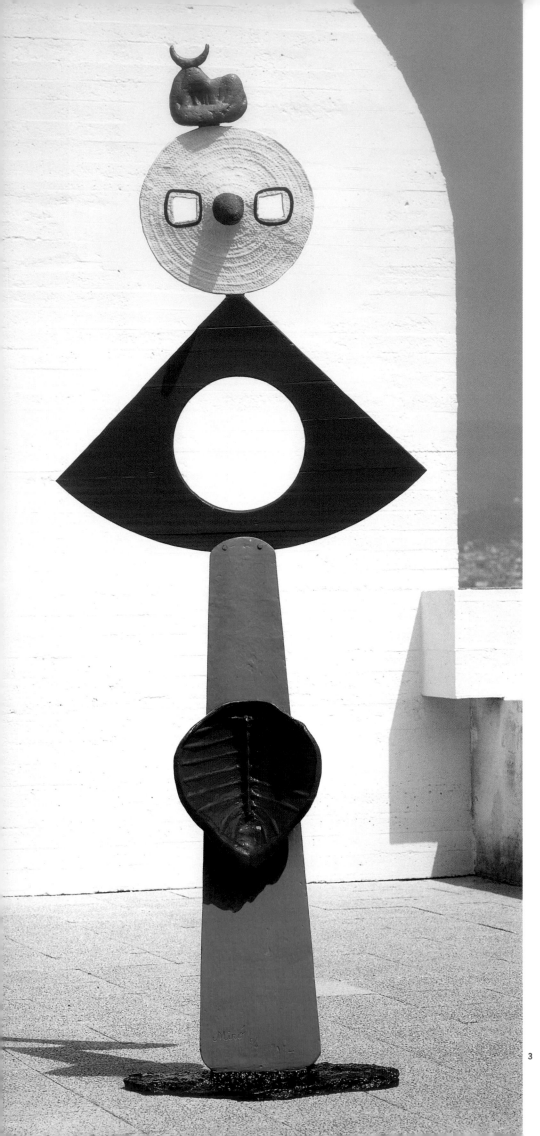

3 La caresse d'un oiseau,
1967
Painted bronze
315 × 112 × 42 cm
124 × 44 × 16½ in
JT no. 86
Foundry: Suisse-Fondeur,
Arcueil
Four numbered examples

3

GROUP

La caresse
d'un oiseau
Caress of a Bird

3

3.1 Fourche
Ballpoint pen on paper
12.4 × 8 cm
4⅞ × 3⅛ in
Inscriptions: *Fourche / 4'55*
Collection of the Fundació
Pilar i Joan Miró a Mallorca
FPIJM DP-0616

3.3 Untitled drawing, October 18, 1963
Ballpoint pen and pencil on paper
21.4 × 15.5 cm
8⅜ × 6⅛ in
Inscriptions: *pintat de / blanc / (amb ferro)
/ caretes penjant / amb cadeneta i / decorades
amb / colors violents / 18/10/63*
Collection of the Fundació Pilar i Joan Miró
a Mallorca
FPIJM DP-0633

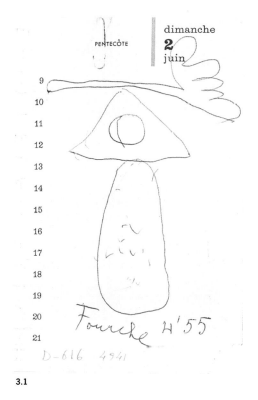

3.1

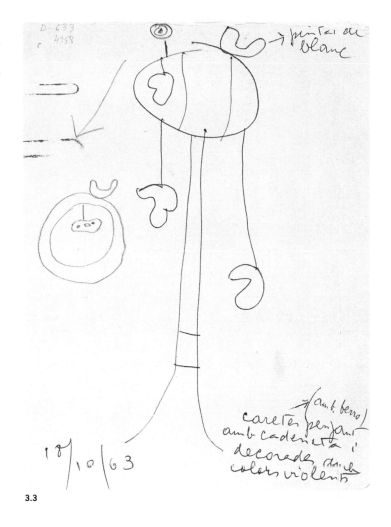

3.3

**3.2 Untitled sketchbook
drawing, 1958–1959**
Ballpoint pen on paper
(sketchbook Q I)
24.5 × 34.7 cm
9⅝ × 13⅜ in
Inscriptions: *forca que / giri
amb el vent.*
Collection of the Fundació
Pilar i Joan Miró a Mallorca
FPIJM DP-0801; Q I: p. 12 rev.

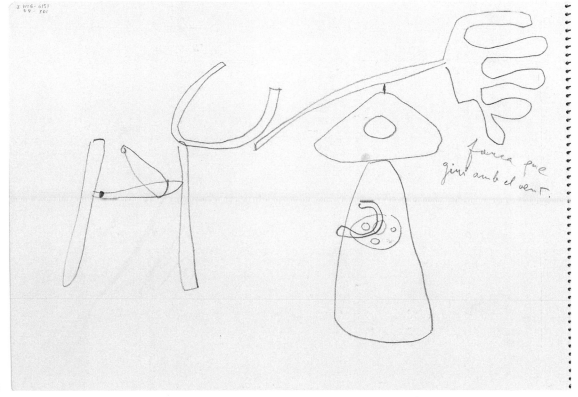

3.2

3.4 Femme et oiseau,
November 1, 1963
Ink on paper
14.9 × 10 cm
5⅞ × 3⅞ in
Inscriptions: *Femme / et oiseau / 1/XI/63*
Collection of the Fundació Pilar i Joan Miró a Mallorca
FPIJM DP-0627

3.5 Femme et oiseau,
November 27, 1963
Ballpoint pen on paper
18.2 × 9.7 cm
7⅛ × 3⅞ in
Inscriptions: *Femme et oiseau / Cadena / Cadeneta / 27/XI/63*
Collection of the Fundació Pilar i Joan Miró a Mallorca
FPIJM DP-0628

3.6 Untitled drawing,
March 10, 1964
Ballpoint pen on paper
15.5 × 12.3 cm
6⅛ × 4⅞ in
Inscriptions: *10/3/64*
Collection of the Fundació Pilar i Joan Miró a Mallorca
FPIJM DP-0634

3.7 Femme et oiseau, Personnage royal,
Femme, December 5, 1963
Graphite on paper (sketchbook Q III)
24.3 × 34.3 cm
9½ × 13½ in
Inscriptions: *Femme et oiseau / Femme / bronze / objecte / personnage royal / personnage royal / Femme et oiseau / (que giri) / 5/12/63*
Collection of the Fundació Pilar i Joan Miró a Mallorca
FPIJM DP-0835.2; Q III: p. 7

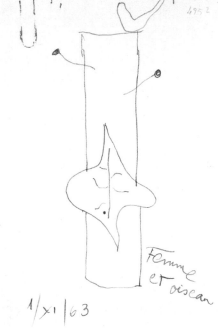

3.4

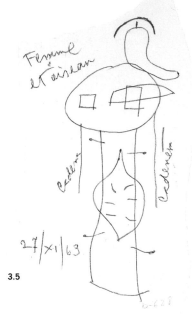

3.5

3.6

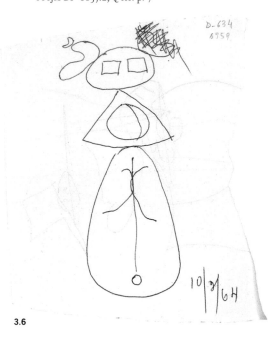

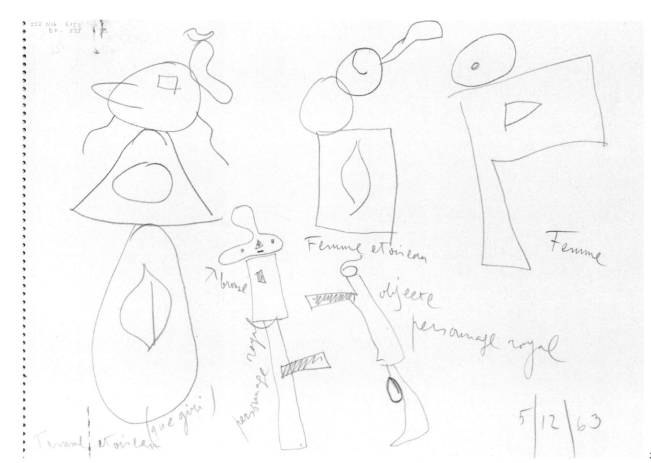

3.7

3.8 Untitled drawing,
August 7, 1964

Ballpoint pen on paper
9 × 6 cm
3½ × 2⅜ in
Inscriptions: *7/8/64*
Collection of the Fundació
Pilar i Joan Miró a Mallorca
FPIJM DP-0577

3.9 Untitled drawing,
September 11, 1964

Ballpoint pen on paper
12.6 × 8.1 cm
5 × 3¼ in
Inscriptions: *11/9/64*
Collection of the Fundació
Pilar i Joan Miró a Mallorca
FPIJM DP-0578

3.10 La caresse d'un oiseau, May 25, 1965

Ballpoint pen on paper (sketchbook "Escultures
1" FJM 3534-3663)
19 × 15 cm
7½ × 5⅞ in
Inscriptions: *La caresse / d'un oiseau / ~~Femme et
oiseau~~ / 25/V/65*
Collection of the Fundació Joan Miró,
Barcelona

FJM 3623 (attached to FJM 3621-b)

3.11 Untitled drawing,
July 24, 1964

Ballpoint pen and graphite
on paper
20 × 15.1 cm
7⅞ × 5⅞ in
Inscriptions: *24/VII/64*
Collection of the Fundació
Pilar i Joan Miró a Mallorca
FPIJM DP-0579a

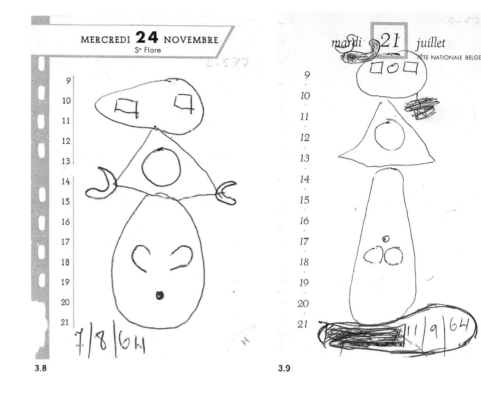

3.8

3.9

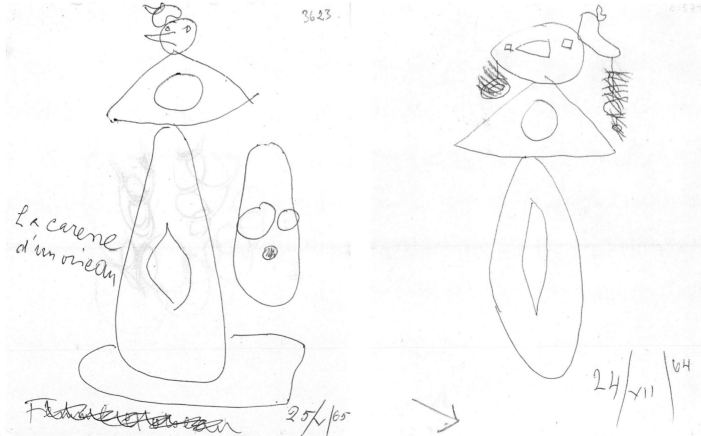

3.10

3.11

3.12 Untitled drawing
Ballpoint pen and colored pencil on paper
(calendar back)
42.5 × 31.8 cm
16¾ × 12½ in
Inscriptions: ~~Personnage / attrapant / un oiseau~~
/ l'oiseau se pose / sur la / niche de / ~~la lune de~~
/ ~~sur ses~~ / doigts // arxivar; back: ~~mirar~~
Collection of the Fundació Joan Miró,
Barcelona
FJM 3989

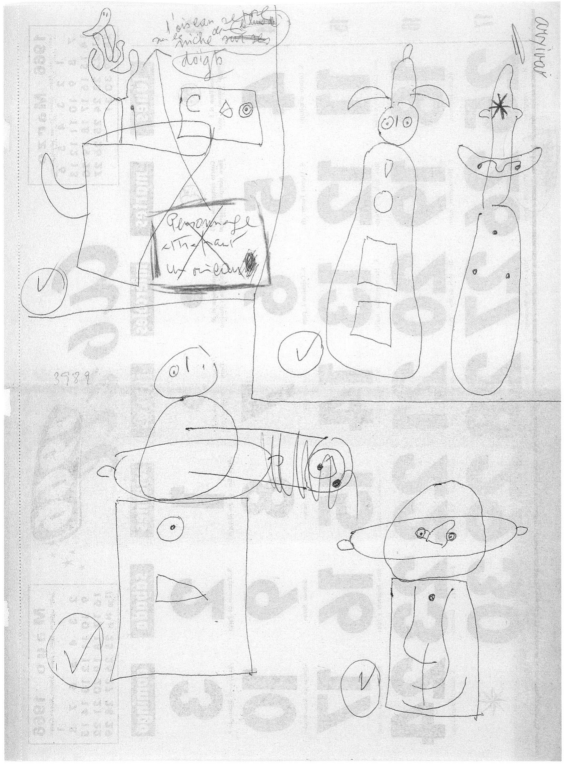

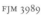

3.12

3.13 Untitled drawing
See 1.12 on page 94

3.14 Palma de Mallorca,
photograph by Casa
Planas, retouched by
Joan Miró (detail)
24 × 17.6 cm
9½ × 6⅞ in
Collection of the Fundació
Joan Miró, Barcelona
FJM 4055

3.15 Photograph by
Casa Planas, retouched
by Joan Miró (detail)
24 × 17.6 cm
9½ × 6⅞ in
Collection of the Fundació
Joan Miró, Barcelona
FJM 4054

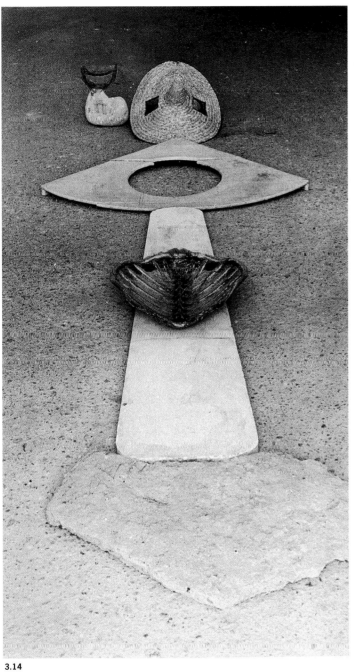

3.14

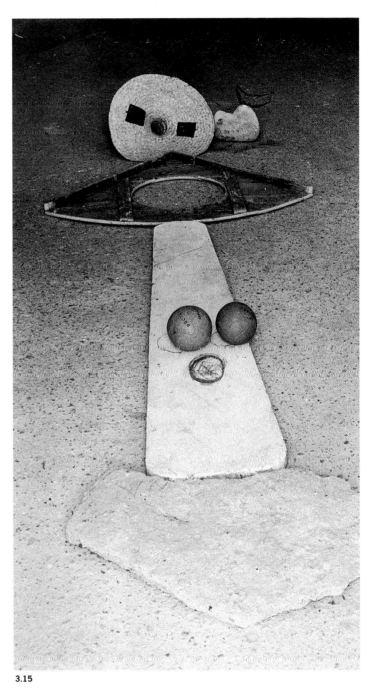

3.15

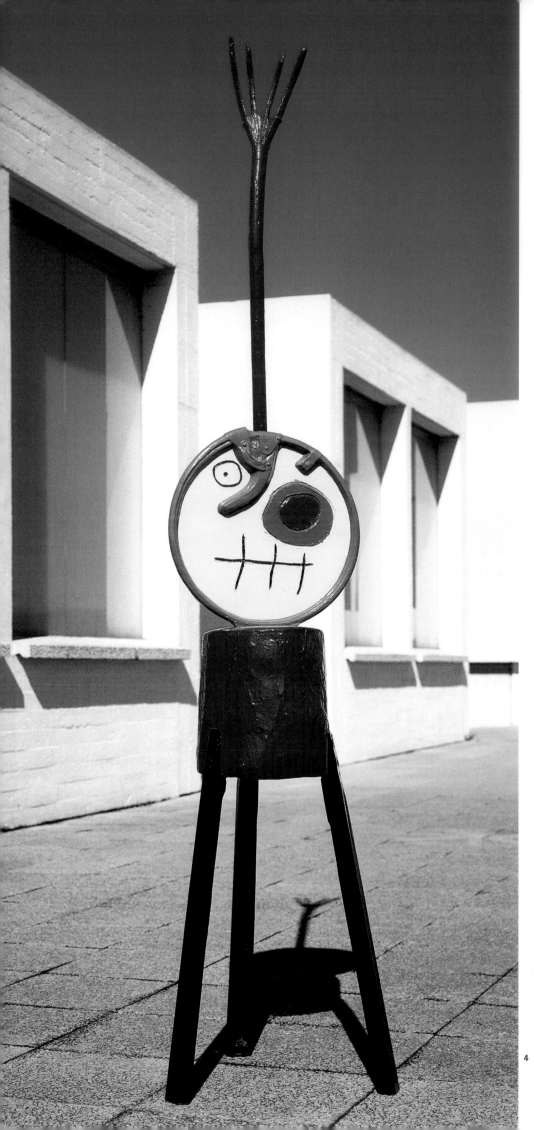

4 Personnage, 1967
Painted bronze
217 × 47 × 39 cm
85⅜ × 18½ × 15⅜ in
JT no. 87
Foundry: T. Clémenti,
Meudon
Four numbered examples

GROUP 4

Personnage
Figure

4

4.1 Personnage (detail)
Ballpoint pen on paper (sketchbook
"Escultures I" FJM 3534-3663)
21.2 × 31.3 cm
8⅜ × 12⅜ in
Inscriptions: *Personnage / 38*
Collection of the Fundació Joan
Miró, Barcelona
FJM 3537-a

**4.2 Photograph by
Claude Gaspari**
24 × 13 cm
9½ × 5⅛ in
Collection of the Fundació
Joan Miró, Barcelona
FJM 4047

4.1

4.3 Femme et oiseau,
Personnage, Sa
majesté, Femme et
oiseau, Personnage
See 2.4 on page 97

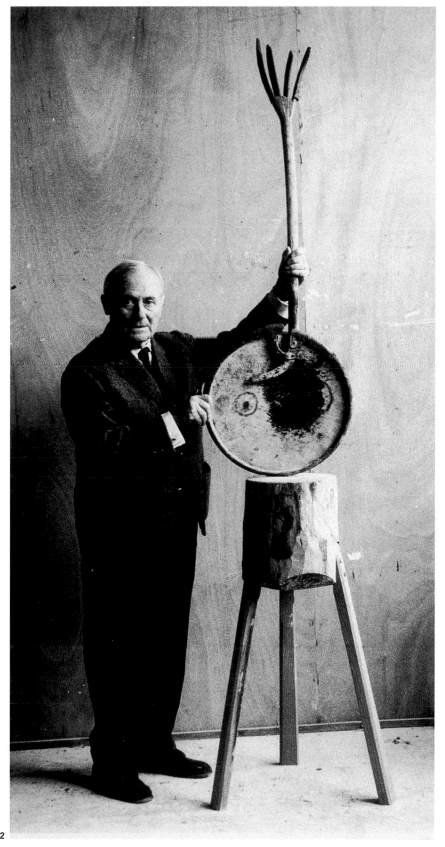

4.2

GROUP 5

Femme assise et enfant
Seated Woman and Child

5 Femme assise et
enfant, 1967
Painted bronze
123 × 39 × 40 cm
48⅜ × 15⅜ × 15¾ in
JT no. 88
Foundry: T. Clémenti,
Meudon
Four numbered examples

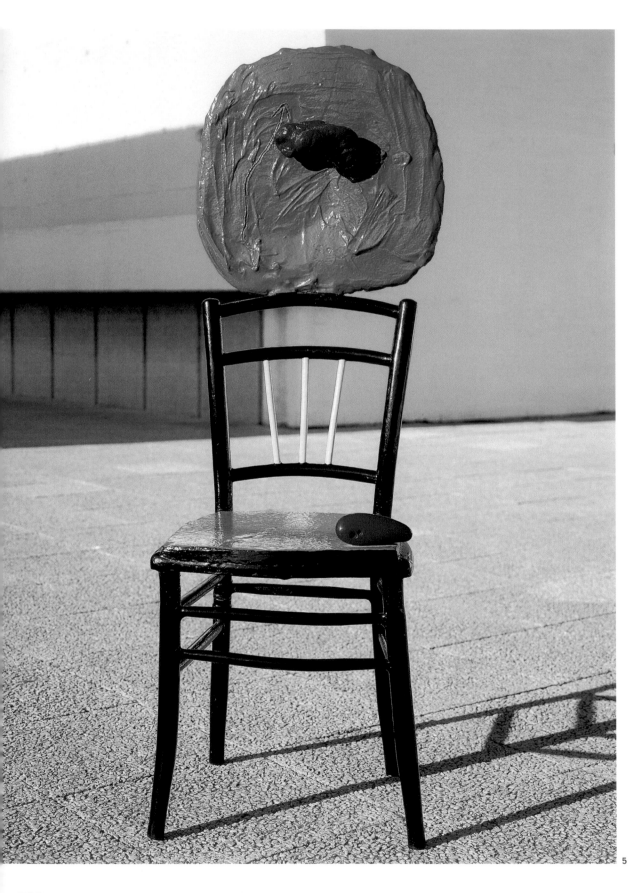

5

5.1 Femme, Femme assise et enfant,
April 25, 1967 (detail)
Pen on paper (sketchbook "Escultures I" 3534-3663)
19 × 15 cm
7½ × 5⅞ in
Inscriptions: *Femme / ~~mere~~ / ~~Femme~~ assise / et
enfant / 25/IV/67 / verso / recto / (?)*
Collection of the Fundació Joan Miró, Barcelona
FJM 3660 (attached to FJM 3659)

5.2 Photograph by
Claude Gaspari,
retouched by Joan Miró
24 × 18.3 cm
9½ × 7¼ in
Collection of the Fundació
Joan Miró, Barcelona
FJM 4038

5.1

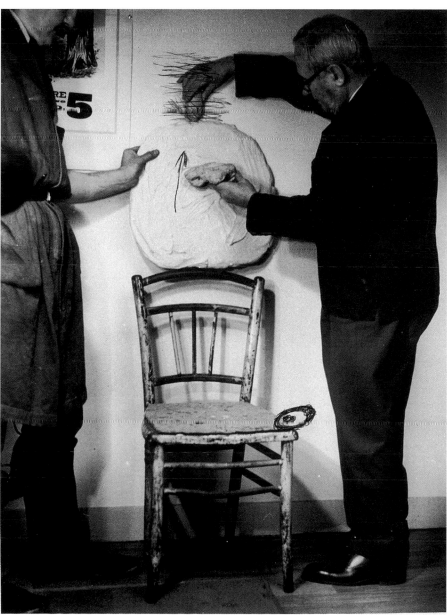

5.2

GROUP 6

Femme et oiseau
Woman and Bird

6 Femme et oiseau, 1967
Painted bronze
135 × 50 × 42 cm
53⅛ × 19⅝ × 16½ in
JT no. 89
Foundry: T. Clémenti,
Meudon
Four numbered examples

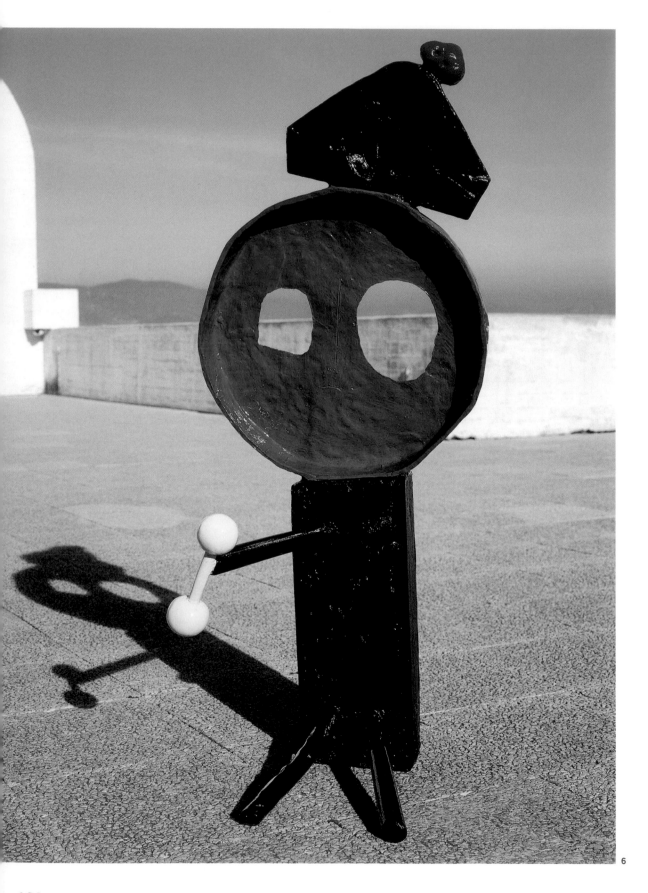

6

6.1 Untitled drawing, September 27, 1960
Ink, graphite, and wax color on paper
16.1 × 24.8 cm
6⅜ × 9¾ in
Inscriptions: *bronze / blau / Bronze / ? / taula / robada* [?] */ 27/9/60*
Collection of the Fundació Pilar i Joan Miró a Mallorca
FPIJM DP-0630

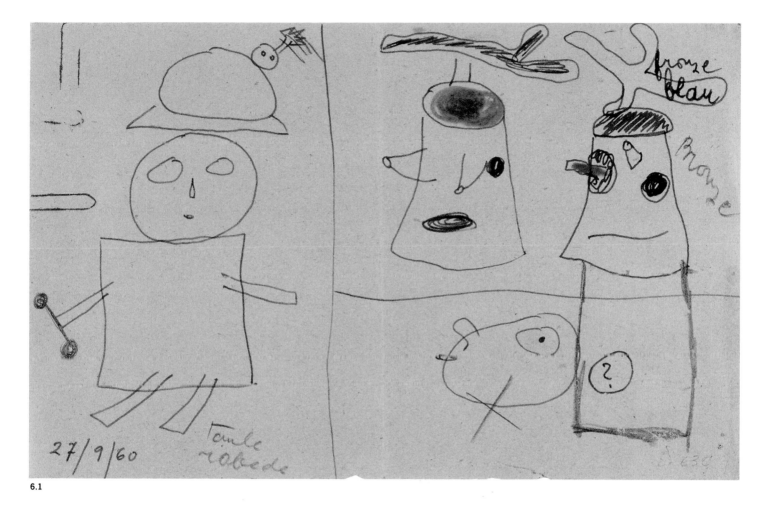

6.1

6.2 Untitled
sketchbook drawing
See 1.4 on page 92

6.3 Femme et oiseau,
Personnage, Sa
majesté, Femme et
oiseau, Personnage
See 2.4 on page 97

6.4 Untitled drawing,
October 2, 1960
Ink on paper
21.2 × 13.8 cm
8⅜ × 5⅜ in
Inscriptions: *2/10/60*
Collection of the Fundació
Pilar i Joan Miró a Mallorca
FPIJM DP-0632

6.5 Untitled drawing
Ballpoint pen on paper
9.8 × 17.3 cm
3⅞ × 6¾ in
Inscriptions: *per caixa*
ensaimades / posar un pes en
lloc / d'una cullera
Collection of the Fundació
Pilar i Joan Miró a Mallorca
FPIJM DP-0631

6.6 Femme et oiseau
Ballpoint pen on paper (sketchbook
"Escultures I," FJM 3534-3663)
21.3 × 31 cm
8⅜ × 12¼ in
Inscriptions: *Femme et oiseau / 42*
Collection of the Fundació Joan
Miró, Barcelona
FJM 3550

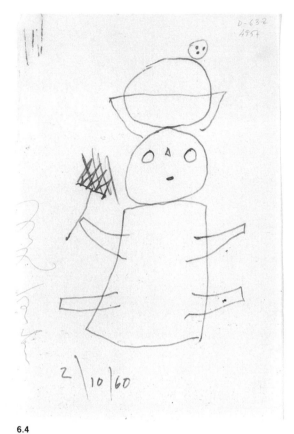

6.4

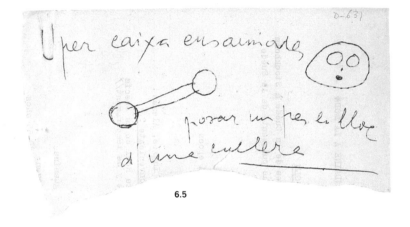

6.5

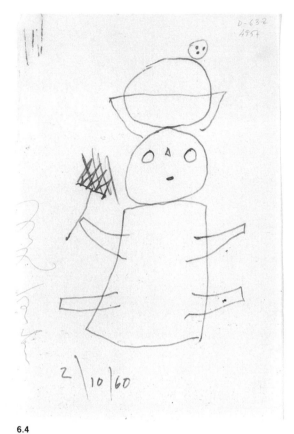

6.6

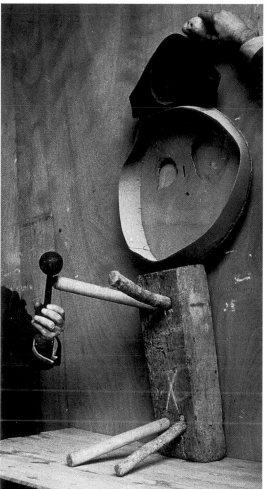

6.7

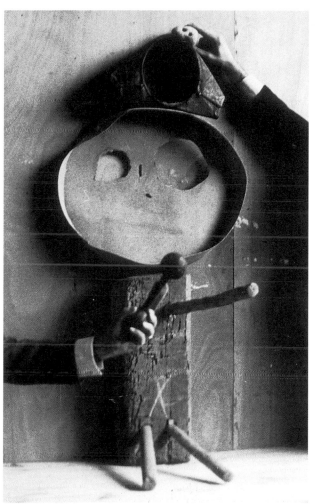

6.9

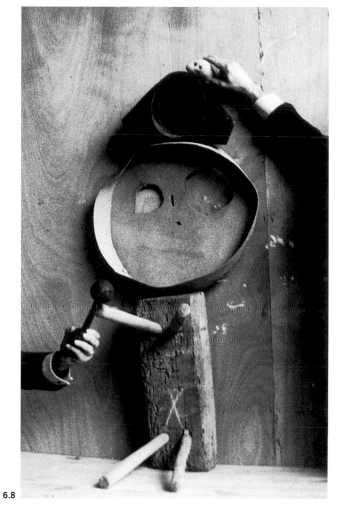

6.8

6.7 Photograph by
Claude Gaspari
24 × 13.4 cm
9½ × 5¼ in
Collection of the Fundació
Joan Miró, Barcelona
FJM 4043

6.8 Photograph by
Claude Gaspari
24 × 15.3 cm
9½ × 6 in
Collection of the Fundació
Joan Miró, Barcelona
FJM 4044

6.9 Photograph by
Claude Gaspari
24 × 15.3 cm
9½ × 6 in
Collection of the Fundació
Joan Miró, Barcelona
FJM 4042

GROUP

Sa majesté
Your Majesty

**7 Sa majesté,
1967–1968**
Painted bronze
120 × 30 × 30 cm
47¼ × 11¾ × 11¾ in
JT no. 90
Foundry: T. Clémenti,
Meudon
Four numbered examples

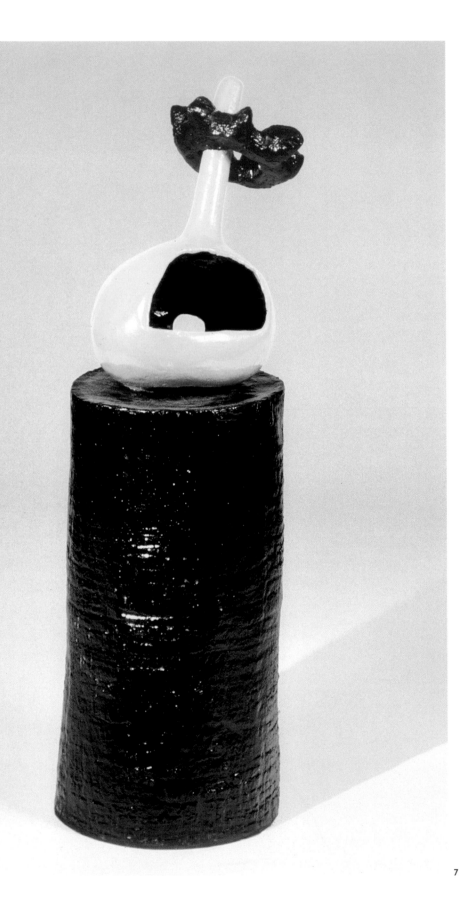

7

7.1 Sa majesté
Graphite, colored wax pencil, and ballpoint pen on paper (sketchbook Q I)
24.5 × 34.9 cm
9⅝ × 13¾ in
Inscriptions: *augmentar* / *V* / *augmentar* / *augmentar* / *augmentar* / *II* /
ciment amb mosaic, / *vidres I matèries, com* / *Gaudí* / *elements mòbils,* / *no*
fixos / *bronze I* / *ciment amb* / *matèries, etc* / *II* / *Sa majesté* / *Le Roi* /
carbassa / *amb bronze* / *cap* / *amb* / *bronze* / *V* / *Sa majesté* / *La Reine—*
Bronze / *tronc* / *palmera* / *X*
Collection of the Fundació Pilar i Joan Miró a Mallorca
FPIJM DP-0797; Q I: p. 10 rev.

7.2 Personnage royal, Femme et oiseau,
Personnage, December 5, 1963
Graphite on paper (sketchbook Q III)
24.3 × 34.3 cm
9½ × 13½ in
Inscriptions: *cap bronze* / *Personnage* / *Personnage*
royal / *Femme et oiseau* / *que giri* / *5/12/63.*
Collection of the Fundació Pilar i Joan Miró
a Mallorca
FPIJM DP-0836; Q III: p. 8

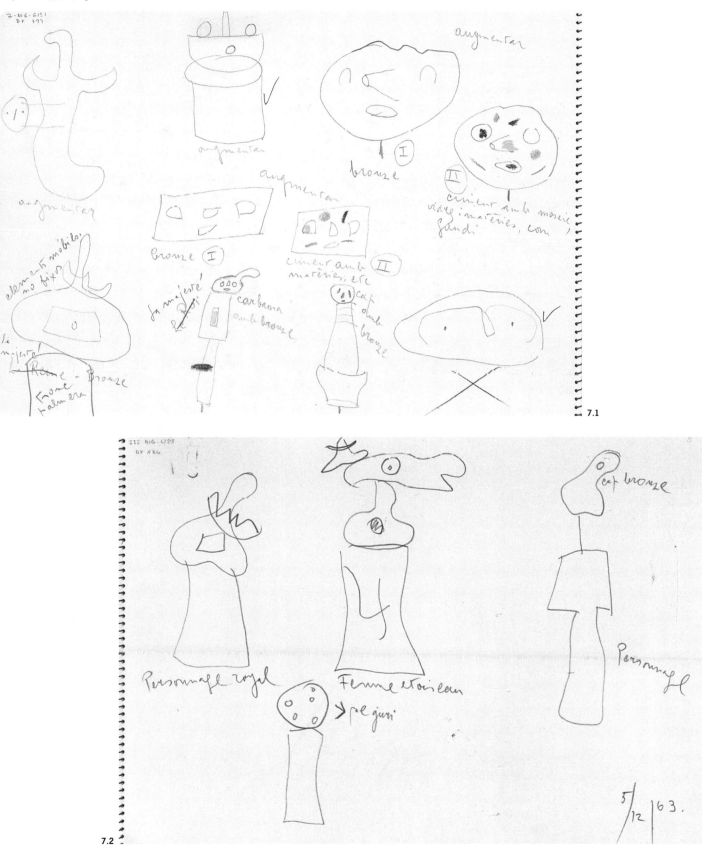

7.1

7.2

7.3 Sa majesté
Pen on paper (sketchbook
"Escultures I" FJM 3534-3663)
21.2 × 31 cm
8⅜ × 12¼ in
Inscriptions: *Sa majesté / 39*
Collection of the Fundació Joan
Miró, Barcelona
FJM 3538-a

7.4 Femme
Ballpoint pen on paper (sketchbook
"Escultures I," FJM 3534-3663)
21.3 × 31 cm
8⅜ × 12¼ in
Inscriptions: *Femme / 80*
Collection of the Fundació Joan
Miró, Barcelona
FJM 3646

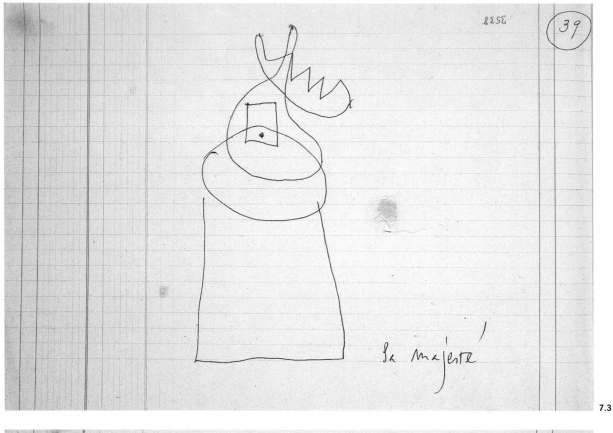

7.3

7.4

7.5 Photograph by
Claude Gaspari
23 × 18 cm
9 × 7 in
Collection of the Fundació
Joan Miró, Barcelona
FJM 4045

7.5

**7.6 Untitled
sketchbook drawing**
See 1.4 on page 92

7.7 Femme et oiseau,
Personnage, Sa
majesté, Femme et
oiseau, Personnage
See 2.4 on page 97

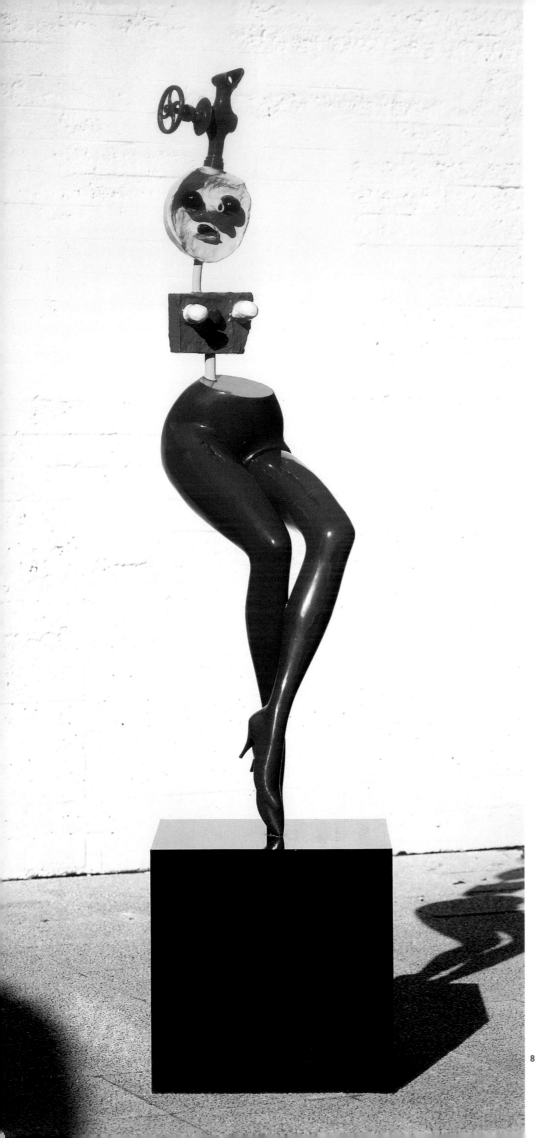

8 Jeune fille s'évadant,
1968
Painted bronze
216 × 50 × 56 cm
85 × 19⅝ × 22 in
JT no. 110
Foundry: Suisse-Fondeur,
Arcueil
Four numbered examples

8
GROUP

Jeune fille s'évadant
Girl Escaping

8

8.1 Untitled drawing,
November 25, 1964
Ballpoint pen on paper
19.8 × 15.1 cm
7¾ × 5⅞ in
Inscriptions: *I / 25/XI/64*
Collection of the Fundació
Pilar i Joan Miró a Mallorca
FPIJM DP-0587

8.2 Untitled drawing,
November 25, 1964
Ballpoint pen on paper
19.8 × 15.1 cm
7¾ × 5⅞ in
Inscriptions: *II / 25/XI/64*
Collection of the Fundació
Pilar i Joan Miró a Mallorca
FPIJM DP-0588

8.3 Untitled drawing,
November 25, 1964
Ballpoint pen on paper
19.8 × 15.2 cm
7¾ × 6 in
Inscriptions: *25/XI/64*
Collection of the Fundació
Pilar i Joan Miró a Mallorca
FPIJM DP-0593

8.4 Untitled drawing,
February 1, 1965
Ballpoint pen on paper
19.9 × 15.1 cm
7⅞ × 5⅞ in
Inscriptions: *1/2/65 / I*
Collection of the Fundació
Pilar i Joan Miró a Mallorca
FPIJM DP-0585

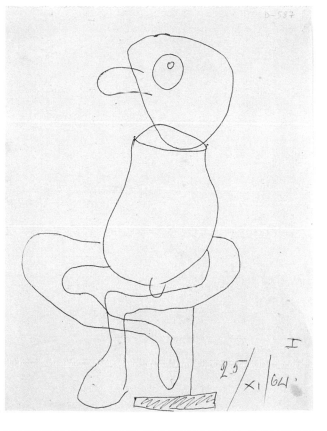

8.1

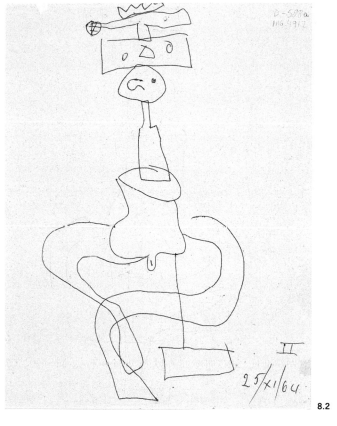

8.2

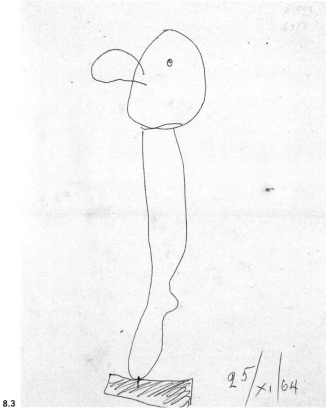

8.3

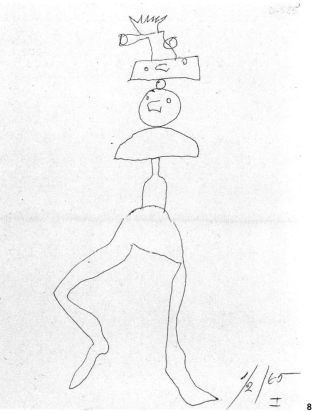

8.4

8.5 Untitled drawing,
February 1, 1965
Ballpoint pen on paper
19.9 × 15.1 cm
7⅞ × 5⅞ in
Inscriptions: *1/2/65 / II*
Collection of the Fundació
Pilar i Joan Miró a Mallorca
FPIJM DP-0586

8.6 Jeune fille s'évadant
Ballpoint pen on paper (sketchbook
"Escultures 1" FJM 3534-3663)
19 × 15 cm
7½ × 5⅞ in
Inscriptions: *Jeune fille / s'évadant
/ Femme*
Collection of the Fundació Joan
Miró, Barcelona
FJM 3631

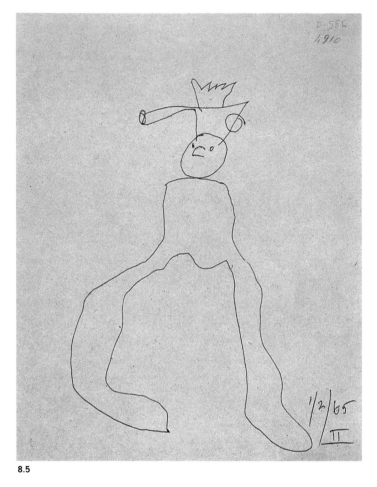

8.5

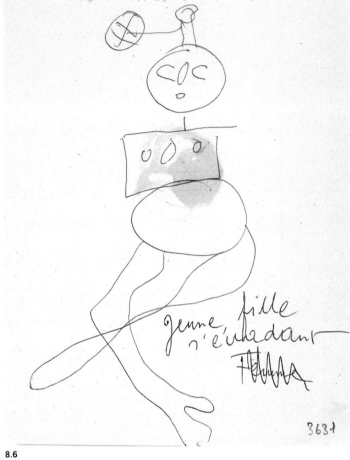

8.6

8.7 Untitled drawing
See 1.12 on page 94

9 Personnage, 1968
Painted bronze
165 × 65 × 40 cm
65 × 25⅝ × 15¾ in
JT no. 111
Foundry: T. Clémenti,
Meudon
Four numbered examples

GROUP

Personnage
Figure

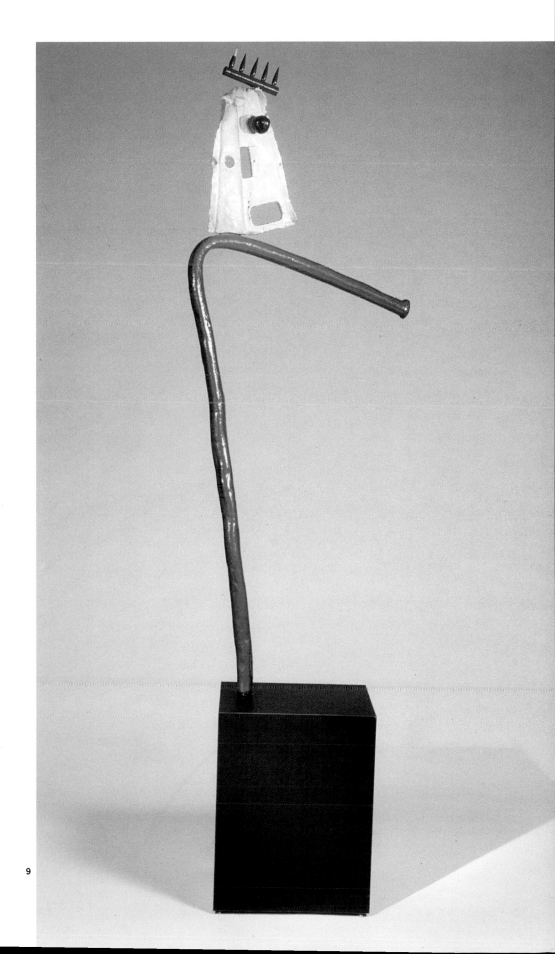

9

9.1 Personnage (detail)
Ballpoint pen on paper
(sketchbook "Escultures I"
FJM 3534-3663)
21.2 × 31 cm
8⅜ × 12¼ in
Inscriptions: *Personnage / 40*
Collection of the Fundació
Joan Miró, Barcelona
FJM 3543-a

9.2 Photograph by
Claude Gaspari
24 × 16.8 cm
9½ × 6⅝ in
Collection of the Fundació
Joan Miró, Barcelona
FJM 4039

9.3 Photograph by
Claude Gaspari
24 × 15.4 cm
9½ × 6 in
Collection of the Fundació
Joan Miró, Barcelona
FJM 4040

9.4 Femme et oiseau,
Personnage, Sa
majesté, Femme et
oiseau, Personnage
See 2.4 on page 97

9.1

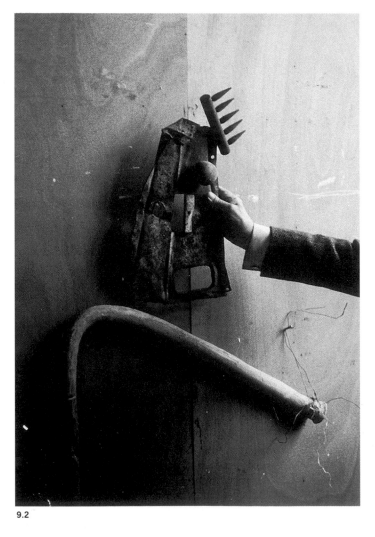

9.2

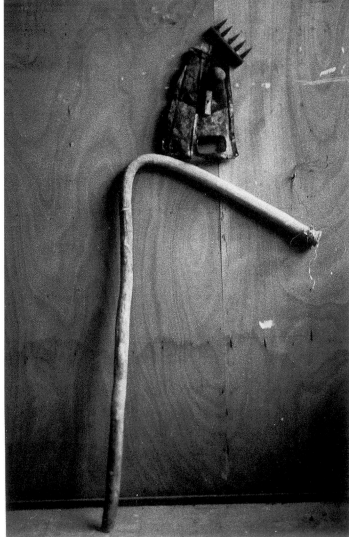

9.3

GROUP **10**

Monsieur et madame
Sir and Madam

10 Monsieur et madame, 1969
Painted bronze
100 × 31 × 31 and 68 × 38 × 38 cm
39⅜ × 12¼ × 12¼ and 26¾ × 15 × 15 in
JT no. 122
Foundry: T. Clémenti, Meudon
Four numbered examples

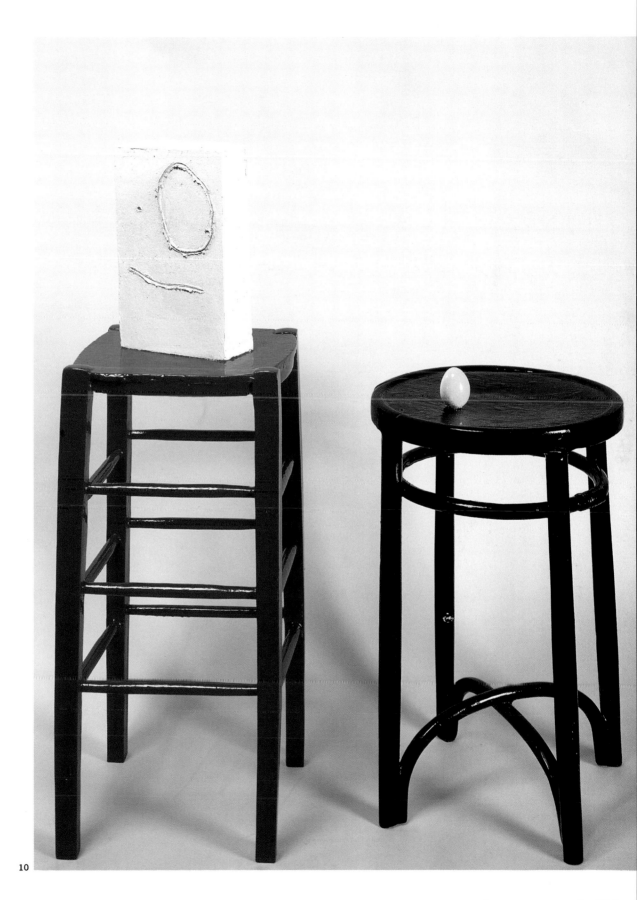

10

10.1 Untitled drawing, July 7, 1967

Ballpoint pen and colored pencil on paper (calendar back)

16 × 30.5 cm

6¼ × 12 in

Inscriptions: *1 // 2 / Femme // 3 // 4 / ajuntar-hi quelcom / 5 // Fondre / 1-Homme et Femme / 2-Femme / 3-Femme / 4-Femme / 5-Femme / Clementi // enviar / 2-4-5 // Deixar en observació els / 3 Homme i Femme que són à París // Falta registrar-los album // 7/VII/67*; back: *Clementi*

Collection of the Fundació Joan Miró, Barcelona

FJM 4026

10.2 Monsieur et madame

Ballpoint pen on paper

15.4 × 19.9 cm

6⅛ × 7⅞ in

Inscriptions: *page 88 / Monsieur et Madame*

Collection of the Fundació Pilar i Joan Miró a Mallorca

FPIJM DP-0670

10.1

10.2

10.3 Untitled drawing
Ballpoint pen on paper
20.5 × 27.7 cm
8⅛ × 10⅞ in
Inscriptions: *arxivar / ces deux objets
peuvent doivent / se déplacer librement /
posés sur un socle // A. 1 // B. A II*
Collection of the Fundació Joan Miró,
Barcelona
FJM 3999

10.4 Monsieur, madame
Ballpoint pen on paper (sketchbook
"Escultures I" FJM 3534-3663)
21.3 × 31 cm
8⅜ × 12¼ in
Inscriptions: *Monsieur, madame /
Homme et Femme / 77*
Collection of the Fundació Joan
Miró, Barcelona
FJM 3640-a

10.3

10.4

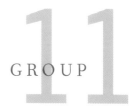

11 Homme et femme dans la nuit, 1969
Painted bronze
78 × 45 × 45 and 87 × 32 × 32 cm
30¾ × 17¾ × 17¾ and 34¼ × 12⅝ × 12⅝ in
JT no. 136
Foundry: T. Clémenti, Meudon
Four numbered examples

11.1 Untitled drawing
Ballpoint pen on paper
20.5 × 27.7 cm
8⅛ × 10⅞ in
Inscriptions: *Ces objets doivent rester / fixé sur le / socle // A B / I // B A B. II*
Collection of the Fundació Joan Miró, Barcelona
FJM 4000

11.2 Homme et femme dans la nuit
Pen on paper (sketchbook "Escultures I" FJM 3534-3663)
21.3 × 31 cm
8⅜ × 12¼ in.
Inscriptions: *Homme et Femme / dans la nuit / 76*
Collection of the Fundació Joan Miró, Barcelona
FJM 3638-a

11.1

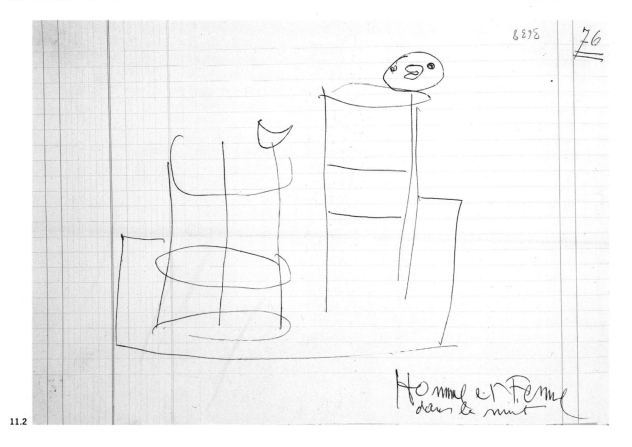

11.2

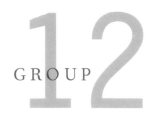
Femme échevelée
Disheveled Woman

12 Femme échevelée,
1969
Painted bronze
70 × 72 × 41 cm
27½ × 28⅜ × 16⅛ in
JT no. 132
Foundry: T. Clémenti,
Meudon
Four numbered examples

12

12.1 Femme
Pen on paper (sketchbook
"Escultures I" FJM 3534-3663)
21.2 × 31 cm
8⅜ × 12¼ in
Inscriptions: *Femme* / 75
Collection of the Fundació
Joan Miró, Barcelona
FJM 3634-b

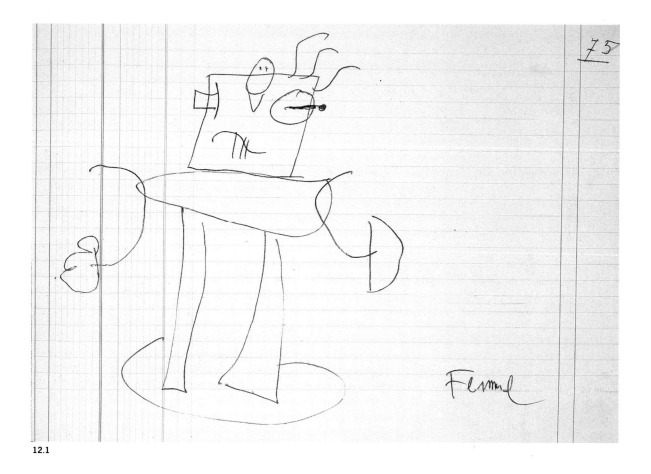

12.1

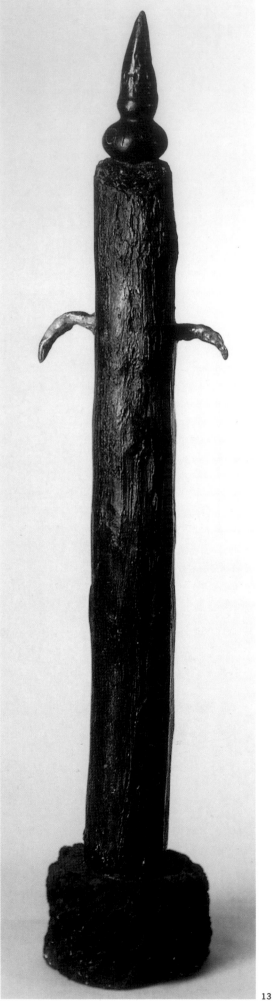

13 Femme et oiseau, 1969
Painted bronze
160 × 34 × 30 cm
63 × 13⅜ × 11¾ in
JT no. 140
Foundry: T. Clémenti, Meudon
Two numbered examples

GROUP

Femme et oiseau
Woman and Bird

13

GROUP 14 **Femme et oiseau**
Woman and Bird

14a, 14b Femme et oiseau,
1971 (front and back)
Painted bronze
78 × 42 × 42 cm
30¾ × 16½ × 16½ in
JT no. 196
Foundry: Valsuani et Fils,
Bagneux
Two numbered examples

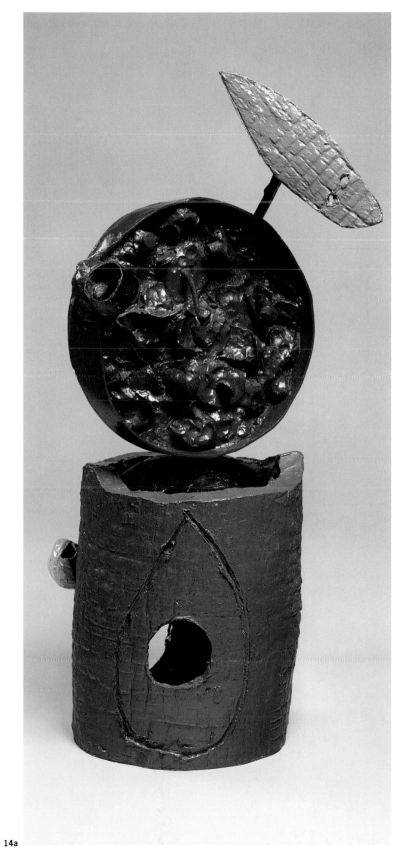

14a

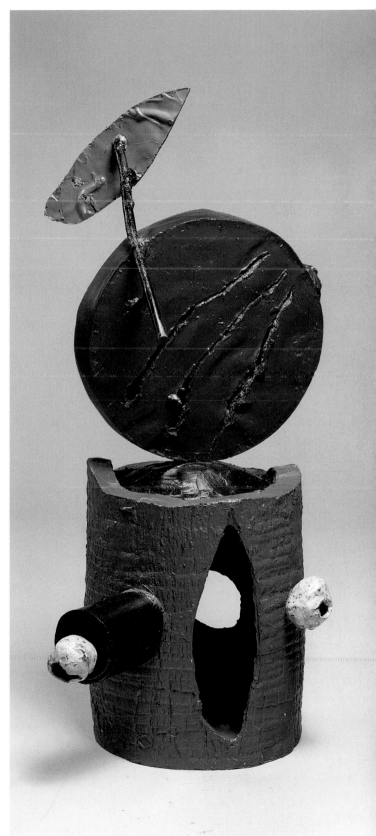

14b

14.1 Objecte
Ballpoint pen on paper (sketchbook Q I)
24.5 × 34 cm
9⅝ × 13⅜ in
Inscriptions: *Son / Altesse / guardo / arandela / ferro
/ ~~objecte~~ / objecte / objecte / Femme / objecte / objecte
/ Galeta / d'Inca / (suite 5 teles) / tronc / palmera*
Collection of the Fundació Pilar i Joan Miró
a Mallorca
FPIJM DP-0799; Q I: p.II rev.

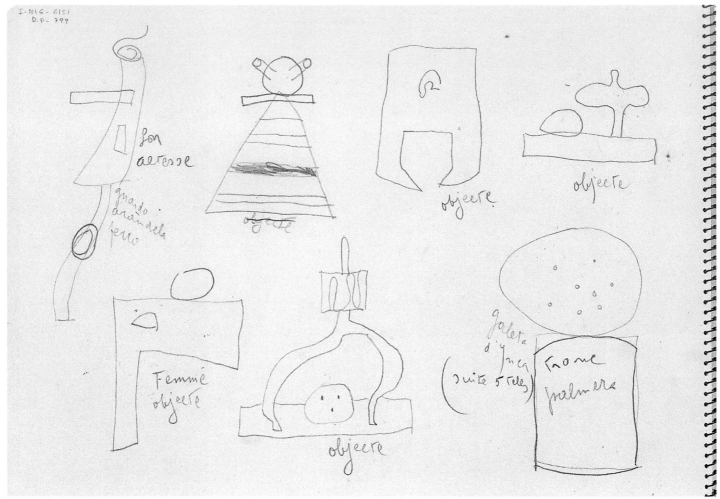

14.1

14.2 Femme et oiseau, December 31, 1970
Ballpoint pen and colored pencil on paper
21.1 × 29.7 cm
8¼ × 11¾ in
Inscriptions: *pintat / 31/XII/70 / ~~Personnage~~ / Femme et oiseau*
Collection of the Fundació Joan Miró, Barcelona
FJM 3963

14.3 Personnage
Ballpoint pen on paper (sketchbook FJM 3664-3719)
21.2 × 31 cm
8⅜ × 12¼ in
Inscriptions: *Personnage*
Collection of the Fundació Joan Miró, Barcelona
FJM 3686-b

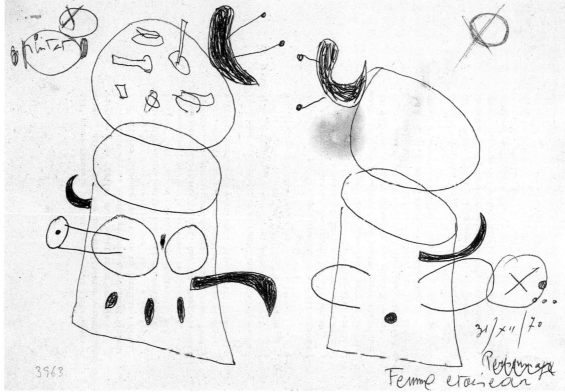

14.2

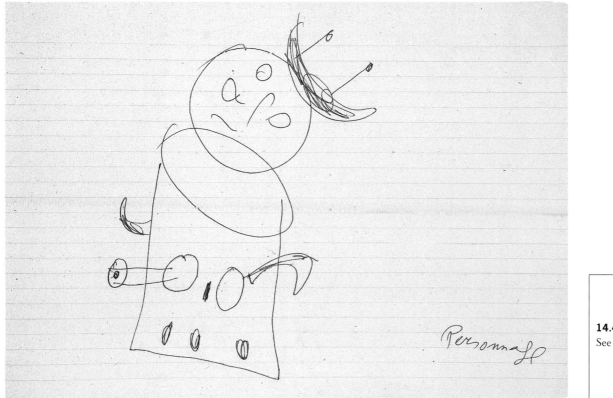

14.3

14.4 Untitled drawing
See 3.12 on page 102

15 Oiseau sur un rocher,
1971
Painted bronze
44 × 36 × 21 cm.
17⅜ × 14¼ × 8¼ in
JT no. 197
Foundry: Valsuani et Fils,
Bagneux
Two numbered examples

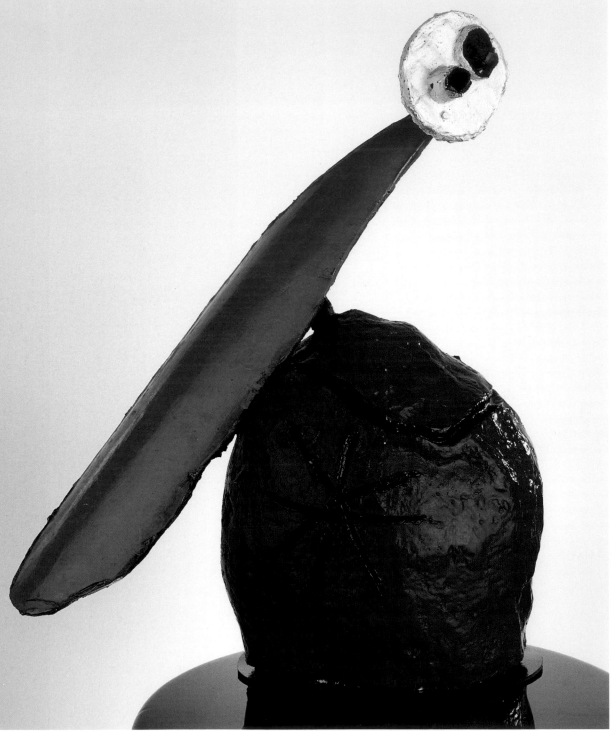

15

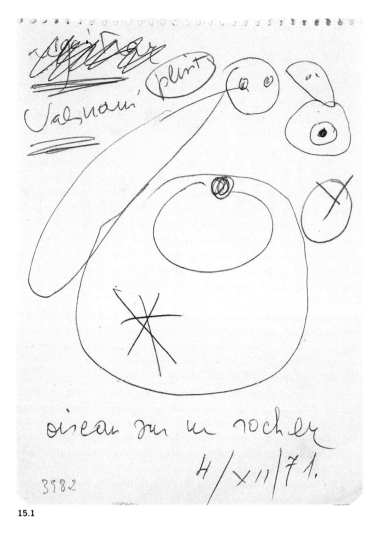

15.1

15.1 Oiseau sur un rocher,
December 4, 1971
Ballpoint pen on paper
21.1 × 15 cm
8¼ × 5⅞ in
Inscriptions: ~~registrar~~ / *Valsuari* /
peint / *oiseau sur un rocher* /
4/XII/71
Collection of the Fundació Joan
Miró, Barcelona
FJM 3982

15.2 Oiseau sur un rocher
Ballpoint pen on paper
(sketchbook FJM 3664-3719)
21.2 × 31 cm
8⅜ × 12¼ in
Inscriptions: *oiseau sur un rocher*
Collection of the Fundació Joan
Miró, Barcelona
FJM 3711-b

15.2

GROUP **16** **Femme**
Woman

16 Femme, 1971
Painted bronze
51 × 44 × 29 cm
20⅛ × 17⅜ × 11⅜ in
JT no. 198
Foundry: Valsuani et Fils,
Bagneux
Two numbered examples

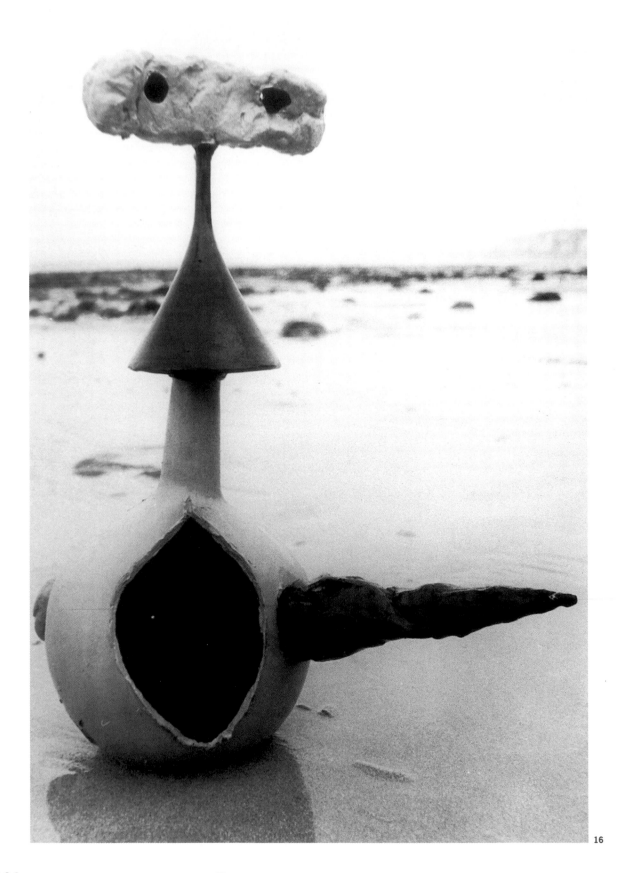

16

16.1 Projet pour un monument II. Femme
Ballpoint pen and colored
pencil on paper (calendar back)
33.5 × 27.5 cm
13¼ × 10⅞ in
Inscriptions: *Bis / Prójet pour
/ un / Monument / II // fang
/ couleur / Femme*
Collection of the Fundació
Joan Miró, Barcelona
FJM 3985

16.2 Femme (detail)
Ballpoint pen on paper
(sketchbook FJM 3664-3719)
21.2 × 31 cm
8⅜ × 12¼ in
Inscriptions: *Femme*
Collection of the Fundació
Joan Miró, Barcelona
FJM 3718-b

16.3 Femme (detail)
Ballpoint pen on paper
(sketchbook FJM 3664-3719)
21.2 × 32 cm
8⅜ × 12⅝ in
Collection of the Fundació
Joan Miró, Barcelona
FJM 3704-b

16.1

16.2

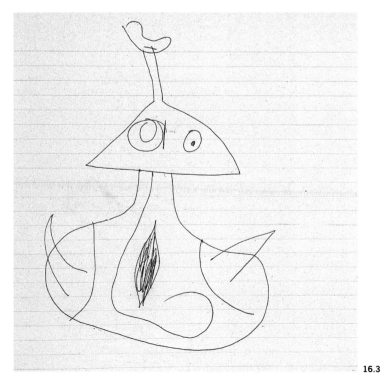

16.3

GROUP 17

Femme
Woman

17 Femme, 1971
Painted bronze
65.5 × 14.5 × 7.5 cm.
25¾ × 5¾ × 3 in
JT no. 199
Foundry: Valsuani et Fils
Two numbered examples

17.1 Femme, March 22,
1971
Ballpoint pen and colored
pencil on paper (calendar back)
33.7 × 25.5 cm
13¼ × 10 in
Inscriptions: *pintat / Femme /
22/III/71*
Collection of the Fundació
Joan Miró, Barcelona
FJM 3983

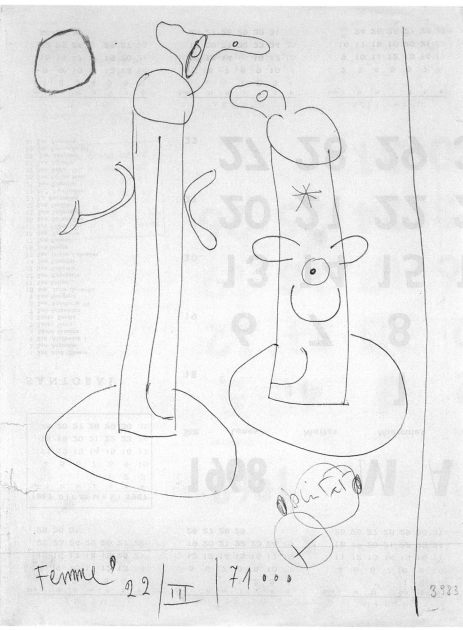

17.1

17.2 Untitled drawing,
July 7, 1967
See 10.1 on page 122

17

GROUP 18 **Personnage**
Figure

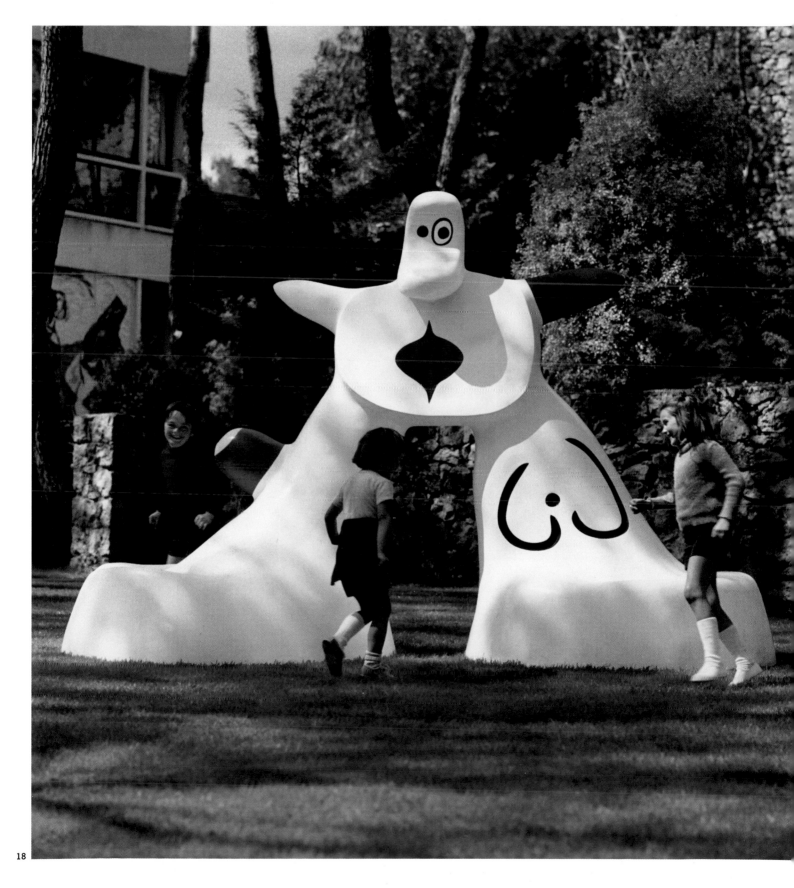

18 Personnage, 1972
Painted synthetic resin
225 × 345 × 160 cm
88⅜ × 135⅞ × 63 in
JT no. 225
Reproduction: Haligon,
Périgny-sur-Yerres
One example

18

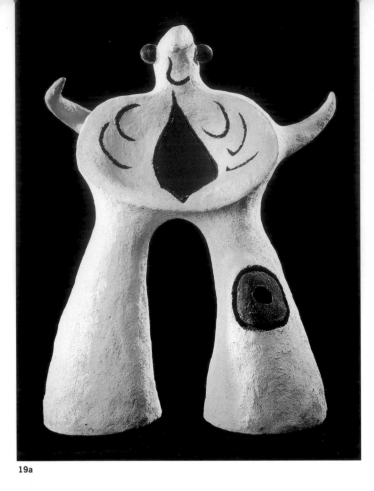

19a

19a Projet pour un
monument, 1972
Plaster
51 × 38.5 × 25 cm
20⅛ × 15⅛ × 9⅞ in
JT no. 226
Reproduction: Haligon,
Périgny-sur-Yerres
One example

19b Projet pour un
monument, 1972–1979
Plaster
51 × 38.5 × 25 cm
20⅛ × 15⅛ × 9⅞ in
JT no. 300 (second state
of JT no. 226)
Reproduction: Haligon,
Périgny-sur-Yerres
One example

19
GROUP

Projet pour un monument
Project for a Monument

19c Projet pour un
monument, 1979–1985
Painted bronze
51 × 38.5 × 25 cm
20⅛ × 15⅛ × 9⅞ in
Based on JT no. 300
Foundry: Bonvicini, Verona
Six numbered examples

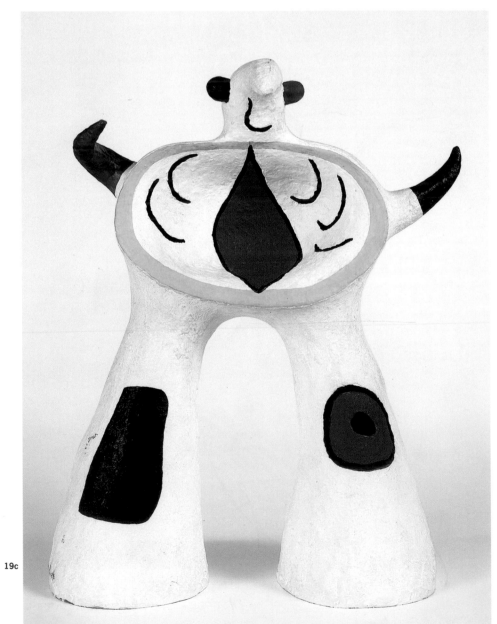

19c

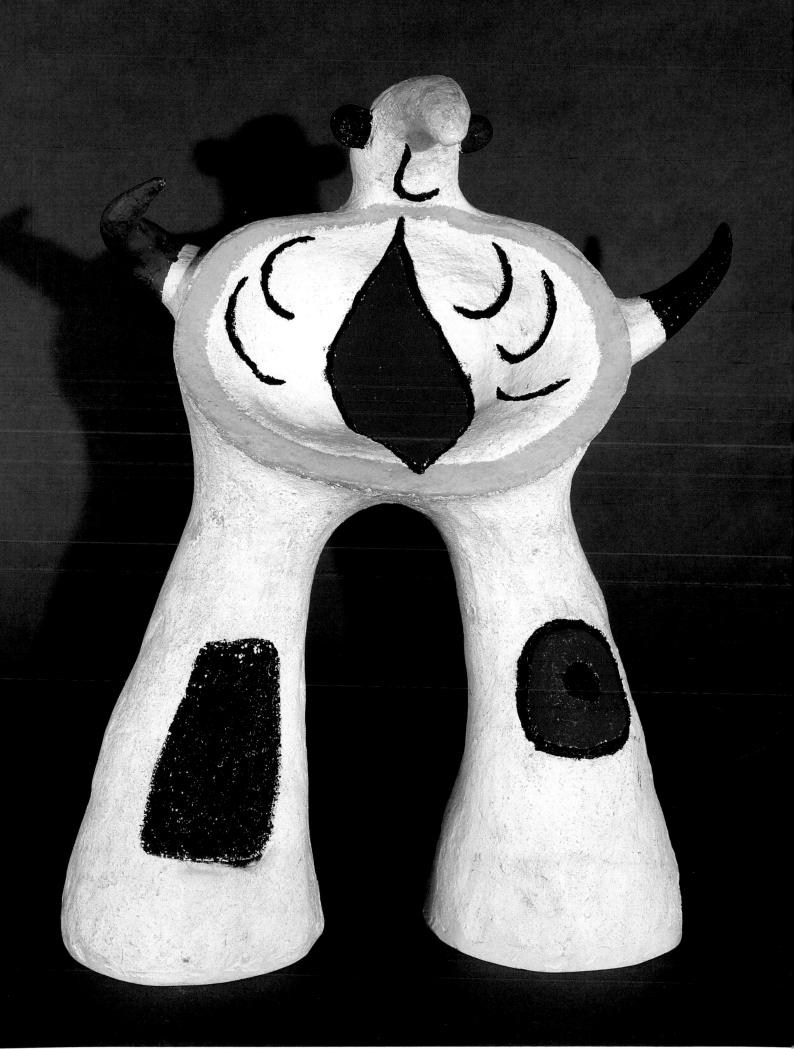

GROUP 19: PROJET POUR UN MONUMENT (PROJECT FOR A MONUMENT) **139**

19.1 Untitled sketchbook drawing, September 29, 1958

Ballpoint pen and wax color on paper (sketchbook drawing)

24.5 × 34.7 cm

9⅝ × 13⅝ in

Inscriptions: *(II) X / 0'30 / 0'45 / fer el mateix model amb fang i retreballar-lo / X / [fer] guix i retreballar-lo / X / augmentar-lo 5 vegades amb bronze / X / fer socle / X / Mtg. 29/9/58.*

Collection of the Fundació Pilar i Joan Miró a Mallorca

FPIJM DP-0785: Q I: p. 4

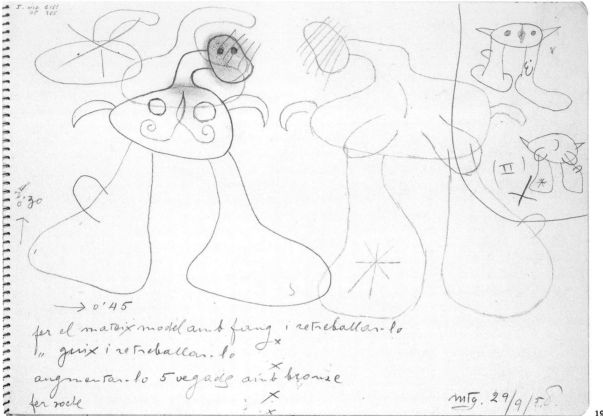

19.1

19.2 Femme s'adressant à la foule, November 2, 1971

Ballpoint pen on paper (envelope)

26.5 × 22.5 cm

10⅜ × 8⅞ in

Inscriptions: *Femme s'adressant à / la foule / el blanc l'embrutarà / la gent ? / sortie / 2/XI/71. / ~~150.000~~ $ net / 200.000 / Demanar preu net / 200.000 $ / en Joanet hi aniria, a càrrec / d'ells, per ajudar-los*

Collection of the Fundació Pilar i Joan Miró a Mallorca

FPIJM DP-0004

19.2

19.3 Untitled drawing,
November 3, 1971
Ballpoint pen and wax color
on paper
15.5 × 19.8 cm
6⅛ × 7¾ in
Inscriptions: *3/XI/71. I X*
Collection of the Fundació
Pilar i Joan Miró a Mallorca
FPIJM DP-0002

19.4 Untitled drawing,
November 3, 1971
Ballpoint pen and wax color
on paper
15.5 × 19.8 cm
6⅛ × 7¾ in
Inscriptions: *X 3/XI/71. II*
Collection of the Fundació
Pilar i Joan Miró a Mallorca
FPIJM DP-0003

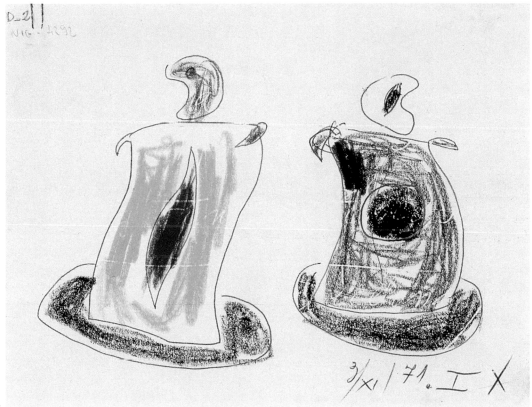

19.3

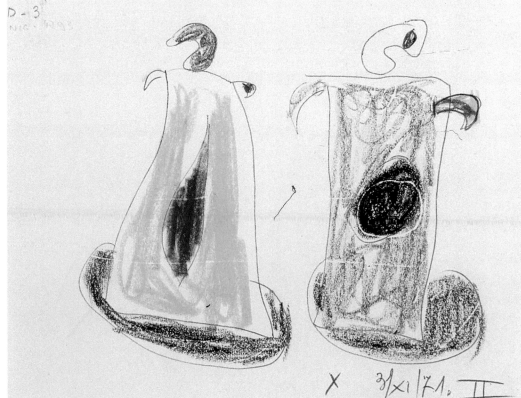

19.4

19.5 Femme devant la foule, November 4, 1971
Ballpoint pen and wax color on paper
15.4 × 19.7 cm
6 × 7¾ in
Inscriptions: *Femme devant la foule / 4/XI/71*
Collection of the Fundació Pilar i Joan Miró a Mallorca
FPIJM DP-0001

19.6 Untitled drawing
Ballpoint pen and wax color on paper
21 × 29.6 cm
8¼ × 11⅝ in
Inscriptions: *fer una escultura / H. / uns 4 m. / X no*
Collection of the Fundació Pilar i Joan Miró a Mallorca
FPIJM DP-0438

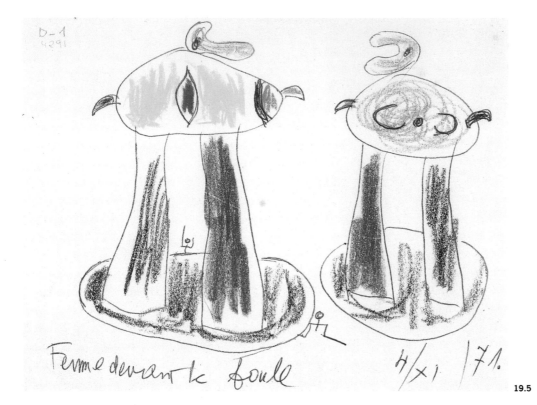

19.5

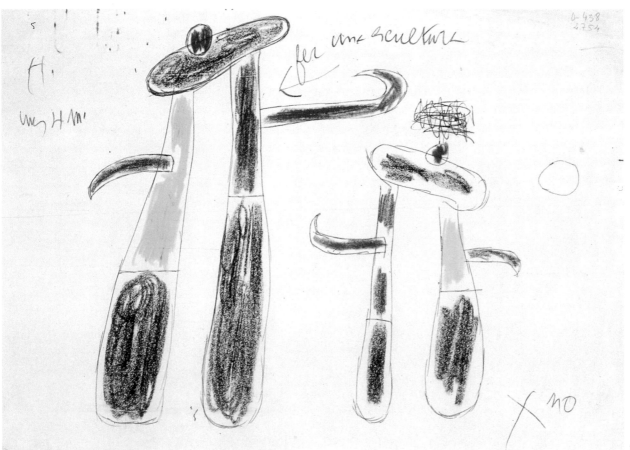

19.6

19.7 Untitled drawing
Ballpoint pen and wax color
on paper
15.9 × 10.9 cm
6¼ × 4¼ in
Inscriptions: *I / 5 m. / II*
Collection of the Fundació
Pilar i Joan Miró a Mallorca
FPIJM DP-0213

19.8 Untitled drawing
Ballpoint pen on paper
29.7 × 21 cm
11¾ × 8¼ in
Inscriptions: *retraballar-la* / *esc.* /
~~*Los Angeles*~~ / *per Central-Park* /
[—-] / *i fer fondre* / *per* / *Parellada*
Collection of the Fundació Pilar i
Joan Miró a Mallorca
FPIJM DP-0449

19.9 Maternité
Ballpoint pen on paper
20 × 21 cm
7⅞ × 8¼ in
Inscriptions: ~~*Com personnage*~~ /
~~*gothique*~~ / ~~*bronze*~~ / *Maternité* /
donar a fondre / *a Parellada*
Collection of the Fundació Pilar i
Joan Miró a Mallorca
FPIJM DP-0452

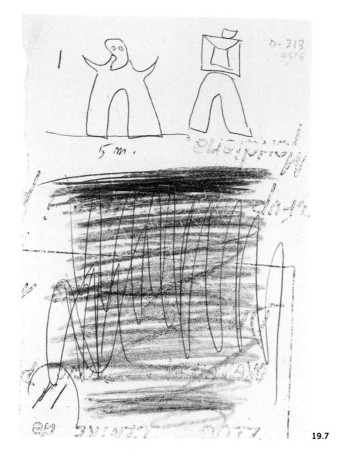

19.7

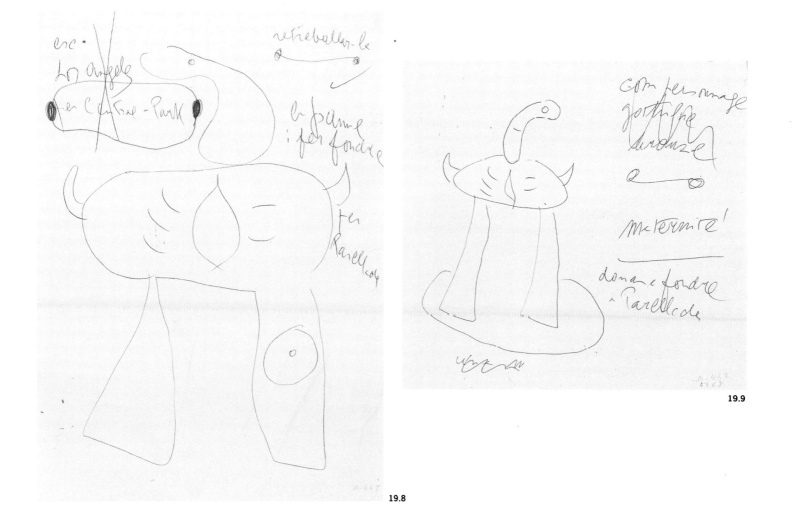

19.8

19.9

19.10 Photograph
12.8 × 8.8 cm
5 × 3½ in
Collection of the Fundació
Joan Miró, Barcelona
FJM 3927

19.11 Photomontage
Photography and ballpoint
pen on paper
25.2 × 20.6 cm
9⅞ × 8⅛ in
Collection of the Fundació
Pilar i Joan Miró a Mallorca
FPIJM DP-1251 bis

19.12 Photograph
20.4 × 25.3 cm
8 × 10 in
Inscriptions (on the back): *site
sur le fleuve*
Collection of the Fundació Joan
Miró, Barcelona
FJM 3870

19.13 Photomontage
Photography and ballpoint pen
on paper
20.4 × 25.3 cm
8 × 10 in
Collection of the Fundació
Pilar i Joan Miró a Mallorca
FPIJM DP-1251

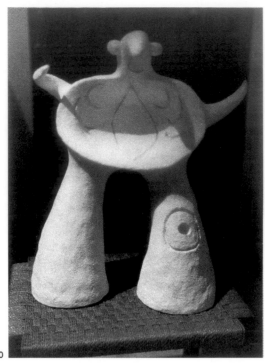

19.10

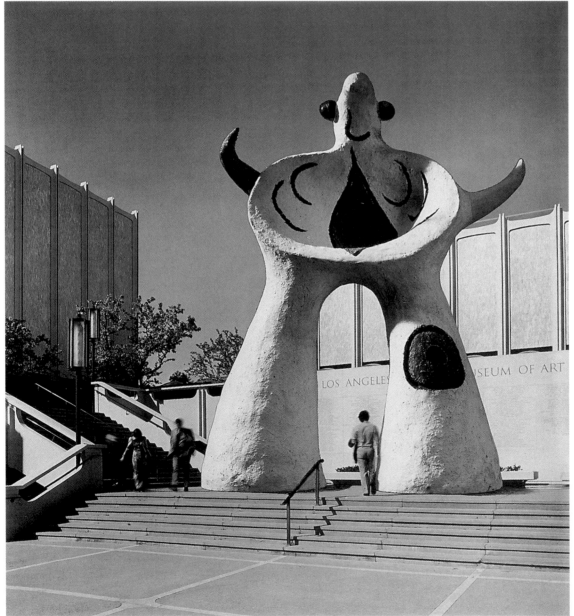

19.11

19.12

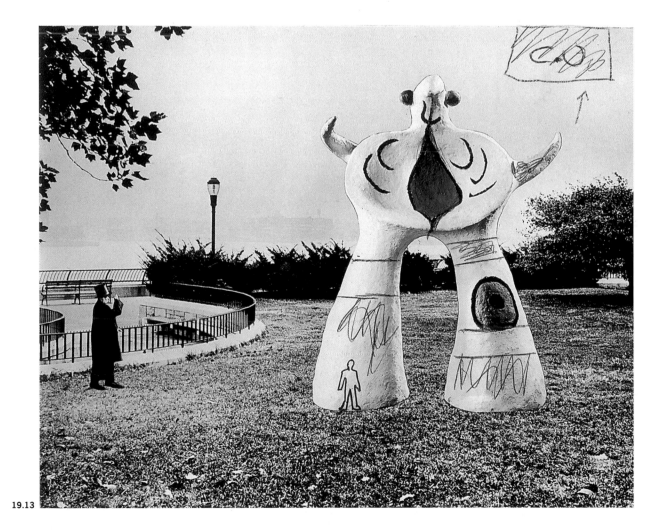

19.13

Personnage

Figure

20 Personnage, 1972
Painted resin
206 × 289 × 245 cm
81⅛ × 113¾ × 96½ in
JT no. 237
Reproduction: Haligon,
Périgny-sur-Yerres
One example

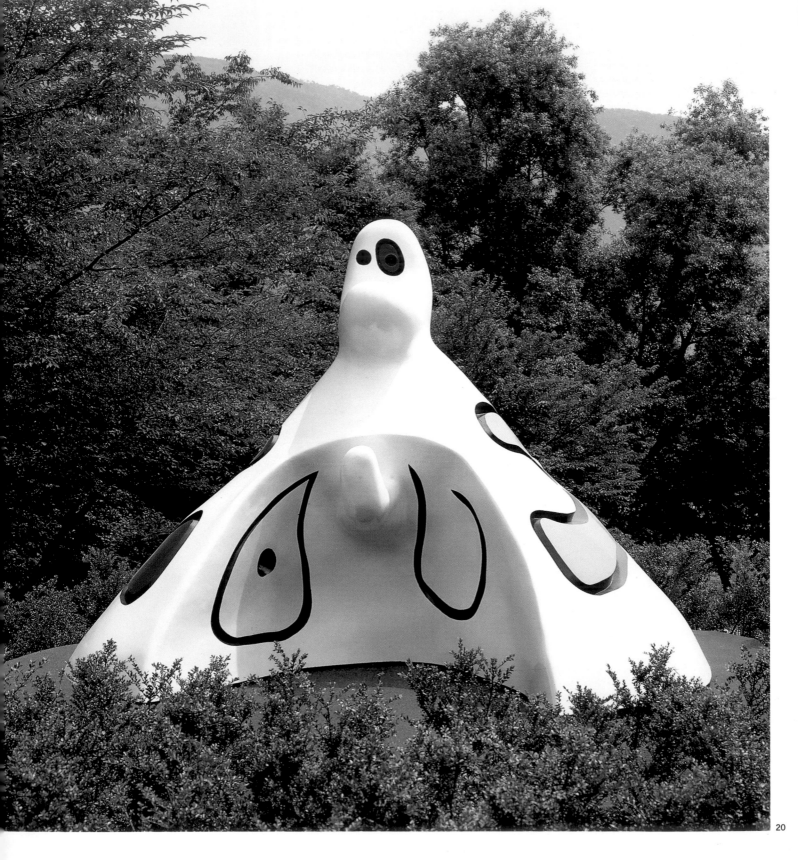

20

GROUP 21

Personnage
Figure

21 Personnage, 1972
Painted resin
320 × 120 × 100 cm.
126 × 47¼ × 39⅜ in
JT no. 238
Reproduction: Haligon,
Périgny-sur-Yerres
One example

21.1 Femme, August 9, 1977
Ballpoint pen on paper
17.6 × 22.2 cm
6⅞ × 8¾ in
Inscriptions: *Femme /
9/VIII/77 / inclinar*
Collection of the Fundació
Pilar i Joan Miró a Mallorca
FPIJM DP-0214

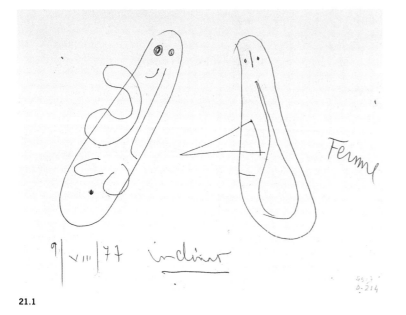

21.1

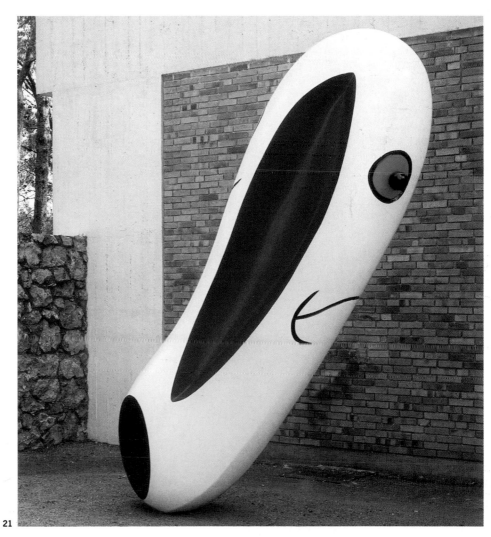

21

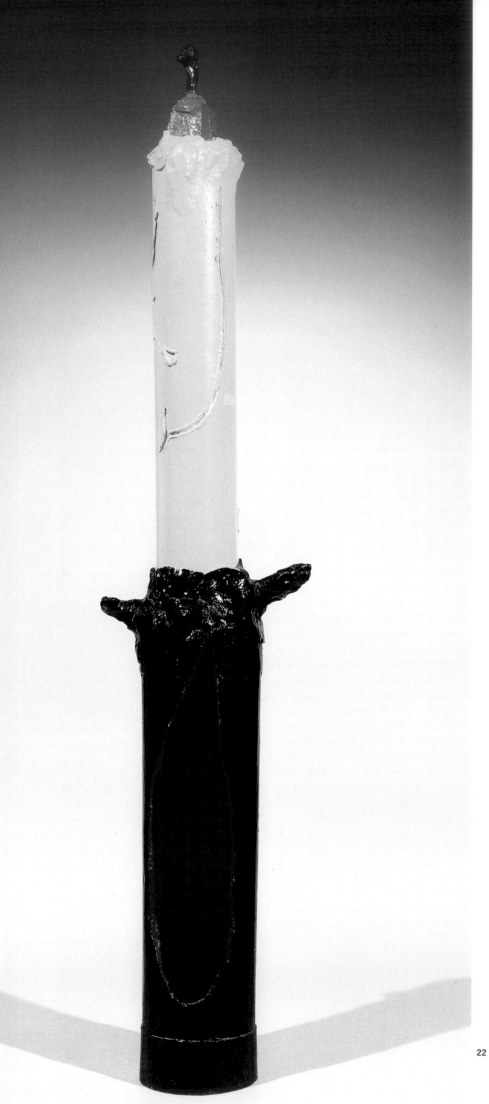

22 Projet pour un
monument, 1973
Painted bronze
133 × 22 × 28 cm.
52⅜ × 8⅝ × 11 in
JT no. 259
Foundry: Valsuani et Fils,
Bagneux
Two numbered examples

GROUP 22

Projet pour un monument
Project for a Monument

22.1 Projet pour un
monument II. Femme
See 16.1 on page 135

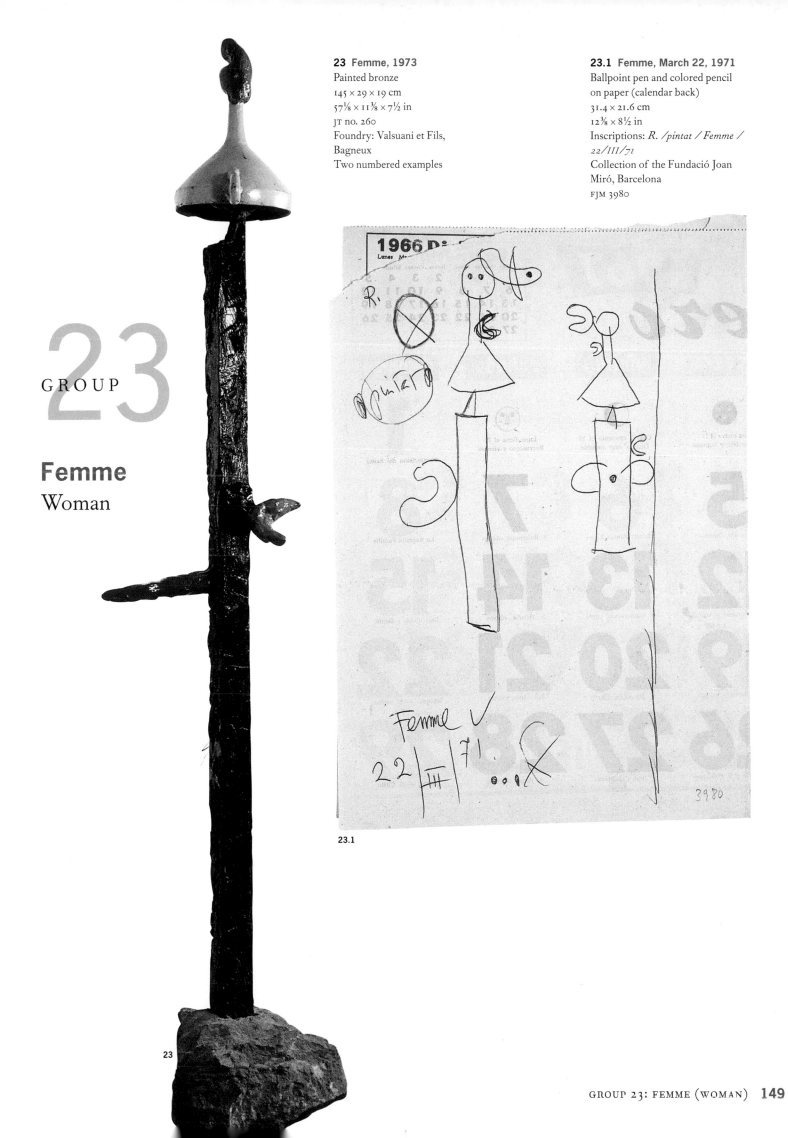

23 Femme, 1973
Painted bronze
145 × 29 × 19 cm
57⅛ × 11⅜ × 7½ in
JT no. 260
Foundry: Valsuani et Fils,
Bagneux
Two numbered examples

23.1 Femme, March 22, 1971
Ballpoint pen and colored pencil
on paper (calendar back)
31.4 × 21.6 cm
12⅜ × 8½ in
Inscriptions: *R. /pintat / Femme /
22/III/71*
Collection of the Fundació Joan
Miró, Barcelona
FJM 3980

23.1

GROUP
23

Femme
Woman

23

23.2 Femme
Ballpoint pen on paper
(sketchbook 3664-3719)
21.2 × 32 cm
8⅜ × 12½ in
Inscriptions: *Femme*
Collection of the Fundació
Joan Miró, Barcelona
FJM 3685-b

23.3 Femme
Ballpoint pen on paper
(sketchbook 3664-3719)
21.2 × 32 cm
8⅜ × 12½ in
Inscriptions: *Femme*
Collection of the Fundació
Joan Miró, Barcelona
FJM 3701-b

23.2

23.3

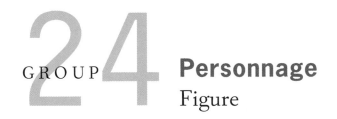

GROUP 24 **Personnage**
Figure

24 Personnage, 1974
Resin
190 × 152 × 173 cm
74¾ × 59⅞ × 68⅛ in
JT no. 264
Reproduction: Haligon,
Périgny-sur-Yerres
One example

24

24.1 Personnage
Ballpoint pen on paper
(sketchbook FJM 3664-3719)
21.2 × 31 cm
8⅜ × 12¼ in
Inscriptions: *Personnage //
Personnage*
Collection of the Fundació
Joan Miró, Barcelona
FJM 3671-b

24.2 Personnage
Ballpoint pen on paper
(sketchbook FJM 3664-3719)
21.2 × 31 cm
8⅜ × 12¼ in
Inscriptions: *Personnage*
Collection of the Fundació
Joan Miró, Barcelona
FJM 3715

24.1

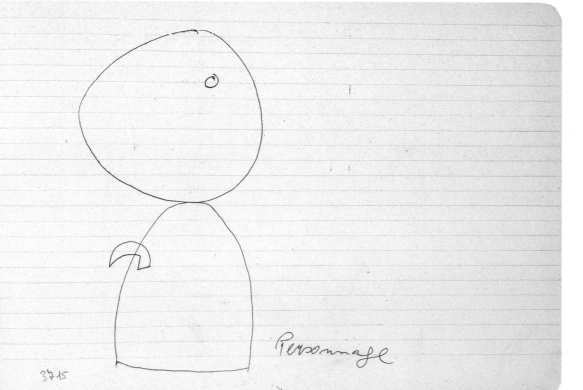

24.2

24.3 Untitled drawing
Ballpoint pen and wax color
on paper
16.5 × 18.5 cm
6½ × 7¼ in
Collection of the Fundació
Pilar i Joan Miró a Mallorca
FPIJM DP-0040

24.4 Untitled drawing
Ballpoint pen and wax color
and pencil
16.5 × 18.5 cm
6½ × 7¼ in
Collection of the Fundació
Pilar i Joan Miró a Mallorca
FPIJM DP-0040 rev.

24.5 Untitled drawing
Ballpoint pen and wax color
on paper
19.8 × 15.5 cm
7¾ × 6⅛ in
Inscriptions: *Central / Park
/ ? // V./g./b.*
Collection of the Fundació
Joan Miró, Barcelona
FJM 3846

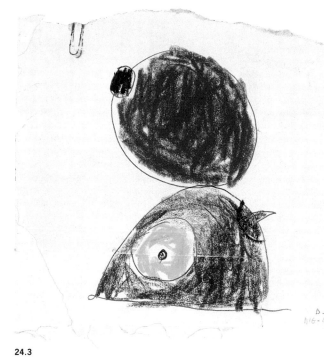

24.3

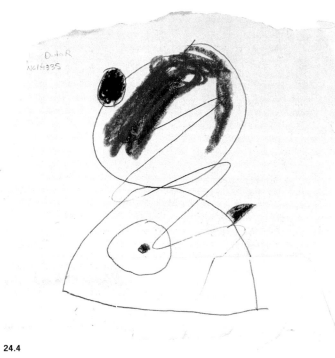

24.4

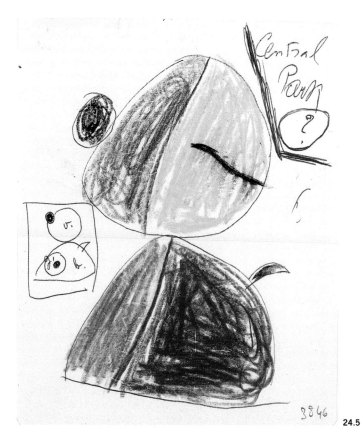

24.5

24.6 Personnage
Ballpoint pen on paper
19.5 × 13.5 cm
7½ × 5⅜ in
Inscriptions: *fet / ~~reveure~~ / ~~registrar~~
/ marbre blanc / més gran / Haligon
/ ~~bronze~~ / Achevé / Personnage*
Collection of the Fundació Joan
Miró, Barcelona
FJM 3840

24.7 Femme, oiseaux
Ballpoint pen and wax color on paper
12.6 × 8 cm
5 × 3⅛ in
Inscriptions: *Femme, oiseaux / Litos
/ 1 per Maeght / 1 Nacions Unides*
Collection of the Fundació Pilar i
Joan Miró a Mallorca
FPIJM DP-0697

24.8 Femme, Personnage
Ballpoint pen on paper
15 × 21.1 cm
5⅞ × 8¼ in
Inscriptions: *~~que em torni la
pedra~~ / Femme 1m. //
Personnage / 1m.90*
Collection of the Fundació
Joan Miró, Barcelona
FJM 3969

24.6

24.7

24.8

24.9 Personnage, October 30, 1971
Ballpoint pen, wax color and graphite on paper
25.9 × 20.6 cm
10¼ × 8⅛ in
Inscriptions: *registrar* / ~~*Personnage Femme*~~ *Personnage*
/ *Valsuani* / *30/X/71* / ~~*la té Joanet*~~ / *la té en Valsuani*
/ *en I. 80, en* / *Joanet ho recorda* / *molt bé*
Collection of the Fundació Pilar i Joan Miró
a Mallorca
FPIJM DP-0014

24.9

GROUP **25**

Le Père Ubu
Père Ubu

25 Le Père Ubu, 1974
Painted synthetic resin
180 × 150 × 145 cm
70⅞ × 59 × 57 in
JT no. 265
Reproduction: Haligon,
Périgny-sur-Yerres
One example

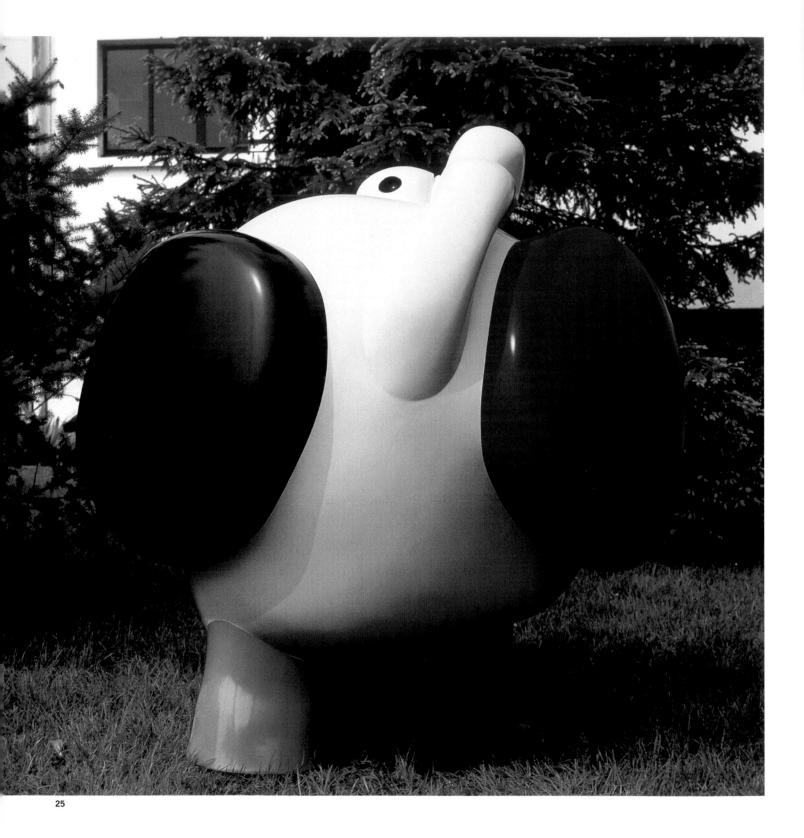

25

25.1 Le Père Ubu II, March 26, 1973

Ballpoint pen on paper
15.5 × 19.8 cm
6⅛ × 7¾ in
Inscriptions: *26/III/73 / Le Père Ubu / II / 2m / 170 cm*
Collection of the Fundació Joan Miró, Barcelona
FJM 3849

25.2 Personnage, October 30, 1971
Le Père Ubu, March 27, 1973

Ballpoint pen on paper (sketchbook Q VIII)
31 × 21.5 cm
12¼ × 8½ in
Inscriptions: *Personnage / 30/X/71 / 27/III/73 / Le Père Ubu / 27/III/73 / Le Père Ubu*
Collection of the Fundació Pilar i Joan Miró a Mallorca
FPIJM DP-0893 Q VIII; p. 4

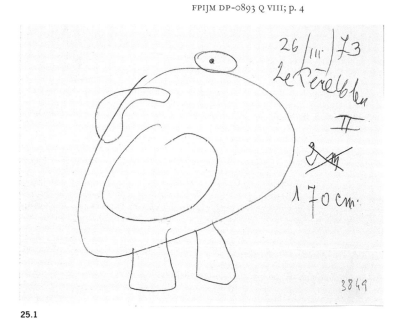

25.1

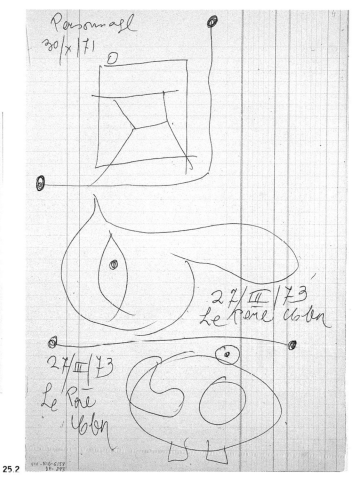

25.2

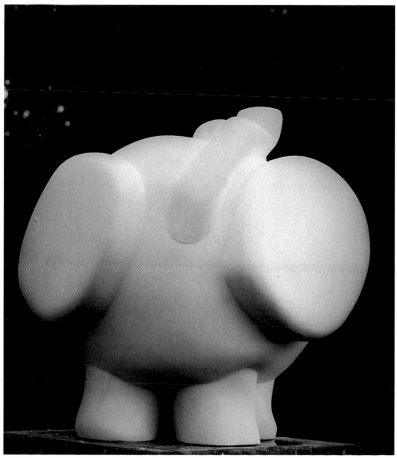

25.3

25.3 Photograph
19.9 × 17.5 cm
7⅞ × 6⅞ in
Collection of the Fundació Joan Miró, Barcelona
FJM 3850

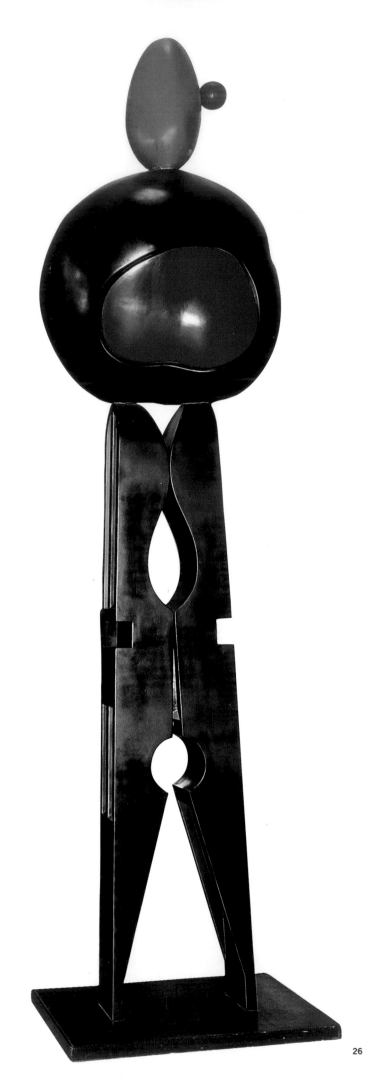

26 Personnage, 1974
Resin
374 × 90 × 90 cm
147¼ × 35⅜ × 35⅜ in
JT no. 266
Reproduction: Haligon,
Périgny-sur-Yerres
One example

GROUP

Personnage
Figure

26

26.1 Femme, October 26, 1971
Ballpoint pen on paper
19.9 × 15.5 cm
7⅞ × 6⅛ in
Inscriptions: *Femme / 26/X/71 /*
agrandir comme / bouteille / a
reveure guix / i terra
Collection of the Fundació Joan
Miró, Barcelona
FJM 3938

26.2 Untitled drawing
Ballpoint pen on paper
18.3 × 5.7 cm
7¼ × 2¼ in
Collection of the Fundació
Pilar i Joan Miró a Mallorca
FPIJM DP-0041

26.3 Untitled drawing,
September 22, 1972
Ballpoint pen and wax color on
paper (sketchbook Q VI)
29.5 × 19.7 cm
11⅝ × 7¾ in
Inscriptions: *22/IX/72. / 15 à 20 m.*
Collection of the Fundació Pilar i
Joan Miró a Mallorca
FPIJM DP-0877 Q VI: p. 2

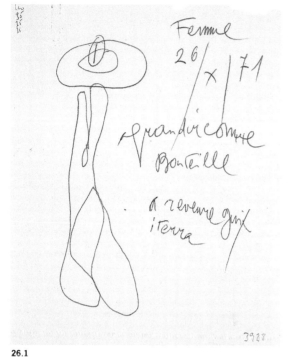

26.1

26.2

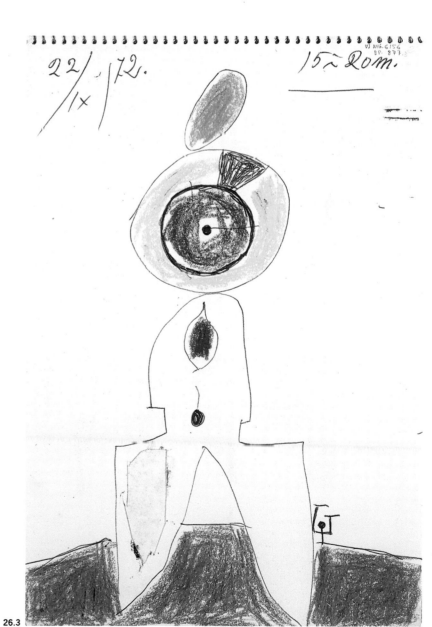

26.3

GROUP 27

Personnage et oiseaux
Figure and Birds

27 Maquette for Personnage et oiseaux, 1980
Painted wood
73.7 × 61 × 22.9 cm
29 × 24 × 9 in
Museum of Fine Arts,
Houston; Gift of Texas
Commerce Bankshares, Inc.,
Gerald D. Hines Interest and
United Energy Resources, Inc.

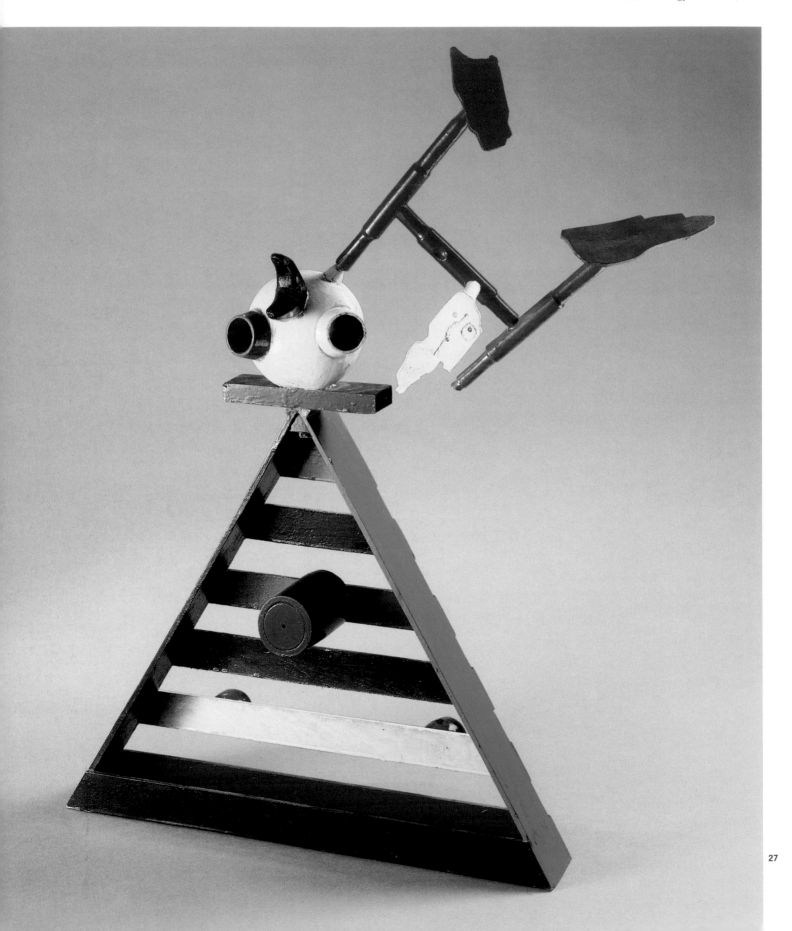

27.1 Untitled drawing, September 19, 1959 (detail)
Ballpoint pen and ink on cardboard (sketchbook Q I)
24.5 × 34.7 cm
9⅝ × 13⅝ in
Inscriptions: *19/9/59*
Collection of the Fundació Pilar i Joan Miró a Mallorca
FPIJM DP-0790; Q I: p. 6 verso

27.2 Femme et oiseau, Tête, Femme, Personnage, Objecte personnage, December 5, 1963
Graphite on paper (sketchbook Q III)
24.3 × 34.3 cm
9½ × 13½ in
Inscriptions: *objecte / personnage / Femme / Femme et oiseau / Tête / personnage / 5/12/63*
Collection of the Fundació Pilar i Joan Miró a Mallorca
FPIJM DP-0841; Q III: p. 13

27.1

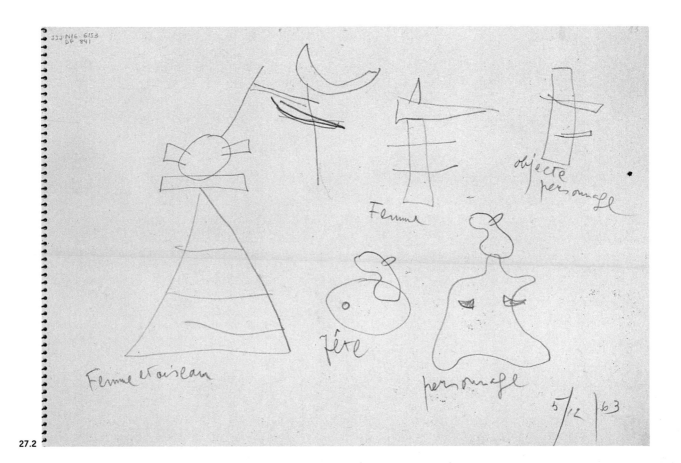

27.2

27.3 Personnage et oiseau. Oiseau migrateur posé sur la tête d'une femme en pleine nuit
Ballpoint pen, color pencil, and wax on paper (calendar back)
33.5 × 49.5 cm
13¼ × 19½ in
Inscriptions: *C. / lementi / Personnage et oiseau / / canviar títol / oiseau migrateur posé sur la tête d'une Femme / en pleine nuit*
Collection of the Fundació Joan Miró, Barcelona
FJM 4003-4004

27.4 Personnage et oiseau
Ballpoint pen on paper (sketchbook "Escultures 1" 3534-3663)
21.2 × 31 cm
8⅜ × 12¼ in
Inscriptions: *Personnage et oiseau*
Collection of the Fundació Joan Miró, Barcelona
FJM 3566

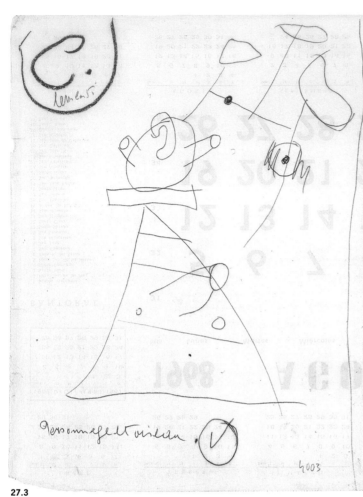

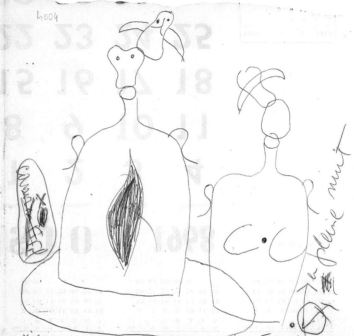

27.3

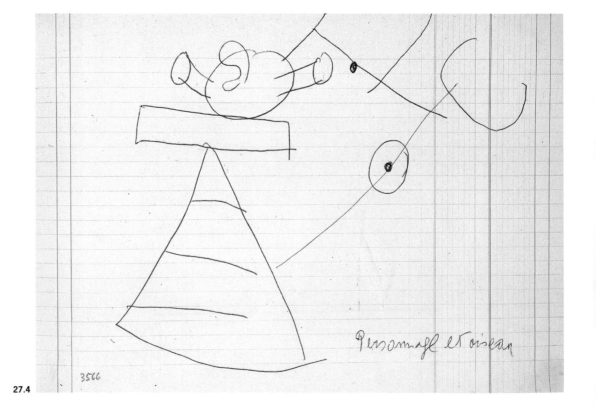

27.4

27.5 Untitled drawing
Ballpoint pen on paper
19 × 15.7 cm
7½ × 6¼ in
Inscriptions: *entièrement peint / (non à l'huile) / 3 éléments* [sic] */ acier / 15 m. / Texas*
Collection of the Fundació Pilar i Joan Miró a Mallorca
FPIJM DP-0679

27.6 Anonymous
Untitled mechanical drawing, c.1980
Graphite and wax color on paper
28 × 21.7 cm
11 × 8½ in
Inscriptions: *élément 1. couleur /* [élément] *2. couleur /* [élément] *3. couleur / les éléments rouges seront en bronze / la base triangulaire verte serait en / acier / ou / avec patine rouille* [sic] */* [avec patine] *peltre- / 1 / 2 / 3 / 148,5 cm. / 12. / 98 cm*
Collection of the Fundació Pilar i Joan Miró a Mallorca
FPIJM C-0429.3

27.7 Objecte
See 14.1 on page 130

27.5

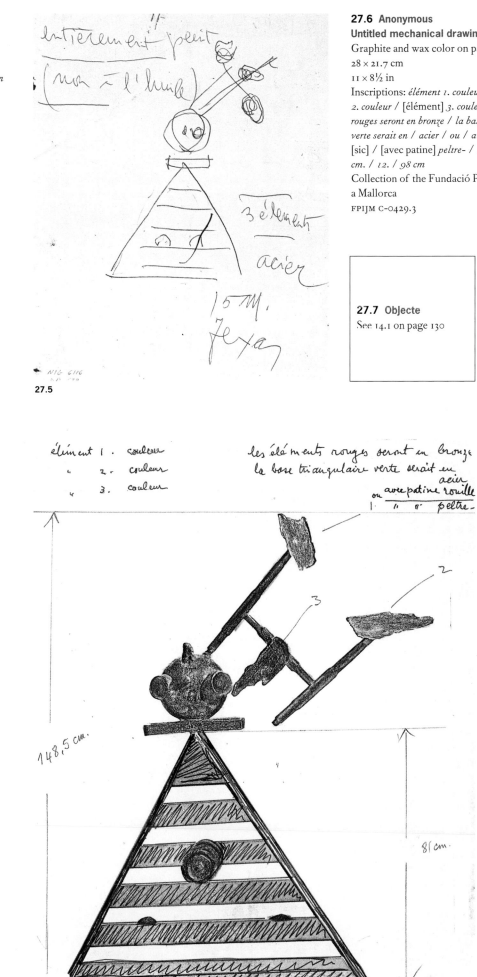

27.6

Checklist of the Exhibition

Femme et oiseau, 1967
Painted bronze
260 × 85 × 48 cm
102⅜ × 33½ × 18⅞ in
JT no. 57
Catalogue no. 1; not in exhibition
Foundry: Suisse-Fondeur, Arcueil
Four numbered examples

Untitled sketchbook drawing, 1958–1959
Ballpoint pen and wax color on paper (sketchbook Q I)
34.7 × 24.5 cm
13⅝ × 9⅝ in
Catalogue no. 1.1
Collection of the Fundació Pilar i Joan Miró a Mallorca
FPIJM DP-0779; Q I: p. 1

Femme assise, May 11, 1961
Ballpoint pen and graphite on paper
12.5 × 7.9 cm
4⅞ × 3⅛ in
Catalogue no. 1.2
Collection of the Fundació Pilar i Joan Miró a Mallorca
FPIJM DP-0617

Personnage, Femme assise, Personnage, February 13, 1962
Pencil on paper
29 × 42.5 cm
11⅜ × 16¾ in
Catalogue no. 1.3; not in exhibition
Collection of the Fundació Pilar i Joan Miró a Mallorca
FPIJM DP-0623

Untitled sketchbook drawing
Graphite on paper (sketchbook Q I)
24.5 × 34.9 cm
9⅝ × 13¾ in
Catalogue nos. 1.4, 6.2, 7.6
Collection of the Fundació Pilar i Joan Miró a Mallorca
FPIJM DP-0798; Q I: p. 11

Femme assise, November 24, 1963
Ballpoint pen on paper
12.4 × 8.0 cm
4⅞ × 3⅛ in
Catalogue no. 1.5
Collection of the Fundació Pilar i Joan Miró a Mallorca
FPIJM DP-0629

Untitled drawing, September 23, 1964
Ballpoint pen on paper
12.5 × 8.1 cm
4⅞ × 3¼ in
Catalogue no. 1.6
Collection of the Fundació Pilar i Joan Miró a Mallorca
FPIJM DP-0583

Femme assise et oiseau, September 11, 1964
Ballpoint pen on paper
12.6 × 8.1 cm
5 × 3¼ in
Catalogue no. 1.7
Collection of the Fundació Pilar i Joan Miró a Mallorca
FPIJM DP-0584

Untitled drawing, October 29, 1964
Ballpoint pen on paper
15.6 × 11.3 cm
6⅛ × 4½ in
Catalogue no. 1.8
Collection of the Fundació Pilar i Joan Miró a Mallorca
FPIJM DP-0582

Femme assise, November 17, 1964
Ballpoint pen on paper
19.8 × 15.1 cm
7¾ × 5⅞ in
Catalogue no. 1.9
Collection of the Fundació Pilar i Joan Miró a Mallorca
FPIJM DP-0581

Untitled drawing, January 10, 1965
Ballpoint pen on paper
19.6 × 14.9 cm
7¾ × 5⅞ in
Catalogue no. 1.10
Collection of the Fundació Pilar i Joan Miró a Mallorca
FPIJM DP-0580

Femme et oiseau
Ballpoint pen on paper (sketchbook "Escultures I" FJM 3534-3663)
19 × 15 cm
7½ × 5⅞ in
Catalogue no. 1.11
Collection of the Fundació Joan Miró, Barcelona
FJM 3628 (attached to FJM 3626-b)

Untitled drawing
Ballpoint pen, colored pencil, and graphite pencil on paper
33.2 × 48.9 cm
13 × 19¼ in
Catalogue nos. 1.12, 3.13, 8.7
Collection of the Fundació Joan Miró, Barcelona
FJM 4051-4052

Photograph by Casa Planas, retouched by Joan Miró
24.× 17.6 cm
9½ × 6⅞ in
Catalogue no. 1.13
Collection of the Fundació Joan Miró, Barcelona
FJM 4053

Femme et oiseau (also known as Tête et oiseau), 1967
Painted bronze
200 × 115 × 72 cm
78¾ × 45¼ × 28⅜ in
JT no. 85
Catalogue no. 2; not in exhibition
Foundry: T. Clémenti, Meudon
Four numbered examples

Untitled sketchbook drawing, October 7, 1959
Ballpoint pen and ink on cardboard (sketchbook Q I)
34.7 × 24.5 cm
13⅝ × 9⅝ in
Catalogue no. 2.1
Collection of the Fundació Pilar i Joan Miró a Mallorca
FPIJM DP-0791; Q I: p. 7

Untitled sketchbook drawing, October 7, 1959
Ballpoint pen on paper (sketchbook Q I)
24.5 cm × 34 cm
9¾ × 13½ in
Catalogue no. 2.2
Collection of the Fundació Pilar i Joan Miró a Mallorca
FPIJM D-0795; Q I: p. 9

Femme and Femme et oiseau
Graphite and ballpoint pen on paper (sketchbook Q III)
24.3 × 34.3 cm
9½ × 13½ in
Catalogue no. 2.3

Collection of the Fundació Pilar i Joan Miró a Mallorca
FPIJM DP-0840; Q III: p. 12

Femme et oiseau, Personnage, Sa majesté, Femme et oiseau, Personnage
Ballpoint pen, graphite pencil, and colored pencil on paper
33.2 × 48.8 cm
13 × 19¼ in
Catalogue no. 2.4, 4.3, 6.3, 7.7, 9.4
Collection of the Fundació Joan Miró, Barcelona
FJM 4005-4006

Femme et oiseau
Ballpoint pen on paper (sketchbook "Escultures I" FJM 3534-3663)
21.3 × 31 cm
8⅜ × 12¼ in
Catalogue no. 2.5
Collection of the Fundació Joan Miró, Barcelona
FJM 3547-a

La caresse d'un oiseau, 1967
Painted bronze
315 × 112 × 42 cm
124 × 44 × 16½ in
JT no. 86
Catalogue no. 3
Foundry: Suisse-Fondeur, Arcueil
Four numbered examples
The Eli and Edythe L. Broad Collection, Los Angeles
Edition 2/4

Fourche
Ballpoint pen on paper
12.4 × 8 cm
4⅞ × 3⅛ in
Catalogue no. 3.1
Collection of the Fundació Pilar i Joan Miró a Mallorca
FPIJM DP-0616

Untitled sketchbook drawing, 1958–1959
Ballpoint pen on paper (sketchbook Q I)
24.5 × 34.7 cm
9⅝ × 13⅜ in
Catalogue no. 3.2
Collection of the Fundació Pilar i Joan Miró a Mallorca
FPIJM DP-0801; Q I: p. 12 rev.

Untitled drawing, October 18, 1963
Ballpoint pen and pencil on paper
21.4 × 15.5 cm
8⅜ × 6⅛ in
Catalogue no. 3.3
Collection of the Fundació Pilar i
Joan Miró a Mallorca
FPIJM DP-0633

Femme et oiseau, November 1, 1963
Ink on paper
14.9 × 10 cm
5⅞ × 3⅞ in
Catalogue no. 3.4
Collection of the Fundació Pilar i
Joan Miró a Mallorca
FPIJM DP-0627

Femme et oiseau, November 27, 1963
Ballpoint pen on paper
18.2 × 9.7 cm
7⅛ × 3⅞ in
Catalogue no. 3.5
Collection of the Fundació Pilar i
Joan Miró a Mallorca
FPIJM DP-0628

Untitled drawing, March 10, 1964
Ballpoint pen on paper
15.5 × 12.3 cm
6⅛ × 4⅞ in
Catalogue no. 3.6
Collection of the Fundació Pilar i
Joan Miró a Mallorca
FPIJM DP-0634

Femme et oiseau, Personnage royal, Femme, December 5, 1963
Graphite on paper (sketchbook Q III)
24.3 × 34.3 cm
9½ × 13½ in
Catalogue no. 3.7
Collection of the Fundació Pilar i
Joan Miró a Mallorca
FPIJM DP-0835.2; Q III: p. 7

Untitled drawing, August 7, 1964
Ballpoint pen on paper
9 × 6 cm
3½ × 2⅜ in
Catalogue no. 3.8
Collection of the Fundació Pilar i
Joan Miró a Mallorca
FPIJM DP-0577

Untitled drawing, September 11, 1964
Ballpoint pen on paper
12.6 × 8.1 cm
5 × 3¼ in
Catalogue no. 3.9
Collection of the Fundació Pilar i
Joan Miró a Mallorca
FPIJM DP-0578

La caresse d'un oiseau, May 25, 1965
Ballpoint pen on paper (sketchbook
"Escultures I" FJM 3534-3663)
19 × 15 cm
7½ × 5⅞ in
Catalogue no. 3.10
Collection of the Fundació Joan
Miró, Barcelona
FJM 3623 (attached to FJM 3621-b)

Untitled drawing, July 24, 1964
Ballpoint pen and graphite on paper
20 × 15.1 cm
7⅞ × 5⅞ in
Catalogue no. 3.11
Collection of the Fundació Pilar i
Joan Miró a Mallorca
FPIJM DP-0579a

Untitled drawing
Ballpoint pen and colored pencil
on paper
42.5 × 31.8 cm
16¾ × 12½ in
Catalogue nos. 3.12, 14.4
Collection of the Fundació Joan
Miró, Barcelona
FJM 3989

Palma de Mallorca, photograph by Casa Planas, retouched by Joan Miró
24 × 17.6 cm
9½ × 6⅞ in
Catalogue no. 3.14
Collection of the Fundació Joan
Miró, Barcelona
FJM 4055

Photograph by Casa Planas, retouched by Joan Miró
24 × 17.6 cm
9½ × 6⅞ in
Catalogue no. 3.15
Collection of the Fundació Joan
Miró, Barcelona
FJM 4054

Personnage, 1967
Painted bronze
217 × 47 × 39 cm
85⅜ × 18½ × 15⅜ in
JT no. 87
Catalogue no. 4
Foundry: T. Clémenti, Meudon
Four numbered examples
Collection of the Fundació Joan
Miró, Barcelona
FJM 7269
Edition N 0

Personnage
Ballpoint pen on paper (sketchbook
"Escultures I" FJM 3534-3663)
21.2 × 31.3 cm
8⅜ × 12⅜ in
Catalogue no. 4.1
Collection of the Fundació Joan
Miró, Barcelona
FJM 3537-a

Photograph by Claude Gaspari
24 × 13 cm
9½ × 5⅛ in
Catalogue no. 4.2
Collection of the Fundació Joan
Miró, Barcelona
FJM 4047

Femme assise et enfant, 1967
Painted bronze
123 × 39 × 40 cm
48⅜ × 15⅜ × 15¾ in
JT no. 88
Catalogue no. 5
Foundry: T. Clémenti, Meudon
Four numbered examples
Collection of the Fundació Joan
Miró, Barcelona
FJM 7270
Edition N 0

Femme, Femme assise et enfant, April 25, 1967
Pen on paper (sketchbook
"Escultures I" 3534-3663)
19 × 15 cm
7½ × 5⅞ in
Catalogue no. 5.1
Collection of the Fundació Joan
Miró, Barcelona
FJM 3660 (attached to FJM 3659)

Photograph by Claude Gaspari, retouched by Joan Miró
24 × 18.3 cm
9½ × 7¼ in
Catalogue no. 5.2
Collection of the Fundació Joan
Miró, Barcelona
FJM 4038

Femme et oiseau, 1967
Painted bronze
135 × 50 × 42 cm
53⅛ × 19⅝ × 16½ in
JT no. 89
Catalogue no. 6
Foundry: T. Clémenti, Meudon
Four numbered examples
Acquavella Modern Art
Edition 3/4

Untitled drawing, September 27, 1960
Ink, graphite, and wax color on paper
16.1 × 24.8 cm
6⅜ × 9¾ in
Catalogue no. 6.1
Collection of the Fundació Pilar i
Joan Miró a Mallorca
FPIJM DP-0630

Untitled drawing, October 2, 1960
Ink on paper
21.2 × 13.8 cm
8⅜ × 5⅜ in
Catalogue no. 6.4
Collection of the Fundació Pilar i
Joan Miró a Mallorca
FPIJM DP-0632

Untitled drawing
Ballpoint pen on paper
9.8 × 17.3 cm
3⅞ × 6¾ in
Catalogue no. 6.5
Collection of the Fundació Pilar i
Joan Miró a Mallorca
FPIJM DP-0631

Femme et oiseau
Ballpoint pen on paper (sketchbook
"Escultures I," FJM 3534-3663)
21.3 × 31 cm
8⅜ × 12¼ in
Catalogue no. 6.6
Collection of the Fundació Joan
Miró, Barcelona
FJM 3550

Photograph by Claude Gaspari
24 × 13.4 cm
9½ × 5¼ in
Catalogue no. 6.7
Collection of the Fundació Joan
Miró, Barcelona
FJM 4043

Photograph by Claude Gaspari
24 × 15.3 cm
9½ × 6 in
Catalogue no. 6.8
Collection of the Fundació Joan
Miró, Barcelona
FJM 4044

Photograph by Claude Gaspari
24 × 15.3 cm
9½ × 6 in
Catalogue no. 6.9
Collection of the Fundació Joan
Miró, Barcelona
FJM 4042

Sa majesté, 1967–1968
Painted bronze
120 × 30 × 30 cm
47¼ × 11¾ × 11¾ in
JT no. 90
Catalogue no. 7
Foundry: T. Clémenti, Meudon
Four numbered examples
Acquavella Modern Art
Editon 3/4

Sa majesté
Graphite, colored wax pencil,
and ballpoint pen on paper
(sketchbook Q I)
24.5 × 34.9 cm
9⅝ × 13¾ in
Catalogue no. 7.1
Collection of the Fundació Pilar i
Joan Miró a Mallorca
FPIJM DP-0797; Q I: p. 10 rev.

**Personnage royal, Femme et
oiseau, Personnage, December 5,
1963**
Graphite on paper (sketchbook
Q III)
24.3 × 34.3 cm
9½ × 13½ in
Catalogue no. 7.2
Collection of the Fundació Pilar i
Joan Miró a Mallorca
FPIJM DP-0836; Q III: p. 8

Sa majesté
Pen on paper (sketchbook
"Escultures I" FJM 3534-3663)
21.2 × 31 cm
8⅜ × 12¼ in
Catalogue no. 7.3
Collection of the Fundació Joan
Miró, Barcelona
FJM 3538-a

Femme
Ballpoint pen on paper (sketchbook
"Escultures I," FJM 3534-3663)
21.3 × 31 cm
8⅜ × 12¼ in
Catalogue no. 7.4
Collection of the Fundació Joan
Miró, Barcelona
FJM 3646

Photograph by Claude Gaspari
23 × 18 cm
9 × 7 in
Catalogue no. 7.5
Collection of the Fundació Joan
Miró, Barcelona
FJM 4045

Photograph by Claude Gaspari
22.5 × 15 cm
8⅞ × 5⅞ in
Not in catalogue
Collection of the Fundació Joan
Miró, Barcelona
FJM 4046

Jeune fille s'évadant, 1968
Painted bronze
216 × 50 × 56 cm
85 × 19⅝ × 22 in
JT no. 110
Catalogue no. 8
Foundry: Suisse-Fondeur, Arcueil
Four numbered examples
Collection of the Fundació Joan
Miró, Barcelona
FJM 8650
Edition N 0

**Untitled drawing, November 25,
1964**
Ballpoint pen on paper
19.8 × 15.1 cm
7¾ × 5⅞ in
Catalogue no. 8.1
Collection of the Fundació Pilar i
Joan Miró a Mallorca
FPIJM DP-0587

**Untitled drawing, November 25,
1964**
Ballpoint pen on paper
19.8 × 15.1 cm
7¾ × 5⅞ in
Catalogue no. 8.2
Collection of the Fundació Pilar i
Joan Miró a Mallorca
FPIJM DP-0588

**Untitled drawing, November 25,
1964**
Ballpoint pen on paper
19.8 x 15.1 cm
7¾ x 5⅞ in
Not in catalogue
Collection of the Fundació Pilar i
Joan Miró a Mallorca
FPIJM DP-0588 rev.

**Untitled drawing, November 25,
1964**
Ballpoint pen on paper
19.8 × 15.2 cm
7¾ × 6 in
Catalogue no. 8.3
Collection of the Fundació Pilar i
Joan Miró a Mallorca
FPIJM DP-0593

Untitled drawing, February 1, 1965
Ballpoint pen on paper
19.9 × 15.1 cm
7⅞ × 5⅞ in
Catalogue no. 8.4
Collection of the Fundació Pilar i
Joan Miró a Mallorca
FPIJM DP-0585

Untitled drawing, February 1, 1965
Ballpoint pen on paper
19.9 × 15.1 cm
7⅞ × 5⅞ in
Catalogue no. 8.5
Collection of the Fundació Pilar i
Joan Miró a Mallorca
FPIJM DP-0586

Jeune fille s'évadant
Ballpoint pen on paper (sketchbook
"Escultures I" FJM 3534-3663)
19 × 15 cm
7½ × 5⅞ in
Catalogue no. 8.6
Collection of the Fundació Joan
Miró, Barcelona
FJM 3631

Personnage, 1968
Painted bronze
165 × 65 × 40 cm
65 × 25⅝ × 15¾ in
JT no. 111
Catalogue no. 9
Foundry: T. Clémenti, Meudon
Four numbered examples
Acquavella Modern Art
Edition 3/4

Personnage
Ballpoint pen on paper (sketchbook
"Escultures I" FJM 3534-3663)
21.2 × 31 cm
8⅜ × 12¼ in
Catalogue no. 9.1
Collection of the Fundació Joan
Miró, Barcelona
FJM 3543-a

Photograph by Claude Gaspari
24 × 16.8 cm
9½ × 6⅝ in
Catalogue no. 9.2
Collection of the Fundació Joan
Miró, Barcelona
FJM 4039

Photograph by Claude Gaspari
24 × 15.4 cm
9½ × 6 in
Catalogue no. 9.3
Collection of the Fundació Joan
Miró, Barcelona
FJM 4040

Monsieur et madame, 1969
Painted bronze
100 × 31 × 31 cm and 68 × 38 × 38 cm
39⅜ × 12¼ × 12¼ and 26¾ × 15 × 15 in
JT no. 122
Catalogue no. 10
Foundry: T. Clémenti, Meudon
Four numbered examples
Thomas Ammann Fine Art
Edition 3/4

Untitled drawing, July 7, 1967
Ballpoint pen and colored pencil on
paper
16 × 30.5 cm
6¼ × 12 in
Catalogue nos. 10.1, 17.2
Collection of the Fundació Joan
Miró, Barcelona
FJM 4026

Monsieur et madame
Ballpoint pen on paper
15.4 × 19.9 cm
6⅛ × 7⅞ in
Catalogue no. 10.2
Collection of the Fundació Pilar i
Joan Miró a Mallorca
FPIJM DP-0670

Untitled drawing
Ballpoint pen on paper
20.5 × 27.7 cm
8⅛ × 10⅞ in
Catalogue no. 10.3
Collection of the Fundació Joan
Miró, Barcelona
FJM 3999

Monsieur, madame
Ballpoint pen on paper (sketchbook
"Escultures 1" FJM 3534-3663)
21.3 × 31 cm
8⅜ × 12¼ in
Catalogue no. 10.4
Collection of the Fundació Joan
Miró, Barcelona
FJM 3640-a

**Homme et femme dans la nuit,
1969**
Painted bronze
78 × 45 × 45 and 87 × 32 × 32 cm
30¾ × 17¾ × 17¾ and 34¼ × 12⅝ ×
12⅝ in
JT no. 136
Catalogue no. 11; not in exhibition
Foundry: T. Clémenti, Meudon
Four numbered examples

Untitled drawing
Ballpoint pen on paper
20.5 × 27.7 cm
8⅛ × 10⅞ in
Catalogue no. 11.1
Collection of the Fundació Joan
Miró, Barcelona
FJM 4000

Homme et femme dans la nuit
Pen on paper (sketchbook
"Escultures 1" FJM 3534-3663)
21.3 × 31 cm
8⅜ × 12¼ in.
Catalogue no. 11.2
Collection of the Fundació Joan
Miró, Barcelona
FJM 3638-a

Femme échevelée, 1969
Painted bronze
70 × 72 × 41 cm
27½ × 28⅜ × 16⅛ in
JT no. 132
Catalogue no. 12
Foundry: T. Clémenti, Meudon
Four numbered examples
JPMorgan Chase Tower Collection
Edition 3/4

Femme, c. November 20, 1964?
Pen on paper (sketchbook
"Escultures 1" FJM 3534-3663)
21.2 × 31 cm
8⅜ × 12¼ in
Catalogue no. 12.1
Collection of the Fundació Joan
Miró, Barcelona
FJM 3634-b

Femme et oiseau, 1969
Bronze
160 × 34 × 30 cm
63 × 13⅜ × 11¾ in
JT no. 140
Catalogue no. 13; not in exhibition
Foundry: T. Clémenti, Meudon
Two numbered examples

Femme, c. November 20, 1964?
Ballpoint pen on paper (sketchbook,
"Escultures 1" FJM 3534-3663)
21.2 × 31 cm
8⅜ × 12¼ in.
Not in catalogue
Collection of the Fundació Joan
Miró, Barcelona
FJM 3632

Femme
Ballpoint pen on paper (sketchbook
"Escultures 1," FJM 3534-3663)
21.2 × 31 cm
8⅜ × 12¼ in
Not in catalogue
Collection of the Fundació Joan
Miró, Barcelona
FJM 3644-b

Femme et oiseau, 1971
Painted bronze
78 × 42 × 42 cm
30¾ × 16½ × 16½ in
JT no. 196
Catalogue no. 14
Foundry: Valsuani et Fils, Bagneux

Two numbered examples
Marcel Elefant, Monte Carlo, Monaco
Edition 2/2

Objecte
Ballpoint pen on paper (sketchbook
Q 1)
24.5 × 34 cm
9⅜ × 13⅜ in
Catalogue nos. 14.1, 27.7
Collection of the Fundació Pilar i
Joan Miró a Mallorca
FPIJM DP-0799; Q 1: p.11 rev.

**Femme et oiseau, December 31,
1970**
Ballpoint pen and colored pencil
on paper
21.1 × 29.7 cm
8¼ × 11¾ in
Catalogue no. 14.2
Collection of the Fundació Joan
Miró, Barcelona
FJM 3963

Personnage
Ballpoint pen on paper (sketchbook
FJM 3664-3719)
21.2 × 31 cm
8⅜ × 12¼ in
Catalogue no. 14.3
Collection of the Fundació Joan
Miró, Barcelona
FJM 3686-b

Oiseau sur un rocher, 1971
Painted bronze
44 × 36 × 21 cm.
17⅜ × 14¼ × 8¼ in
JT no. 197
Catalogue no. 15; not in exhibition
Foundry: Valsuani et Fils, Bagneux
Two numbered examples

**Oiseau sur un rocher, December 4,
1971**
Ballpoint pen on paper
21.1 × 15 cm
8¼ × 5⅞ in
Catalogue no. 15.1
Collection of the Fundació Joan
Miró, Barcelona
FJM 3982

Oiseau sur un rocher
Ballpoint pen on paper (sketchbook
FJM 3664-3719)

21.2 × 31 cm
8⅜ × 12¼ in
Catalogue no. 15.2
Collection of the Fundació Joan Miró,
Barcelona
FJM 3711-b

Femme, 1971
Painted bronze
51 × 44 × 29 cm
20⅛ × 17⅜ × 11⅜ in
JT no. 198
Catalogue no. 16; not in exhibition
Foundry: Valsuani et Fils, Bagneux
Two numbered examples

Projet pour un monument II. Femme
Ballpoint pen and colored pencil
on paper
33.5 × 27.5 cm
13¼ × 10⅞ in
Catalogue nos. 16.1, 22.1
Collection of the Fundació Joan
Miró, Barcelona
FJM 3985

Femme
Ballpoint pen on paper (sketchbook
FJM 3664-3719)
21.2 × 31 cm
8⅜ × 12¼ in
Catalogue no. 16.2
Collection of the Fundació Joan
Miró, Barcelona
FJM 3718-b

Femme
Ballpoint pen on paper (sketchbook
FJM 3664-3719)
21.2 × 32 cm
8⅜ × 12⅝ in
Catalogue no. 16.3
Collection of the Fundació Joan
Miró, Barcelona
FJM 3704-b

Femme, 1971
Painted bronze
65.5 × 14.5 × 7.5 cm.
25¾ × 5¾ × 3 in
JT no. 199
Catalogue no. 17
Foundry: Valsuani et Fils
Two numbered examples
Collection of Mme Sylvie Baltazart-
Eon, Paris
Edition 2/2

Femme, March 22, 1971
Ballpoint pen and colored pencil
on paper
33.7 × 25.5 cm
13¼ × 10 in
Catalogue no. 17.1
Collection of the Fundació Joan
Miró, Barcelona
FJM 3983

Personnage, 1972
Painted synthetic resin
225 × 345 × 160 cm
88⅝ × 135⅞ × 63 in
JT no. 225
Catalogue no. 18; not in exhibition
Reproduction: Haligon, Périgny-
sur-Yerres
One example
Location unknown

Projet pour un monument, 1972
Plaster
51 × 38.5 × 25 cm
20⅛ × 15⅛ × 9⅞ in
JT no. 226
Catalogue no. 19a; not in exhibition
Reproduction: Haligon, Périgny-
sur-Yerres
One example
Location unknown

**Projet pour un monument,
1972–1979**
Plaster
51 × 38.5 × 25 cm
20⅛ × 15⅛ × 9⅞ in
JT no. 300 (second state of
JT no. 226)
Catalogue no. 19b
Reproduction: Haligon, Périgny-
sur-Yerres
One example
Acquavella Modern Art

**Projet pour un monument,
1979–1985**
Painted bronze
51 × 38.5 × 25 cm
20⅛ × 15⅛ × 9⅞ in
Based on JT no. 226
Catalogue no. 19c; not in exhibition
Foundry: Bonvicini, Verona
Six numbered examples

**Untitled sketchbook drawing,
September 29, 1958**
Ballpoint pen and wax color on paper
(sketchbook drawing)
24.5 × 34.7 cm
9⅝ × 13⅝ in
Catalogue no. 19.1
Collection of the Fundació Pilar i
Joan Miró a Mallorca
FPIJM DP-0785: Q I: p. 4

**Femme s'adressant à la foule,
November 2, 1971**
Ballpoint pen on paper (envelope)
26.5 × 22.5 cm
10⅜ × 8⅞ in
Catalogue no. 19.2
Collection of the Fundació Pilar i
Joan Miró a Mallorca
FPIJM DP-0004

**Untitled drawing, November 3,
1971**
Ballpoint pen and wax color on paper
15.5 × 19.8 cm
6⅛ × 7¾ in
Catalogue no. 19.3
Collection of the Fundació Pilar i
Joan Miró a Mallorca
FPIJM DP-0002

**Untitled drawing, November 3,
1971**
Ballpoint pen and wax color on paper
15.5 × 19.8 cm
6⅛ × 7¾ in
Catalogue no. 19.4
Collection of the Fundació Pilar i
Joan Miró a Mallorca
FPIJM DP-0003

**Femme devant la foule,
November 4, 1971**
Ballpoint pen and wax color on paper
15.4 × 19.7 cm
6 × 7¾ in
Catalogue no. 19.5
Collection of the Fundació Pilar i
Joan Miró a Mallorca
FPIJM DP-0001

Untitled drawing
Ballpoint pen and wax color
on paper
21 × 29.6 cm
8¼ × 11⅝ in
Catalogue no. 19.6

Collection of the Fundació Pilar i
Joan Miró a Mallorca
FPIJM DP-0438

Untitled drawing
Ballpoint pen and wax color
on paper
15.9 × 10.9 cm
6¼ × 4¼ in
Catalogue no. 19.7
Collection of the Fundació Pilar i
Joan Miró a Mallorca
FPIJM DP-0213

Untitled drawing
Ballpoint pen on paper
29.7 × 21 cm
11¾ × 8¼ in
Catalogue no. 19.8
Collection of the Fundació Pilar i
Joan Miró a Mallorca
FPIJM DP-0449

Maternité
Ballpoint pen on paper
20 × 21 cm
7⅞ × 8¼ in
Catalogue no. 19.9
Collection of the Fundació Pilar i
Joan Miró a Mallorca
FPIJM DP-0452

Photograph
12.8 × 8.8 cm
5 × 3½ in
Catalogue no. 19.10
Collection of the Fundació Joan
Miró, Barcelona
FJM 3927

Photomontage
Photography and ballpoint pen
on paper
25.2 × 20.6 cm
9⅞ × 8⅛ in
Catalogue no. 19.11
Collection of the Fundació Pilar i
Joan Miró a Mallorca
FPIJM DP-1251 bis

Photograph
20.4 × 25.3 cm
8 × 10 in
Catalogue no. 19.12
Collection of the Fundació Joan
Miró, Barcelona
FJM 3870

Photomontage
Photography and ballpoint pen
on paper
20.4 × 25.3 cm
8 × 10 in
Catalogue no. 19.13
Collection of the Fundació Pilar i
Joan Miró a Mallorca
FPIJM DP-1251

Photograph
12.8 × 8.8 cm
5 × 3½ in
Not in catalogue
Collection of the Fundació Joan
Miró, Barcelona
FJM 3930

Photograph
12.8 × 8.8 cm
5 × 3½ in
Not in catalogue
Collection of the Fundació Joan
Miró, Barcelona
FJM 3931

Photograph
12.8 × 8.8 cm
5 × 3½ in
Not in catalogue
Collection of the Fundació Joan
Miró, Barcelona
FJM 3932

Femme
Ballpoint pen on paper
20.7 × 15 cm
8⅛ × 5⅞ in
Not in catalogue
Collection of the Fundació Pilar i
Joan Miró a Mallorca
FPIJM DP-0421

Untitled drawing
Graphite and ballpoint pen on paper
29.8 × 21 cm
11¾ × 8¼ in
Not in catalogue
Collection of the Fundació Pilar i
Joan Miró a Mallorca
FPIJM DP-0719.1

Personnage, 1972
Painted resin
206 × 289 × 245 cm
81⅛ × 113¾ × 96½ in
JT no. 237

Catalogue no. 20; not in exhibition
Reproduction: Haligon, Périgny-
sur-Yerres
One example
The Hakone Open-Air Museum

Personnage, 1972
Painted resin
320 × 120 × 100 cm.
126 × 47¼ × 39⅜ in
JT no. 238
Catalogue no. 21; not in exhibition
Reproduction: Haligon, Périgny-
sur-Yerres
One example
Fondation Maeght

Femme, August 9, 1977
Ballpoint pen on paper
17.6 × 22.2 cm
6⅞ × 8¾ in
Catalogue no. 21.1
Collection of the Fundació Pilar i
Joan Miró a Mallorca
FPIJM DP-0214

Projet pour un monument, 1973
Painted bronze
133 × 22 × 28 cm.
52⅜ × 8⅝ × 11 in
JT no. 259
Catalogue no. 22; not in exhibition
Foundry: Valsuani et Fils, Bagneux
Two numbered examples

Femme, 1973
Painted bronze
145 × 29 × 19 cm
57⅛ × 11⅜ × 7½ in
JT no. 260
Catalogue no. 23; not in exhibition
Foundry: Valsuani et Fils, Bagneux
Two numbered examples

Femme, March 22, 1971
Ballpoint pen and colored pencil
on paper
31.4 × 21.6 cm
12⅜ × 8½ in
Catalogue no. 23.1
Collection of the Fundació Joan
Miró, Barcelona
FJM 3980

Femme
Ballpoint pen on paper (sketchbook
3664-3719)

21.2 × 32 cm
8⅜ × 12½ in
Catalogue no. 23.2
Collection of the Fundació Joan
Miró, Barcelona
FJM 3685-b

Femme
Ballpoint pen on paper (sketchbook
3664-3719)
21.2 × 32 cm
8⅜ × 12½ in
Catalogue no. 23.3
Collection of the Fundació Joan
Miró, Barcelona
FJM 3701-b

Personnage, 1974
Resin
190 × 152 × 173 cm
74¾ × 59⅞ × 68⅛ in
JT no. 264
Catalogue no. 24; not in exhibition
Reproduction: Haligon, Périgny-
sur-Yerres
One example
Location unknown

Personnage
Ballpoint pen on paper (sketchbook
FJM 3664-3719)
21.2 × 31 cm
8⅜ × 12¼ in
Catalogue no. 24.1
Collection of the Fundació Joan
Miró, Barcelona
FJM 3671-b

Personnage
Ballpoint pen on paper (sketchbook
FJM 3664-3719)
21.2 × 31 cm
8⅜ × 12¼ in
Catalogue no. 24.2
Collection of the Fundació Joan
Miró, Barcelona
FJM 3715

Untitled drawing
Ballpoint pen and wax color
and pencil
16.5 × 18.5 cm
6½ × 7¼ in
Catalogue no. 24.3
Collection of the Fundació Pilar i
Joan Miró a Mallorca
FPIJM DP-0040

Untitled drawing
Ballpoint pen and wax color
on paper
16.5 × 18.5 cm
6½ × 7¼ in
Catalogue no. 24.4
Collection of the Fundació Pilar i
Joan Miró a Mallorca
FPIJM DP-0040 rev.

Untitled drawing
Ballpoint pen and wax color
on paper
19.8 × 15.5 cm
7¾ × 6⅛ in
Catalogue no. 24.5
Collection of the Fundació Joan
Miró, Barcelona
FJM 3846

Personnage
Ballpoint pen on paper
19.5 × 13.5 cm
7½ × 5⅜ in
Catalogue no. 24.6
Collection of the Fundació Joan
Miró, Barcelona
FJM 3840

Femme, oiseaux
Ballpoint pen and wax color
on paper
12.6 × 8 cm
5 × 3⅛ in
Catalogue no. 24.7
Collection of the Fundació Pilar i
Joan Miró a Mallorca
FPIJM DP-0697

Femme, Personnage
Ballpoint pen on paper
15 × 21.1 cm
5⅞ × 8¼ in
Catalogue no. 24.8
Collection of the Fundació Joan
Miró, Barcelona
FJM 3969

Personnage, October 30, 1971
Ballpoint pen, wax color and
graphite on paper
25.9 × 20.6 cm
10¼ × 8⅛ in
Catalogue no. 24.9
Collection of the Fundació Pilar i
Joan Miró a Mallorca
FPIJM DP-0014

Le Père Ubu, 1974
Painted synthetic resin
180 × 150 × 145 cm
70⅞ × 59 × 57 in
JT no. 265
Catalogue no. 25; not in exhibition
Reproduction: Haligon, Périgny-
sur-Yerres
One example
Helly Nahmad Galleries, London

Le Père Ubu II, March 26, 1973
Ballpoint pen on paper
15.5 × 19.8 cm
6⅛ × 7¾ in
Catalogue no. 25.1
Collection of the Fundació Joan Miró,
Barcelona
FJM 3849

Personnage, October 30, 1971
Le Père Ubu, March 27, 1973
Ballpoint pen on paper (sketchbook Q VIII)
31 × 21.5 cm
12¼ × 8½ in
Catalogue no. 25.2
Collection of the Fundació Pilar i Joan
Miró a Mallorca
FPIJM DP-0893 Q VIII; p. 4

Photograph
19.9 × 17.5 cm
7⅞ × 6⅞ in
Catalogue no. 25.3
Collection of the Fundació Joan Miró,
Barcelona
FJM 3850

Personnage, 1974
Resin
374 × 90 × 90 cm
147¼ × 35⅜ × 35⅜ in
JT no. 266
Catalogue no. 26
Reproduction: Haligon, Périgny-
sur-Yerres
One example
"Colección Testimonio" de "la Caixa,"
Barcelona

Femme, October 26, 1971
Ballpoint pen on paper
19.9 × 15.5 cm
7⅞ × 6⅛ in
Catalogue no. 26.1
Collection of the Fundació Joan Miró,
Barcelona
FJM 3938

Untitled drawing
Ballpoint pen on paper
18.3 × 5.7 cm
7¼ × 2¼ in
Catalogue no. 26.2
Collection of the Fundació Pilar i
Joan Miró a Mallorca
FPIJM DP-0041

**Untitled drawing, September 22,
1972**
Ballpoint pen and wax color on
paper (sketchbook Q VI)
29.5 × 19.7 cm
11⅞ × 7¾ in
Catalogue no. 26.3
Collection of the Fundació Pilar i
Joan Miró a Mallorca
FPIJM DP-0877 Q VI: p. 2

**Maquette for Personnage et
oiseaux, 1980**
Painted wood
73.7 × 61 × 22.9 cm
29 × 24 × 9 in
Catalogue no. 27
Museum of Fine Arts, Houston;
Gift of Texas Commerce
Bankshares, Inc., Gerald D. Hines
Interest and United Energy
Resources, Inc.

**Untitled drawing, September 19,
1959**
Ballpoint pen and ink on cardboard
(sketchbook Q I)
24.5 × 34.7 cm
9⅝ × 13⅝ in
Catalogue no. 27.1
Collection of the Fundació Pilar i
Joan Miró a Mallorca
FPIJM DP-0790; Q I: p. 6 verso

**Femme et oiseau, Tête, Femme,
Personnage, Objecte personnage,
December 5, 1963**
Graphite on paper (sketchbook
Q III)
24.3 × 34.3 cm
9½ × 13½ in
Catalogue no. 27.2
Collection of the Fundació Pilar i
Joan Miró a Mallorca
FPIJM DP-0841; Q III: p. 13

**Personnage et oiseau. Oiseau
migrateur posé sur la tête d'une
femme en pleine nuit**
Ballpoint pen, color pencil, and wax
on paper
33.5 × 49.5 cm
13¼ × 19½ in
Catalogue no. 27.3
Collection of the Fundació Joan Miró,
Barcelona
FJM 4003-4004

Personnage et oiseau
Ballpoint pen on paper (sketchbook
"Esculteres I" 3534-3663)
21.2 × 31 cm
8⅜ × 12¼ in
Catalogue no. 27.4
Collection of the Fundació Joan Miró,
Barcelona
FJM 3566

Untitled drawing
Ballpoint pen on paper
19 × 15.7 cm
7½ × 6¼ in
Catalogue no. 27.5
Collection of the Fundació Pilar i Joan
Miró a Mallorca
FPIJM DP-0679

Telegram from New York
Not in catalogue
Collection of the Fundació Pilar i Joan
Miró a Mallorca
FPIJM DP-0679 rev.

Anonymous
Untitled mechanical drawing, c.1980
Graphite and wax color on paper
28 × 21.7 cm
11 × 8½ in
Catalogue no. 27.6
Collection of the Fundació Pilar i Joan
Miró a Mallorca
FPIJM C-0429.3

**Technical note about sculpture,
December 5, 1963**
Ink, pencil, wax pencil (sketchbook
Q III)
34.5 x 24 cm
13⅜ x 9½ in
Not in catalogue
Collection of the Fundació Pilar i Joan
Miró a Mallorca
FPIJM D-3674, Q III; p. 4

Sketchbook pages on the checklist
are taken from the following:

Esculteres I, 1964–1969
Collection of the Fundació Joan
Miró, Barcelona
FJM 3534-3663

Sketchbook
Collection of the Fundació Joan
Miró, Barcelona
FJM 3664-3719

Sketchbook Q I
Collection of the Fundació Pilar i
Joan Miró a Mallorca

Sketchbook Q III
Collection of the Fundació Pilar i
Joan Miró a Mallorca

Sketchbook Q VI
Collection of the Fundació Pilar i
Joan Miró a Mallorca

Sketchbook Q VIII
Collection of the Fundació Pilar i
Joan Miró a Mallorca

Selected Bibliography

This bibliography concentrates on works most relevant to Miró's painted sculptures. Lists of publications that cover the artist's entire *œuvre* may be found in Jeffett 1992 and Lanchner 1993.

Dupin, Jacques. *Miró*. Barcelona and New York: Ediciones Polígrafa, S.A. and Harry N. Abrams, Inc., Publishers, 1993.

Dupin, Jacques, Dean Swanson, and Joan Miró. Walker Art Center. *Miró Sculptures*, exh.cat. Minneapolis: Walker Art Center, 1971.

Fundació Joan Miró. *Obra de Joan Miró: Dibuixos, pintura, escultura, ceràmica, tèxtils*. Barcelona: Fundació Joan Miró–Centre d'Estudis d'Art Contemporani, 1988.

Greenberg, Clement. *Joan Miró*. New York: The Quadrangle Press, 1948. Reprint. New York: Arno Press, 1969.

Griswold, William M. and Jennifer Tonkovich. *Pierre Matisse and his Artists*, exh.cat. New York: The Pierpont Morgan Library, 2002.

Jeffett, William. *Joan Miró: Sculpture*, exh.cat. London: South Bank Centre, 1990.

Jeffett, William. *Poesia a l'Espai: Miró i l'Escultura*, exh.cat. Mallorca: Fundació Pilar i Joan Miró a Mallorca, 1996.

Jeffett, William. *Sculpture into Objects; Objects into Sculpture: A Study of the Sculpture of Joan Miró in the Context of the Parisian and Catalan Avant-gardes, 1928–1983*. London: University of London, Courtauld Institute, Ph.D. thesis, 1992.

Jouffroy, Alain and Joan Teixidor. *Miró Sculptures*. Paris: Maeght Éditeur. 1980.

Krauss, Rosalind and Margit Rowell. *Joan Miró: Magnetic Fields*, exh.cat. New York: The Solomon R. Guggenheim Foundation, 1972.

Carolyn Lanchner. *Joan Miró*, exh.cat. New York: The Museum of Modern Art, 1993.

Malet, Rosa Maria and William Jeffett. *Joan Miró: Paintings and Drawings*, exh.cat. London: Whitechapel Art Gallery, 1992. Also published as *Impactes: Joan Miró 1929–1941*. Barcelona: Fundació Joan Miró, 1988.

Malet, Rosa Maria and William Jeffett. *Miró: Matière et couleur*, exh.cat. Lausanne: Musée Olympique, 1994.

Miró, Joan. *Joan Miró: Selected Writings and Interviews*. Margit Rowell (ed.). Boston: G. K. Hall & Co., 1986.

Moure, Gloria. *Miró Escultor*, exh.cat. Barcelona: Fundació Joan Miró–Centre d'Estudis d'Art Contemporani, 1987.

Raillard, Georges. *Ceci est la couleur de mes rêves: Entretiens avec Joan Miró*. Paris: Seuil, 1977.

Rose, Barbara. *Miró in America*, exh.cat. Houston: The Museum of Fine Arts, 1982.

Rowell, Margit. *The Last Bronze Sculptures, 1981–1983*, exh.cat. New York: Pierre Matisse Gallery, 1987.

Rubin, William S. *Dada, Surrealism, and their Heritage*, exh.cat. New York: The Museum of Modern Art, 1968.

Rubin, William. *Miró in the Collection of the Museum of Modern Art*, exh.cat. New York: The Museum of Modern Art, 1973.

Russell, John. *Joan Miró: Sculpture in Bronze and Ceramic, 1967–1969, Recent Etchings and Lithographs*, exh.cat. New York: Pierre Matisse Gallery, 1970.

Russell, John. *Matisse: Father and Son*. New York: Harry N. Abrams, Inc., Publishers, 1999.

Schjeldahl, Peter. *Toward a New Miró*, exh.cat. New York: The Pace Gallery, 1984.

Sert, Josep Lluís. *Miró: Sculpture*, exh.cat. New York: Pierre Matisse Gallery, 1976.

Sert, Josep Lluís. *Miró: Painted Sculpture and Ceramics*, exh.cat. New York: Pierre Matisse Gallery, 1980.

Soby, James Thrall. *Joan Miró*, exh.cat. New York: The Museum of Modern Art, 1959.

Sweeney, James Johnson. *Joan Miró*, exh.cat. New York: The Museum of Modern Art, 1941.